Edward Steichen

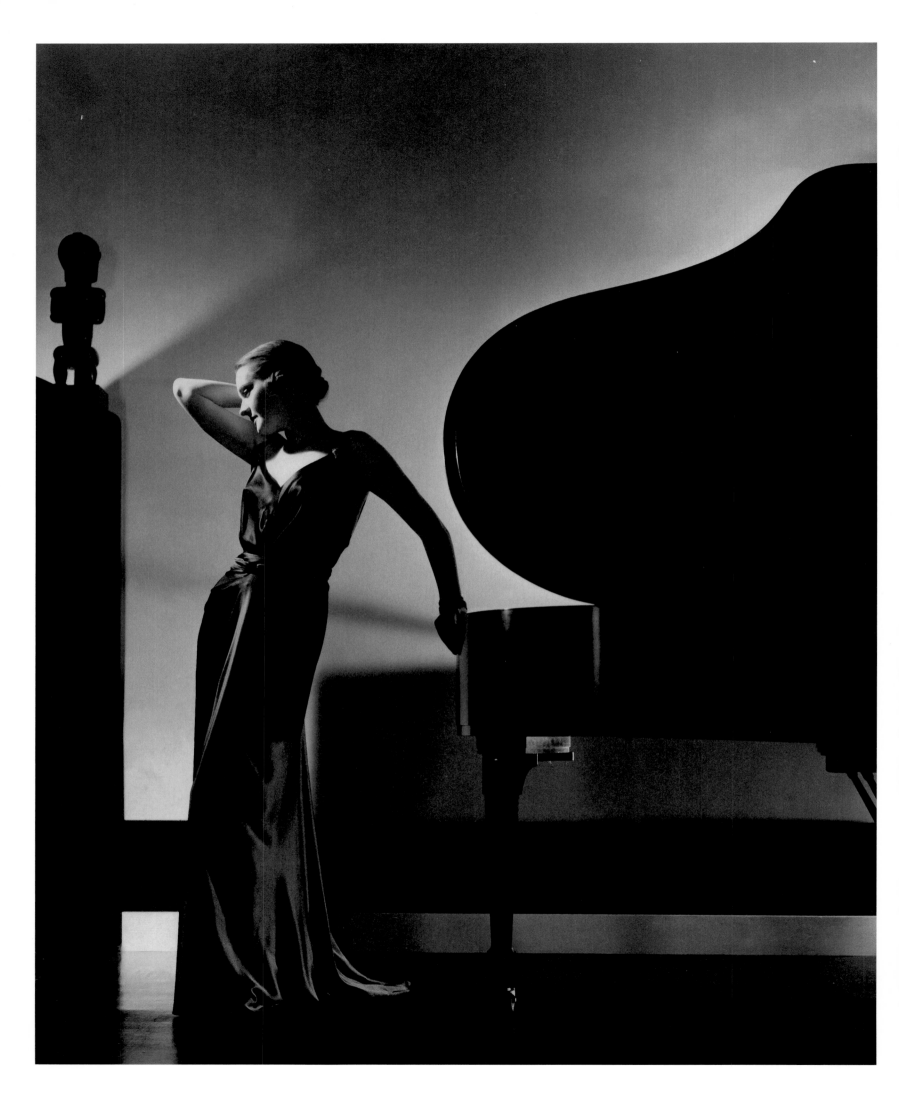

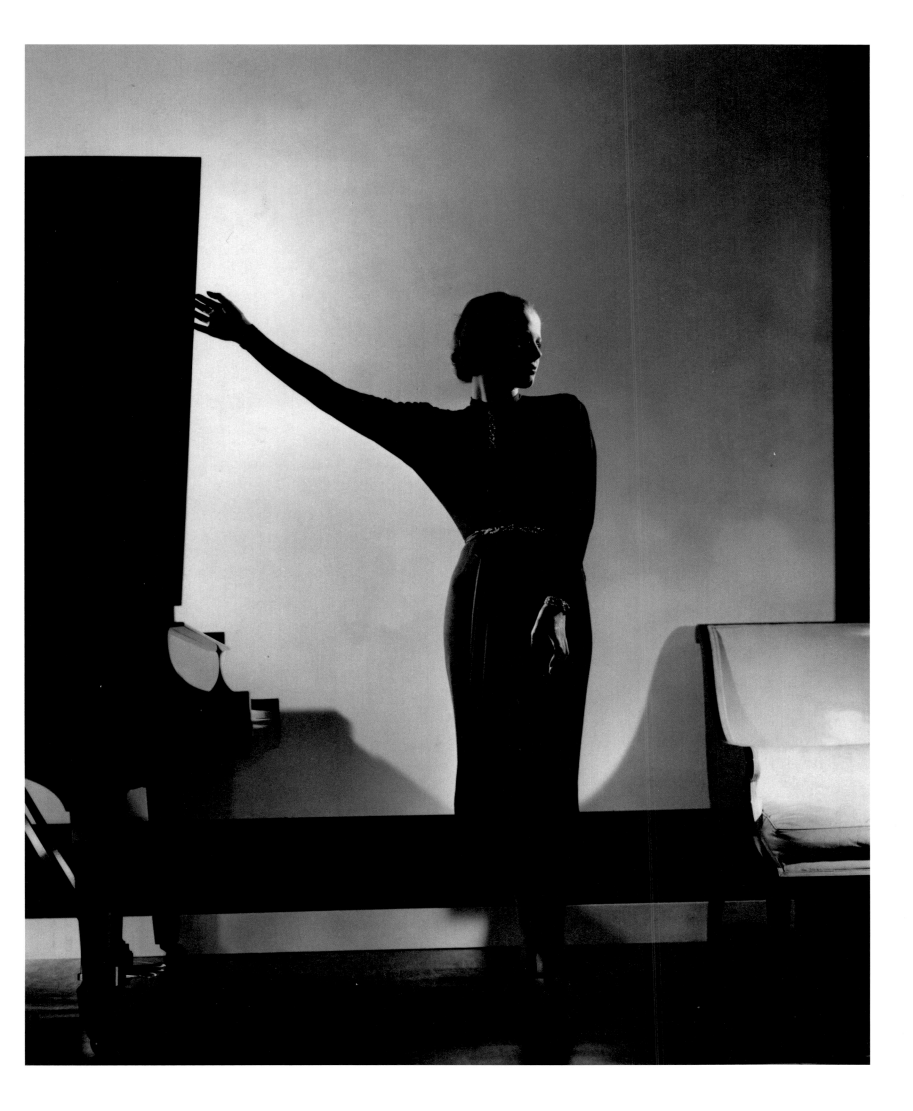

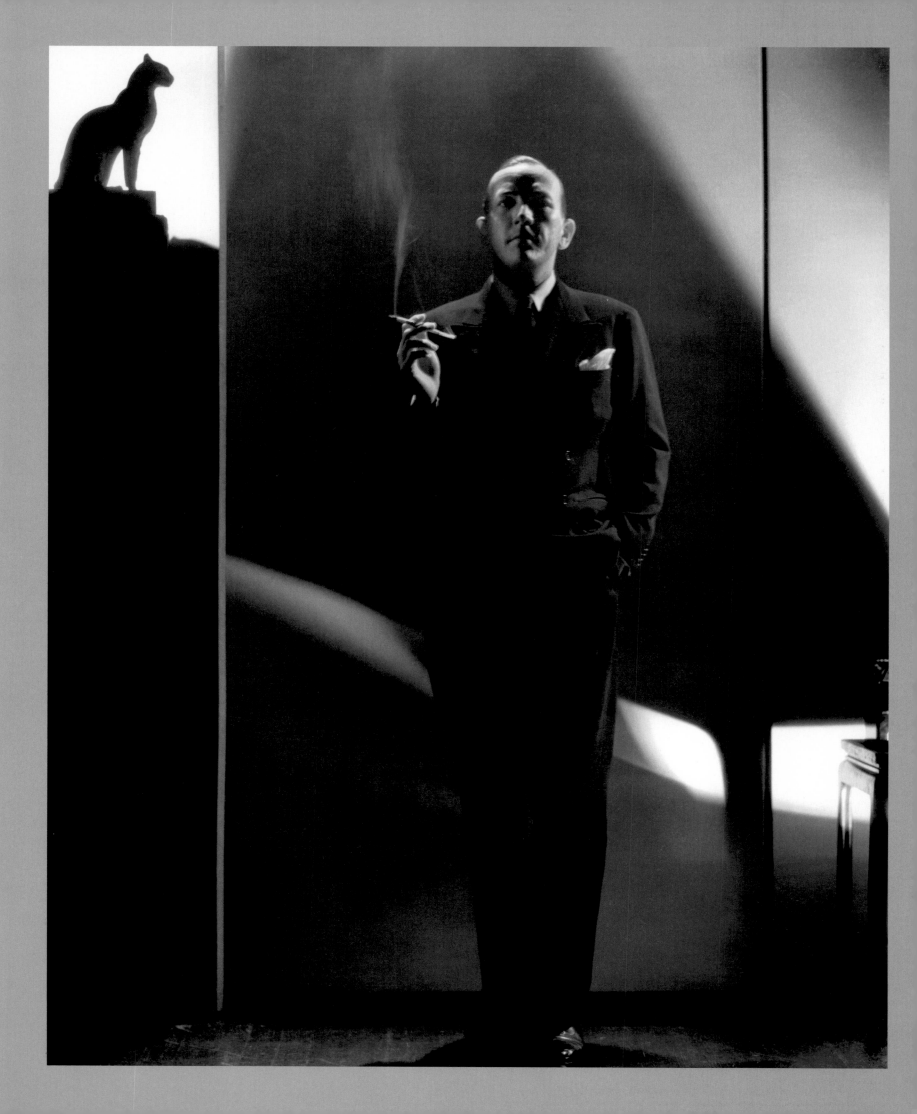

Edward Steichen

In High Fashion
The Condé Nast Years
1923–1937

William A. Ewing and Todd Brandow

WITH ESSAYS BY

Tobia Bezzola

William A. Ewing

Nathalie Herschdorfer

Carol Squiers

Foundation for the Exhibition of Photography, Minneapolis,

and the Musée de l'Elysée, Lausanne

This book was published on the occasion of the exhibition *Edward Steichen: In High Fashion, The Condé Nast Years, 1923–1937*, organized by the Foundation for the Exhibition of Photography, Minneapolis, and the Musée de l'Elysée, Lausanne.

Exhibition Itinerary

Jeu de Paume, Paris
October 9–December 30, 2007

Kunsthaus Zürich, Zürich
January 11–March 30, 2008

Chiostri di San Domenico, Reggio Emilia
April 15–June 8, 2008

Museo del Traje, Madrid
June 24–September 22, 2008

Kunstmuseum Wolfsburg, Wolfsburg
October 10, 2008–January 1, 2009

International Center of Photography, New York
January 16–May 3, 2009

Williams College Museum of Art, Williamstown, Massachusetts
Summer 2009

Art Gallery of Ontario, Toronto
Fall 2009

© 2008 FEP Editions LLC
4027 Zenith Avenue South
Minneapolis, MN 55410
www.fepeditions.com

"Lights Going All Over the Place" © 2008 Tobia Bezzola; "A Perfect Conjunction" © 2008 William A. Ewing; "In the Days of Chic" © 2008 Nathalie Herschdorfer; "Edward Steichen at Condé Nast Publications" © 2008 Carol Squiers

All rights reserved. No part of this publication may be reproduced or transmitted in any form or by any means, electronic or mechanical, including photocopy, recording, or any other information storage and retrieval system, or otherwise without express written permission of FEP Editions LLC.

Library of Congress Cataloging-in-Publication Data

Ewing, William A.
 Edward Steichen : in high fashion, the Condé Nast years, 1923–1937 / William A. Ewing and Todd Brandow ; with essays by Tobia Bezzola ... [et al.].
 p. : ill. (some col.) ; cm.
 Published on the occasion of the exhibition Edward Steichen: In high fashion, 1923–1937, organized by the Foundation for the Exhibition of Photography, Minneapolis, and the Musée de l'Elysée, Lausanne, and exhibiting at various museums October 9, 2007–May 3, 2009.
 Includes index.
 ISBN-13: 978-0-393-06677-7
 ISBN-13: 978-0-9796125-0-3
 ISBN-10: 0-9796125-0-0

1. Steichen, Edward, 1879–1973—Exhibitions. 2. Photography, Artistic—Exhibitions. 3. Photographers—United States—20th century. I. Brandow, Todd. II. Bezzola, Tobia. III. Condé Nast Press. IV. Foundation for the Exhibition of Photography. V. Musée de l'Elysée (Lausanne, Switzerland) VI. Title.

TR647 .S748 2007b
779/.092

The paper in this book meets the guidelines for permanence and durability of the Committee on Production Guidelines for Book Longevity of the Council on Library Resources.

1 2 3 4 5 6 7 8 9 0

Front cover: Actress Mary Heberden, 1935 (Fig. 225)
Back cover: Actor Conrad Veidt, 1929 (Fig. 103)
Pages 2 and 3: "Black": Model Margaret Horan in a black dress by Jay-Thorpe (left) and model Frances Douelon in a black jersey dress (right), 1935
Page 4: Actor and playwright Noel Coward, 1932
Page 8: Actress Clara Bow, 1929
Page 36: Actress Joan Clement, 1924
Page 120: Model Marion Morehouse in a dress by Louiseboulanger with jewelry by Mauboussin, 1929
Page 198: Mrs. Harold E. Talbott, Westbury, Long Island, 1934
Quotation on page 9: Edward Steichen in "Profile: Commander with a Camera," by Matthew Josephson, *New Yorker*, June 17, 1944, p. 37

Printed and bound in Italy

Contents

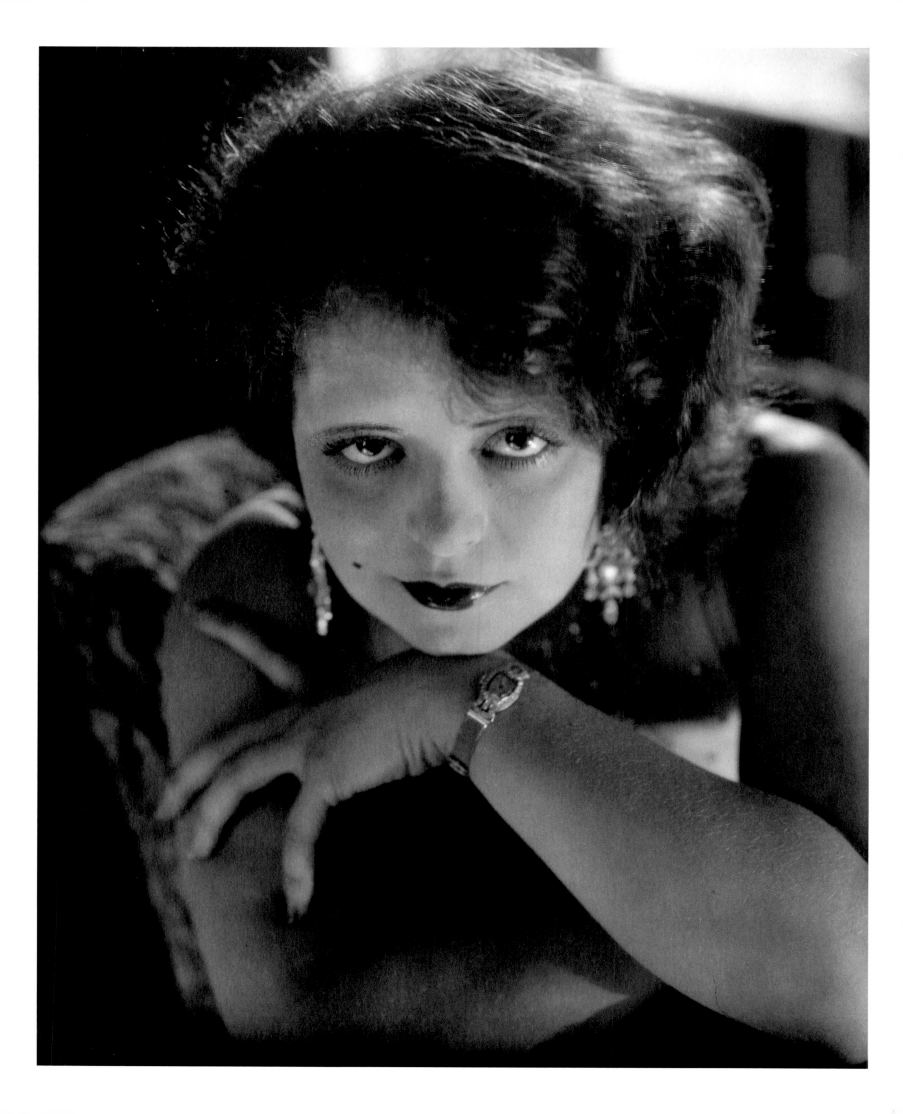

I wanted to work with business, like an engineer.

— EDWARD STEICHEN, 1944

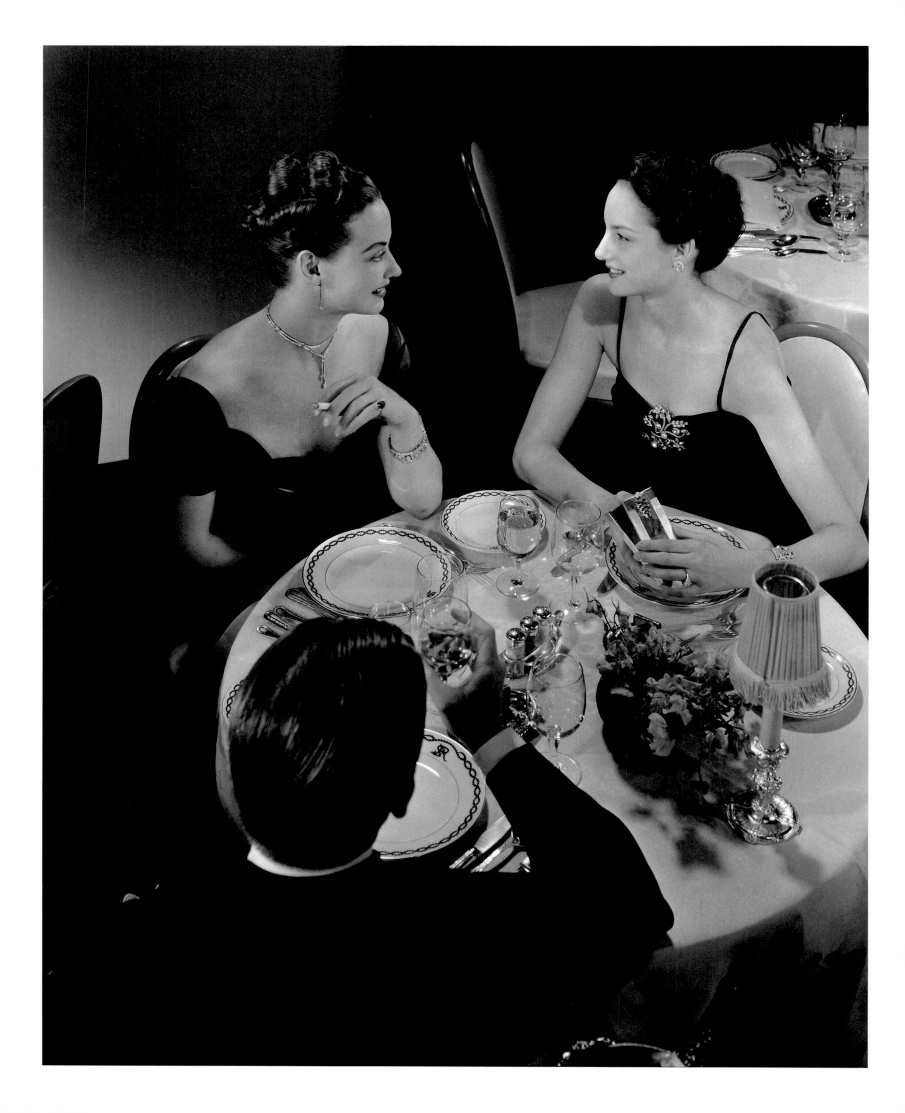

Preface and Acknowledgments: In High Fashion

WILLIAM A. EWING
Director, Musée de l'Elysée

TODD BRANDOW
Director, Foundation for the
Exhibition of Photography

Black top on crêpe sheath by Jay-Thorpe and black taffeta
dress by Saks Fifth Avenue, 1935

Steichen was already a highly successful painter and photographer on both sides of the Atlantic when, early in 1923, he was offered one of the most prestigious positions, and certainly the most lucrative, in photography's commercial domain, that of chief photographer for Condé Nast's fashion and society magazines *Vogue* and *Vanity Fair*.

Steichen leapt at the chance. For the next fifteen years, he would take full advantage of the resources of the Condé Nast empire to produce an oeuvre of unequaled brilliance, putting his exceptional talents to work dramatizing and glamorizing contemporary culture and its high achievers in literature, journalism, dance, sports, politics, theater, film, and, above all, the world of high fashion.

Although Steichen was not the first *real* fashion photographer (that honor must go to the flamboyant Baron Adolphe de Meyer, his predecessor at *Vogue*), he was the first truly *modern* fashion photographer. Indeed, it is no exaggeration to say that he invented modern fashion photography. His influence on the field was immediate, and it has proved long-lasting. Somewhat the same can be said of Steichen's celebrity portraiture, the other side of the Condé Nast coin (and in certain cases the same side, as famous actors and actresses often posed modeling Chanel or Schiaparelli while publicizing their latest Broadway production or Hollywood film). Steichen was among a tiny band of talented photographers who elevated celebrity portraiture from the status of formulaic publicity stills to an aesthetically sophisticated genre in its own right.

No other fashion photographer could rival Steichen for the range of haute couture he covered: Alix (Grès), Callot Soeurs, Chanel, Lanvin, Lelong, Paquin, Poiret, Schiaparelli, Vionnet, Worth, and a host of other designers and fashion houses saw their works depicted creatively and convincingly on the pages of *Vogue*. No other portrait photographer could rival Steichen for the volume of vivid, engaging studies he made of artists, athletes, actors, musicians, writers, and statesmen for *Vanity Fair*: Cecil B. DeMille and Josef von Sternberg among the filmmakers, Winston Churchill and Franklin Delano Roosevelt among the states-men, H. G. Wells and Colette among the writers, Greta Garbo and Gary Cooper among the actors. Overall, Steichen's work constitutes an archive in its own right. And there is no other archive like it.

What astonishes and delights the eye in Steichen's work is the constant rein-vention. Though the incessant demands of the magazines meant that the lion's share of the shootings had to be accomplished in the studio, Steichen seems to have been oblivious to its physical constraints; he continually found new ways to frame his subjects, pose them, and light them. If we look at the work of most of his studio-bound contemporaries (his disciple George Hoyningen-Huene, for example, or even Huene's disciple Horst P. Horst), we find a more limited

repertoire (a few standard props endlessly recycled and lit in each photographer's trademark fashion). Steichen, by comparison, seems the younger, the more inventive, the more creative, the more willing to risk all for an entirely fresh result. At one moment, he is all baroque splendor; at the next, he pares it down to streamlined simplicity. And as Carol Squiers notes in her informative essay, when the studio simply wasn't big enough to give rein to his imagination, Steichen took his models out into glamorous environments. A photographer of lesser ambition would have settled into a comfortable routine, but Steichen needed to give it his all, every time.

Steichen would eventually tire of his fashion and celebrity photography, and as the 1930s progressed, the volume of his work dropped off (though it must be stressed that the quality never slackened). From the beginning of his career, he had maintained an equal interest in horticulture (awards from professional botanical societies attest to his accomplishments), and the world of nature was of profound importance to him. Now he was turning away from the seductive domain of fashion and celebrity and returning to those roots. In 1938, Steichen resigned and abruptly went off to Mexico for some evidently restorative documentary work. Indeed, he might well have abandoned photography shortly thereafter were it not for the outbreak of World War II, which rekindled his interest in the making of what he had always called "useful photographs." After the war (yet another chapter in Steichen's career), he would hang up his cameras, devoting his time to ambitious curatorial efforts at New York's Museum of Modern Art, culminating in the spectacular exhibition *The Family of Man*. But he would never apologize for, or belittle, his fashion and celebrity work or his parallel efforts on behalf of the advertising industry. As Tobia Bezzola makes clear in his perceptive essay, Steichen's commercial work was not an aberration or an unfortunate detour; it was fundamental to his conception of photography.

Even before Steichen began his work for Condé Nast Publications, Frank Crowninshield, *Vanity Fair*'s editor, had heralded him as "the greatest of living portrait photographers." While photography historians may well bristle at the hyperbole (exaggerated claims adhere easily to this man), Condé Nast himself would never have reason to regret his decision to employ Steichen as his chief photographer. Nor, judging from the plates in this book, can we doubt the wisdom of that decision. Steichen's best work has simply never been surpassed.

Although it is true that fashion photographs were destined for the printed page, and though Condé Nast installed state-of-the-art presses, reproduction quality was much inferior to what is possible today. Had Steichen had access to duotone, tritone, and quadratone reproduction (this book is reproduced in the latter), he would have been delighted. And slightly vexed. The quality of printing

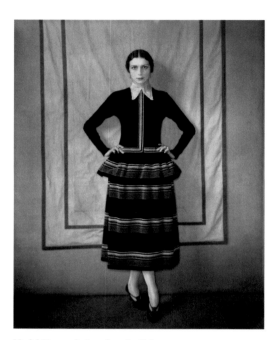

Model Dinarzade in a dress by Poiret, 1924

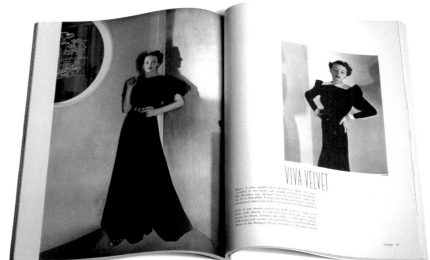

"Paris Still Wears Red," 1927
Vogue, January 15, 1927, pp. 86–87

right:
"Viva Velvet," 1936
Vogue, September 1, 1936, pp. 108–9

in the 1920s and 1930s disguised the often extensive retouching (then as now, one could never be slim enough!), but the enhanced resolution of current printing techniques shows these marks clearly. Nevertheless, we have made no effort to hide them.

The printed page, with its marriage of image and text, would be the rightful focus of a book about *Vogue* or *Vanity Fair*, but this book is about *Steichen's photography*. And the closest we can get to his "eye" is through the photographs as he conceived, designed, and constructed them—not as they were eventually used by the magazines' art directors (the images were often cropped, sometimes severely). Still, it should be noted that Steichen sometimes took a laissez-faire attitude toward the edges of his photographs—we see a bit of a light stand here or the edge of a backdrop there—because he knew that the art director would crop. But most of the time, he seems to have composed perfectly, right to the edges, and as it is always a pleasure to see a master at work, we have reproduced every image fully.

On the other hand, we have decided not to show Steichen's color photography. Certainly there were a number of fine color images in *Vogue*, and in 1932 the magazine published its first color cover with a Steichen (see page 14), but he had been at the magazine for almost a decade before that opportunity arose, and in proportion to the black-and-white work, his color production that followed was minimal. Magazine color photography was in its infancy, and though Steichen was wildly enthusiastic about its potential, he did not have much opportunity

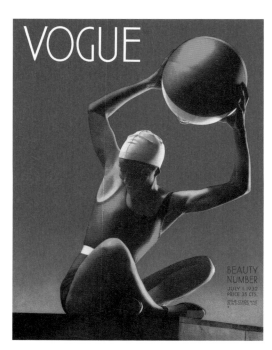

First cover of *Vogue* in color, July 1, 1932

for color work at Condé Nast. His greatest work was done in black and white. (Further complicating the matter is the fact that some of his finest color images were actually hand-colored black-and-white pictures.) In this sense, *Edward Steichen: In High Fashion, The Condé Nast Years, 1923–1937* is true to the "essential Steichen."

In High Fashion is a companion volume to the exhibition catalogue *Edward Steichen: Lives in Photography*, published in 2007 by FEP Editions LLC, for the Foundation for the Exhibition of Photography, Minneapolis, and the Musée de l'Elysée, Lausanne. The idea for this exhibition came to us during our curatorial research for *Edward Steichen: Lives in Photography*, the retrospective exhibition that began its European tour in 2007. The discovery, at the Condé Nast Archive, New York, of two thousand vintage prints from Steichen's period at *Vogue* and *Vanity Fair* was an exciting surprise, and the decision was made to launch a second, complementary exhibition in order to do justice to the full range of this accomplishment. We must therefore begin our list of acknowledgments by expressing our tremendous gratitude to Condé Nast Publications and to the people who work in their archive. The following individuals have made essential contributions to this exhibition, and we thank them all: Edward Klaris, vice president for editorial rights and assets; Shawn Waldron, associate director of editorial rights and assets and chief archivist; Leigh Montville, head of image rights; and Gretchen Fenston, registrar. Primalia Chang and Richard Tang were also very helpful in our initial discussions with Condé Nast, and we are grateful for their help.

The vast majority of the prints for the exhibition and images for the book came from the Condé Nast Archive, but a number of other generous lenders, public and private, contributed works, and we thank Anthony Bannon and Alison Nordstrom of the George Eastman House, International Museum of Photography and Film, Rochester, New York; Howard Greenberg and Nathan Anderson of the Howard Greenberg Gallery, New York; Matthieu Humery; and Sylvio Perlstein.

In High Fashion received immediate support from Régis Durand, then the director of the Jeu de Paume, and we appreciate his role in bringing both of the exhibitions to Paris, thus presenting to the world the largest vintage Steichen exhibition ever assembled since his death. At the Jeu de Paume, we are also appreciative of the efforts of director Marta Gili and her staff, especially Elisabeth Galloy, Véronique Dabin, and Marta Ponsa, who have done an extraordinary job in assembling these two exhibitions together into a harmonious whole.

We thank Christoph Becker and Tobia Bezzola of the Kunsthaus Zürich for quickly recognizing the value of this exhibition in its own right and for being the first to commit to showing it. In this same vein, we are very grateful to all of the

museum curators and directors who have worked to bring *In High Fashion* to their institutions: Sandro Parmiggiani of the Palazzo Magnani, Reggio Emilia, who arranged for the exhibition to be shown at the Chiostri di San Domenico; Elena Hernando of the Spanish Ministry of Culture and Andrés Carretero of the Museo del Traje, Madrid; Markus Brüderlin and Thomas Koehler of the Kunstmuseum Wolfsburg; Willis Hartshorn and Brian Wallis of the International Center of Photography, New York; Morton Owen Schapiro and Lisa G. Corrin of Williams College Museum of Art, Williamstown, Massachusetts; and Matthew Teitelbaum and Sophie Hackett of the Art Gallery of Ontario, Toronto.

Our process of refining the concept of this exhibition and selecting specific images and prints was greatly enhanced by the participation of International Center of Photography curator Carol Squiers, who assisted us with a great deal of direct archival research and contributed a fine essay on Steichen's fashion work. Nathalie Herschdorfer, associate curator at the Musée de l'Elysée, contributed an essay on the role of *Vogue* in the development of high fashion in the United States and informative texts on the models and personalities photographed by Steichen; she also provided essential assistance on our process of image selection and sequencing. Tobia Bezzola's insightful essay on Steichen's society and celebrity portraiture brings the broader perspective of the fine arts to the subject and sheds new light on Steichen's myriad influences.

The Musée de l'Elysée and its entire staff deserve to be thanked for coproducing the exhibition. Of particular note, this undertaking would not have been possible without the constant attention of associate curator Nathalie Herschdorfer. The other coproducing organization, the Foundation for the Exhibition of Photography, Minneapolis, is responsible for managing the exhibition tour and has been instrumental in its realization from the beginning. We extend our deepest thanks to associate curator Pauline Martin for her important contribution and to our senior adviser John Roth for his invaluable guidance.

This book has benefited tremendously from being the second of two that we have published on the subject of Edward Steichen. We have had the cooperation again from both copyright holders, Joanna T. Steichen and Condé Nast Publications, and are extremely grateful for their support. We have been very fortunate to have worked with the same group of superb professionals in creating this book and owe our deep thanks to Katy Homans for a most elegant book design, Mary DelMonico for her skillful direction of the editorial process and production of the book, Martin Senn for his expertise with digital capture and color separations, Michelle Piranio for her careful editing, and Richard G. Gallin for his fine proofreading. Furthermore, we appreciate the interest and support of our distributors and thank the following for making this publication available

If this is used one of the two will have to be reversed to balance.

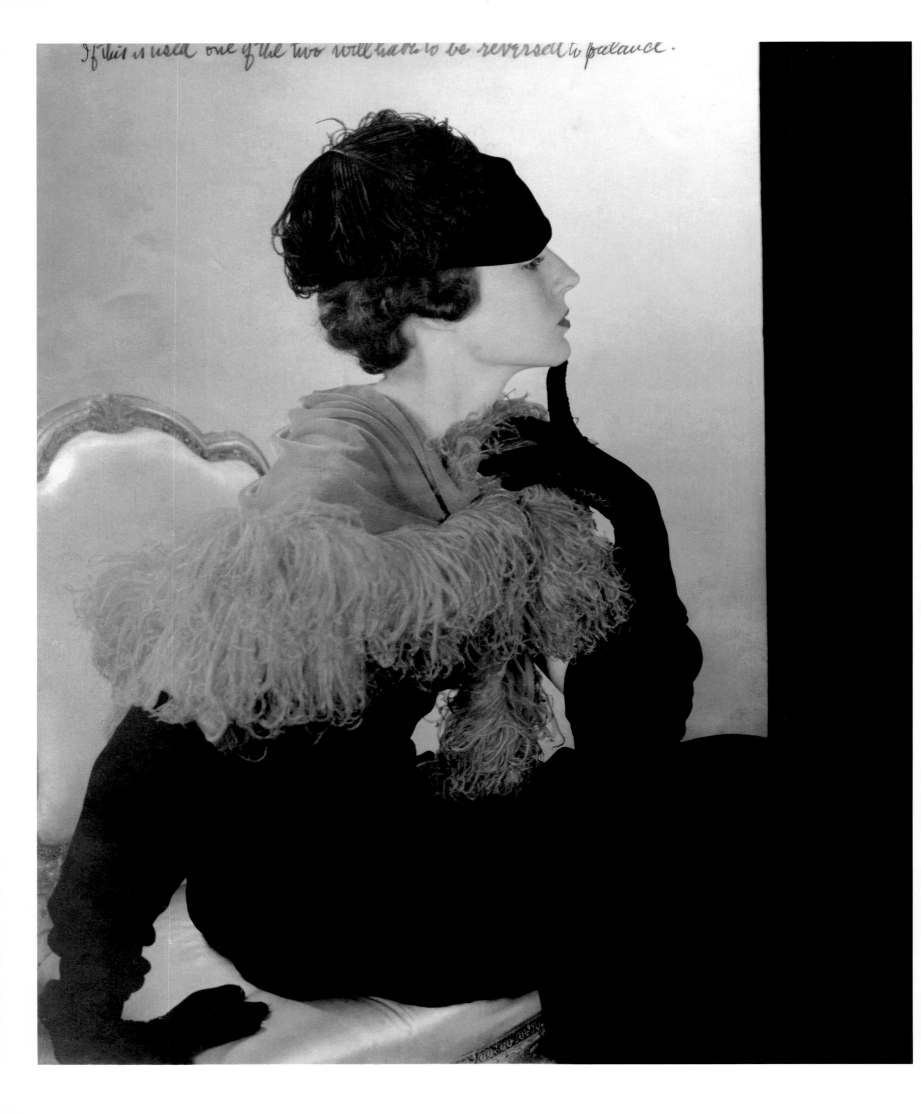

throughout the world; James Mairs and W. W. Norton & Company; Jamie Camplin and Thames and Hudson; Hélène Borraz and Editions Thames and Hudson; Elena Hernandez and the Spanish Ministry of Culture, in association with Lola Martínez de Albornoz and Armero Ediciones; Stefano Piantini and Skira Editore SpA; and Annette Kulenkampff and Hatje Cantz Verlag.

In High Fashion has been a vast project, requiring the collaboration and commitment of numerous individuals. We express our gratitude to all those who have contributed to its realization as both an exhibition and a catalogue: Vincent Angehrn, Jared Bark, Jennifer Belt, Laurent Bergeot, Jean-Christophe Blaser, Jeanne Bouniort, Marzia Branca, Marianne Brown, Nathalie Choquard, Manel Civit, Jean-Jean Clivaz, Corinne Coendoz, A. D. Coleman, Maddy Cougouluegnes, Deanna Cross, Jill Cuthbertson, Gary Davis, Delphine Desveaux, Deke Dusinberre, Jean-Marc Eldin, Pierre Furrer, Barbara Galasso, Véronique Garrigues, Daniel Girardin, Christine Giraud, Pamela Griffiths, Michèle Guibert, Sandra Haldi, Laurence Hanna-Daher, Sarah Hartley, Paul Hawryluk, Richard Hollander, Sophie Horvath, Nancy Jones, Leila Klouche, Diane Landers, Amélie Lavin, Franziska Lentzsch, Dawn Lucas, Natalie Marlow, Aimee Marshall, Karin Marti, Diana Martinez, Magdalena Mayo, Joe McCary, Lenore McMillan, Marie-Claire Mermoud, Eve Miller-Rose, Danielle Muecke, Wataru Okada, Pascale Pahud, Sophie Petit, Jacinto Pico, Elisabeth Pujol, Peter Pürer, Ben Renggli, Mercedes Roldan, Steve Rooney, Milène Rossi, Sacha Roulet, André Rouvinez, Alison Rutherford, Héloïse Schibler, Erin M. A. Schleigh, Rachael Smalley, Molly Sorkin, Hans-Ulrich Spalinger, Radu Stern, John Stomberg, Maia-Mari Sutnik, Colleen Thornton, Michèle Vallotton, Kali Vermès, Hetty Wessels, Amy Widmayer, and Meredith Wisner.

Last but not least, special thanks to Carla Sozzani and Azzedine Alaïa for their invaluable help in communicating Steichen's pioneering work to the fashion community.

Model wearing a hat with black ostrich feathers and an ostrich feather boa, 1933

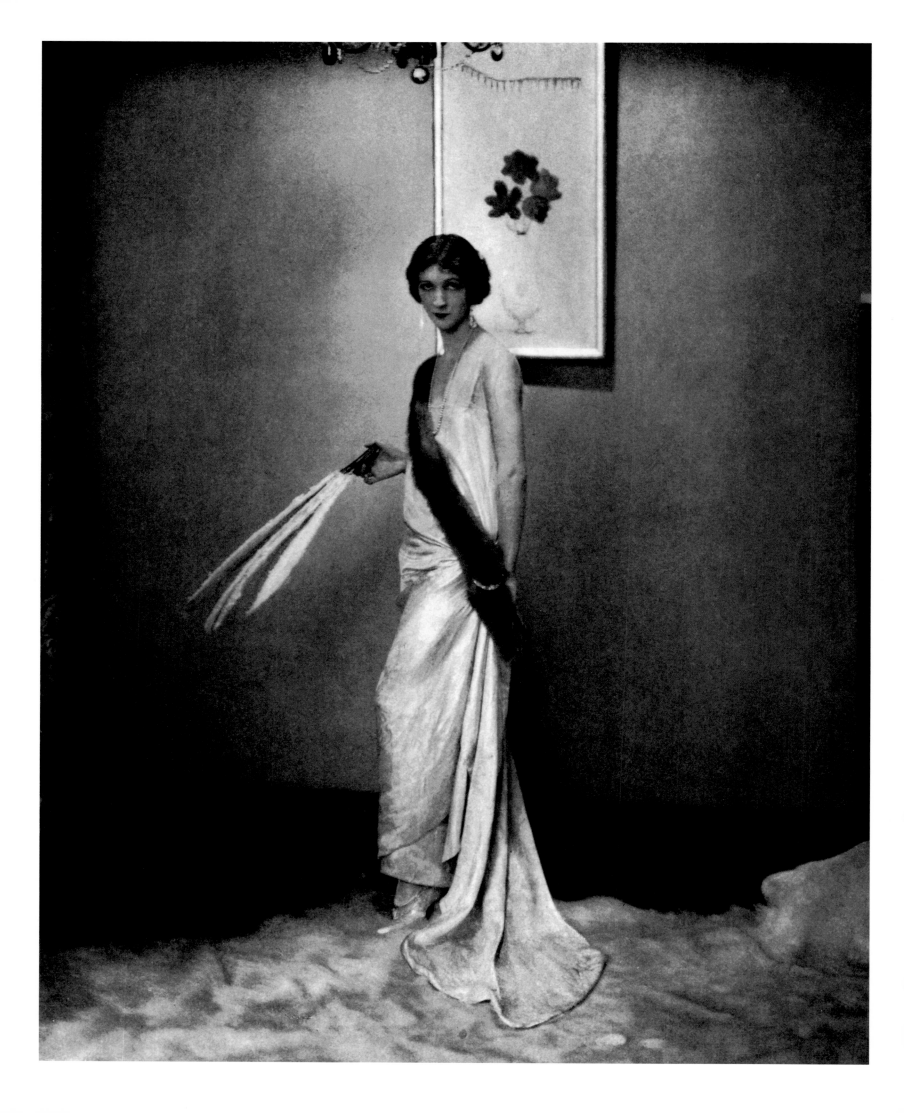

A Perfect Conjunction

WILLIAM A. EWING

The making of beautiful objects and things of ornament, and even of utility, have practically been banished from the realm of art to the more active and more lucrative scope of commerce.
—Edward Steichen, 1908[1]

Even if he was one to make light of his troubles, Edward Steichen had little cause for celebration on New Year's Eve in 1922. He was squarely middle-aged, his marriage had ended in a messy divorce, he had alimony payments to meet and was heavily in debt, and he still had the costly education of his children to consider. At forty-three, his years as an *enfant terrible* in the photography world were a distant memory, and his pioneering role in introducing modern European art to America had been all but forgotten.[2] Outwardly, Steichen still wore the mantle of "paintre and fotographer" with panache,[3] but inwardly he had serious misgivings about his talents with the brush. He was acutely aware of not having kept pace with modern styles of painting, and what he had seen of them he didn't much like. Worse, he had come to the painful conclusion that his own painting was never going to achieve great depth. To complicate things, a good part of his reputation and an important part of his income rested on his continued success as a painter; he regularly had shows in prestigious galleries, and his work generally sold well. And had not *Vanity Fair*, initiating him into its Hall of Fame a few years earlier, done so on the basis of both his photography *and* his painting?[4]

It is all the more impressive then that as the new year began, Steichen stuck to his decision to abandon painting and devote himself entirely to photography. Still, he must have regretted a blithe comment made twenty years earlier, when he told a journalist from his hometown, Milwaukee, that photography was really "only a side issue" and that he was "a painter first, last, and all the time."[5] Resolved as he was to follow a single path, the giving up of a medium that had brought him money, praise, and, for many years, deep personal satisfaction must have felt to some extent like an amputation.

Steichen had also decided at this time to leave Europe, having realized that post–World War I France did not provide sufficient financial opportunities. He had lived there on and off since 1900 and particularly loved his rented country home, Villa L'Oiseau Bleu, at Voulangis, where he had been able to indulge his passion for flowers. Over the years, this ardent botanist (his efforts won him a gold medal from the French Horticultural Society in 1913) had constructed a magnificent garden, and leaving it behind would prove as painful an experience as the decision to abandon painting.[6] But although Steichen had resolved to break decisively from his past and try his luck anew in New York (and that failing, Chicago), he was hardly in an optimistic frame of mind. He even wondered

1. Dancer Désirée Lubovska, 1924

Between Pictorialism and modernism: The photographer's early work at Condé Nast showed signs of an Art Nouveau sensibility that would adjust quickly to the newly emergent style of Art Deco.

2. *The Frost Covered Pool*, 1899

Although Steichen's early landscapes were almost always moody and richly atmospheric in a Whistlerian style, this treatment seems surprisingly modern and offers proof of the artist's versatility.

if moviemaking might not be a more promising option than photography. In a gloomy letter to his sister, Lilian, he admitted that his prospects were "not brilliant."[7] He had no way of knowing, as he sailed from Le Havre on the cheapest possible fare, that he would very soon find himself in dramatically changed circumstances; within a year he would be traveling back to Paris, this time in high style as the Condé Nast empire's preeminent photographer of fashion and celebrity, the highest-paid photographer of his time. From a worrisome disjunction of circumstances to a perfect conjunction in the space of months—the turnaround seems astonishing. Almost overnight, Steichen found himself the right man in the right place at the right time.

If Steichen had come to the conclusion that he was never going to attain what he had hoped for in his painting, he was absolutely sure of his footing in photography. His reputation had been cemented many years earlier, as artists on both sides of the Atlantic acknowledged his work not only for its originality but also for pointing the way forward for the field of photography. Auguste Rodin had spoken for many when he declared, in 1908, that Steichen was "a very great artist and the leading, the greatest photographer of our time."[8]

Steichen had used the early postwar years to reexamine photography's expressive possibilities, sharpen his skills, and rethink the medium's rightful functions. He later described this period at Voulangis, from late 1918 through early 1923, as "a second technical apprenticeship preparing for my newfound conception of the medium as a means of communication."[9] As biographer Penelope Niven notes, Steichen used the flowers and fruits from his garden to render form and volume as "impeccably clear images, resonating with symbolic meaning."[10] These attempts have sometimes since been described as experiments with lighting, but Steichen corrected this misinterpretation later in his life. He explained that they were the equivalent of "what might be called, in music, finger exercises"; he wanted to develop "a clear mental picture of the tone range of various kinds of sensitive material, and just what could be expected of the material."[11] He wanted to fine-tune *himself,* so to speak, in order to be nimble when faced with any kind of subject matter.

These experiments had no doubt been prompted in part by the powerful modernist development known as "straight" photography, a forceful corrective to the moody, diffuse, and romantic Pictorialist style that had long dominated artistic photography and of which Steichen was an acknowledged master. Straight photography was not just about clear, focused pictures as opposed to "fuzzy" ones; it also meant taking stock of the material world in a way that Pictorialism had failed to do—railway tracks and telephone poles rather than gamboling nymphs and

3. *Richard Strauss*, 1904

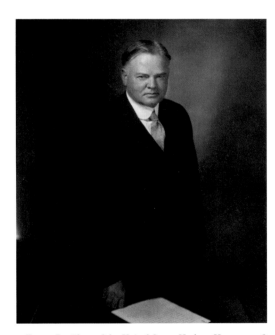

4. Future President of the United States Herbert Hoover, 1928
Vanity Fair, publication date unknown

Long before his arrival at Condé Nast, Steichen was hailed as
a master portraitist, and he often drew on his Pictorialist-era
experiences.

sprites. Steichen had already, in 1915, made some straight photographs (Fig. 83),
and indeed there is a much earlier Milwaukee landscape (sadly, we have only a
newspaper reproduction of the photograph) that shows he was also thoroughly
adept at sharp, unadorned observation (Fig. 2). But the urge to refresh his skills
also grew out of a recent and formative episode of World War I, wherein he pio-
neered the use of aerial reconnaissance photography for the U.S. war effort. The
daunting challenges of taking and interpreting "sharp, clear pictures" triggered
a keen interest in photography's technical potential, which was, he wrote, "com-
pletely different from the pictorial interest I had had as a boy in Milwaukee and
as a young man in Photo-Secession days."[12] The "finger exercises" practiced in
Voulangis and the "exacting science"[13] required of aerial photography would both
be of great value to Steichen's fashion work at Condé Nast.

Nonetheless, the earlier Photo-Secession work would prove most useful
for Steichen. For one thing, he had shown a great aptitude for portraiture. He
had long imagined creating a portfolio of "Great Men"[14] and had already made a
number of portraits that were universally admired in international photography
circles. His studies of the painters George Frederick Watts, William Merritt Chase,
Henri Matisse, and Alphonse Mucha, the sculptor Rodin, the composer Richard
Strauss (Fig. 3), the photographers F. Holland Day and Alfred Stieglitz, and the
writers Anatole France and George Bernard Shaw were acknowledged as master-
pieces by his fellow photographers—and often by the sitters themselves—and his
celebrated portrait of an apparently diabolical J. Pierpont Morgan, with the illu-
sion of a "dagger" in his hand (an accident, according to Steichen, but a welcome
one, especially in view of the photographer's socialist sympathies), was, and is,
widely considered one of the greatest portraits of all time. By 1908, Steichen's
fame was such that he was commissioned to photograph the president of the
United States, Theodore Roosevelt, along with the secretary of war and Republi-
can presidential candidate William Howard Taft (while across the Atlantic, the
famous socialist leader Jean Jaurès sat for him). So it is safe to conclude, from
this only partial list of famous sitters, that the photographer would have long
since gotten over any natural timidity, lack of self-confidence, or paralyzing awe
in the presence of "greatness" by the time he found himself in the Condé Nast
studio face-to-face with the equally illustrious sitters of the 1920s and 1930s.

Moreover, a comment by critic Sadakichi Hartmann in 1900 shows us that
Steichen already had a very particular talent. Hartmann described Steichen's
portraits as "intellectually vivacious," adding that "he gives us a commentary on
the sitter. He is not satisfied showing us how a person looks, *but how he thinks
the person should look*."[15] This skill would be much appreciated by the editors at
Vanity Fair.

5. La Comtesse Marie-Blanche de Polignac, daughter of Jeanne Lanvin, 1926

Steichen's use of props was highly inventive and unorthodox. This clever arrangement allowed him to pose the arms and hands elegantly and at the same time contrasts the hard, straight, "masculine" lines of the furniture with the fluid lines of the dress and the body.

opposite:
6. Actress Ina Claire wearing fashion by Louiseboulanger, in Frederick Lonsdale's play *The Last of Mrs. Cheyney*, 1925

As both a painter and a photographer, Steichen was adept at borrowing from painting styles of the past, as is evident in his portraits showing elegant women admiring themselves in mirrors.

Steichen had the gut instincts of a born press agent, and it is worth noting how he spun his "Great Men" series to the press; it shows how, early on, he was going about the construction of a mystique. "I am not satisfied with the mere reproduction of features and expression," he told a Milwaukee journalist in August 1902, sounding like a grand old man of portraiture. "I cannot make more than one photograph in a day. It means the complete merging of myself in the personality of my subject, a complete loss of my own identity, and when it is over I am in a state of collapse, *almost*."[16]

That Steichen was only twenty-three years old at the time, however, justifies our taking these words with a pinch of salt. Steichen was a strong and healthy young man (he had recently bicycled across Europe), and it must have been hugely exciting to make these studies. Even obtaining the consent of his illustrious sitters was a coup. So one has difficulty imagining Steichen needing to be revived with smelling salts by an anxious president or millionaire; it is more likely that he flew out of the sittings in order to develop his negatives and be sure that he had caught his prey. Steichen's histrionic words above suggest that he was acting out the role of the Romantic artist for his impressionable, provincial Milwaukee audience (the hesitant last word, "almost," betrays him, suggesting that he wasn't quite sure that the reader would believe him). This talent for self-promotion, which he honed over the years (there would be no more *almosts* in his declarations) would be appreciated in later years by Condé Nast. The publisher had learned from Steichen's predecessor, Baron Adolphe de Meyer, how a flamboyant photographer could not only fashion his own mystique but burnish that of the magazine as well.

While Steichen's early portraits of important men would help him develop his approach to male subjects at *Vanity Fair*, his Pictorialist-period photographs of women would prepare him for his fashion work at *Vogue*. This was also true of his paintings, an important consideration given that Steichen would later bring to fashion photography ideas derived from diverse styles of art and, more important, painting's general facility with the portrayal of clothing and (to varying degrees) clothed bodies. Steichen already knew how to expertly render texture, sheen, cut, and the fall and fold of fabric. As a painter he had also learned to depict the subtlest of gestures and the most fleeting of expressions of the women wearing the clothes. As dress historian Anne Hollander reminds us, "clothing appears in all traditions of figurative painting, often filling two-thirds of the frame without seeming to be there," meaning that the artist had to have a fluid mastery over fabric, or "a fabric of vision," as she puts it.[17] "It is obvious that clothes in themselves have mattered enormously to artists, since they are potent visual phenomena in the human world, as strong as faces."[18] Steichen knew and

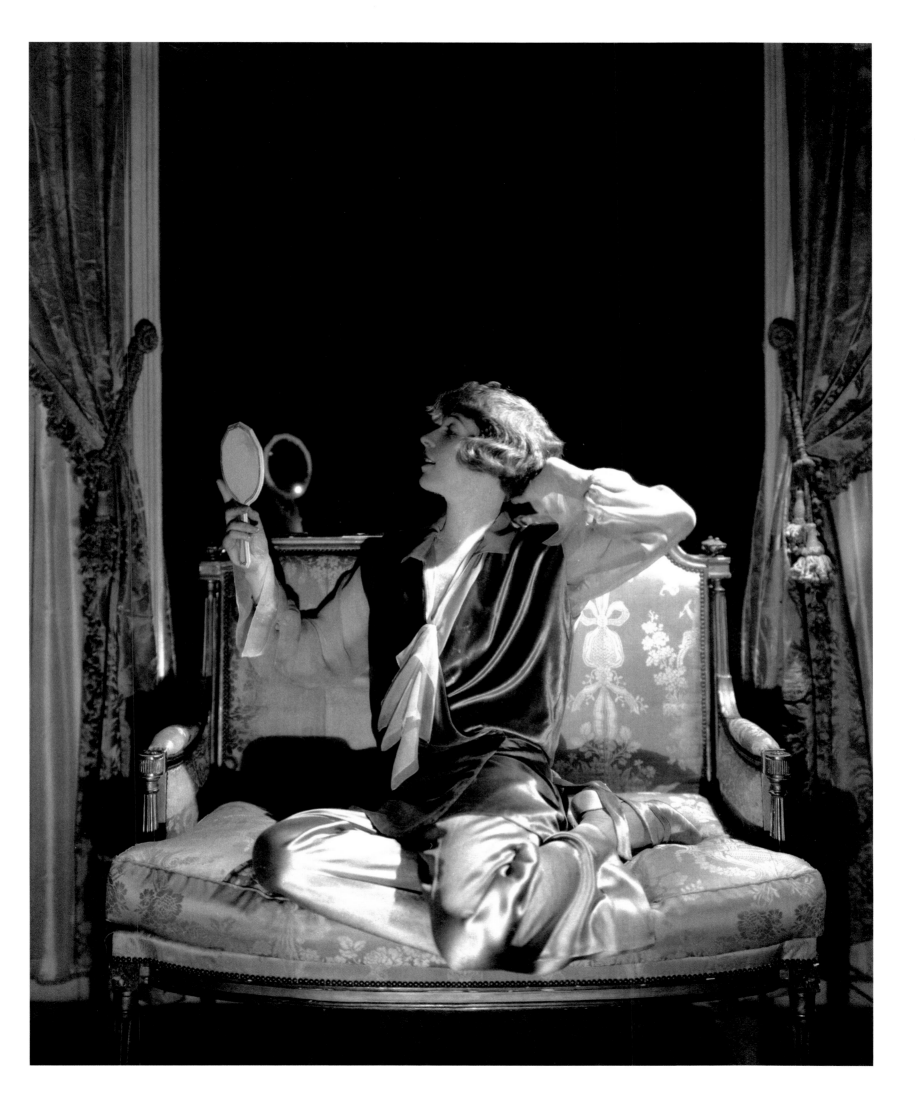

appreciated this great tradition, and, moreover, as Tobia Bezzola explains in his essay in this volume, he made regular and intelligent use of it.

But the painter-photographer went further. He was adamant that portrait photography represented an *advance* over painting: "I am personally willing to avoid the discussion [of painting and photography] and calmly await development, feeling confident that even the most conservative critics will soon discover the superiority, at least in portraiture, of photography per se over the big majority of so-called portrait paintings."[19]

In addition to photographing Mrs. Condé Nast in 1907 (which might well have been the moment when Nast first fixed Steichen on his radar, an awareness no doubt further cemented in August 1917, when *Vanity Fair* published Steichen's picture of Nast's daughter Natica), Steichen produced remarkable portraits of women, including his friend the journalist Agnes Ernst; Lady Ian Hamilton, the wife of a renowned British military officer; fellow photographer and friend Gertrude Käsebier; the actress Eleanora Duse; and the New York socialite Mrs. Philip Lydig. The latter, notes Niven, "enhanced Steichen's growing success and recognition as a fashionable portrait photographer skilled in posing celebrities."[20] Steichen had learned how dress and props (in the case of Mrs. Lydig, the cyclamen for which she was famed were deftly woven into the study—fittingly, they are *part* of her) were essential to the portrayals of such extravagant and elegant women, but he was also capable of dispensing with all this paraphernalia when it was the physiognomy itself that interested him, or when his aim was to capture a state of interiority (Fig. 8).

Steichen had also painted and photographed nudes during his Pictorialist years (Fig. 9), which reminds us that rendering the female body with or without clothes had become standard practice by the time he arrived at Condé Nast. He was also adept at theatrical treatments of the body and the body in motion, which would help later with his *Vanity Fair* portraits of dancers, actors, and actresses. In the early 1920s, for instance, he had photographed Isadora Duncan and her disciple Maria-Theresa Duncan at the Parthenon. Isadora is seen as a tiny figure among the columns, but she is not dwarfed by them; indeed, her noble gesture enfolds the Parthenon in its embrace, as if to remind us that the human being was at the center, not the periphery, of the classical Greek worldview.[21] Here again, Steichen was accumulating valuable experience that would serve him well when dealing with the many theatrical subjects required by his magazine assignments.

There is one other series of Pictorialist-era photographs that will help us appreciate a strand of Steichen's later fashion studies—those taken out of doors. In 1907, Steichen photographed the bustling life of the racetrack, possibly

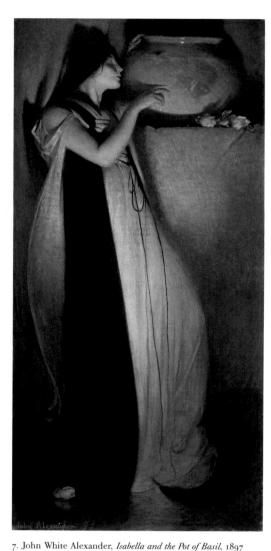

7. John White Alexander, *Isabella and the Pot of Basil*, 1897

There are fascinating parallels in the lives of Alexander and Steichen, both Americans; the former first achieved international success with his idealized depictions of elegant women.

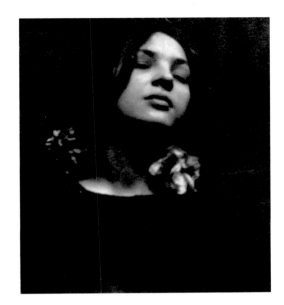

8. *La Rose*, c. 1901

Steichen was a versatile portraitist, at ease working at different distances from his subject; here the emotional state required a close-up.

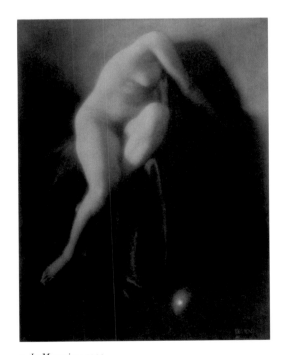

9. *In Memoriam*, 1904

Steichen's experience in painting and photographing the nude female body allowed him a better understanding of how to photograph it clothed.

inspired by the atmosphere of Edgar Degas's *Le défilé* (*Chevaux de course devant les tribunes*) (1866–68). Steichen's *After the Grand Prix—Paris* (1907) might be considered a documentary picture, seizing life on the fly, were it not for his suppression (during the printing process) of the figure of the flower girl in favor of showing his unbridled delight in the elaborate, billowing dresses of the society women. Steichen was a picture *maker*, not a picture *taker*.

But it was the not the first time that Steichen had been attracted to female figures in natural settings: as early as 1897, he had photographed elegantly attired women in richly atmospheric situations, such as *Lady in a Doorway, Milwaukee* (1897). Living in Paris at the turn of the century, Steichen was, moreover, familiar with the prototype of the elegant woman—*la Parisienne*—"sophisticated, perfectly groomed, elegantly dressed, urban and independent," as art historian Erica E. Hirshler summarizes her, noting that even Americans who had never been to Europe were familiar with the type from fashion and cultural magazines freely available in their hometown libraries (Fig. 10).[22] And we know that Steichen had read everything he could find about Paris while planning his initial visit in 1900, spending hours at the Milwaukee Public Library. So when he arrived in Paris and immediately made his way for the Exposition Universelle, he would have understood the significance of the colossal sculpture at the gate, which depicted a fashionable woman whose robe had been designed by the great couturier Madame Paquin—it, too, was called *La Parisienne*.[23]

We know that once in Paris, Steichen took every opportunity to visit the great museums, steeping himself in the painting and sculpture of past and present. The finely accoutered women in works by Jean-Auguste-Dominique Ingres, James Tissot, James Abbott McNeill Whistler, and John Singer Sargent would have been familiar figures to him months into his first sojourn. The older, more experienced Americans whom Steichen looked up to (and often photographed) in Paris—William Merritt Chase and John White Alexander, to name only two of the prominent artists who sat for him—were equally smitten by the beautiful and fashionable women of Paris. Interestingly, Steichen's photographed females, clothed or nude, bear an uncanny resemblance to Alexander's painted women (Fig. 7).[24] Whether in New York or Paris (and he was a jet-setter before jets were invented), Steichen was used to mixing with, and closely observing, fashionable men and women.

Paris was also home to the earliest magazines to take fashion seriously. The fashion plate had been introduced in the 1670s by *Le Mercure Galant*, one of the earliest periodicals to report regularly on fashion, and the first fully fledged fashion magazine, *Cabinet des Modes*, arrived a century later.[25] It seems that even the French Revolution could not halt the inexorable rise of the fashion magazine,

10. Charles-Alexandre Giron, *Femme aux gants dite la Parisienne*, 1883

"La Parisienne" was a type well known to Americans from journals reporting on European cultural life. Steichen's modernist treatment of his model represents an updating of the type.

opposite:
11. Model wearing a coat by Cheney and gloves by J. Suzanne Talbot, 1933

as specialized publications took root in the nooks and crannies of the burgeoning industry (one concentrating on sewing, for instance, while another mixed fashion with theater and social gossip). This growth was fueled by the appearance of lithography and an efficient postal service (allowing for mass distribution from about 1816), the invention of the sewing machine, the birth of haute couture in the early 1850s, and the rise of the grand department store—all of which had the effect of further democratizing fashion. There was even a nineteenth-century stereoscopic magazine, *La Stéréoscope*, complete with 3-D glasses, and a one-man publishing operation, *La Dernière Mode* (though short-lived at eight issues, all in 1874), by the Symbolist poet Stéphane Mallarmé.[26] In other words, fashion was not at all peripheral to the fabric of French cultural life, but a deeply entwined thread of it. As cultural historian Mary E. Davis explains, the constant elevation of fashion during the nineteenth century amounted to a cultural "explosion" and a new interest in the "nexus of fashion and art," which would culminate in a golden age of haute couture—just at the moment when Steichen was called upon to serve its interests.[27] The new magazines of the nineteenth century were guides to living for ever larger numbers of women, weaving in tips for home decoration and entertaining and keeping their readers up to date with the most essential gossip. Any sophisticated American in Paris with the visual curiosity of Steichen would have been hard-pressed *not* to pay attention to this domain of publishing, especially as the illustrations in the magazines were often done by extremely gifted artists. On all sides, it seems, the photographer was being prepared for his future work without his being aware of it.

There is one more aspect of Steichen's early years that explains the ease with which he slipped into his new role at Condé Nast. It concerns what he liked to call "useful photographs," a theme that dates from his days as an apprentice lithographer in Milwaukee and would remain a consistent thread throughout his entire career. Having observed that the designers at the American Fine Art Company were basing their advertising motifs on a stock of woodcuts, Steichen felt that his colleagues would be better served by photographs—of actual Wisconsin pigs, for example—and he offered to take the pictures himself (the offer was accepted and the work was done, according to Steichen, though the photographs have never been found). Steichen would strike this theme of utility for the common good again during World War I, when he dedicated himself to the development of aerial reconnaissance photography.[28] He would be criticized often for his position on this issue, as it was seen as undermining photography's fragile claims for art status. It has been frequently said that in selling his talents to industry, he "abandoned" Stieglitz's high-art aspirations for photography, but anyone who had their eyes open as the duo launched *Camera Work* in 1903

12. Evening shoes by Vida Moore, 1927

No other photographer could rival Steichen in the area of lighting. Indeed, some of the photographer's most iconic imagery — of silverware, cigarette lighters, or shoes, for example — was inspired by banal subject matter.

would have noted Steichen's versatility and his carefully apportioned loyalty to both the sacred and the secular: he had designed the front cover, which heralded a new era of photographic art, and the back cover, which promoted a commercial product.[29] A quarter of a century later, Steichen's brother-in-law, the poet Carl Sandburg, noted that Steichen "sees as many aesthetic values in certain shoe photographs for *Vogue* (Fig. 12) as in photographs of roses and foxglove to which he gave the limit of his toil and creative pressure."[30] Steichen can be accused of naïveté, perhaps, but not of hypocrisy; his position never wavered.

Steichen was also keenly aware of the variety of effects made possible by various kinds of printing processes. His hands-on experience at *Camera Work* (still regarded as having produced some of the finest photogravures of all time) showed him the wide gaps that existed between negatives, hand-drawn prints, and positives produced on high-speed printing presses. A master printer in the various media favored by the Pictorialists — gum, carbon, platinum, and combinations thereof — he learned how to get the most out of halftone reproduction and photogravure, including what mix of tonalities in the original photograph would translate best onto the printed page.

All of the above factors help to explain how, in 1911, he came to make what are generally considered to be the first true fashion photographs, in as much as they are not mere documents (that had been done before) but creative interpretations of haute couture that could be appreciated in their own right (Figs. 15, 16). The designer in question was the great Paul Poiret, and the commission was from the highly regarded Parisian magazine *Art et Décoration*.[31] Editor Lucien Vogel, one of the most knowledgeable men in the business, asked Steichen to interpret Poiret's sensational gowns, with their Orientalist affectations, and it was a measure of Steichen's reputation as a great photographer that the hugely ambitious Poiret accepted Vogel's choice.[32] A lot was riding on the results, as *Art et Décoration* was celebrated for its lively illustrations, and fashion photography had not yet made its entry. Steichen surely knew that Poiret's fine-honed sense of self-promotion and high self-esteem would make the designer a very demanding and highly critical judge of his pictures and that the sophisticated readers of *Art et Décoration* would expect a portfolio of glamorous pictures worthy of the couturier's towering reputation, which indeed Steichen provided.

All Paris was under the thrall of the sets, costumes, and colors of the Ballets Russes, and Poiret's own sumptuous Orientalizing style was at one with the spirited mood. Steichen was no doubt honored by Vogel's proposition. Nancy Hall-Duncan, in her pioneering *History of Fashion Photography*, suggests that Steichen could only have taken on such a blatantly commercial enterprise once his rupture with the high-minded, art-for-art's-sake Stieglitz was final. In New

13. Women at the piano, 1859 (illustrator unknown)
La Mode Illustrée, January 1859

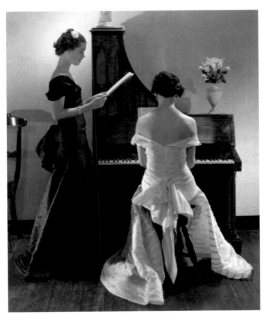

14. Models Mary Taylor and Mrs. Robert H. McAdoo wearing the same dress by Vionnet, one in black taffeta, one in white taffeta, 1934

In the eighteenth and nineteenth centuries, piano playing was an attribute of all well-brought-up young ladies; by the time Steichen toyed with the theme, such a pastime was wrapped more in nostalgia than in fact, but would have appealed to the vanity of his female readers.

York, taking on such an assignment would have been like poking a stick in his mentor's eye. In Paris, it would have been seen by almost any photographer as a golden opportunity.

One wonders if Poiret and Steichen were aware of the fascinating parallels in their lives. They were exactly the same age, born one week apart. Both had shown creative genius as apprentices (Poiret took home scraps from the umbrella business where he worked to make clothes for his sister's dolls, while Steichen was replacing his employer's woodcuts with photographs and suggesting the use of bicycles to speed up communications). Both had had mentors from whom they had parted ways (the couturier Jacques Doucet for Poiret, Stieglitz for Steichen). Both had had supportive mothers in their youth and critical, unsupportive fathers. Both had been innovators. Both had made inroads in color (Poiret's palette was vibrant and intense, while Steichen's autochromes suggested a new world of expressivity in photography). And both shared a deep belief in their respective métiers as worthy of the status of art ("Am I a fool because I claim to be an artist?" demanded Poiret), echoing Steichen's sentiments.[33]

While Steichen explored and promoted the avant-garde over in New York, Poiret explored "the potential the avant-garde had for fashion."[34] To further their aims, each had made use of a gallery to display the art of others: for Poiret it was the Galerie Barbazanges (it was at an opening here that Poiret first met Vogel, setting in motion the first stage of Steichen's fashion photography career), whereas for Steichen it was the Little Galleries of the Photo-Succession (later 291). Finally, both men were committed to publishing images of the highest quality. In his domain, Poiret created new standards of illustration and printing with deluxe limited-edition albums using supremely gifted artists and the finest paper; Steichen's efforts alongside Stieglitz at *Camera Work* were equally impressive. In short, both men were polymaths, artists, entrepreneurs, self-promoters, spokesmen for their fields, and tastemakers. The *New Yorker* heralded Poiret as "one of the continentals who has helped to change the modern retina."[35] The magazine might well have claimed the same for Steichen.

What Steichen was to photography, Poiret was to evening wear. For Paul Cornu, the writer assigned to the *Art et Décoration* article, Poiret's dresses ushered in a new era of decorative art, thus requiring modern decor as the setting. He saw Poiret's style as perfectly balanced between grace and modernity. Steichen's treatments were remarkable: they were Pictorialist, or Symbolist, in manner, which is to say that the mood was Romantic, Orientalist, and mysterious, and detail was suppressed in favor of overall effect. This treatment suited Poiret admirably. Shortly thereafter, he told *Vogue* that he found his "gowns satisfying only when the details of which they are composed disappear in the general harmony of the

whole."[36] Steichen's imagery equaled the brilliance of both Paul Iribe's and Georges Lepape's drawings of Poiret costumes (of 1908 and 1911, respectively).

The most remarkable images of the Steichen series are named after the gowns themselves: *Pompon, Battick,* and *Bakou et Pâtre.* In the first of these, the reader is invited to spy on an intimate moment wherein two women, sisters or friends perhaps, are seen adjusting a new dress, with the play of their arms looking almost like a dance movement from the Ballets Russes. In *Battick,* the evening coat is framed beautifully by the sweeping curves of a staircase, which also echoes and amplifies its motif. Finally, *Bakou et Pâtre* is a magisterial arrangement of curves, straights lines, shadow and light, point and counterpoint, in a composition inspired by Cubism. It is undoubtedly the first *great* fashion photograph.

It is surprising then, that after this magnificent portfolio, Steichen seems to have given fashion photography no further thought. He would later note, matter-of-factly, that "these were probably the first serious fashion photographs ever made,"[37] and yet that clearly wasn't enough of a motivation for him to continue. There is nothing in his oeuvre remotely connected to fashion for more than a decade after this. He was clearly the right man, but he was not yet in the right place or at the right time.

When Steichen, uncertain of his prospects, landed in New York in 1923, it was perhaps to bolster his morale that he opened a recent copy of *Vanity Fair.* He would have certainly remembered how, five years earlier, the magazine had initiated him into its Hall of Fame for having achieved "a great and well-deserved reputation as a photographer"; he was, in fact, the only photographer on its list of societal movers and shakers. He could also hardly have forgotten how, a year earlier, the same magazine had acknowledged him as "our ablest and best-known photographer." And now, by chance, he found himself being lauded again. On a page literally crowing about American supremacy in photography, editor Frank Crowninshield described Steichen as an "unrivaled master" and better still, "the greatest of living portrait photographers."[38] But reading on, Steichen learned with alarm that it was not painting he had abandoned, but photography! He rushed to set the matter straight.

Lunch with Crowninshield and Nast himself followed, the happy result being that Steichen was offered the job of chief photographer for *Vanity Fair,* with, if he wished, fashion assignments for *Vogue.* Delighted, he accepted. The offer must have seemed like manna from heaven. As we have seen, he had already squarely faced his limitations as a painter, having never transcended an essentially decorative style, and simultaneously had come to realize that photography was his true calling, as his mentor Stieglitz had surmised a quarter of a century earlier. Steichen had also recognized an essential limitation of painting

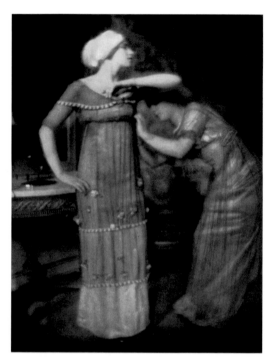

15. *Pompon* (gowns by Poiret), 1911

opposite:
16. *Bakou et Pâtre* (gowns by Poiret), 1911

This landmark body of work for *Art et Décoration* consisted of eleven plates, each quite different and all of a standard nothing short of brilliant, a harbinger of great work to come.

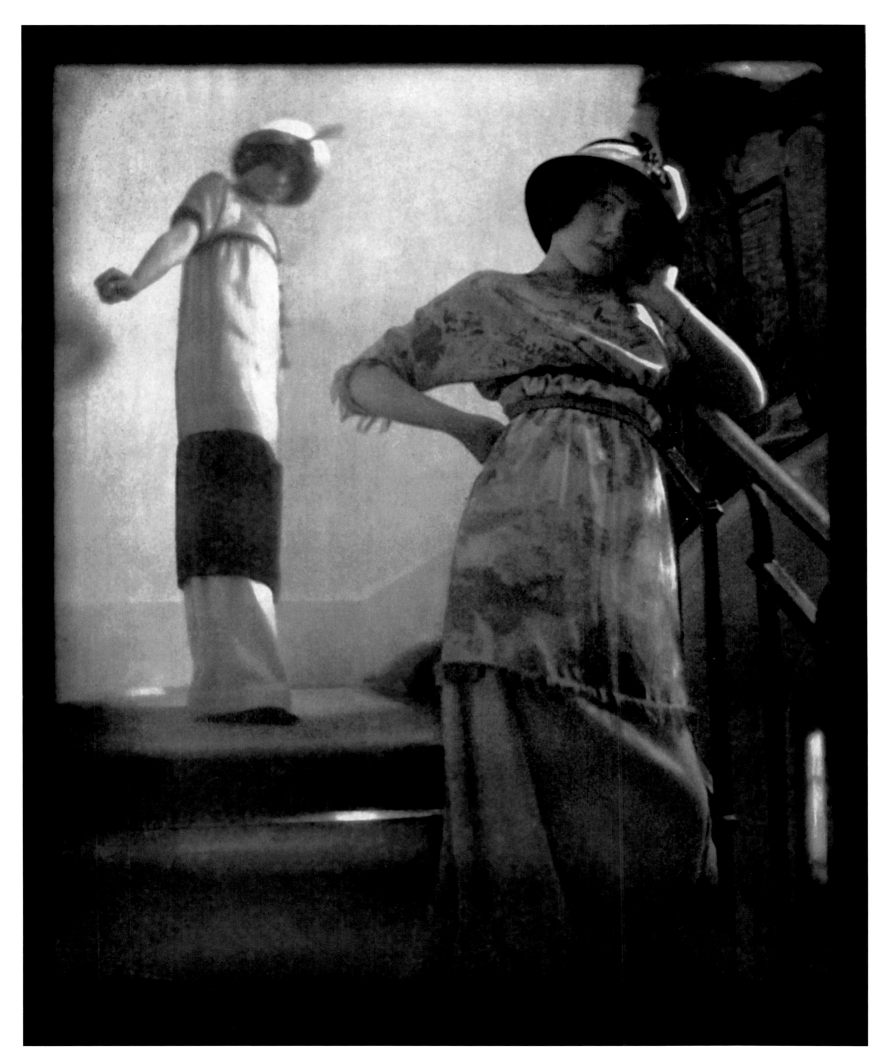

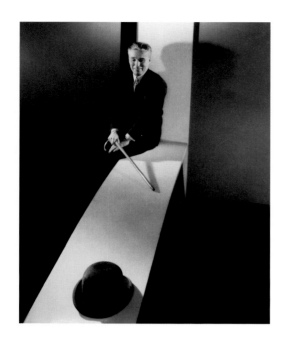

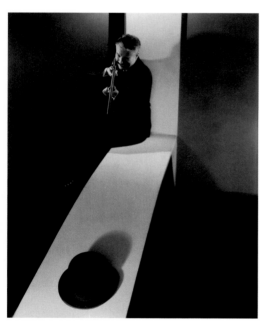

17 AND 18. Charlie Chaplin, 1931

itself in the modern era: it was restricted to a tiny elite, whereas Steichen was feeling the urge "to reach into the world, to participate and communicate."[39] Commercial photography, he thought, had that potential. Thus he turned his back on elegant "wallpaper" for the very rich in favor of ephemeral, massively diffused, thoroughly modern imagery that would have a direct impact on a great number of people's lives.

For his part, Nast was equally delighted. He had lost the services of de Meyer to his rival, William Randolph Hearst at *Harper's Bazaar*, and was in need of a commanding figure to replace the photographer. France meant everything to Nast when it came to matters of fashion, style, and elegant living generally, and he was delighted to have a new photographer who had spent so much time in Paris. On a more practical side, he could see that the trend away from illustration to photography was unstoppable, and he didn't want to be caught unprepared. Photography was faster and cheaper than any other reproduction technique; it rendered detail more precisely; and it was less abstract, able to convince customers that the dresses were worn by *real* women. At the outset of Steichen's fashion career, the lion's share of illustrations were drawn, but midway into it, photography became the dominant partner.[40] And Steichen would be the dominant practitioner.

As for his portraits, Steichen would surpass the expectations of his employer. They, too, appeared "real," as photohistorian Joel Smith notes: "Steichen's best celebrity photographs are realistic in this sense; when his sitters live up to the style in which they have been presented, one is convinced that their personal magnetism inspired the photographer's vision of them, *rather than the other way around.* Set among Steichen's other pictures, which frankly employ reality only as a conduit to ideals and dreams, Steichen's portraits appear strikingly rooted in the physical details of their subjects, and they convincingly worked their way into the public's understanding of the notables he depicted."[41]

Looking back on Steichen's years at Condé Nast, the renowned art director Alexander Liberman noted how Steichen had arrived at the "turning point of pictorial journalism" when technical advances in lithography and high-speed printing *needed* photography.[42] On accepting Nast's offer, Steichen had resolved to learn to make photographs that would go on the printed page. He did so rapidly and effectively. Curator John Szarkowski has noted the way Steichen actually enhanced *Vogue*'s and *Vanity Fair*'s reproduction quality through a novel approach to lighting: "His use of artificial light not only emphasized the real or invented glamour of his subject but also made the reproduction quality of *Vanity Fair* and *Vogue* look even better than it was, by making sure that the essential blocking out of volumes in space was described in terms of clear and simple dis-

tinctions in the gray scale." And Szarkowski concludes insightfully that Steichen's sculptural schema "is so simply rendered that the main structure of the picture will survive even in a Xerox copy."[43]

But this did not mean that Steichen overlooked the importance of minute detail, and sometimes it is the light on a mere fingernail that gives an image its spark. In this regard, it is worth while to recall the photographer's early Pictorialist lessons. Admiring a portrait of George Frederick Watts by fellow photographer Frederick Hollyer, Steichen wrote in 1900: "The corner with that *wondrously fine hand alone might be cut out and hung* as a worthy tribute to the greatest poet among modern British painters."[44] In a sense, he foresaw the power of cropping in magazine photography, a process to which his own photographs would often be subjected.

No one could have denied Paris's fashion supremacy in 1911, and no one could deny that the 1920s proved to be a golden age for haute couture in the French capital. But World War I had given the industry a body blow, and the U.S. economic machine was gearing up for a new age. New York might not have been the center of innovation and design, but it would be the center of the business, and *Vogue*, buttressed by *Vanity Fair*, was poised to become the flagship of a new globalized fashion enterprise. At home, American women were eager to emulate their debonair French cousins, and they had the financial wherewithal. Nast's magazines were the industry gold standard; they would report on, reflect, and dignify fashion. Nast flung the door open to Steichen, and in turn the photographer flung open the portals of desire to an ever-growing class of women who were hungry for high style. Steichen would fulfill his dream of making himself useful. In March 1923, he was finally the right man in the right place at the right time.[45]

1 Edward Steichen, "Painting and Photography," *Camera Work*, no. 23 (July 1908).

2. These and many other issues are addressed in the companion volume to the current catalogue, Todd Brandow and William A. Ewing, eds., *Edward Steichen: Lives in Photography* (exhibition catalogue, with comprehensive bibliography and chronology) (Minneapolis: FEP Editions LLC, in association with W. W. Norton, 2007).

3. Steichen quoted in Penelope Niven, *Steichen: A Biography* (New York: Clarkson Potter Publishers, 1997), 91. The spellings are his.

4. *Vanity Fair*, January 1918, 48.

5. Unidentified Milwaukee newspaper clipping, August 30, 1902, and undated newspaper clipping described only as "Tells About His Work," from Marie Steichen's scrapbook, The Edward Steichen Archive, The Museum of Modern Art, New York.

6. Steichen would, however, return for visits through 1927.

7. Letter from Edward Steichen to his sister, Lilian, [1922], The Edward Steichen Archive, The Museum of Modern Art, New York.

8. Auguste Rodin, interviewed by George Besson, "Pictorial Photography: A Series of Interviews," *Camera Work*, no. 24 (October 1908): 14.

9. Edward Steichen, "My Life in Photography," *Saturday Review*, March 28, 1959, 15–16.

10. Niven, *Steichen: A Biography*, 492.

11. Letter from Edward Steichen to Jacob Deschin, January 24, 1938, The Edward Steichen Archive, The Museum of Modern Art, New York.

12. Niven, *Steichen: A Biography*, 464.

13. An unidentified Royal Air Force officer described Steichen's aerial photography as an "exacting science." Quoted in Niven, *Steichen: A Biography*, 462.

14. Steichen wrote: "My 'Great Men' series includes portraits of Rodin, Maeterlinck, George Frederick Watts, the eminent English artist Zangwell, Lenbach, the great German portrait artist Besnard, who is perhaps the greatest living exponent of the modern school of art, William M. Chase of New York, Mucha, the painter, and many others. Then, too, I have hosts of pictures of young men, who I expect will be great." Quoted in Niven, *Steichen: A Biography*, 93.

15. [Emphasis mine.] Sadakichi Hartmann, "The Influence of Artistic Photography on Interior Decoration," *Camera Work*, no. 2 (April 1903), reprinted in *The Valiant Knights of Daguerre*, ed. Harry W. Lawton and George Knox (Berkeley: University of California Press, 1978), 92.

16. [Emphasis mine.] Unidentified Milwaukee newspaper clipping, August 30, 1902.

17. Anne Hollander, *Fabric of Vision: Dress and Drapery in Painting* (London: National Gallery, 2002), 10.

18. Ibid., 11.

19. Steichen, "Painting and Photography."

20. Niven, *Steichen: A Biography*, 201.

21. See Brandow and Ewing, *Steichen: Lives in Photography*, Fig. 83.

22. Erica E. Hirshler, "At Home in Paris," in *Americans in Paris 1860–1900*, ed. Kathleen Adler, Erica E. Hirshler, and H. Barbara Weinberg (exhibition catalogue) (London: National Gallery, 2006), 79.

23. The statue, by Paul Moreau-Vauthier, was mounted on top of the Porte Monumentale at the Place de la Concorde.

24. There are other interesting parallels between Steichen and Alexander. The latter was born in a small city in Pennsylvania in 1856, began work as an illustrator in New York, moved to Europe in 1877, and settled in Paris in 1891. He painted portraits of notable actors and actresses and was at ease in society. Like Steichen, he maintained close contact with the American art world, returning to the United States in 1901. His first European success came in the 1890s for his paintings on the theme of the idealized woman in elegant surroundings. *Isabella and the Pot of Basil*, shown here, with its macabre/erotic air typical of Symbolist art, was exhibited in Vienna, Munich, and Pittsburgh. Steichen met and photographed Alexander and would have undoubtedly found the latter's successes inspiring.

25. Mary E. Davis, *Classic Chic: Music, Fashion, and Modernism* (Berkeley: University of California Press, 2006), 7–9.

26. For a general overview of the press in France, see Claude Bellanger, Jacques Godechot, Pierre Guiral, and Fernand Terrou, eds, *Histoire générale de la presse française*, 5 vols. (Paris: Presses Universitaires de France, 1969). Davis also gives an excellent overview in *Classic Chic*, 1–15.

27. Davis, *Classic Chic*, 8.

28. Steichen was first assigned to the photographic section of the Army Air Service Signal Corps, which was responsible for all U.S. war photography. However, on seeing some aerial photography firsthand, he arranged to be transferred to the new American Expeditionary Force Air Service, which had aerial photography as part of its mandate.

29. The first issue of *Camera Work* was published in January 1903.

30. Quoted in Niven, *Steichen: A Biography*, 536.

31. Paul Cornu, "L'Art de la robe," *Art et Décoration*, April 1911, 101–18.

32. Not that Steichen needed any more work in early 1911. Frenetic talent scout that he was, he had been involved in feverish preparations for the Paul Cézanne watercolor and painting exhibition he had selected for Stieglitz's 291 gallery in New York, and he was also making ready for the Pablo Picasso show that would follow. Steichen somehow found the time in February for a trip to London, where he consulted with fellow photographers on an important exhibition and built "a nice little fire" of promotion under it, as he reported back to Stieglitz. (Letter from Edward Steichen to Alfred Stieglitz, February 1911, Alfred Stieglitz Archive, Beinecke Rare Book and Manuscript Library, Yale University, New Haven, Connecticut.) As for his own work, an evident priority, he was concentrating on an extremely lucrative commission to paint a series of murals for his wealthy American millionaire friend, Eugene Meyer.

33. "Poiret on the Philosophy of Dress," *Vogue*, October 15, 1913, 41.

34. Davis, *Classic Chic*, 44.

35. Palmer White, *Poiret* (New York: Clarkson N. Potter, 1973), 23.

36. "Poiret on the Philosophy of Dress," *Vogue*, October 15, 1913, 41.

37. The text accompanied a reproduction of Natica Nast, titled "Portrait of a Child," in *Vanity Fair*, August 1917 (p. 32).

38. Frank Crowninshield, "Master American Portrait Photographers," *Vanity Fair*, January 23, 1923, 54.

39. Niven, *Steichen: A Biography*, 502.

40. In 1930, Condé Nast Publications spent approximately $100,000.00 on art and $40,000.00 on photography. By 1933, the figures were $73,000.00 and $60,000.00 respectively. By 1940, the balance had tipped in the other direction. Caroline Seebohm, *The Man Who Was Vogue: The Life and Times of Condé Nast* (New York: Viking Press, 1982), 187.

41. [Emphasis mine.] Joel Smith, *Edward Steichen: The Early Years* (exhibition catalogue) (Princeton, N.J.: Princeton University Press in association with the Metropolitan Museum of Art, 1999), 27.

42. Quoted in Niven, *Steichen: A Biography*, 512.

43. John Szarkowski, *Photography Until Now* (exhibition catalogue) (New York: Museum of Modern Art, 1989), 190.

44. [Emphasis mine.] Edward Steichen, "British Photography from an American Point of View," *Camera Notes* 4, no. 3 (January 1901): 179. The article was originally published in *Amateur Photographer* 32 (November 2, 1900): 343–45.

45. Upon Steichen's retirement in 1937, Condé Nast wrote a letter of appreciation to his chief photographer: "I always felt that you (along with Edna Chase and Frank Crowninshield) were, in a true sense, founders of this business. . . . You will never know dear Edward, what your work has meant to Vogue, or what your loyalty has meant to Vogue and to me personally; the feeling that I could always lean on you, that you were a rock that would not move or alter. Affectionately and gratefully yours. Condé." Letter from Condé Nast to Edward Steichen, September 27, 1937, Condé Nast Archive, Condé Nast Publications, Inc., New York.

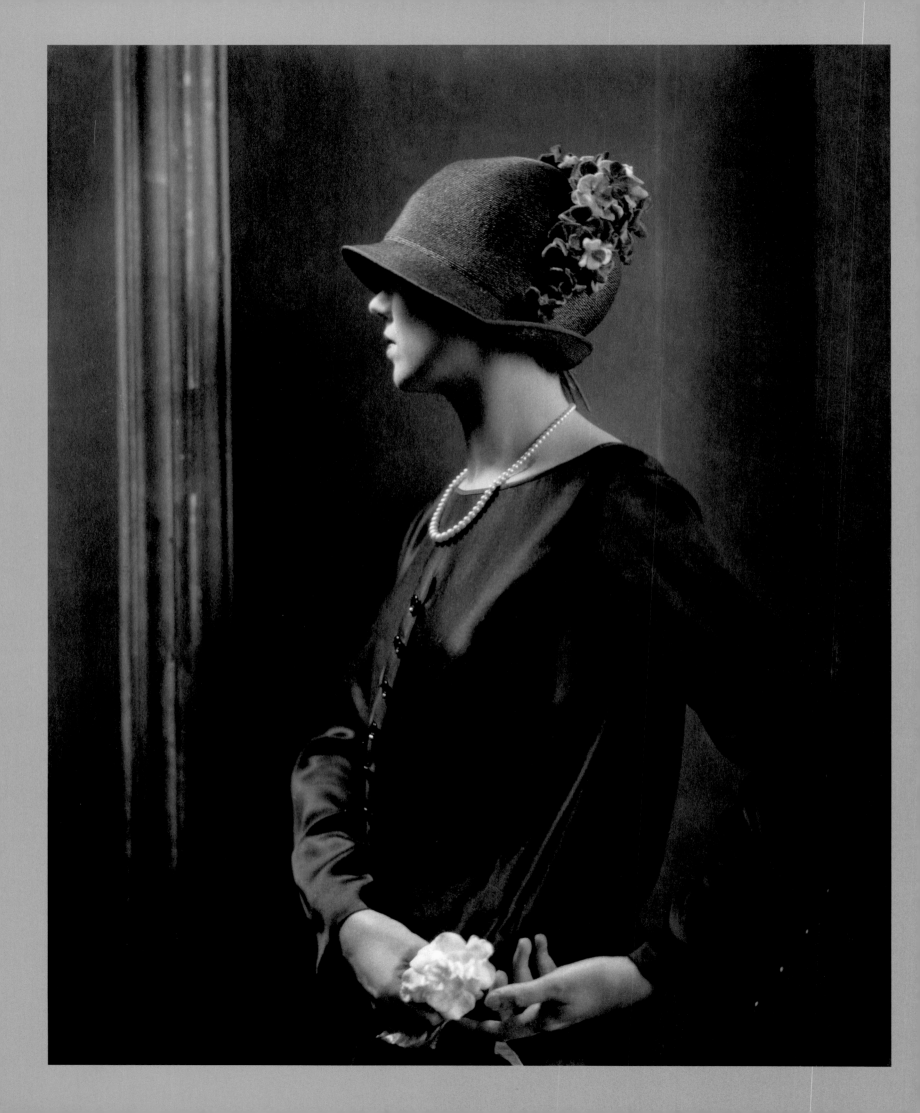

PLATES 1 *I will sign the pictures*

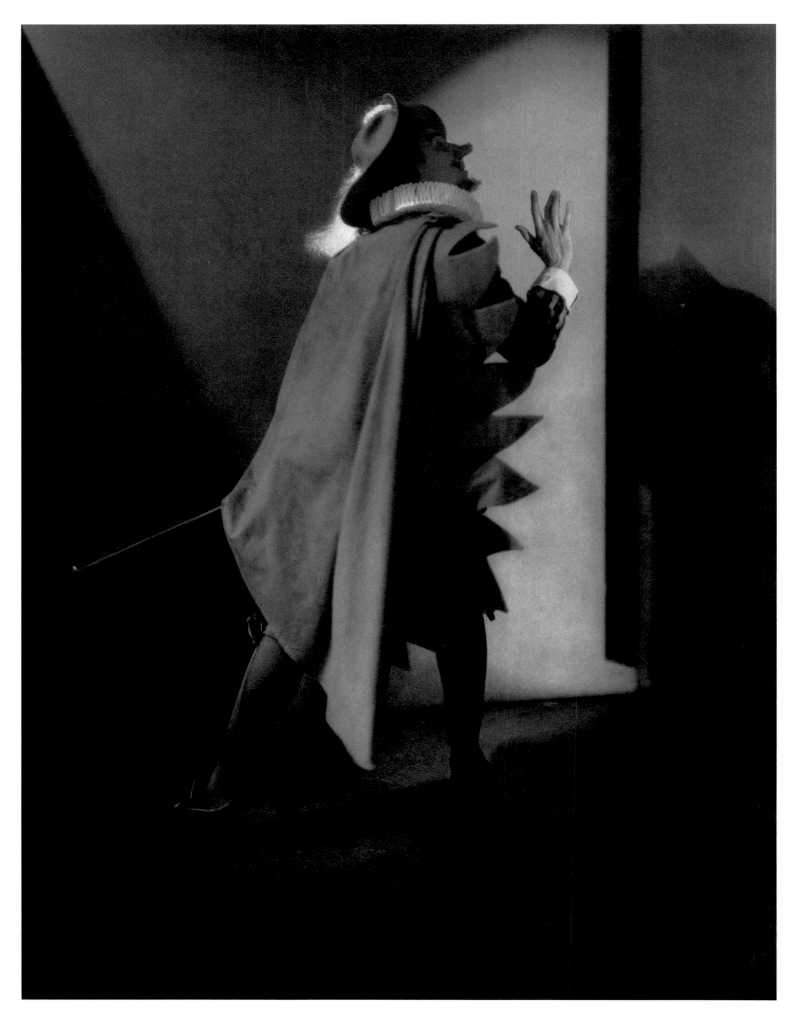

19. ACTOR WALTER HAMPDEN AS CYRANO, 1923

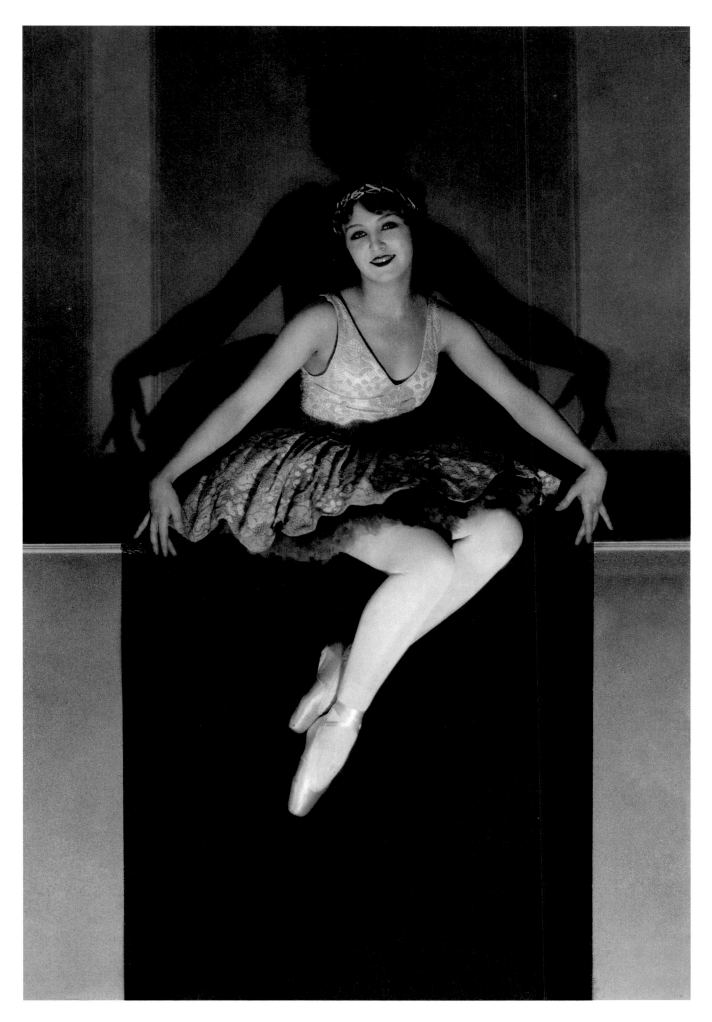

20. ACTRESS MARY EATON FROM THE FOLLIES, 1923

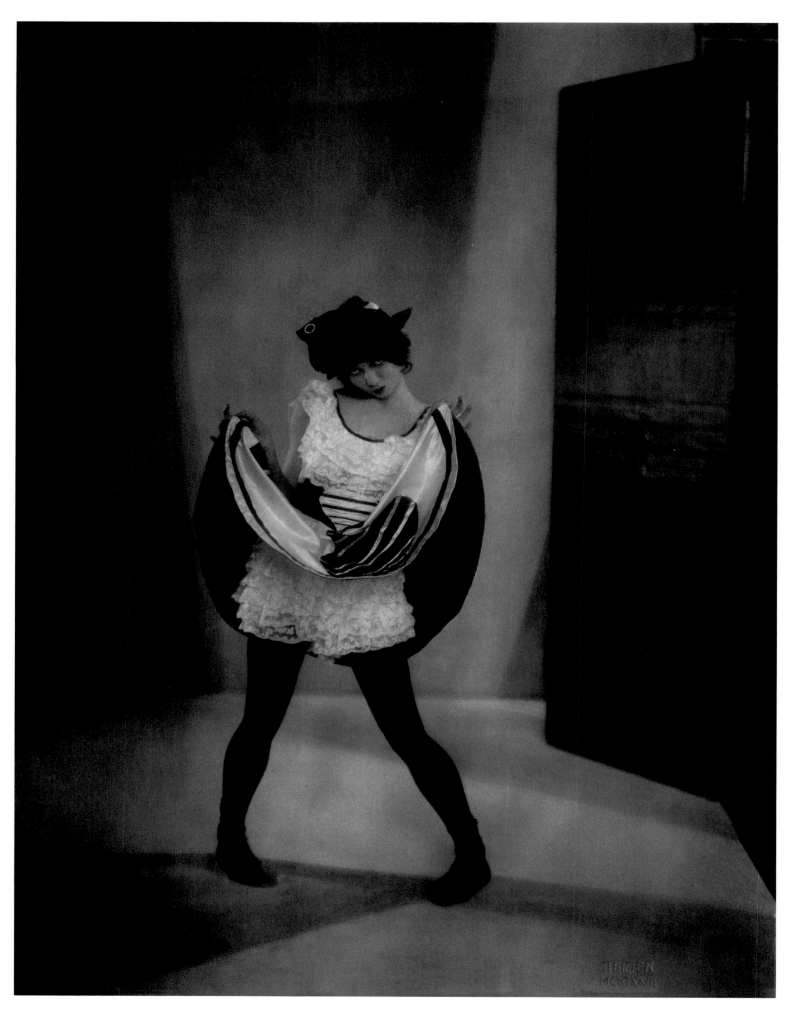

21. DANCER MARGARET SEVERN, 1923

40

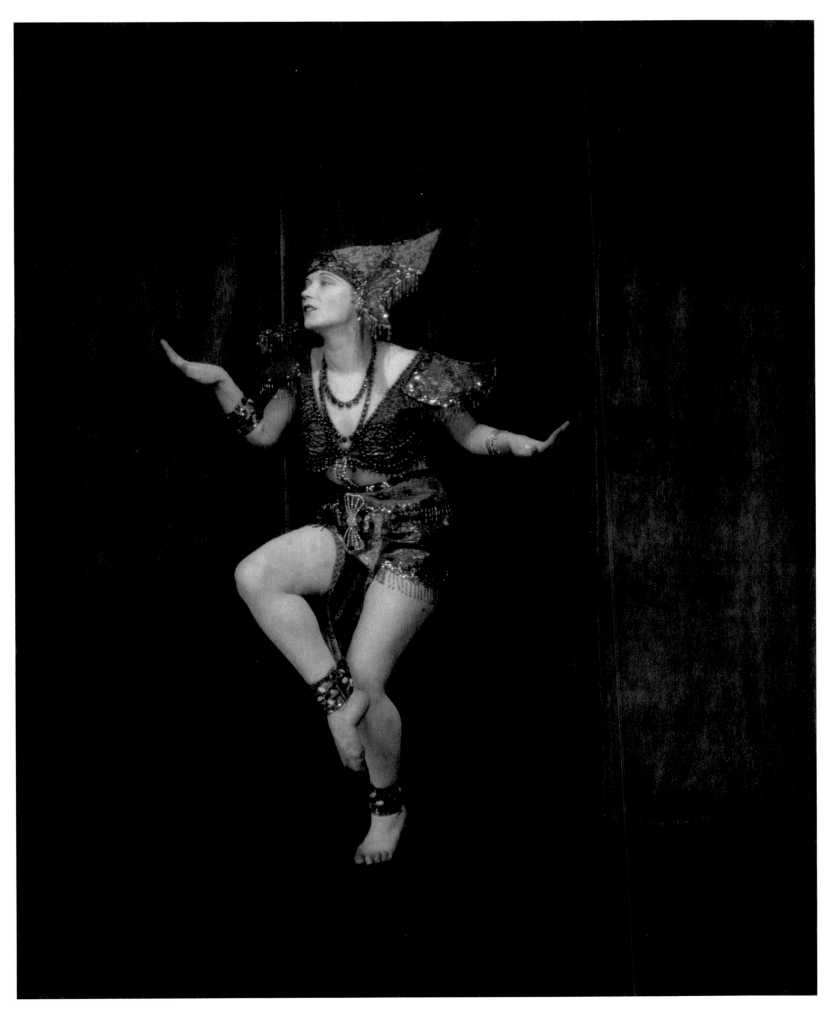

22. DANCER GILDA GRAY AS A JAVANESE DANCER, 1923

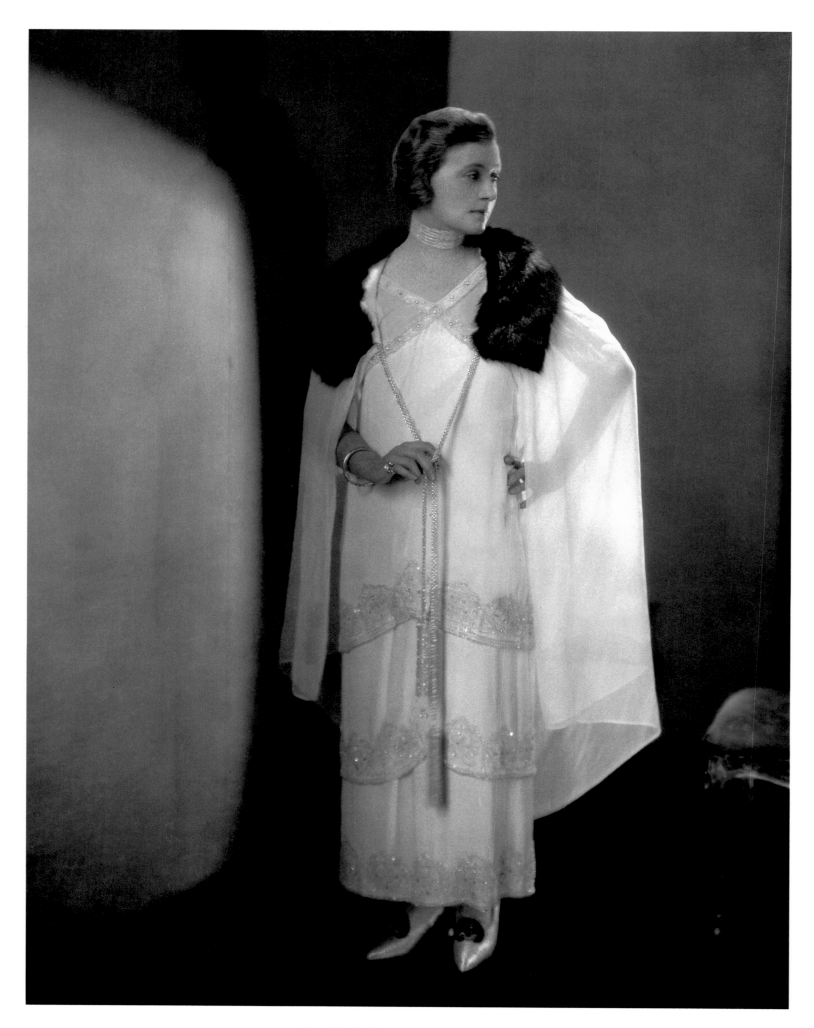

23. ACTRESS LUCILE WATSON IN THE PLAY *THE FAR CRY*, 1924

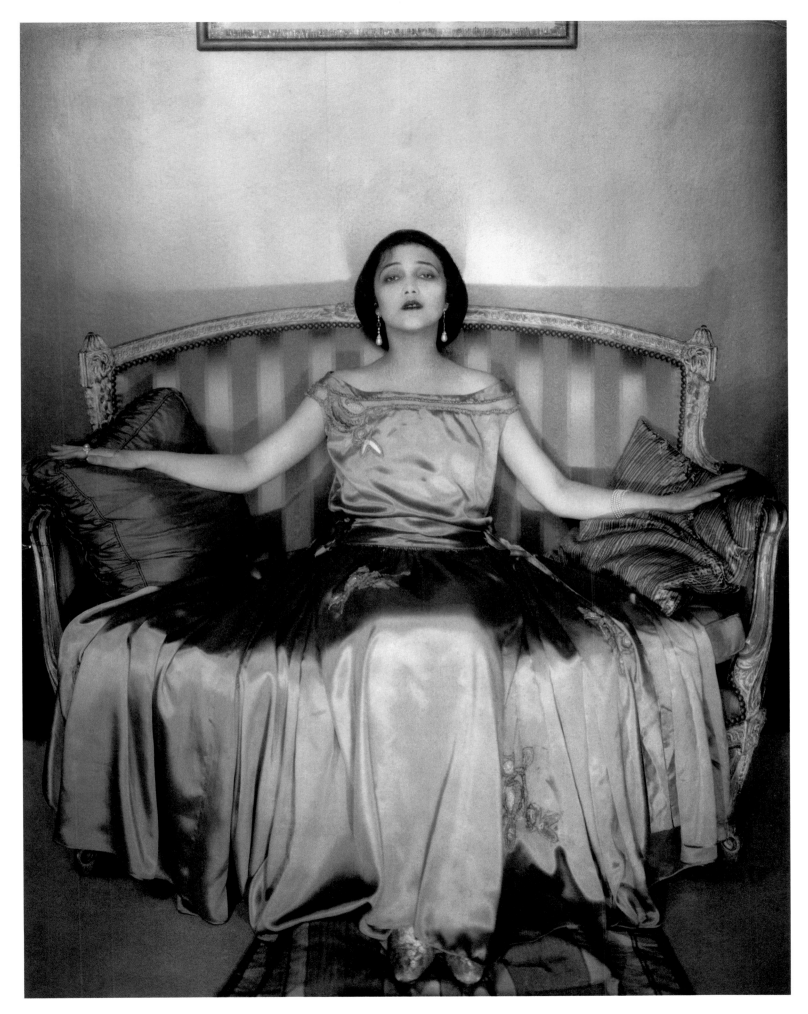

24. ACTRESS JETTA GOUDAL WEARING A SATIN GOWN BY LANVIN, 1923

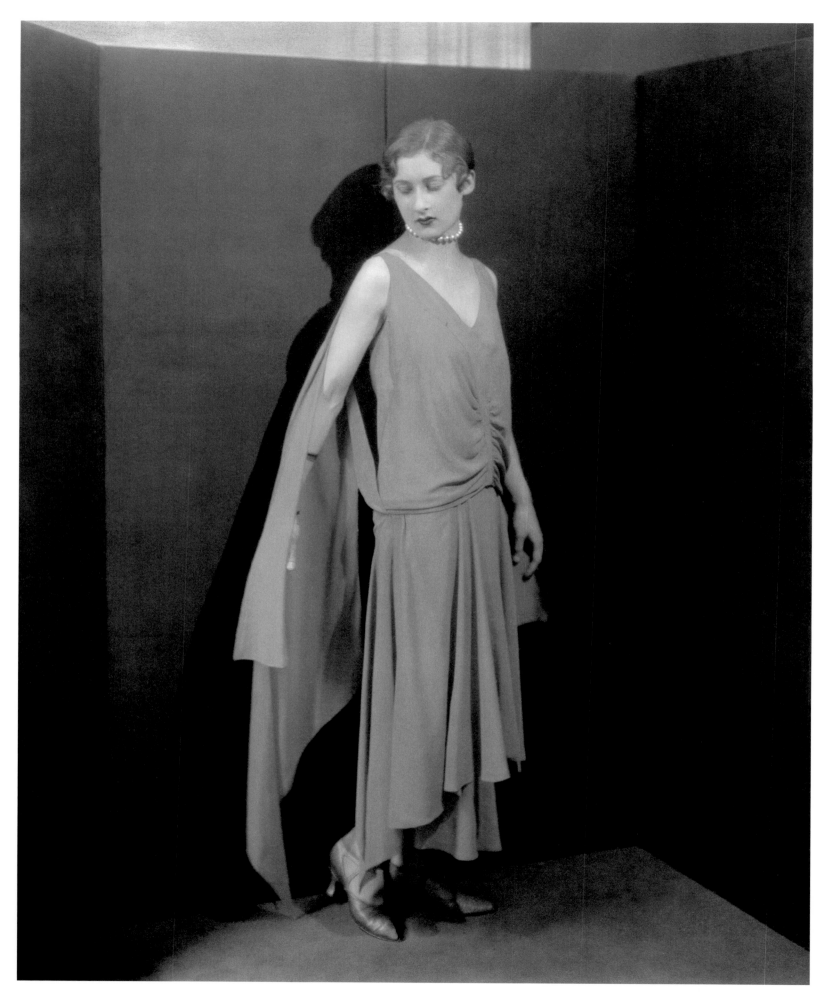

25. MADAME NADINE VARDA WEARING A CRÊPE EVENING GOWN BY CHANEL, 1924

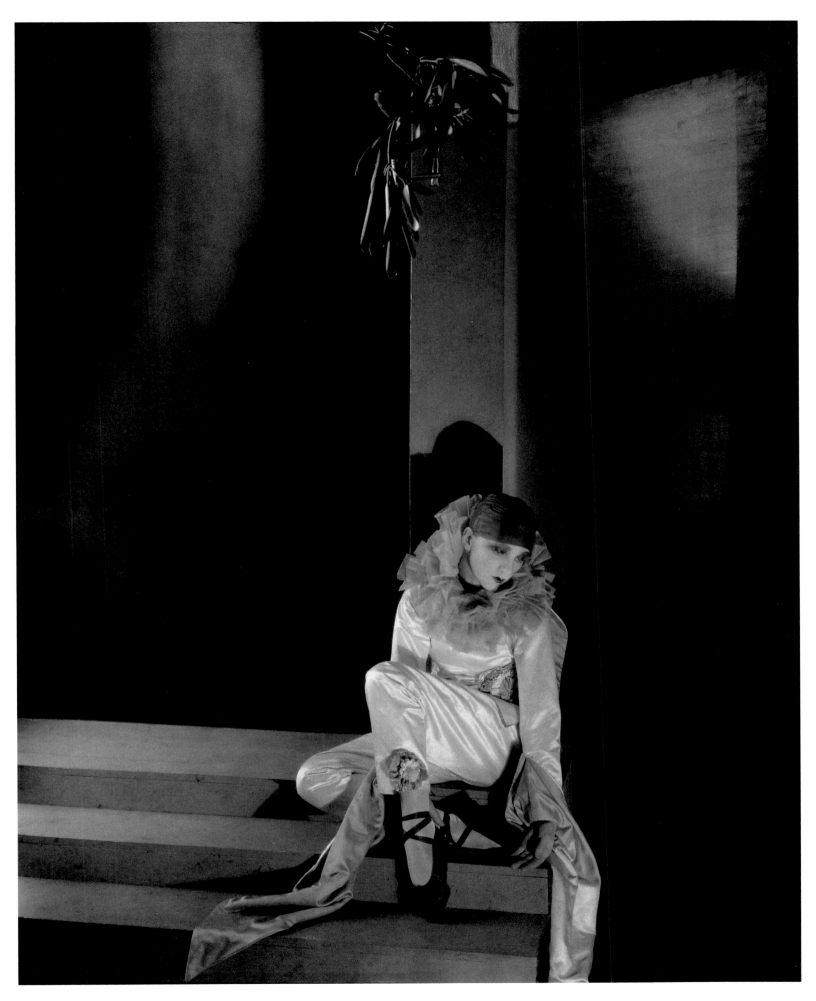

26. ACTRESS GERTRUDE LAWRENCE AS PIERROT IN ANDRÉ CHARLOT'S PLAY *MIGNONETTE AND MAIDEN-GLOW*, 1924

27. PRINCESS YOUSSOUPOFF, 1924

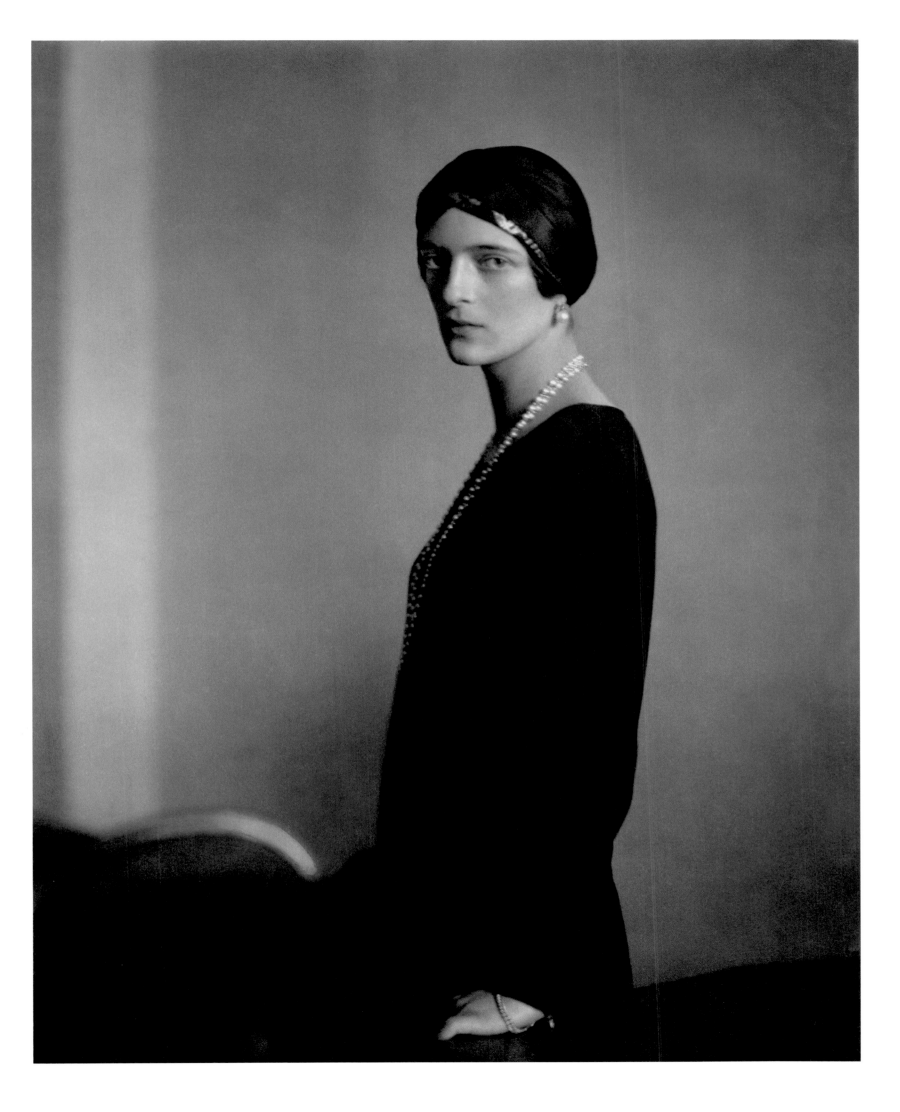

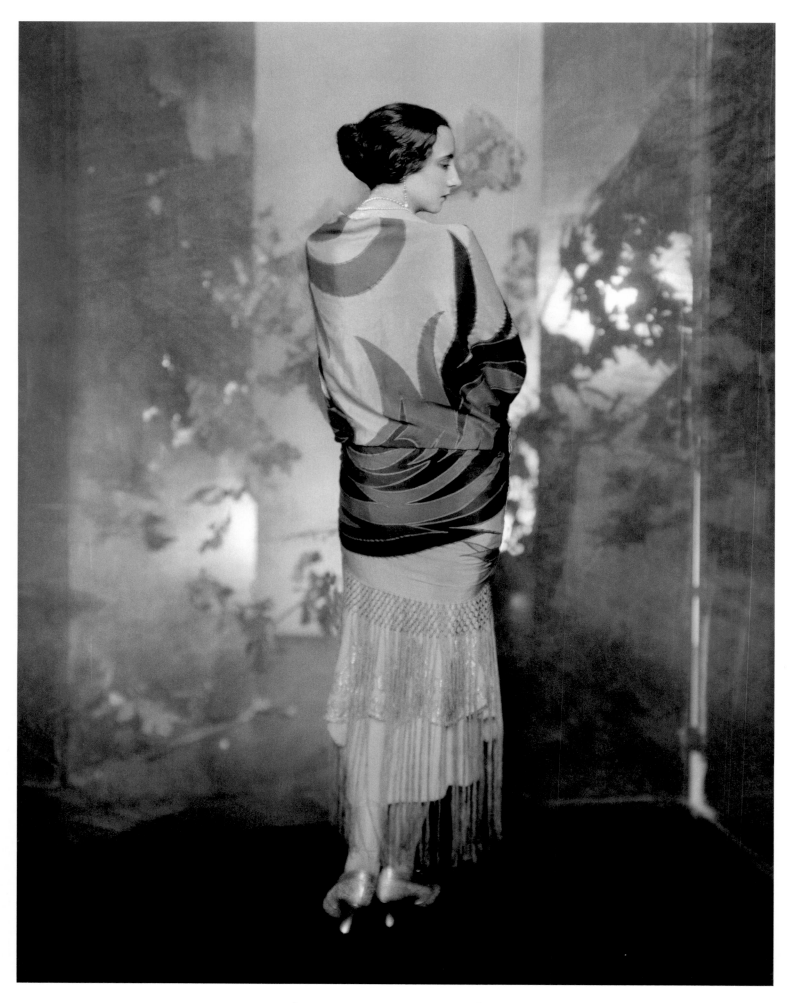

28. MODEL WEARING A SHAWL OF CRÊPE DE CHINE HAND-PAINTED BY RUSSIAN ARTISTS, 1924

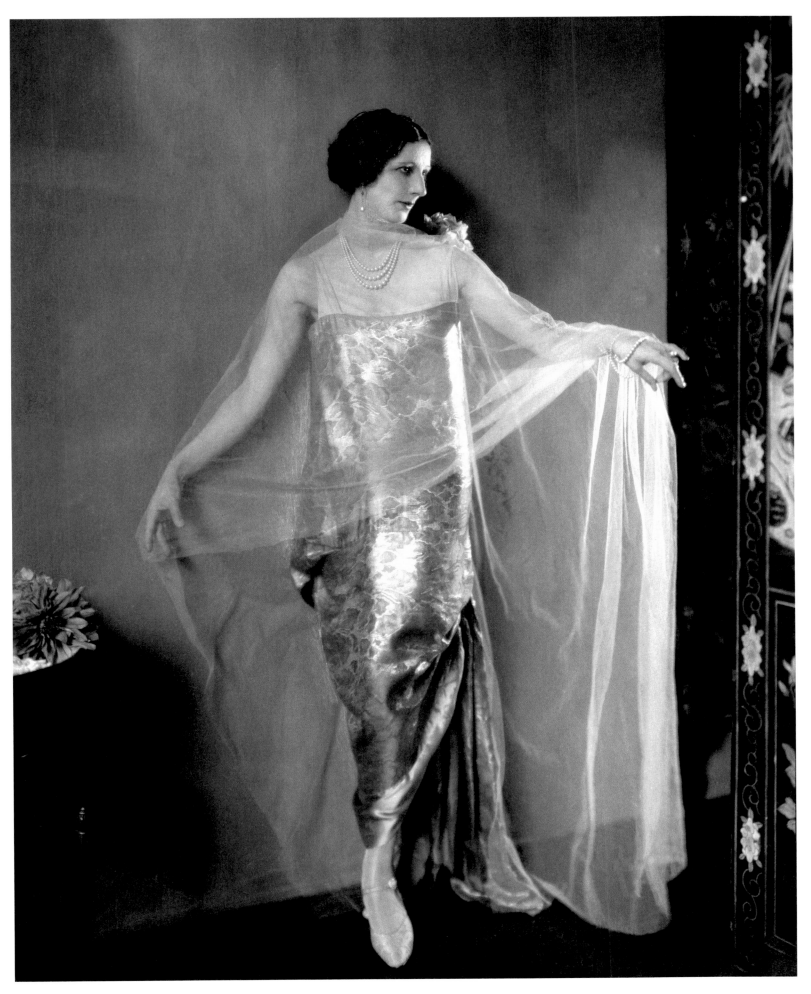

29. DANCER DÉSIRÉE LUBOVSKA WEARING A BROCADE EVENING GOWN AND A TULLE
SCARF BY CALLOT, 1924

30. ACTRESS CARLOTTA MONTEREY WEARING A DIAMOND HEAD BANDEAU BY CARTIER
AND A WHITE ERMINE WRAP WITH A WHITE FOX COLLAR, 1924

31. ACTOR HENRY HULL IN THE PLAY *THE YOUNGEST*, 1923

32. ACTRESS ALDEN GAY WEARING AN EVENING DRESS BY CHANEL, 1924

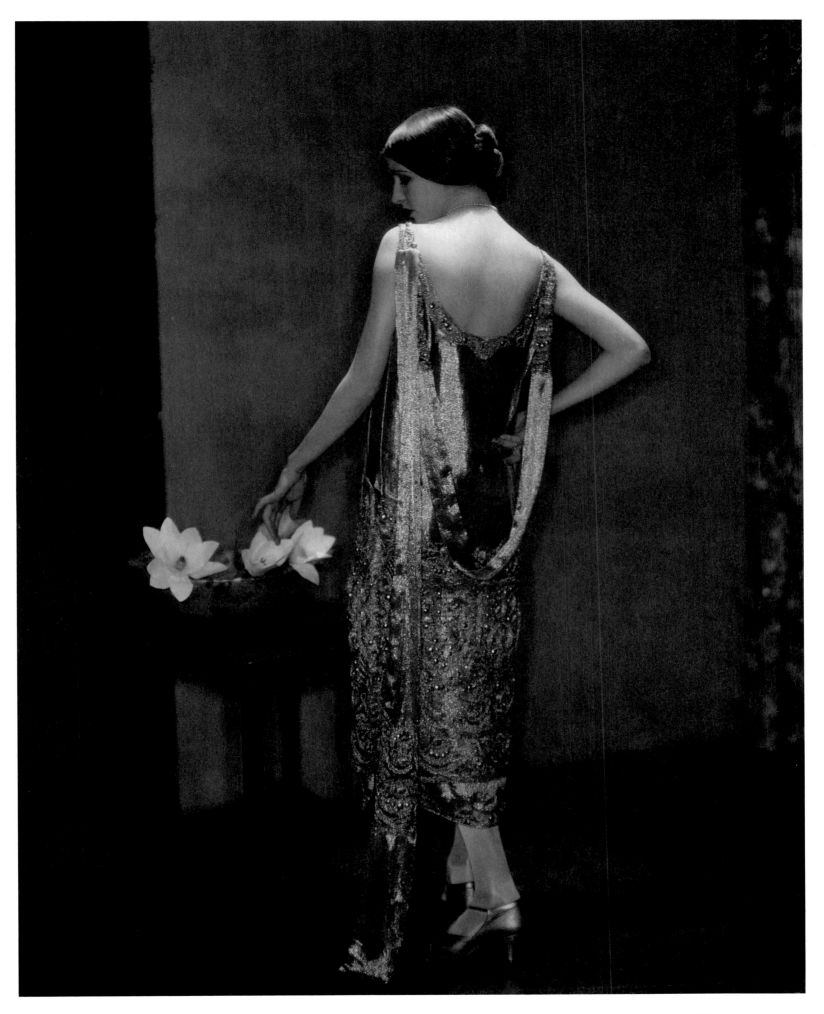

33. MODEL MARION MOREHOUSE WEARING AN EVENING GOWN BY CHANEL, 1924

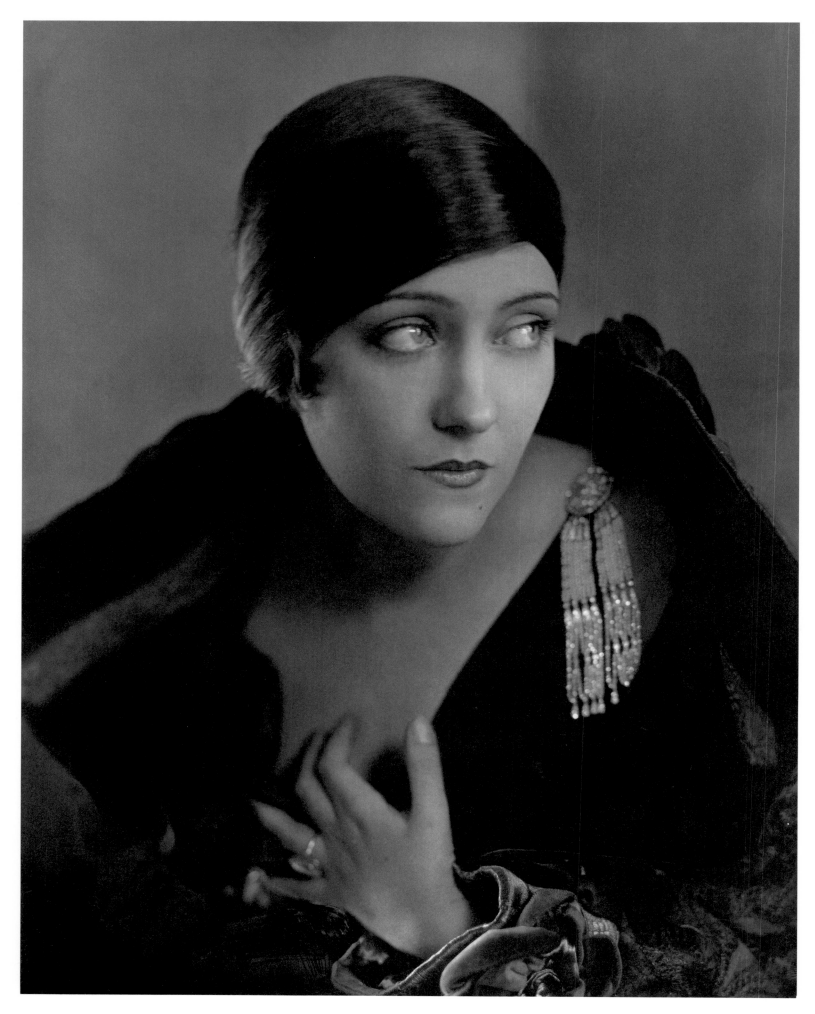

34. ACTRESS GLORIA SWANSON, 1924

35. ACTOR LOUIS WOLHEIM, 1924

36. ACTRESS GLORIA SWANSON, 1924

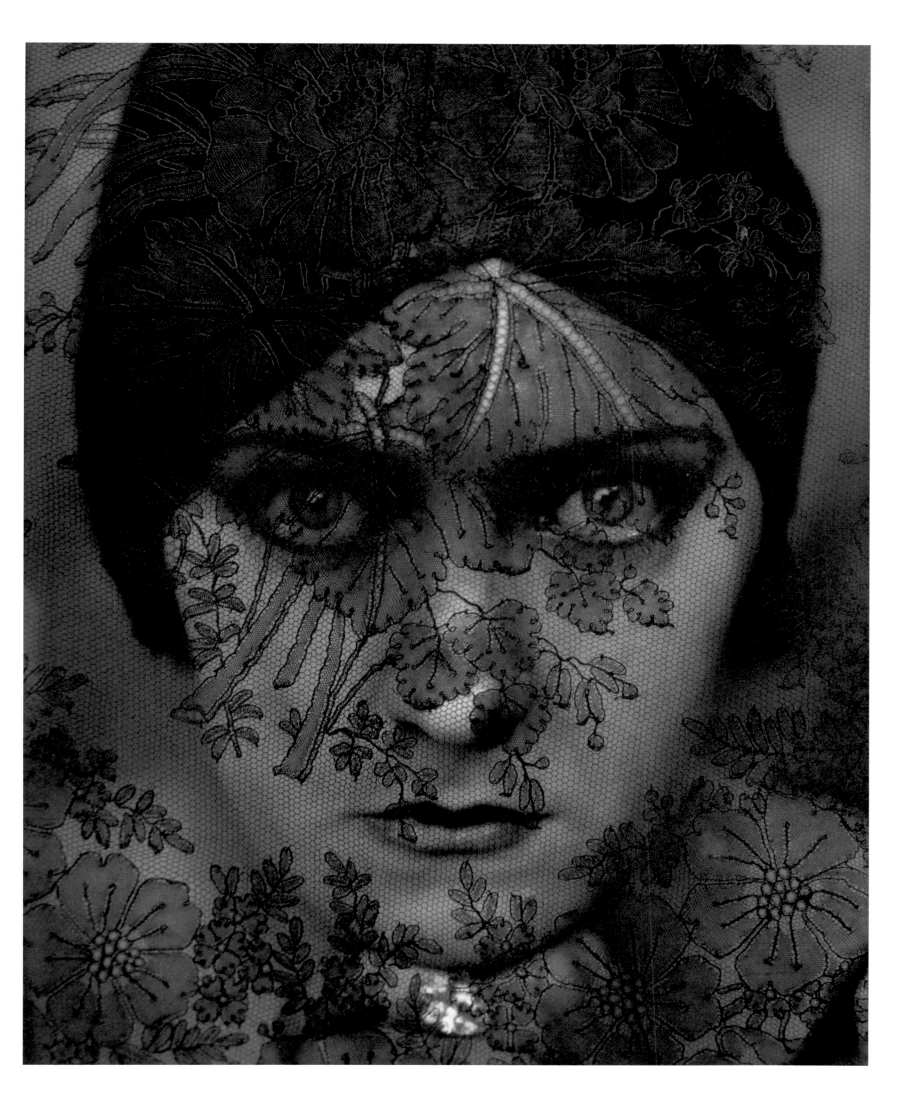

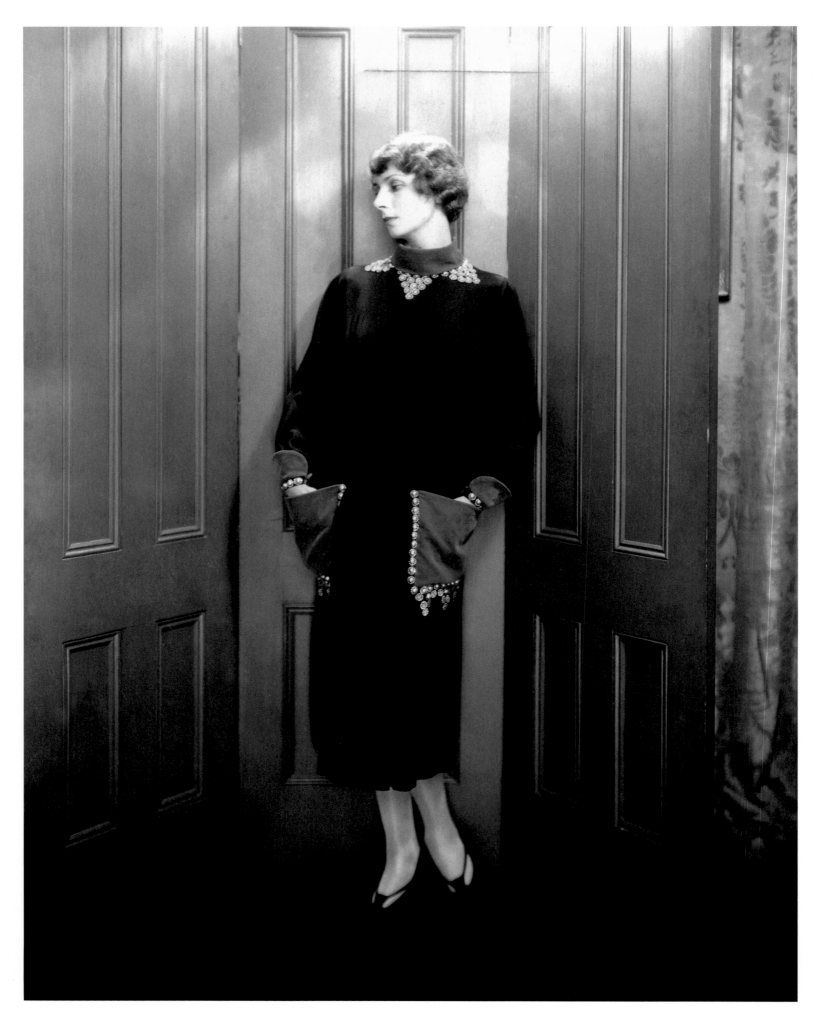

37. MODEL DINARZADE WEARING A CRÊPE DE CHINE DRESS BY LANVIN, 1924

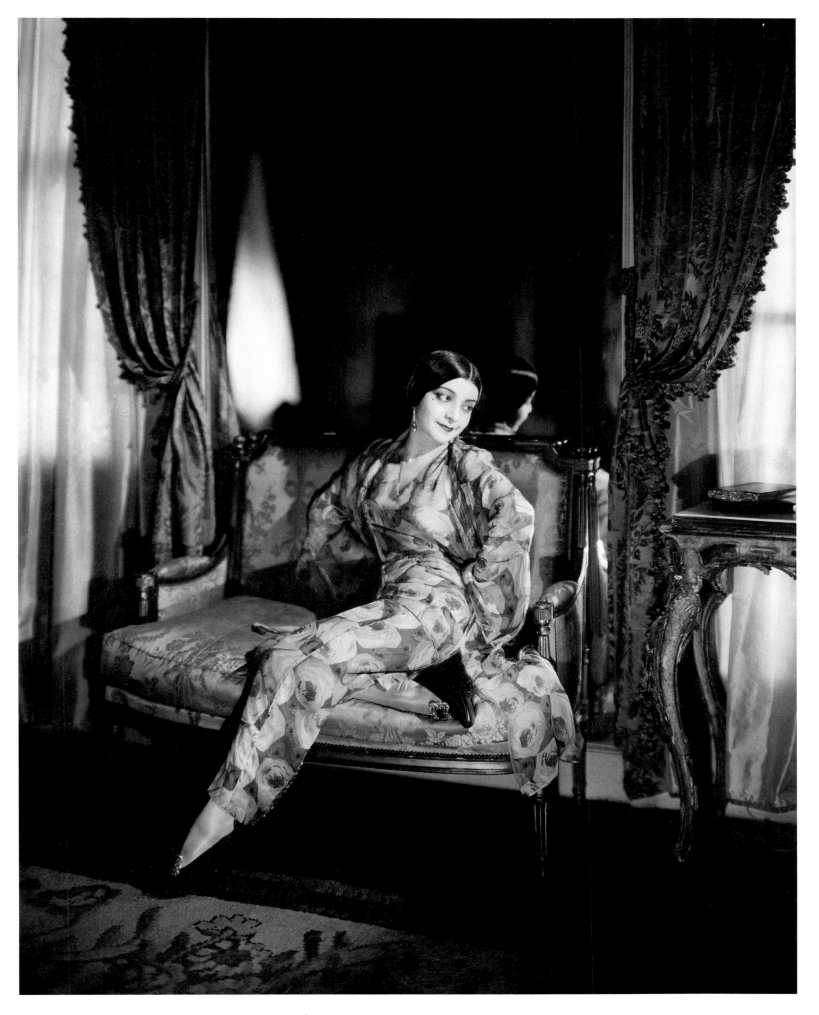

38. MODEL WEARING FASHION BY MOLYNEUX, 1925

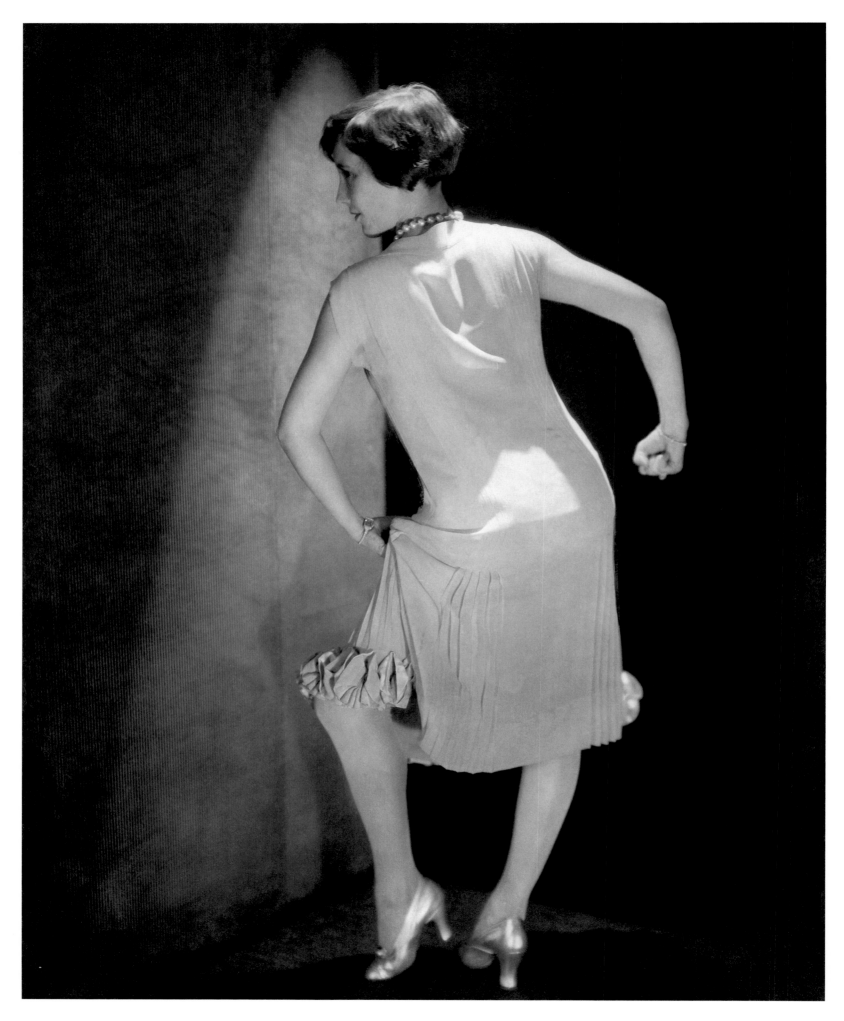

39. ACTRESS BESSIE LOVE DANCING THE CHARLESTON, 1925

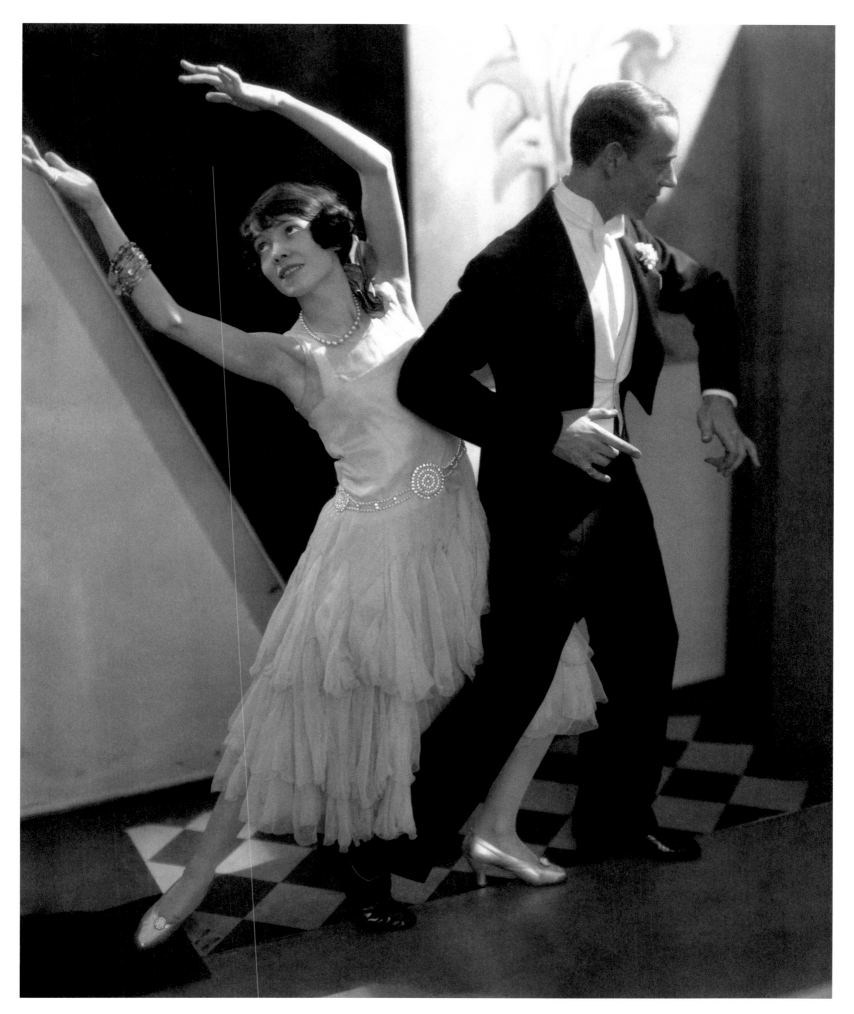

40. DANCERS ADELE AND FRED ASTAIRE AT THE TROCADERO CLUB, 1925

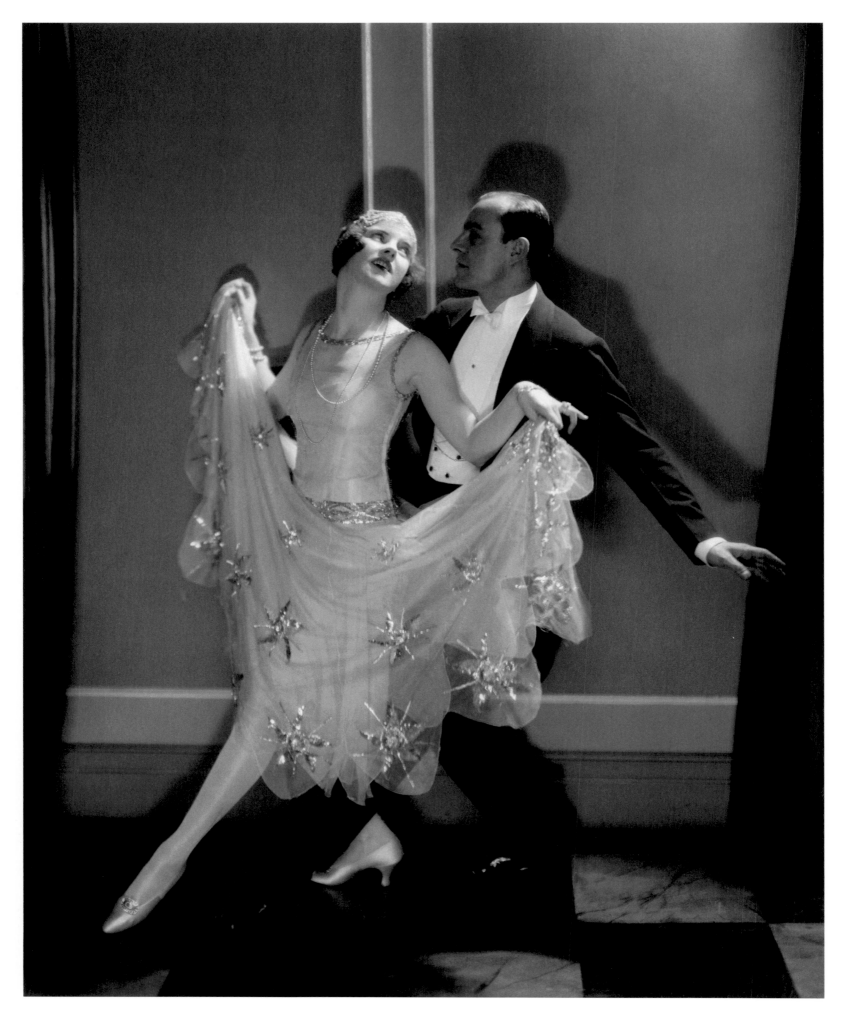

41. DANCERS LEONORE HUGHES AND MAURICE MOUVET, 1924

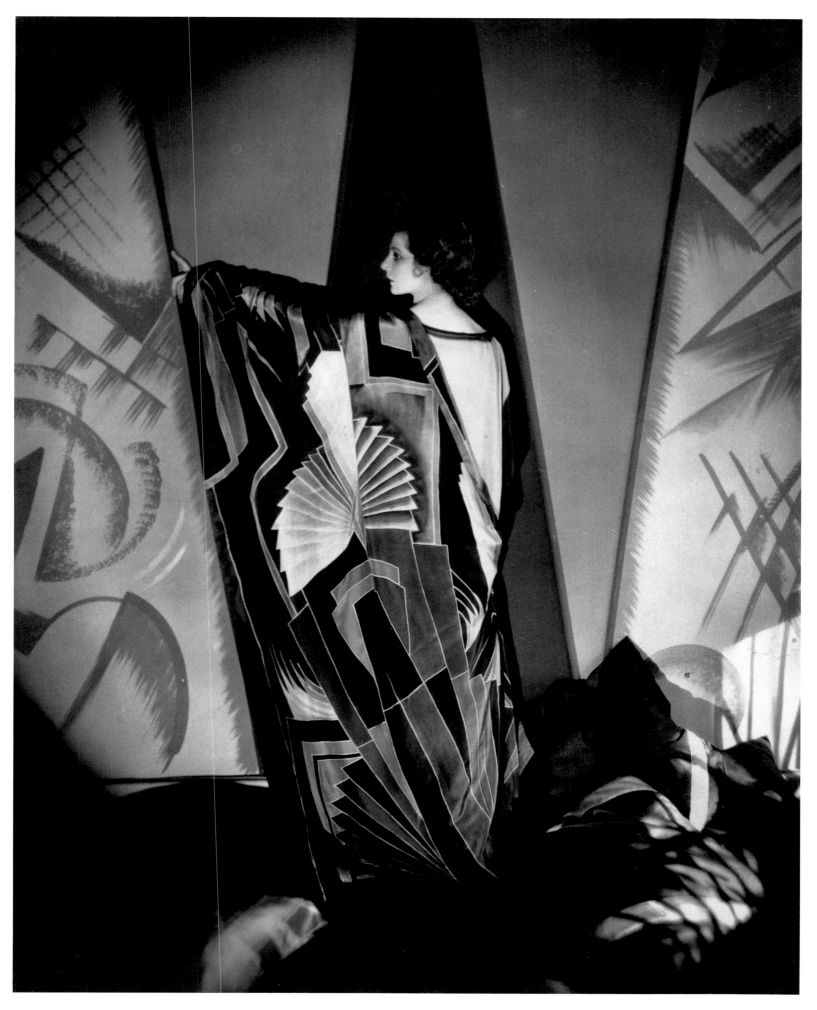

42. TAMARIS WITH A LARGE ART DECO SCARF, 1925

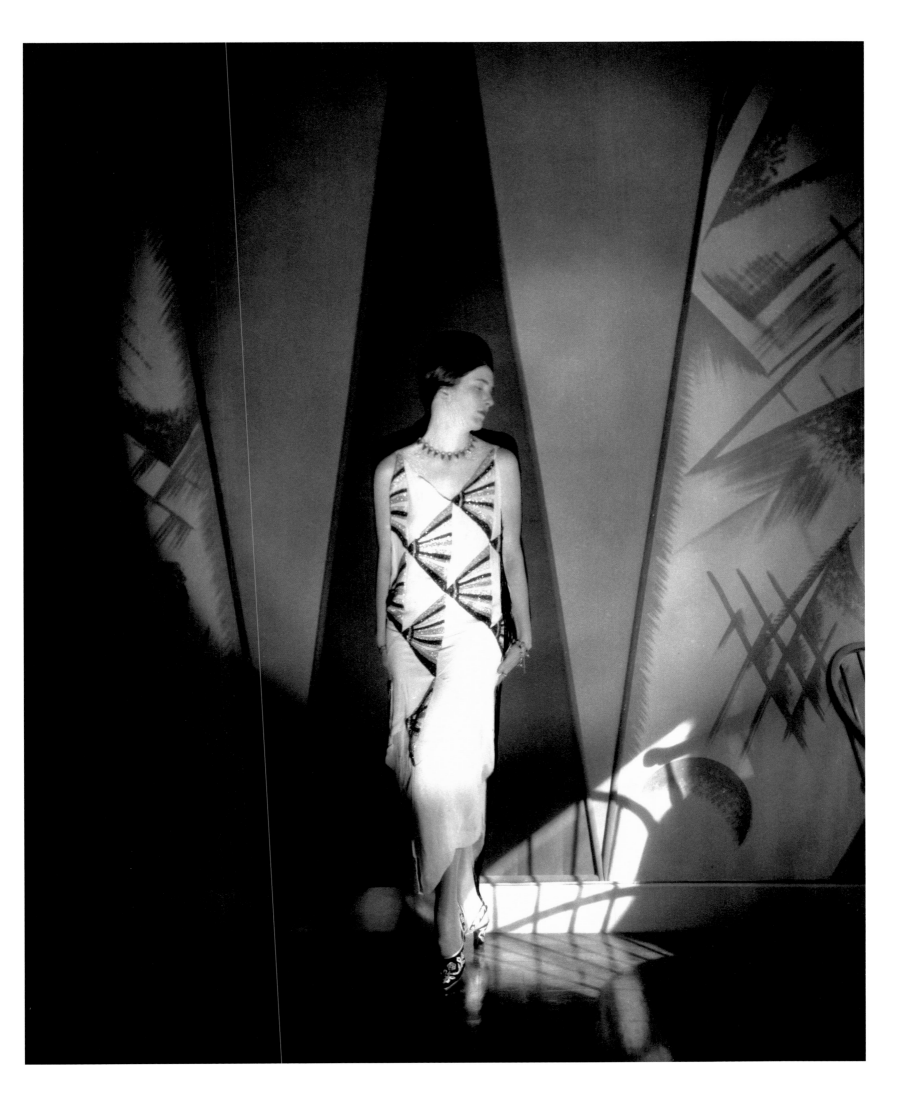

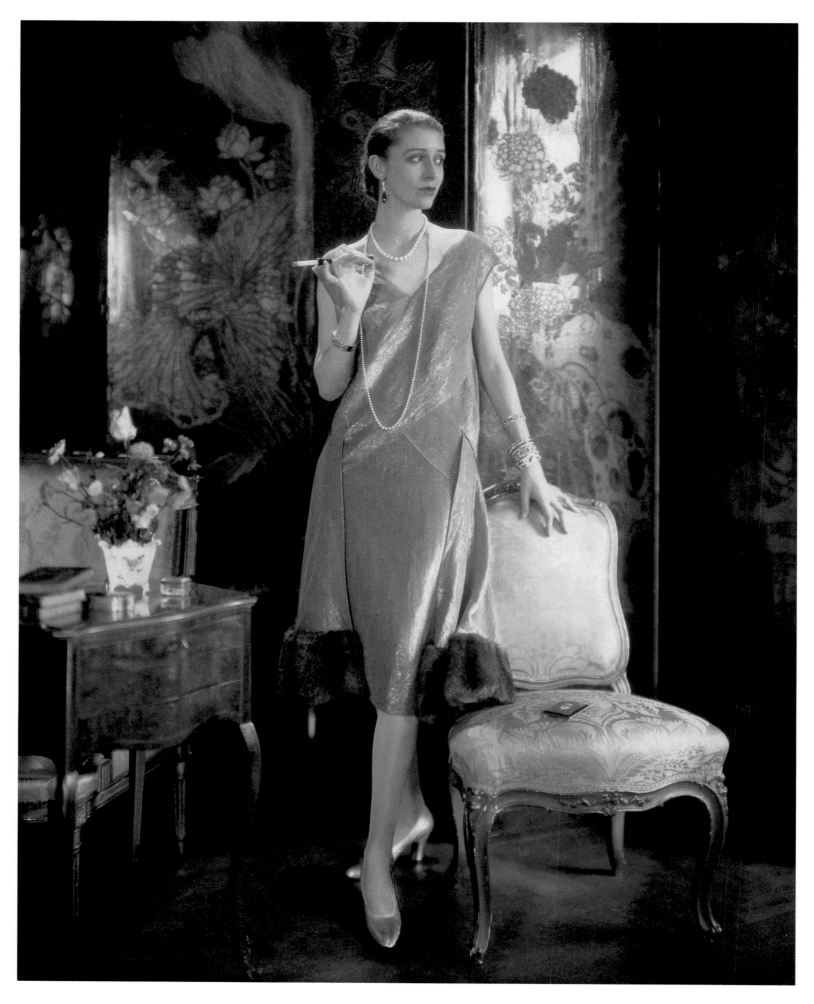

44. MODEL MARION MOREHOUSE WEARING A DRESS BY LELONG AND JEWELRY BY BLACK,
STARR AND FROST, 1925

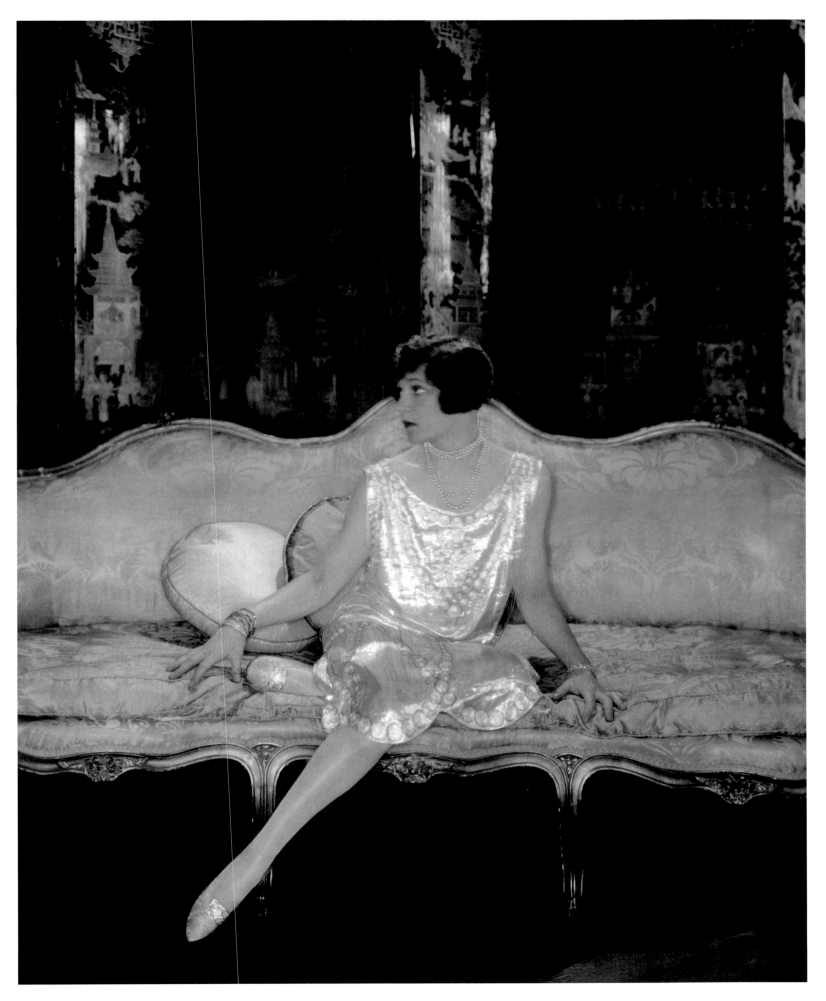

45. ACTRESS ALICE BRADY DRESSED FOR THE PLAY *SOUR GRAPES*, 1926

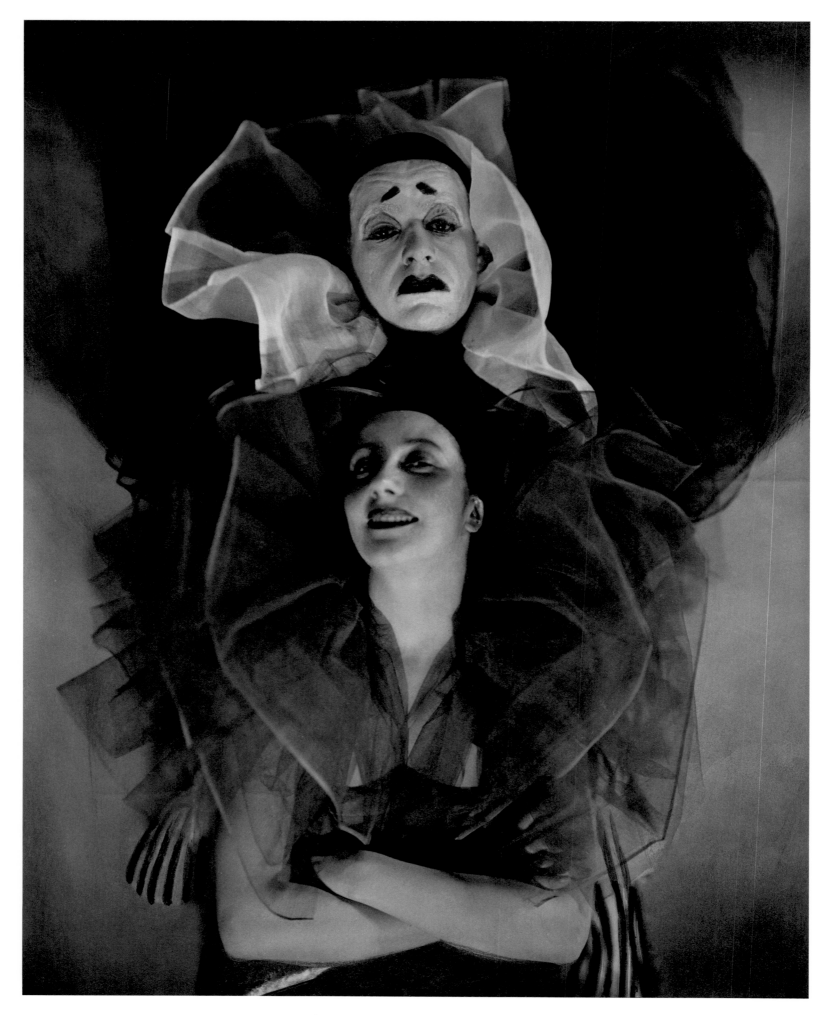

46. ACTORS LYNN FONTANNE AND ALFRED LUNT, 1925

47. ACTOR W. C. FIELDS AT THE ZIEGFELD FOLLIES, 1925

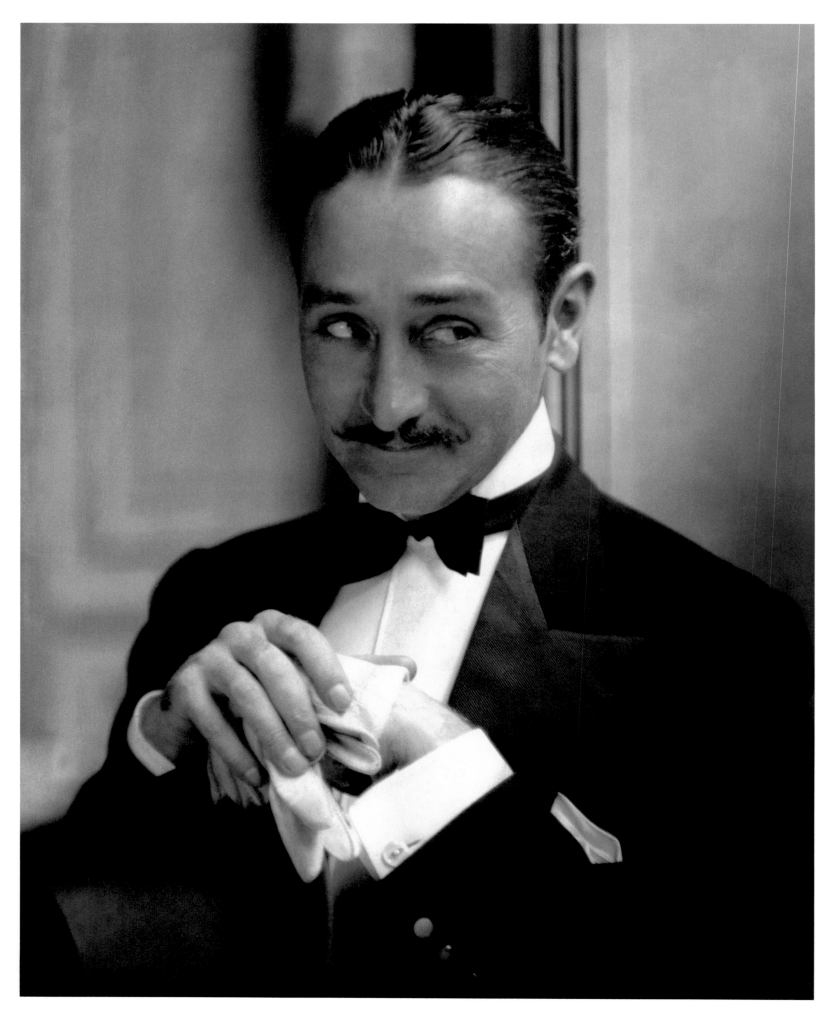

48. ACTOR ADOLPHE MENJOU, 1925

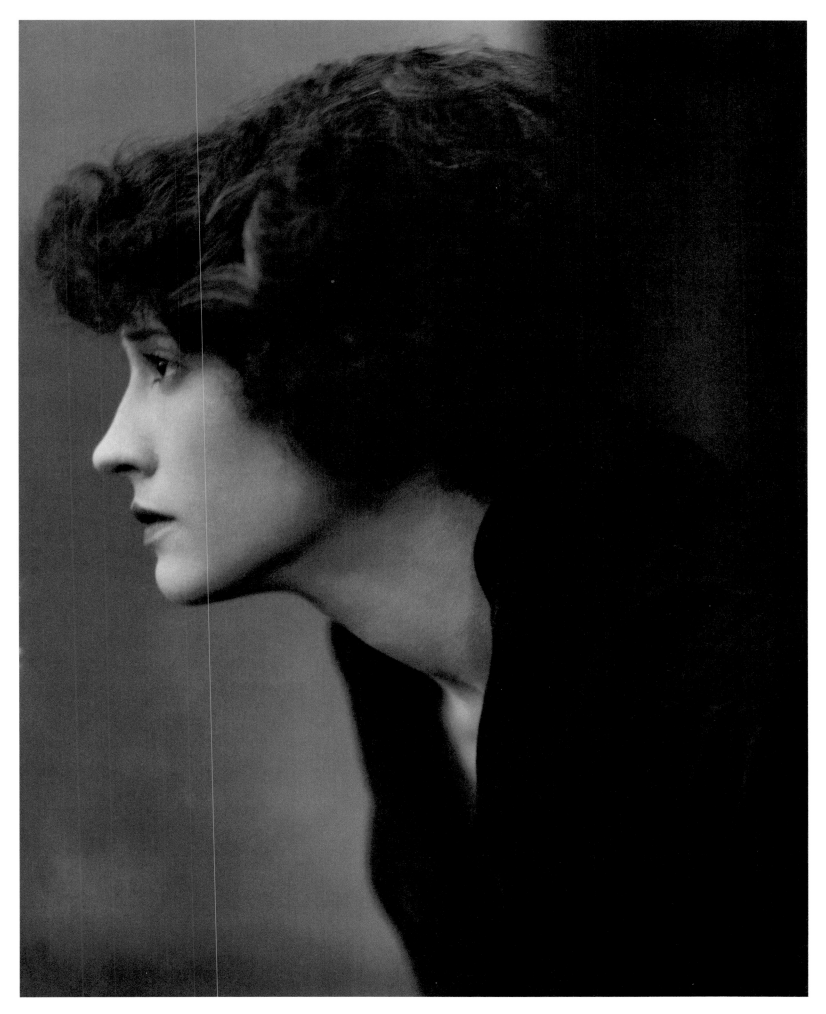

49. ACTRESS HELEN MENKEN, 1925

50. ACTRESS POLA NEGRI, 1925

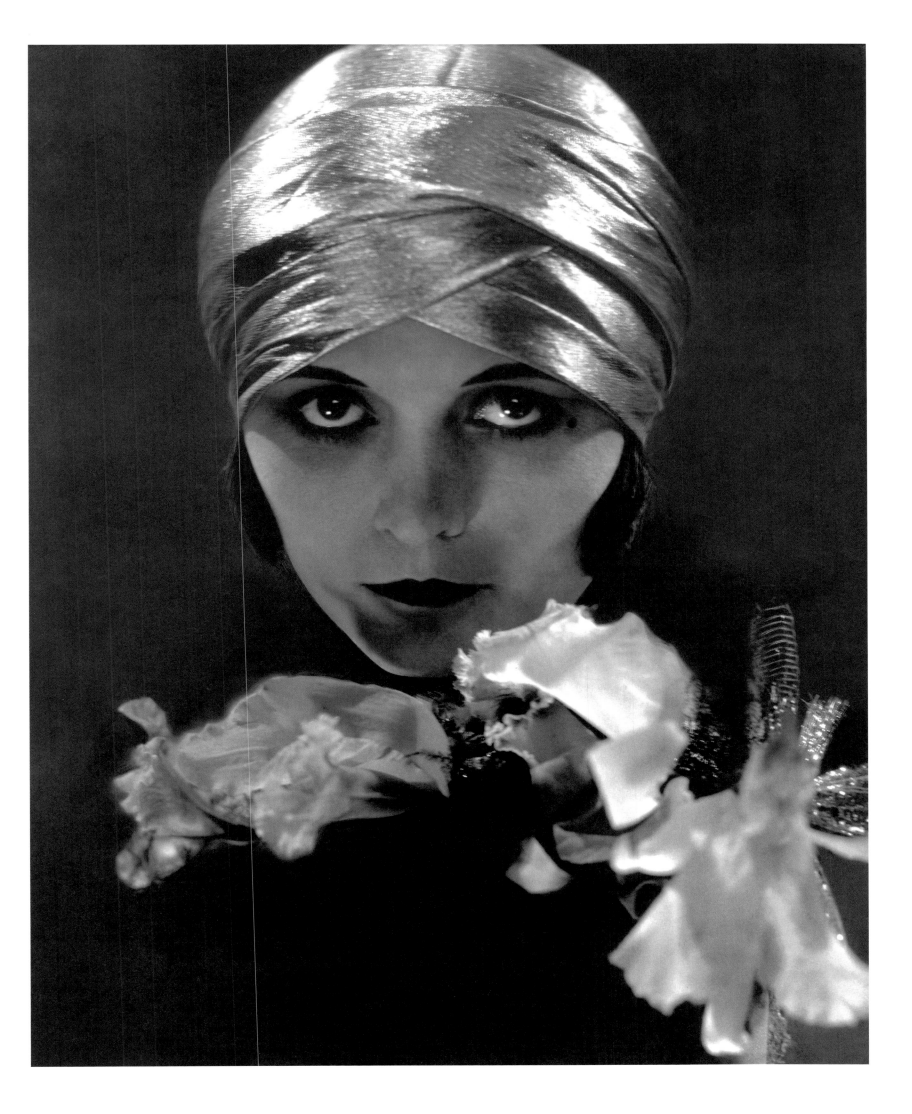

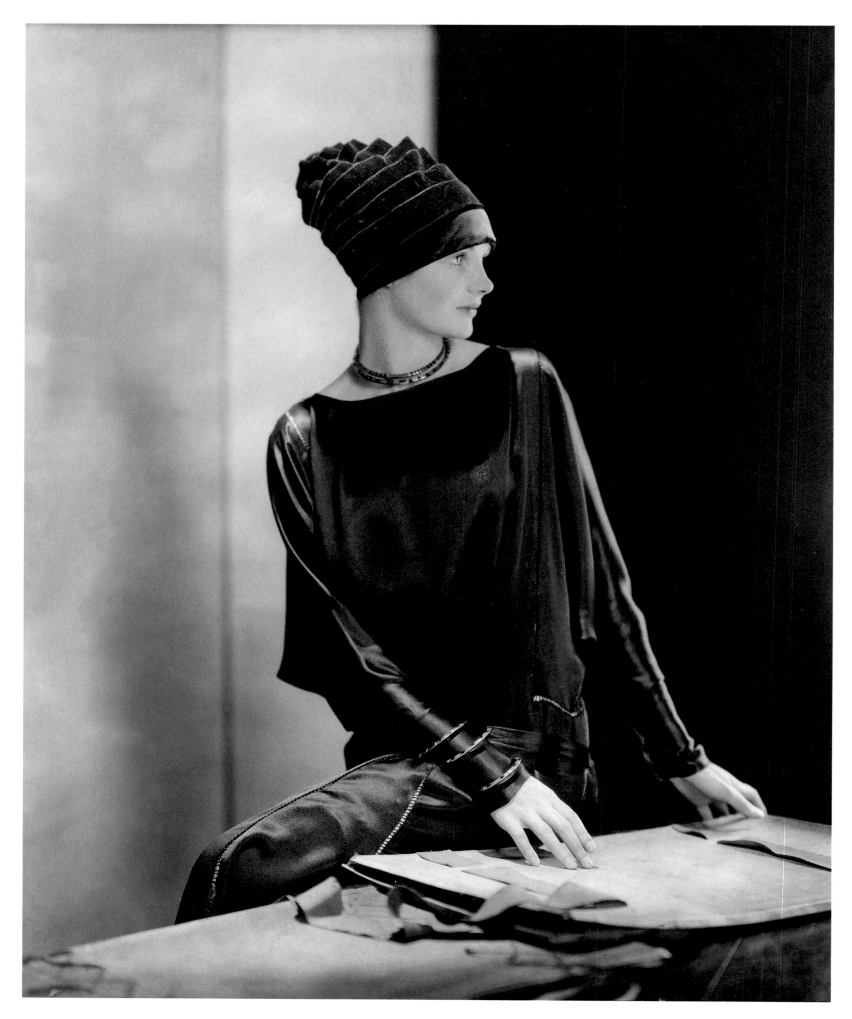

51. MODEL DOROTHY SMART WEARING A BLACK VELVET HAT BY MADAME AGNÈS, 1926

52. ACTOR ADOLPHE MENJOU, 1925

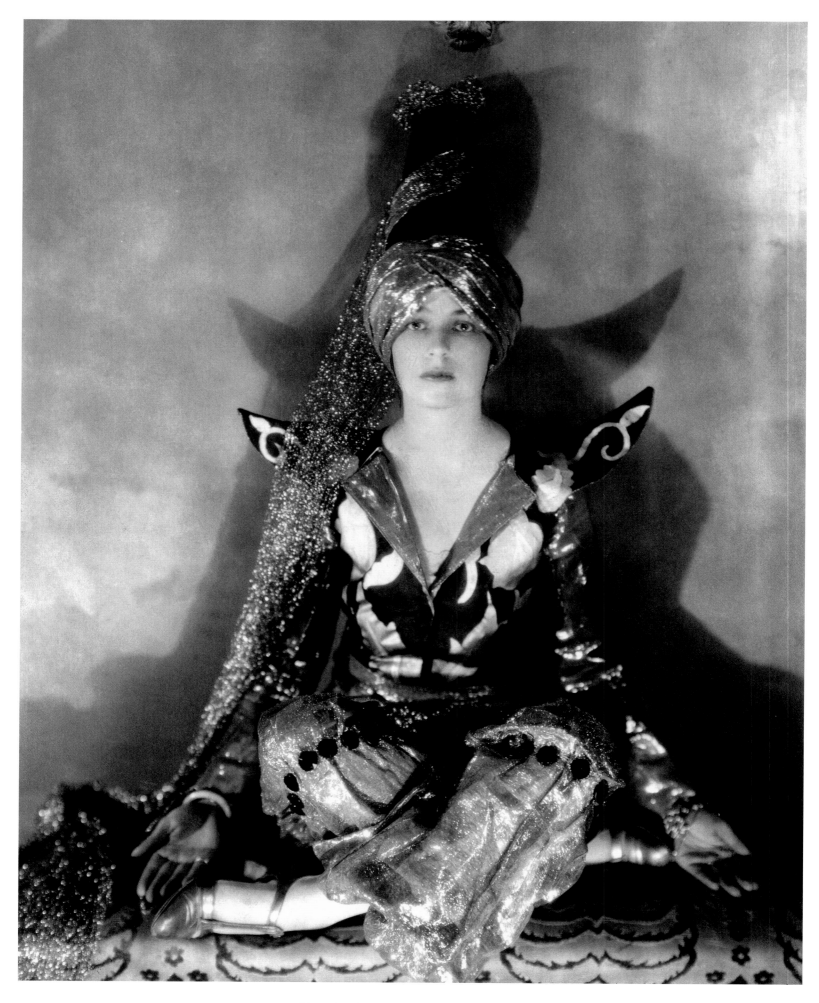

53. MRS. FAL DE SAINT PHALLE IN A COSTUME BY WILLIAM WEAVER FOR THE PERSIAN
FÊTE AT THE PLAZA HOTEL, 1924

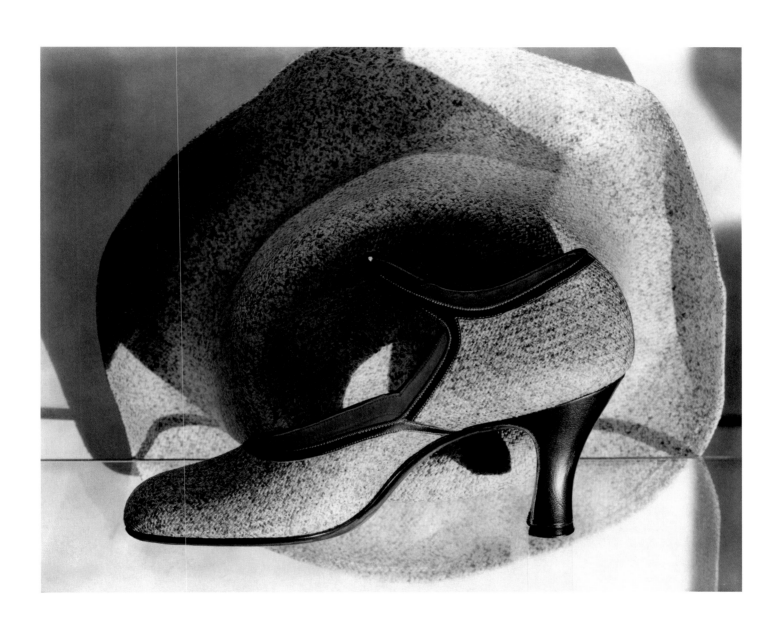

54. SUMMER SHOES AND HAT BY HENNING, 1927

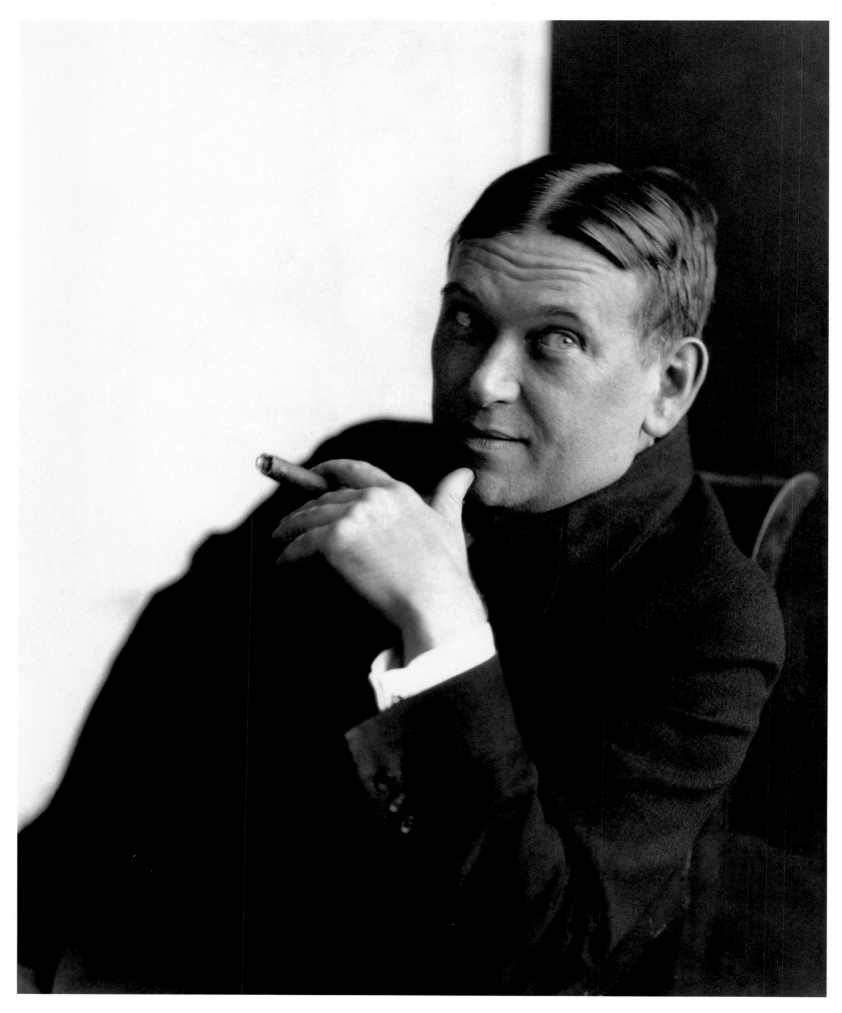

55. WRITER H. L. MENCKEN, 1926

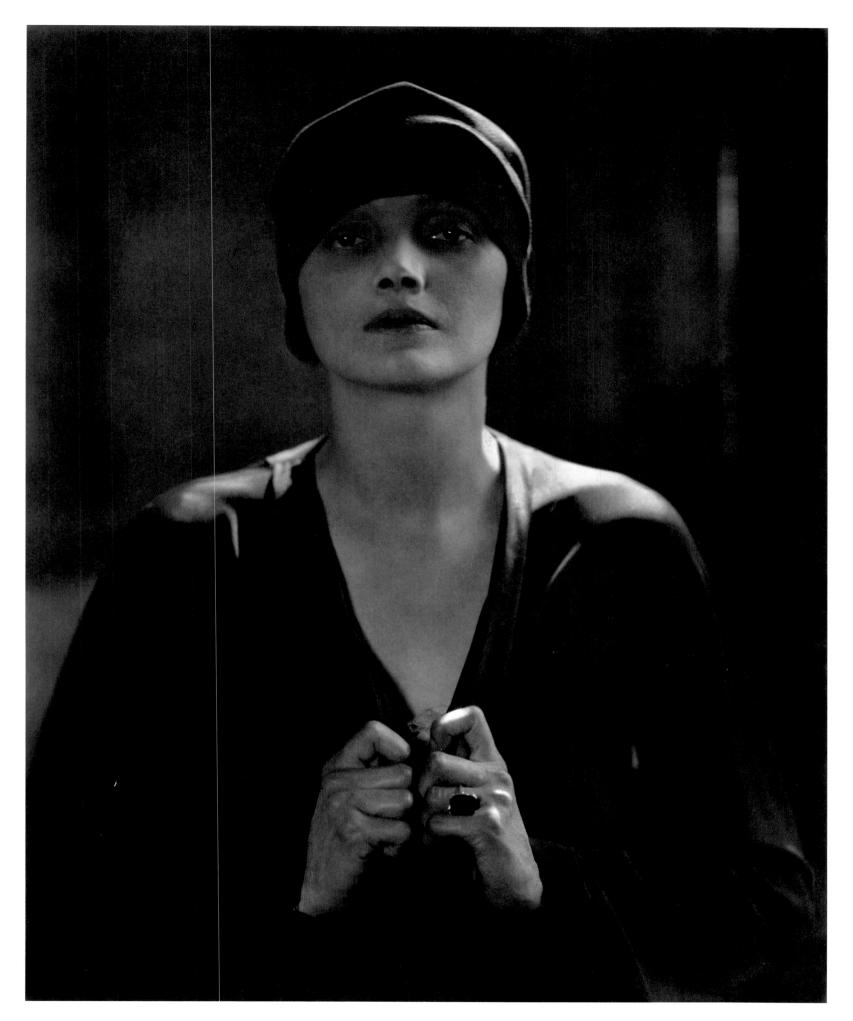

56. ACTRESS KATHARINE CORNELL, 1926

57. CHARLIE CHAPLIN, 1925

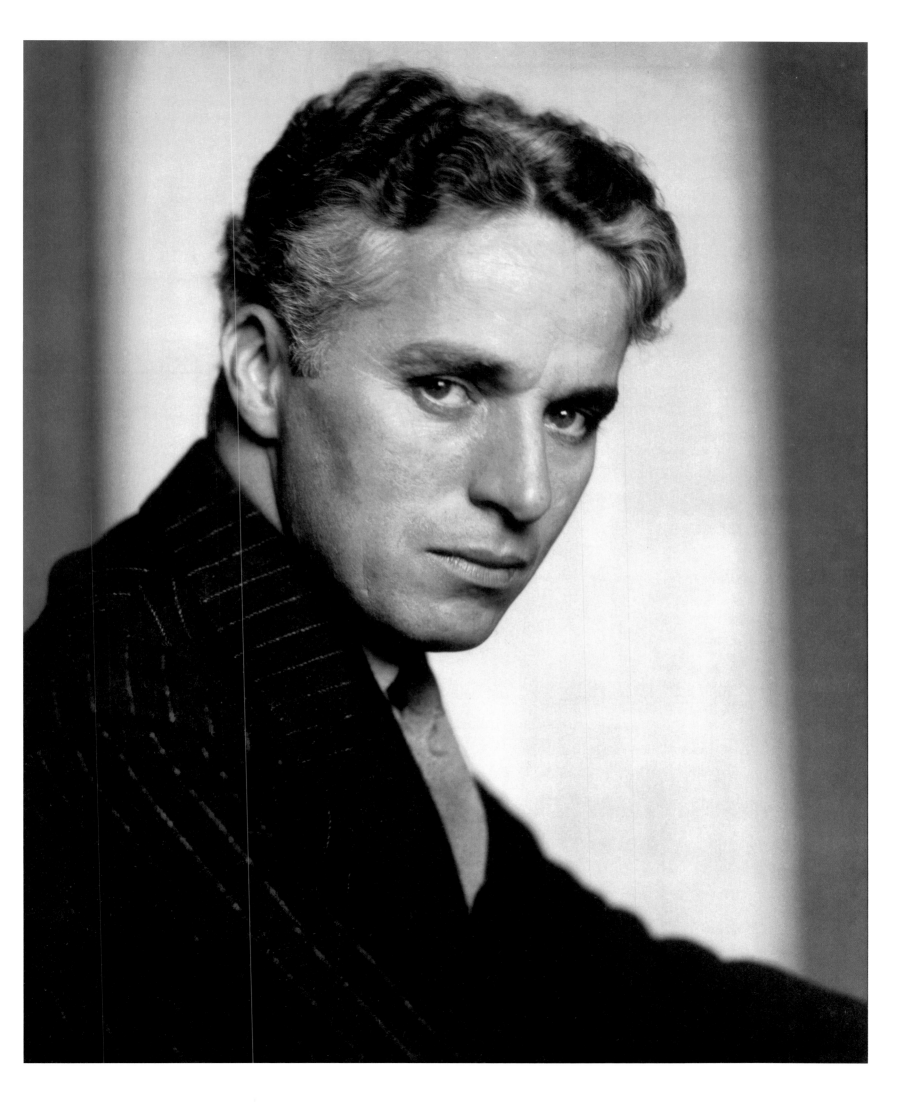

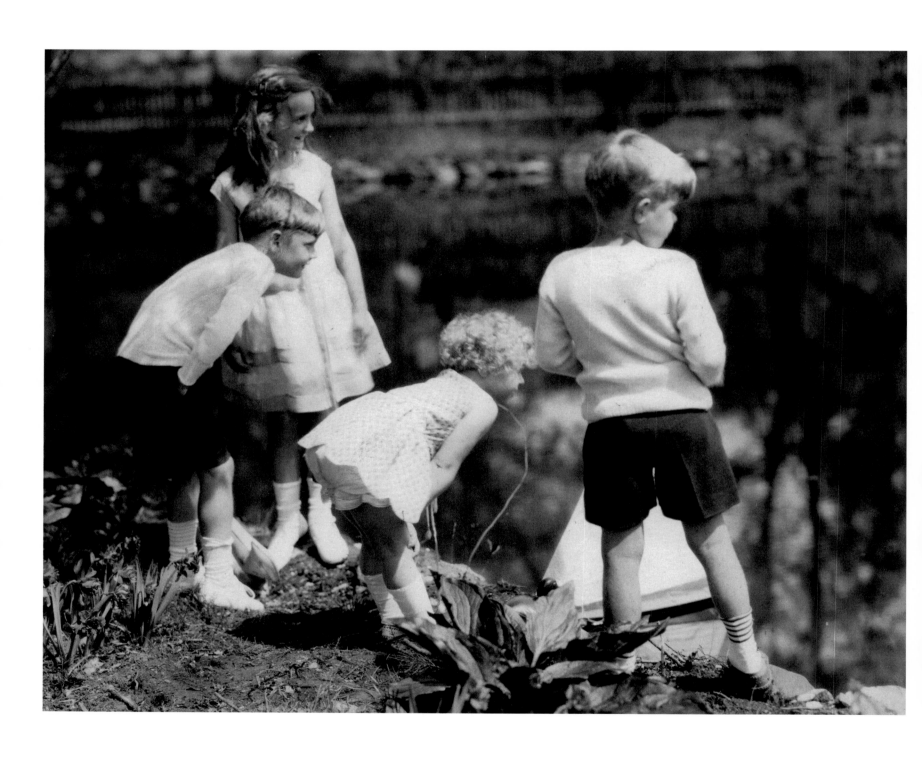

58. CHILD MODELS BY A POND, 1926

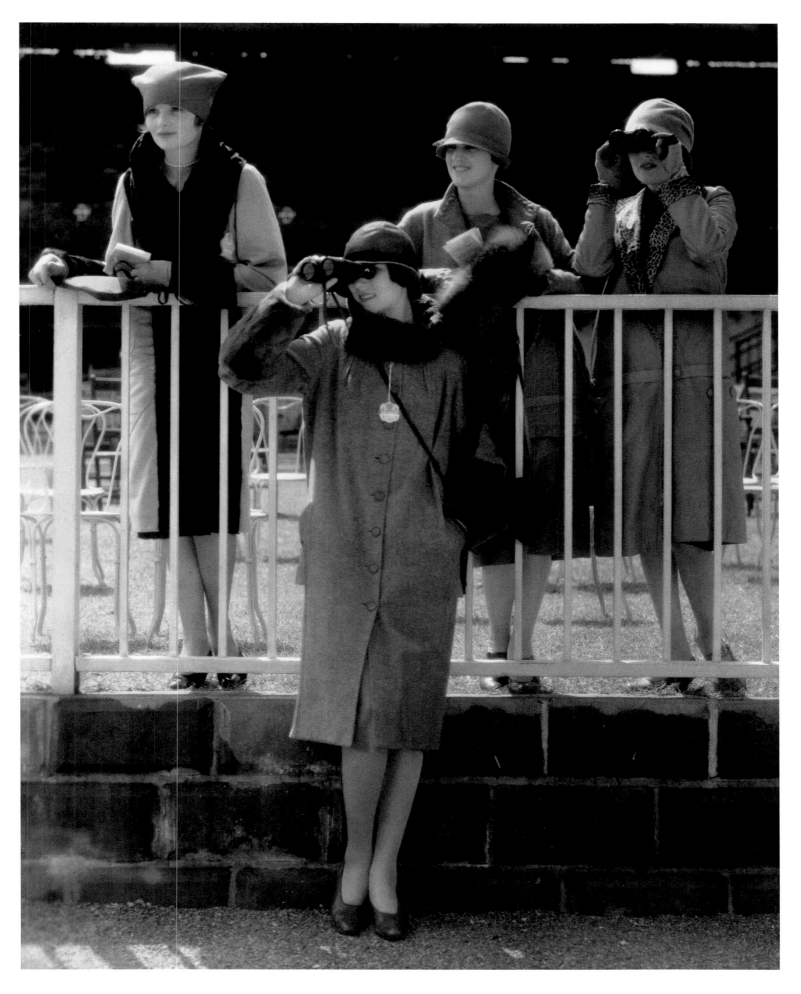

59. BELMONT RACETRACK, NEW YORK. IN FRONT, MODEL WEARING A HAT AND A WOOL COAT BY LANVIN. LEFT, MODEL WEARING A COAT BY WORTH AND A HAT BY J. SUZANNE TALBOT. THE TWO OTHER MODELS WEARING FASHION BY MOLYNEUX, 1926

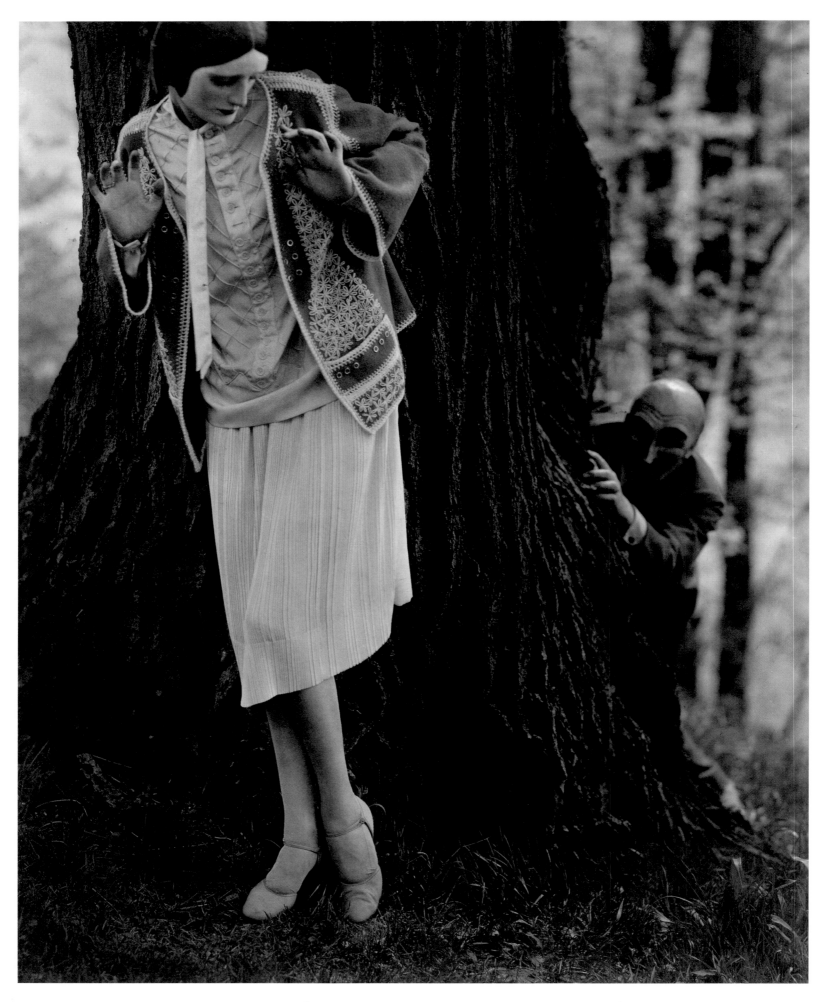

60. MODEL MARION MOREHOUSE WEARING FASHION BY TAPPÉ; MASKS BY THE ILLUSTRATOR
W. T. BENDA, 1926

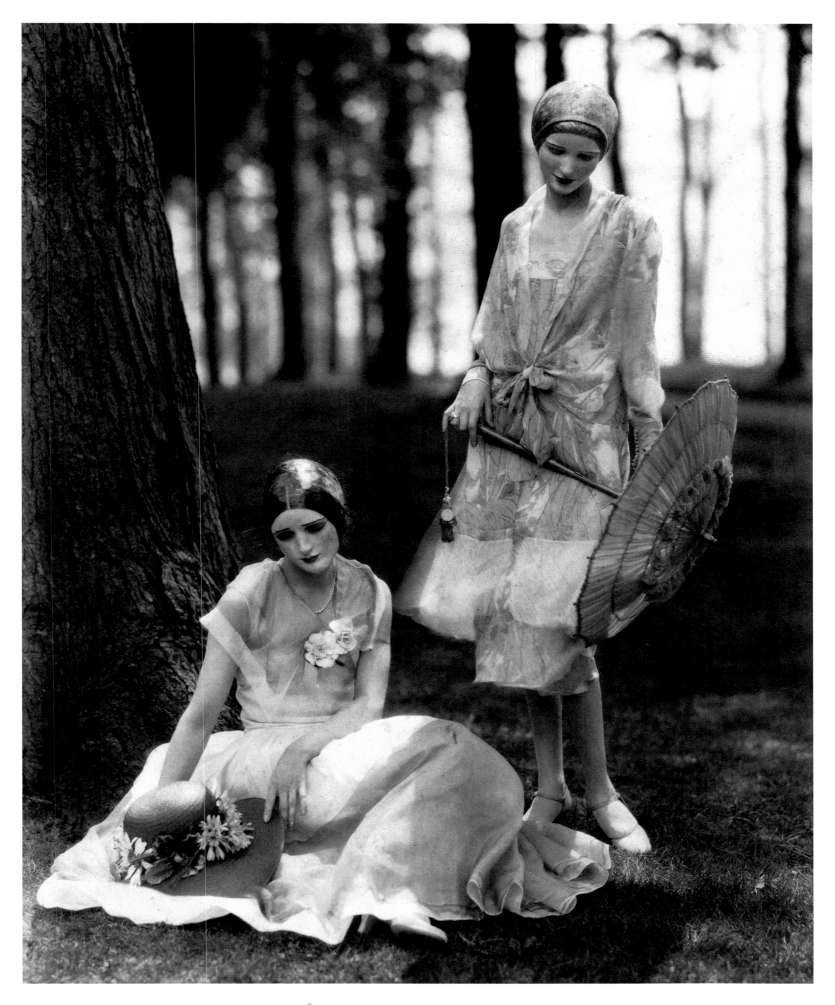

61. MODEL MARION MOREHOUSE IN A BOUFFANT DRESS AND ACTRESS HELEN LYONS IN A LONG
SLEEVE DRESS BY KARGÈRE; MASKS BY THE ILLUSTRATOR W. T. BENDA, 1926

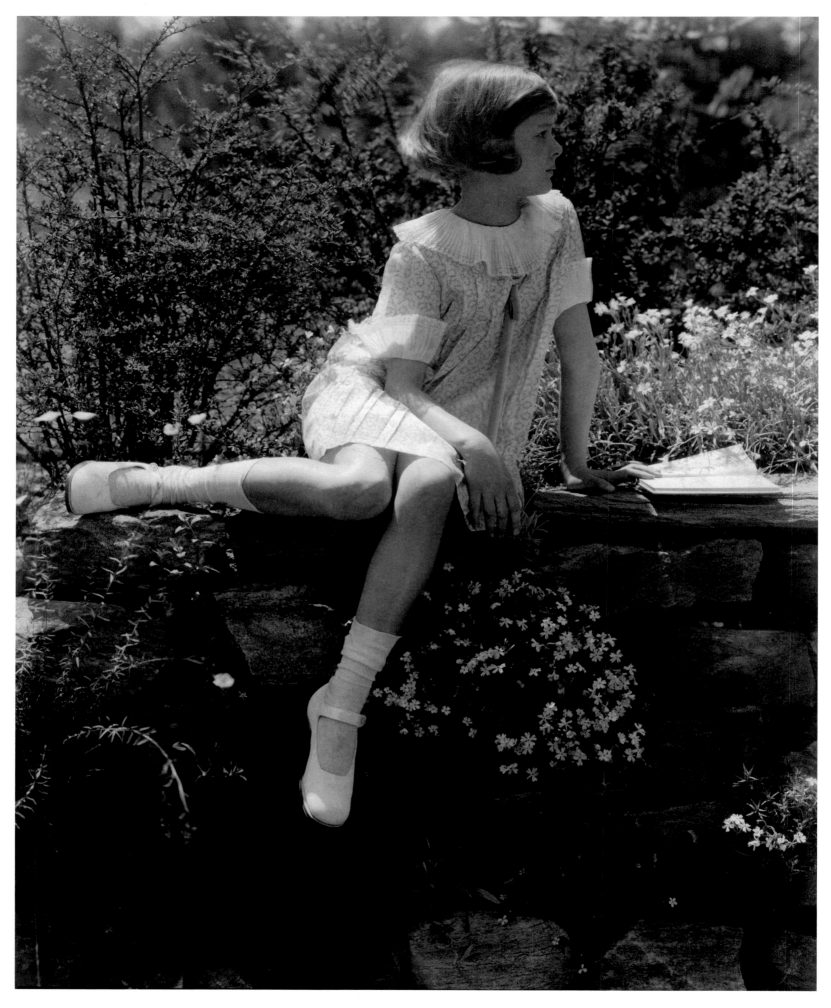

62. CHILD MODEL WEARING A PLEATED CRÊPE DRESS, 1927

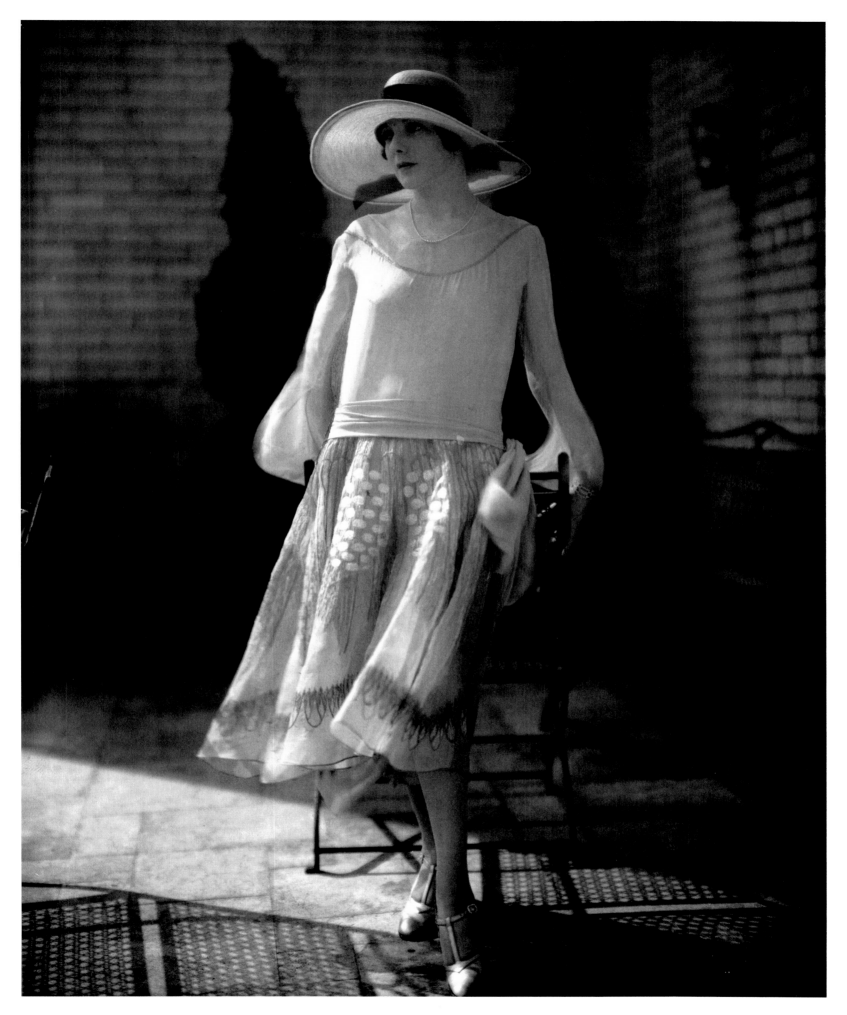

63. ACTRESS ALMA RUBENS WEARING FASHION BY LOUISEBOULANGER, 1925

64. MODEL WEARING EVENING SANDALS AND A WRAP BY DRECOLL; MALE MODEL WEARING SHOES BY MCAFEE, 1926

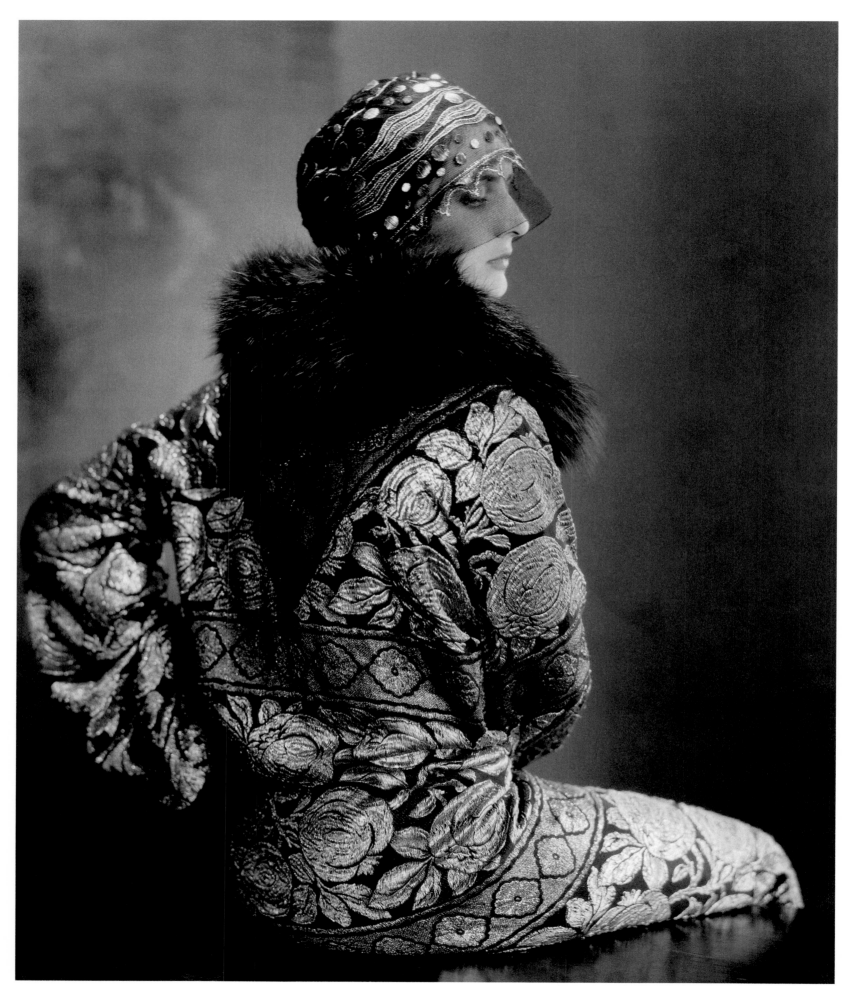

65. MODEL WEARING A BLACK TULLE HEADDRESS BY J. SUZANNE TALBOT AND A BROCADE COAT
WITH BLACK FOX COLLAR, 1925

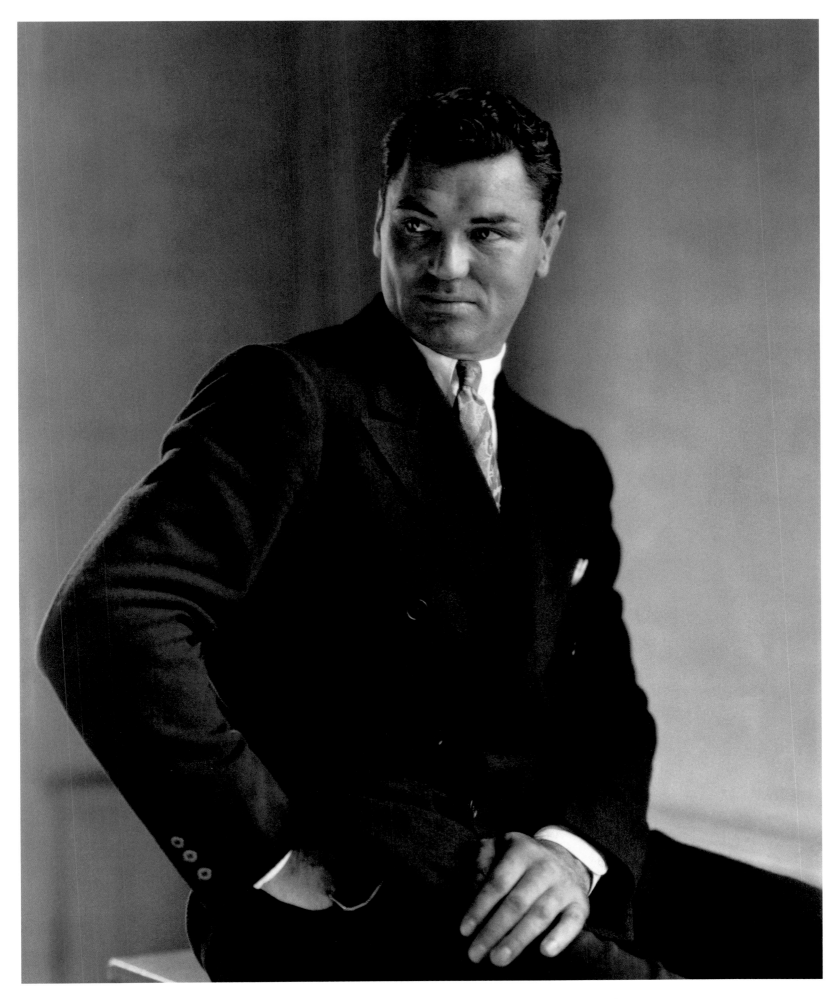

66. HEAVYWEIGHT BOXING CHAMPION JACK DEMPSEY, 1926

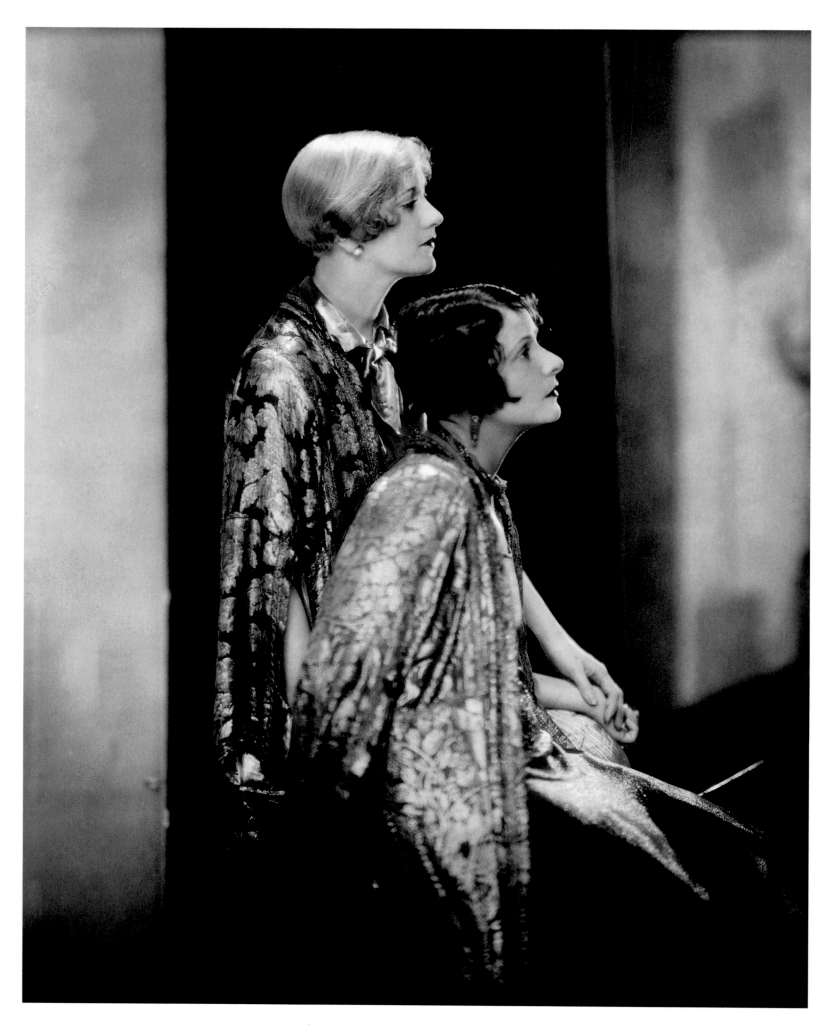

67. ACTRESSES NORMA AND CONSTANCE TALMADGE, 1927

68. PRODUCER IRVING THALBERG, 1927

69. ACTOR HAROLD LLOYD, 1927

94

70. ACTOR WILLIAM HAINES IN A WEST POINT CADET'S UNIFORM, 1927

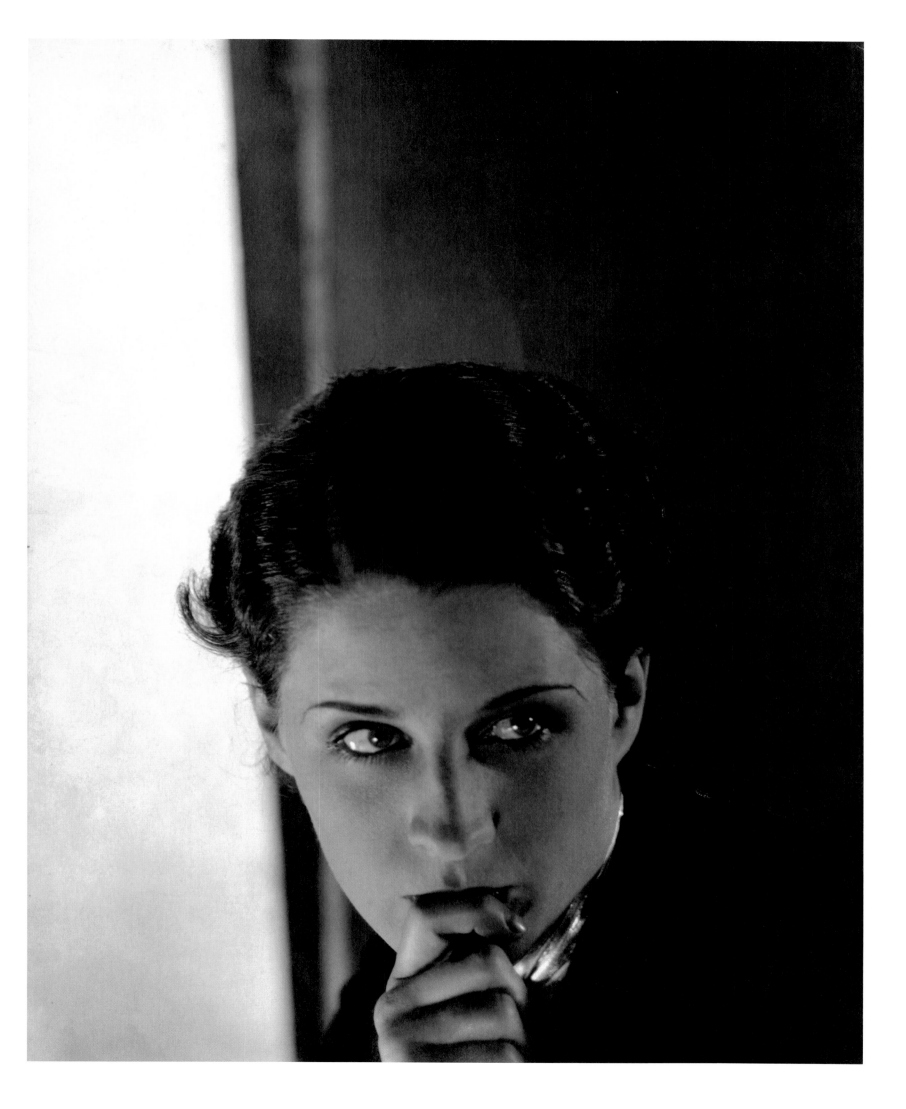

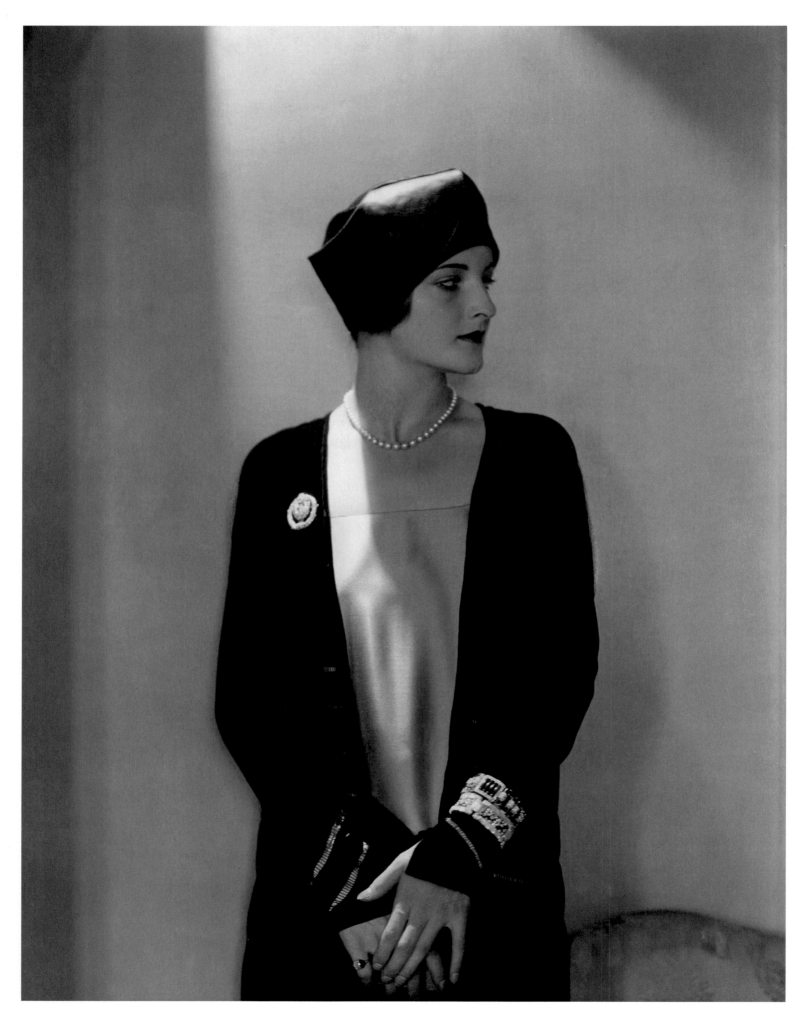

72. MODEL JULE ANDRÉ WEARING A DRESS BY VIONNET AND A TOQUE BY REBOUX, 1927

73. ACTOR LESLIE HOWARD, 1927

74. DANCER PORTIA GRAFTON WEARING A BEACH COAT AND SHORTS BY PATOU WITH A
TOP BY KURZMAN 1927

75. MODEL MARION MOREHOUSE WEARING A RIDING HABIT, 1927

76. SCULPTOR JACOB EPSTEIN, 1927

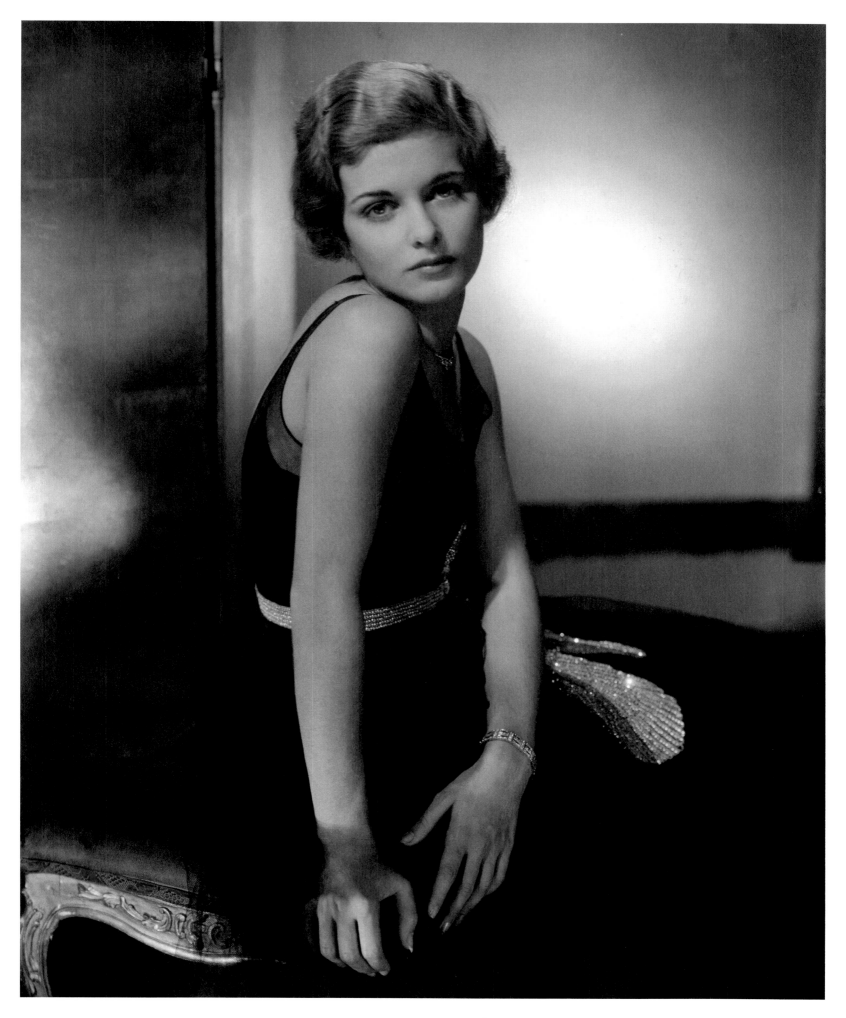

77. ACTRESS JOAN BENNETT, 1928

78. ACTRESS GRETA GARBO, 1928

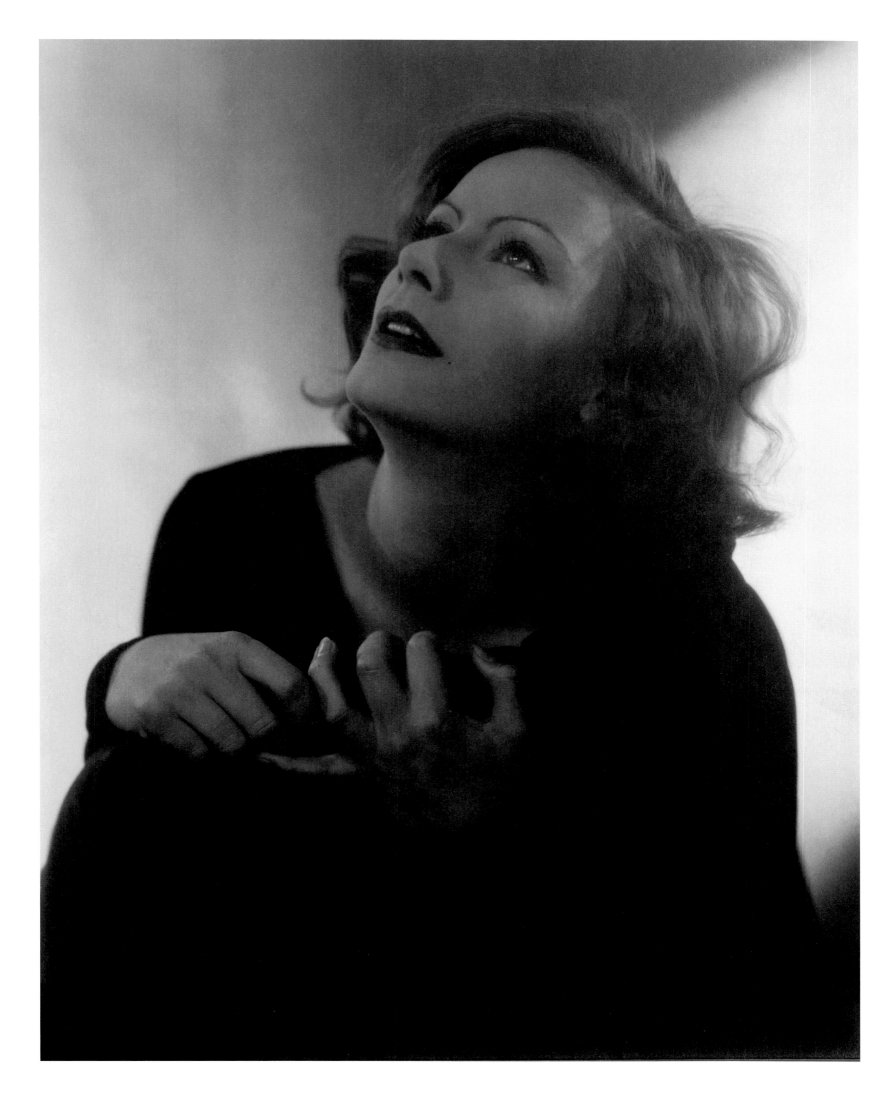

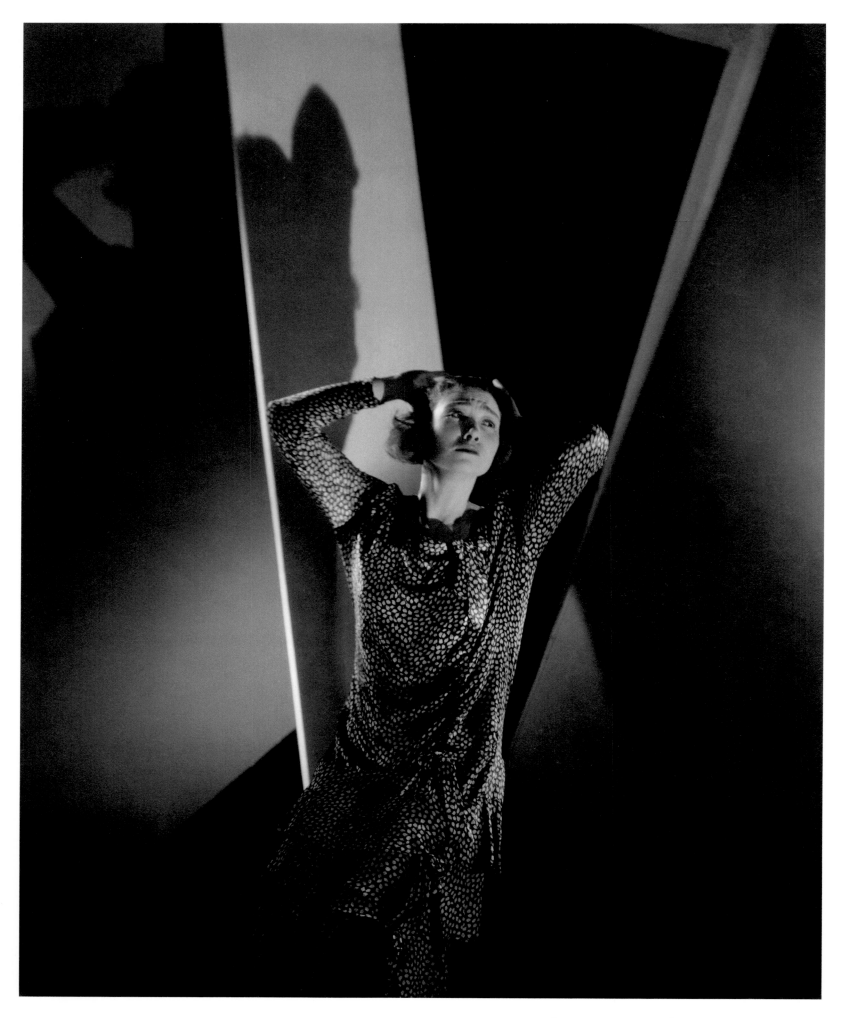

79. ACTRESS FAY BAINTER IN LOUIS VERNEUIL'S PLAY *JEALOUSY*, 1928

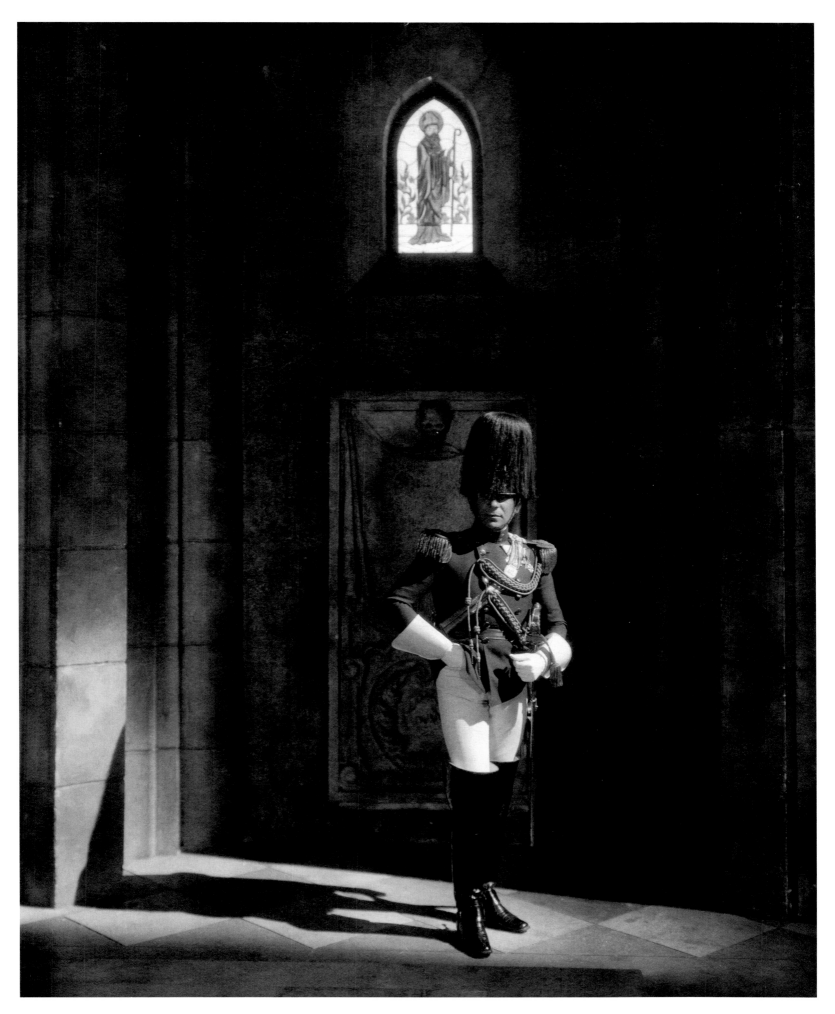

80. ACTOR AND FILMMAKER ERICH VON STROHEIM IN *THE WEDDING MARCH*, 1927

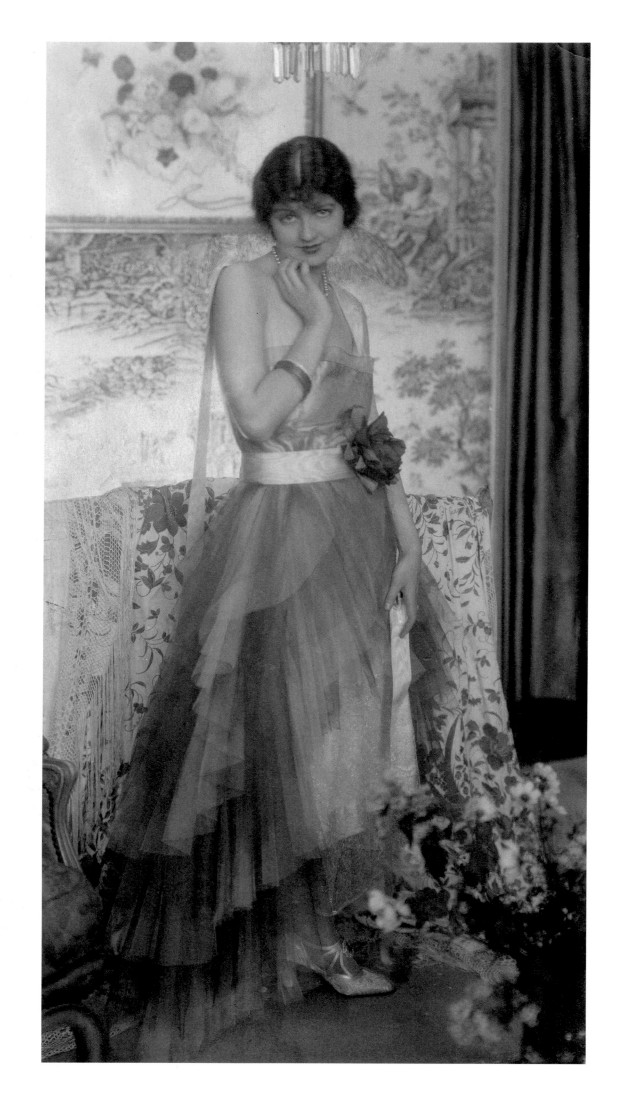

Edward Steichen at Condé Nast Publications

CAROL SQUIERS

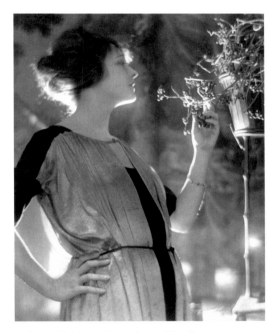

82. Baron Adolphe de Meyer, Actress Elsie Ferguson wearing a dress by Callot, 1920

De Meyer's dreamy, backlit photos set the pace for fashion photography in *Vogue* from 1913 until his 1922 departure for the rival magazine *Harper's Bazaar*.

opposite:
81. Actress Doris Kenyon wearing fashion by Callot, 1923

Although Steichen brought a modernist sensibility to the advertising photos he began making in 1923, for his fashion images he initially reverted to an older, softer Pictorialist style.

One of the most controversial career changes in the history of photography occurred in 1923, when Edward Steichen took a job in commercial image-making.[1] He had gained renown as a painter and Pictorialist photographer years earlier and was the exemplar, handpicked by Alfred Stieglitz, of the photographer as artist.[2] But two decades later, he seemed to betray Stieglitz's crusade when he became chief photographer for Condé Nast Publications, making fashion photographs and portraits for *Vogue* and celebrity portraits for *Vanity Fair*. Within a short time, he also began doing advertising photography for assorted clients through the J. Walter Thompson company and then other advertising agencies as well. Steichen would later maintain that he had abandoned Pictorialism during World War I in favor of straight, sharp-focus photography, dispensing with the soft-focus visual atmospherics of the style that had established his international reputation as a photographic artist. But although he did adopt a more modern style for certain types of photography, most notably his advertising work, Steichen continued to make use of the Pictorialist aesthetic in his fashion work for a number of years.

FASHION: PICTORIALISM TO MODERNISM

In her 1979 catalogue *The History of Fashion Photography*, curator Nancy Hall-Duncan mapped out what has become the standard perception about Steichen's evolution as a fashion photographer. "Steichen's early work for *Vogue* was a weak, groping interpretation of [Adolphe] de Meyer's style, but he moved quickly and definitively toward the creation of his own representations," she writes. "His work differed from de Meyer's in that his photographs were no longer dependent on the look of frailty which backlighting produced, but derived their effect from strong, clean lines, plain backgrounds, and a new assertive model, the 'flapper.' Within a year Steichen replaced pictorialism, then the most popular form of fashion depiction, with 'modernism.'"[3] Like Steichen, de Meyer had originally made his name as a photographic artist working in the Pictorialist style associated with the Linked Ring group in England and Stieglitz's Photo-Secession in New York. Prior to Steichen's ascent at Condé Nast Publications, de Meyer's dreamy, backlit imagery had defined the look of portrait and fashion photography in *Vogue* (Fig. 82) from 1913 until his 1922 departure for the Hearst-owned rival magazine *Harper's Bazaar*.[4]

Nast's need for someone to replace de Meyer, his star photographer, coincided with Steichen's need for a well-remunerated position: he had gone through a bruising divorce and had alimony and debts to pay off and two daughters to support. Photographer Paul Strand reported that Steichen told him at the time that he was "sick and tired of being poor" and was going to join Condé Nast for two years of

commercial photography so he could then go back to painting.[5] He accepted the position of chief photographer for *Vogue* and *Vanity Fair* in March 1923, the same month he turned forty-four. Within weeks, his first fashion and portrait photographs were printed in *Vogue*, which meant that he had little time to conceptualize how he might approach these new modes of depiction.[6] He was stepping into a position vacated by a fellow Pictorialist who had essentially created the look of fashion photography and the fashionable woman in the early twentieth century.

Nast had been shocked by de Meyer's defection to his rival. This sense of betrayal might have fueled a belief that maintaining some continuity with the Pictorialist style de Meyer had established, and updating it, was a better idea than abandoning it altogether. Steichen certainly had the ability to completely change the look of fashion photography from the start of his time at Condé Nast. He had made a number of sharply focused photographs in a clean, modernist style during and after World War I and readily deployed that new style in his advertising imagery from 1923 on. One of his modernist still lifes, *Lotus* (Fig. 83), was reproduced in *Vanity Fair* just months after he arrived.[7] But for his fashion images, he reverted to an older, softer, Pictorialist style (Fig. 81). It would take him several years to embrace straight photography in fashion. The transition would fully occur once Mehemed Fehmy Agha, a Ukrainian-born art director, was brought from the German edition of *Vogue* to redesign Nast's American magazines in 1928.

There could be a number of reasons why Nast wouldn't have wanted the visual style of his magazines to change too quickly and might have preferred the incremental modernism that Steichen provided. Once Agha's innovations began turning up in *Vogue*, readers protested the changes.[8] More important, as art historian Patricia Johnston has pointed out in regard to advertising photography of the 1920s, "pictorialist remnants signified an elegant, upper-class 'artistic' atmosphere."[9] That well-established depiction of rarefied living was not easily replaced. What was simpler to change were some of de Meyer's overused visual effects, among them his shimmering backlighting. According to Steichen, during his first year at *Vogue*, he used only one light plus daylight to illuminate his subjects, falling back on his longtime experience as a (Pictorialist) portrait photographer, when a single light source had become his signature style.[10] At Condé Nast, he took the light level down considerably, using shadowy darkness the way de Meyer had used spangled light to signify glamour and allure.

Just as the profession of fashion photography was new and evolving, so, too, was the profession of fashion modeling. The women who posed for Steichen were drawn from a diverse group of attractive women, including stage and film actresses, socialites, and models who worked for stores such as Bergdorf Goodman.[11] The dancer Leonore Hughes was one of Steichen's first models at

83. *Lotus*, 1915

Soon after Steichen began working at Condé Nast, this elegant still life was reproduced in *Vanity Fair* (July 1923), evidence of his evolving modernist aesthetic, which had begun almost a decade earlier.

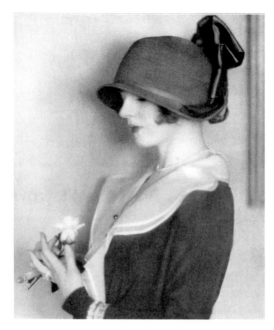

84. "The Uptilting Poke Shape Intrigues Reboux": Leonore Hughes, 1923

To show off a new straw hat by the milliner Caroline Reboux, dancer Leonore Hughes posed demurely with downcast eyes in this soft-focus fashion photograph.

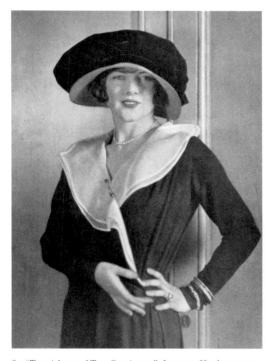

85. "Terpsichore of Two Continents": Leonore Hughes, 1923

Steichen probably photographed Hughes's portrait for *Vanity Fair* at the same session in which she modeled new spring hats for *Vogue*. In her portrait, depicting her as a "Terpsichore of Two Continents," she gazes directly, and seductively, at the viewer.

Vogue, posing for a story on spring hats in the April 15, 1923, issue (Fig. 84). Two weeks later, she was also featured in *Vanity Fair* in a full-page personality portrait by Steichen that announced her impending dance tour abroad (Fig. 85).[12]

The pose Hughes strikes in her "portrait," slightly swiveling one hip toward the viewer, is virtually identical to that in one of the fashion pictures, and it is probable that they were done at the same time. What marks her *Vanity Fair* portrait as distinct from her fashion pictures is the direct gaze she levels at the viewer—the gaze of a talented, independent woman, albeit one who still broadcasts seduction with her half-opened lips. In most of the fashion images, she looks demurely away or gazes down at a flower that is threaded through her artfully splayed fingers. This representation of the graceful but essentially decorative female hand was a standard trope of femininity and privilege in fashion images in the 1920s, but one that would be infused with a little Surrealist humor by younger photographers such as Horst P. Horst and Cecil Beaton in the following decade.

Despite Steichen's lingering allegiance to Pictorialism, he did set out to create his own vision of the fashionable modern woman. One way he achieved that was with posture. Throughout the 1920s, his models often stood or sat in ramrod-straight positions, which contrasted with de Meyer's florid, exaggerated poses, all thrusting hips and arched backs.[13] One model who could enliven the formulaic standing pose was Marion Morehouse, a favorite of Steichen's, who turns up in the pages of *Vogue* in the mid-1920s. With her mischievous sidelong glances and nonchalant gestures, she brought wit and cool sexuality into Steichen's images. Although fashionable facial expressions tended toward the regally glacial, Morehouse had a megawatt smile that would occasionally burn from the page.

The photographs of Morehouse are a capsule version of the way Steichen used backgrounds and compositional elements in his photos, and of his evolution from Pictorialist to modernist. One 1926 image shows Morehouse and Martha Lorber relaxing in silk and satin lounging pajamas (Fig. 86).[14] It was shot, like many of Steichen's images, in the sizable penthouse drawing room of Nast's new thirty-room duplex apartment on Park Avenue, which was decorated by Elsie de Wolfe (Fig. 87). The two women smile at each other, legs nonchalantly curled under them on a Regency needlepoint sofa with an elaborately painted, black-lacquered Chinese screen behind them. Steichen creates a darkly atmospheric scene that looks much more alluring and dramatic than straight photographic depictions of the same scene show it to be.[15] Although the two models are in relatively sharp focus, the sofa and screen form a richly patterned, slightly unfocused ambience of antique-furnished wealth.

Steichen also favored the black-and-white marble floor in the upstairs hallway of the duplex. He often moved furniture into the hallway, where he might

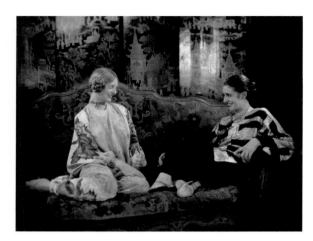

86. "In the Realm of Négligée": Martha Lorber and Marion Morehouse, 1926

This casual scene of two young women in lounging pajamas relaxing on a Regency needlepoint sofa before a lacquered Chinese screen was photographed in the penthouse drawing room of Condé Nast's apartment (below).

87. Condé Nast's apartment, 1928 (unidentified photographer)

In his early years at the magazines, Steichen often used Nast's new thirty-room Park Avenue apartment as his stage set and prop room.

opposite:
88. Models wearing a gown trimmed with tiny pearl buttons (left) and a piqué dress (right), 1935

Well into his career in fashion photography, Steichen sought new locations, themes, and compositional strategies, photographing in smart New York art galleries, sleek modern apartments, and chic hotels.

play the geometry of the white squares and the rectilinear elements of a set of double doors or a floral-patterned settee against the sensuous lines of designer gowns. One of his most gorgeous images was shot in the hallway and shows Morehouse wearing a dazzling smile and a Chéruit sequin-covered frock twinkling in the light (Fig. 90). By designing his own sets using Nast's apartment as his prop room, Steichen tried to create a modern atmosphere without abandoning all the traditional accoutrements of the upper class.

But modern design was making its presence felt, especially after the 1925 Exposition Internationale des Arts Décoratifs et Industriels Modernes (International Exposition of Modern Industrial and Decorative Arts), held in Paris. Steichen photographed clothing covered in bold abstract designs from both American and French designers, including the artist Sonia Delaunay, with stylized "modernistic" backdrops in raking light (Fig. 42).[16] A caption declared that although these garments started as "an amazing eccentricity of the mode," they have now "come to be regarded as a striking, but accepted version of summer chic."[17]

As noted, modern design came to *Vogue* with the arrival of Agha. From Berlin he brought an appreciation of the modernist visual experiments that were taking place among European avant-garde artists and designers. By this time, Nast himself had realized that *Vogue* and *Vanity Fair*, which had fussy page layouts cluttered with oddly shaped photographs, needed a more contemporary look and had asked Agha to redesign his magazines. He also encouraged him to use a design scheme first proposed by the graphic artist Benito to revamp *Vogue*, emphasizing page design that is "simple, pure, clear, legible like a modern architect's plan."[18] Although Steichen had sometimes used simple geometric backgrounds in his early photographs, he had definitely preferred the setting of Nast's antique-filled abode. After Agha arrived, Steichen relied more on stark geometry, using rectilinear panels that could be quickly assembled into abstract background compositions in his studio and that played against the sleek forms of modernist tables and chairs.

Steichen's photographs likewise became pared down and sharpened. His fuzzy shadows became starkly angled, and multiple light sources created complex plays of shadow and light, volume and depth. In one image of Morehouse, he positioned her in front of an abstract-patterned piano he had designed (Fig. 95). Using multiple light sources and movable panels, he created an interplay of rectilinear shapes and shadows across the background, an intricate visual display of the modernist sensibility.

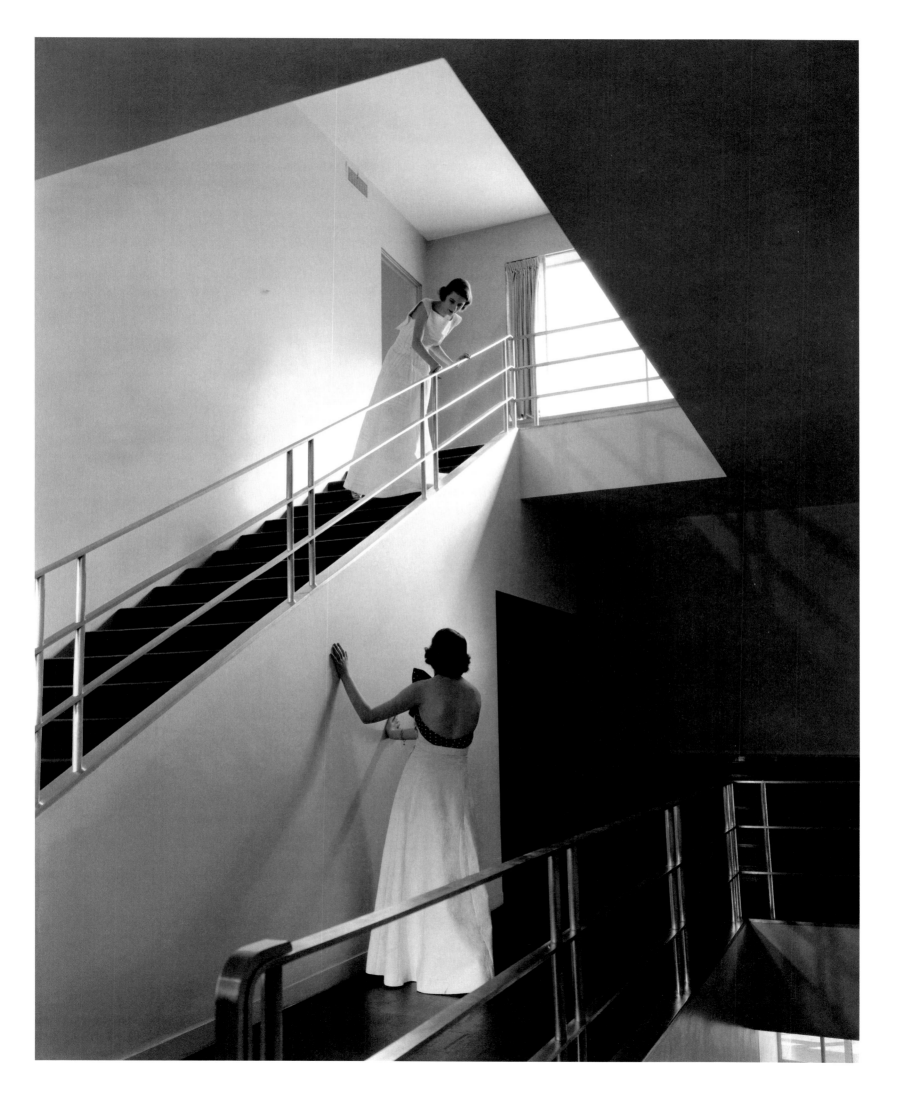

89. Model wearing a hat by Molyneux and a dress by Bergdorf Goodman; other hats by Sally Victor and Madame Agnès, 1934

Paintings of milliners and their wares by Edgar Degas seem to be a source for Steichen's photographs of warm-weather chapeaux.

opposite:
90. Model Marion Morehouse in a dress by Chéruit, in Condé Nast's apartment, 1927

With her nonchalant stances and dazzling smile, Marion Morehouse was an elegant exemplar of the provocative new woman of the 1920s and Steichen's favorite model.

PORTRAITS: "ONE INSTANT OF REALITY"

While Steichen was continuing to refine and reformulate the fashion photograph, he was doing the same with the personality portrait for both *Vogue* and *Vanity Fair*. New York was the center of American high culture and the performing arts, and Nast publications paid close attention to them. Steichen made portraits of the stars of the New York stage, often in costume and in character. The numerous dancers he depicted ranged from vaudevillian Gilda Gray in Orientalist mode to modern dance pioneer Martha Graham portrayed as a stark silhouette (Figs. 22, 123). Stage actors were preferred as subjects over film actors throughout the 1920s, although the procession of serious actors from the stage to Hollywood was noted with interest. After talking pictures supplanted silent films in the late 1920s, Hollywood stars made increasing appearances in Condé Nast magazines.

Actresses had long doubled as models in fashion spreads, but in *Vanity Fair*, entertainers, actors, composers, writers, directors, statesmen, diplomats, and athletes were all featured in full-page portraits that celebrated their talent and position. Steichen made many of his most memorable portraits for Condé Nast: Gloria Swanson smoldering behind a scrim of black lace (Fig. 36); Greta Garbo brooding (Fig. 102); and Charlie Chaplin clowning with a bowler hat and cane (Figs. 17, 18). Portraits had been a staple for him from his earliest years, when he took his famed images of Auguste Rodin, Stieglitz and his daughter Kitty, and J. P. Morgan.

As a young man, Steichen had conceived of a project to do portraits of "Great Men," something that required time and patience. Among his most revered early subjects was Rodin, whom the photographer visited for a year before he began taking pictures of him. In a 1902 newspaper article, he contrasted his empathetic, time-consuming method with the hasty superficiality of the commercial photographer: "It means the complete merging of myself in the personality of my subject, a complete loss of my own identity. . . . The commercial photographer, with his forty sittings a day, cannot of course enter into the individuality of the sitter as I do."[19] But after years of making portraits, which included a stint as a professional portrait photographer in New York and more than a decade of photographing for magazines, Steichen's opinion of portraiture's requirements and possibilities had changed. "It is quite impossible to make what is called a real portrait of a person," he told an audience in Rochester, New York, in 1936. "It is impossible to include both laughter and tears in one picture—both tragedy and comedy in one face at the same moment. . . . But what we can do is to get one instant of reality out of that person. Then you have got something that really is that person."[20] His schedule demanded that he take multiple photographs in sometimes short periods of time, and so the "instant" he was looking for was

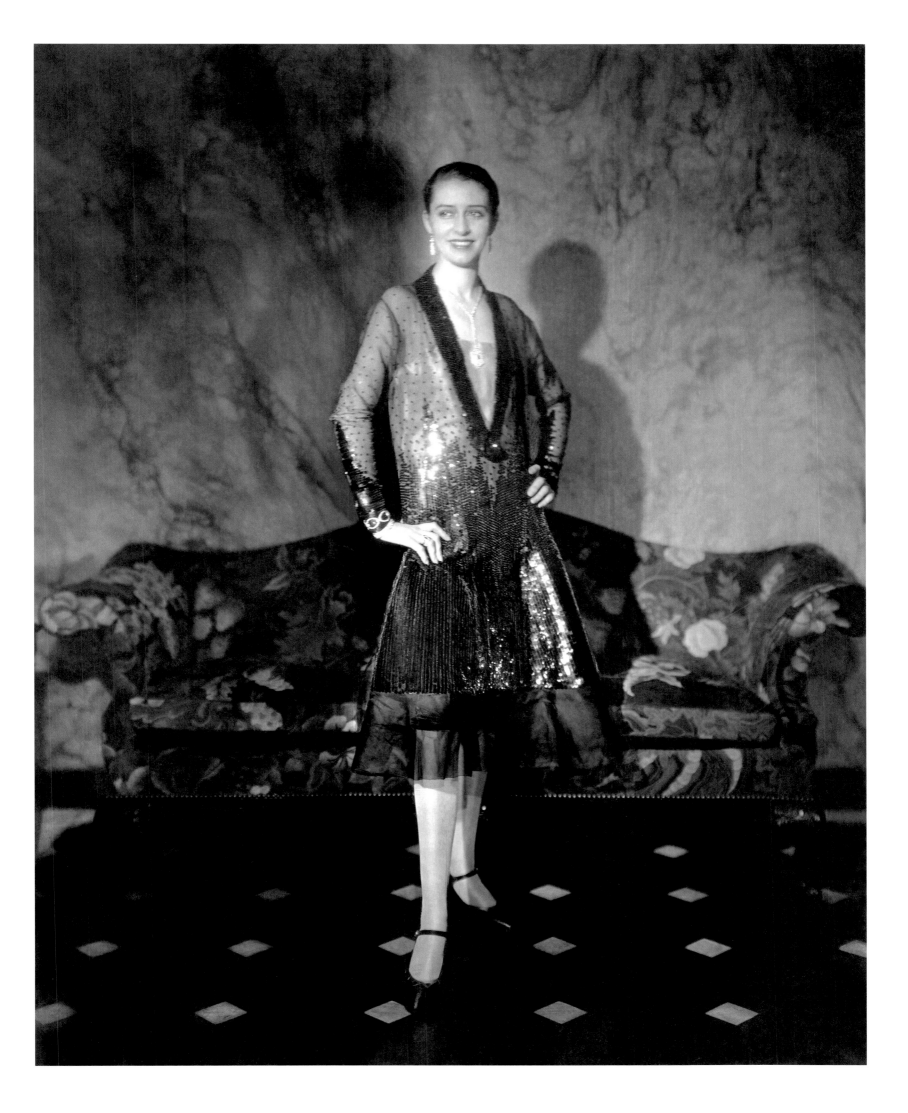

both literal and figurative. In one sitting with Chaplin, Steichen claimed to have gotten nine pictures, all presumably good, in ten minutes.[21]

Steichen photographed creative people and statesmen in a couple of different ways, either as portrait subjects in their own right or as characters inhabiting their current role. They were most often allowed to dominate the page with little or no background decor and to strike more varied poses than fashion models could. The influence of dramatic, high-contrast Hollywood movies and film stills is evident in Steichen's portraits, and he periodically mentioned their importance when he talked about photography. Although Pictorialist softness is sometimes evident, Steichen now looked at these personalities with a sharper eye. In one early image, the turban-wrapped head of the film star Pola Negri seems to float above an array of sinister orchids, an exotic beauty emerging from the darkness into a hard light (Fig. 50). Steichen often employed a colder, crisper illumination in his celebrity images, and he became adept at using multiple light sources to throw inky shadows and to model the figure. The romantic, twinkling backlighting of de Meyer became in Steichen's hands a frosty glow that arises from dark horizon lines and seems to herald greatness (Fig. 92).

Into the mid-1930s, Steichen maintained a preeminent position in magazine photography, even introducing color into Condé Nast's editorial pages in 1931. Although color film wasn't available until 1935, color reproduction in print was possible. Steichen made the first color photographic cover for *Vogue* in 1932 (see page 14), and color images made increasing appearances in the pages of *Vogue* and *Vanity Fair*, both as posed photographs and as images that were credited as "Color Snapshots by Steichen." The latter usually showed groups of women in casual poses, trying on summer clothes or skiwear, or groups of entertainers resting backstage, putting on makeup, or giving a performance.[22] These snapshots were more unstudied than the photographs Steichen usually made, and that informality could have been his way of dealing with what he saw as color photography's imperfections. "Let me say right off the bat that no good color photographs have been made as yet," he told the Rochester audience in 1936.[23] Despite his seeming modesty, during the 1930s, Steichen seemed to successfully experiment with every viable form of color and its reproduction.

He continued his pictorial innovations in black and white too. Two of his most inventive and influential fashion spreads, both done in black and white, appeared in *Vogue* in 1935. In "Black," a grand piano with its lid open takes center stage, creating a lovely silhouetted shape, while to either side a model stands almost in shadow, striking uncharacteristically stagy poses against a light-filled ground (see pages 2 and 3). In "White," a white horse inexplicably stands with three white-garbed models against a white-tiled wall that appears to be in a

91. "Have You Heard," 1935
Vogue, July 1, 1935, p. 58

Steichen created a vision of fashionable female camaraderie in this simple image of whispering women, a theme that Richard Avedon and other photographers would use to good effect decades later.

92. Writer Thomas Mann, 1934

In portraits of artists and statesmen alike, Steichen often cast a frosty glow of light evoking greatness.

shower room, but is in fact in Steichen's studio (Fig. 221).[24] He sought new locations, photographing fashion in smart New York art galleries, sleek modern apartments, and chic hotels, as well as new thematic and compositional strategies (Fig. 88). He probably used Edgar Degas's paintings of milliners as inspiration for images depicting warm-weather chapeaux (Fig. 89). In a photograph of two women whispering conspiratorially (Fig. 91), he introduced a vision of fashionable female camaraderie, trying out a theme that Richard Avedon and other photographers would use to good effect several decades later.

Steichen did a tremendous amount of work in the early 1930s and then seemed to slow down and lose his focus by mid-decade. Although his style had set the pace for other photographers for years, they now began gaining on him.[25] Surrealism, classicism, humor, and movies were just a few of the influences that younger photographers such as Horst and Beaton tapped to create their often irreverent images.

Steichen continued to turn out beautifully composed portraits of politicians and stars. But when Beaton showed the famed hostess Elsa Maxwell as the "Social Dictator" in the May 1934 issue of *Vanity Fair*, he posed her in an oversized crown and plastered the scene with arch, hand-drawn decorations. This funny send-up of society and its portraits made Steichen's respectful image, in the same issue, of Democratic Party powerhouse "Big Jim" Farley holding his straw boater look tame and old-fashioned.[26] When Steichen began trying out Surrealistic contrivances such as extreme scale changes and dreamy poses in his fashion photos (Fig. 93), he must have realized it was time to stop. He retired from Condé Nast in 1937 and closed his New York studio late that year.[27]

The story as it still stands is that Steichen started doing fashion and celebrity photography to make some money after years of struggle. Steichen later recalled that Nast had offered to leave the photographer's name off the fashion images, assuming that Steichen would consider the editorial world to be a step down.[28] But rather than viewing this work as something that would result in a loss of prestige, Steichen foresaw the growing social, cultural, and economic impact of the still photograph on the printed page—a progression that unfolded during his tenure at Condé Nast as more illustrated publications came into being and pictures of all sorts, both moving and still, began to pervade modern life. He already knew how to take portraits when he began working at the magazines, and what he didn't know about fashion he learned from *Vogue*'s peerless fashion editor Carmel Snow. And so he pushed the evolution of photography even as he rushed to keep pace, creating exquisitely lit and elegantly composed photographs that held the page and had enough novelty and chic to appeal to momentary fashions, and yet had the gravity and grace to allow them

to outlive their time. In his years at Condé Nast, Steichen made a tremendous number of photographs, many of which are middling to good. But a great number are more than that—they are wonderful, imaginative documents of glamour, talent, ego, and style.

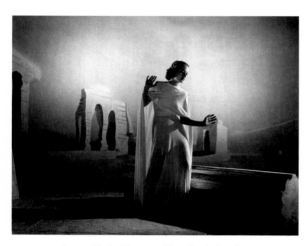

93. Actress Merle Oberon as Messalina in Josef von Sternberg's film *I, Claudius*, in a decor by Bebe Berard, 1937

In the last years of his Condé Nast career, Steichen was sometimes influenced by new trends and younger photographers. Merle Oberon's dreamy, sleepwalker's stance is a pose more common to the Surrealist-inflected photographs of Cecil Beaton than to the streamlined portrayals of Steichen.

My thanks to the many people who contributed to this essay with assistance, patience, encouragement, and ideas: William A. Ewing and Nathalie Herschdorfer at the Musée de l'Elysée, Lausanne; Willis E. Hartshorn, Brian Wallis, Christopher Phillips, Catherine Kunkemueller, and Inês Dias at the International Center of Photography, New York; Peter Galassi, Susan Kismaric, and Whitney Gaylord at the Museum of Modern Art, New York; and Shawn Waldron, Marianne Brown, and Gillian Masland at the Condé Nast Archive, Condé Nast Publications, Inc., New York.

1. I am using the term "commercial" broadly to mean any type of photography that is assigned to the photographer to produce in exchange for salary, including editorial and advertising photos that are made primarily to be reproduced in magazines.

2. See especially Catherine Tuggle, "Steichen and the Photography-as-Art Debate: Silencing the Cuckoo's Call," *History of Photography* 17, no. 4 (Winter 1993): 343–51.

3. Nancy Hall-Duncan, *The History of Fashion Photography* (exhibition catalogue) (New York: Alpine Book Company, 1979), 49.

4. De Meyer's photographs—society portraits—first appear in *Vogue* in 1913, but his initial fashion imagery would not appear in the magazine until 1917.

5. Grace M. Mayer, undated note recording a conversation she had with Paul Strand in 1974, Condé Nast Period file, The Edward Steichen Archive, The Museum of Modern Art, New York. This story mutates over the years. In 1936, Steichen told an audience of camera club members that after World War I he "came to the conclusion that painting belonged to the past—that as a painter I was producing nothing but high-grade wallpapers for wealthy people" and that he was therefore going back to photography. "Photographic Illustration," typescript of a lecture by Edward J. Steichen, Strong Auditorium, Rochester, New York, January 27, 1936, pp. 4–5, The Edward Steichen Archive, The Museum of Modern Art, New York.

6. According to Grace M. Mayer's chronology of Steichen's career, in 1925 alone he had more than four hundred credit lines on photographs printed in *Vogue* and *Vanity Fair*. Grace M. Mayer, "Steichen's Way," vol. 2 (work in progress), typescript, p. 54, chronology by Grace M. Mayer, bibliography by Daniel Pearl, The Edward Steichen Archive, The Museum of Modern Art, New York.

7. "The Lotus: A Study in Surfaces by Edward Steichen," *Vanity Fair*, July 1923, 34.

8. Caroline Seebohm reports that while some readers protested the changes to the magazine, Agha insisted that the new design elements, including sans-serif type and asymmetrical layouts, were good business decisions, noting that other publications were copying them. Caroline Seebohm, *The Man Who Was Vogue: The Life and Times of Condé Nast* (New York: Viking Press, 1982), 231.

9. Patricia Johnston, *Real Fantasies: Edward Steichen's Advertising Photography* (Berkeley and Los Angeles: University of California Press, 1997), 82.

10. Edward Steichen, *A Life in Photography* (Garden City, NY: Doubleday, published in collaboration with the Museum of Modern Art, New York, 1963), chap. 7, "Fashion Photography and Fabric Designs," n.p.; see also Weston J. Naef, *The Collection of Alfred Stieglitz: Fifty Pioneers of Modern Photography* (New York: Metropolitan Museum of Art, 1978), 451, illus. no. 470.

11. In 1935, *Vogue* did a picture layout called "New York's Fashion Models," in which it pointed out that "During the past ten years, the profession of fashion modeling—whether for advertisers or for smart magazines, like *Vogue*—has become a recognized and profitable profession." Photos of twelve of "the loveliest and most famous models of the day" were reproduced in it. It was also noted that six "are listed (as if anyone cared) in the Social Register." *Vogue*, May 1935, 42–43.

12. "Spring Features the Small Hat," *Vogue*, April 15, 1923, 66; "'Terpischore of Two Continents': Leonore Hughes," *Vanity Fair*, May 1, 1923, 38.

13. Hall-Duncan quotes a "gently" mocking 1939 memo to Condé Nast from *Vogue* art director M. F. Agha regarding de Meyer's style: "To be alluring, a model must clutch her hips; to be glamorous, she must lean over backwards." Hall-Duncan, *The History of Fashion Photography*, 40.

14. "In the Realm of Négligée: The Pyjama Now Shares Equal Honour with the Lovely Trailing Tea-Gown," *Vogue*, November 15, 1926, 55.

15. Photographs showing the decor of the "public" rooms of the apartment, where Nast threw his storied parties, were reproduced in "The New York Apartment of Condé Nast, Esq. Decorations by Elsie de Wolfe," *Vogue*, August 1, 1928, 44–47. My thanks to Marianne Brown at the Condé Nast Archive for supplying me with a copy of this article.

16. Johnston points out that in the 1920s, "the commercial photography sphere developed a distinct application of modernist tenets that came to be identified as *modernistic*." See Johnston, *Real Fantasies*, 121–23. The term "modernistic" was also used by *Vogue*'s caption writers, who applied it to art as well as to fashion; see *Vogue*, June 1, 1925, 70, and *Vogue*, October 1, 1925, 71.

17. "Modernistic Art Has a Daring Way with the Mode," *Vogue*, June 1, 1925, 70–72. Delaunay's name was given in the caption on page 71 as Sonia de Launay. *Vogue*'s own page design hadn't caught up yet with the new look, and the photographs of the new mode were enclosed by old-fashioned, hand-drawn borders.

18. Seebohm, *The Man Who Was Vogue*, 226–31. *Vanity Fair* was also running articles on new developments in the arts, such as one by the Dada poet Tristan Tzara on "The Dada Masks of Hiler," *Vanity Fair*, July 1924, 46, 88.

19. "Tells About His Work: Edward J. Steichen Speaks of Some of His Ideas About Art in Photography," unsigned, undated clipping from an unidentified Milwaukee newspaper probably published in August 1902, from Marie Steichen's scrapbook, The Edward Steichen Archive, The Museum of Modern Art, New York.

20. Steichen, "Photographic Illustration," 15.

21. Ibid., 16.

22. *Vanity Fair*, April 1935, 38–39; *Vanity Fair*, July 1935, 32–33; *Vanity Fair*, October 1935, 32–33; *Vogue*, June 15, 1935, 46–47; and *Vogue*, December 1, 1935, 50–53.

23. Steichen, "Photographic Illustration," addendum B.

24. "Black," *Vogue*, November 1, 1935, 68–69; "White," *Vogue*, January 1, 1936, 36–37. Although the site of "White" has often been identified as a "lavatory," Steichen's assistant, Noel H. Deeks, confirmed that the walls of the studio on Sixty-ninth Street that Steichen occupied for a few years had white tiling. Written communication, Noel H. Deeks to Grace M. Mayer, January 15, 1979, The Edward Steichen Archive, The Museum of Modern Art, New York.

25. The photographer Horst P. Horst said that *Vogue*'s editors demanded that other photographers work "in the style of Steichen." Horst to Hall-Duncan, in conversation, February 1977. Quoted in Hall-Duncan, *The History of Fashion Photography*, 55.

26. "Elsa Maxwell Social Dictator," *Vanity Fair*, May 1934, 24, and "'Big Jim' Farley: Democratic Salesman," ibid., 29.

27. Written communication, Noel H. Deeks to Grace M. Mayer, April 4, 1975, The Edward Steichen Archive, The Museum of Modern Art, New York. Penelope Niven gives the date as January 1, 1938, but provides no source for it. Penelope Niven, *Steichen: A Biography* (New York: Clarkson Potter Publishers, 1997), 569.

28. Steichen declined the offer, later writing that "if I made a photograph, I would stand by it with my name." Steichen, *A Life in Photography*, chap. 7, "Fashion," n.p.

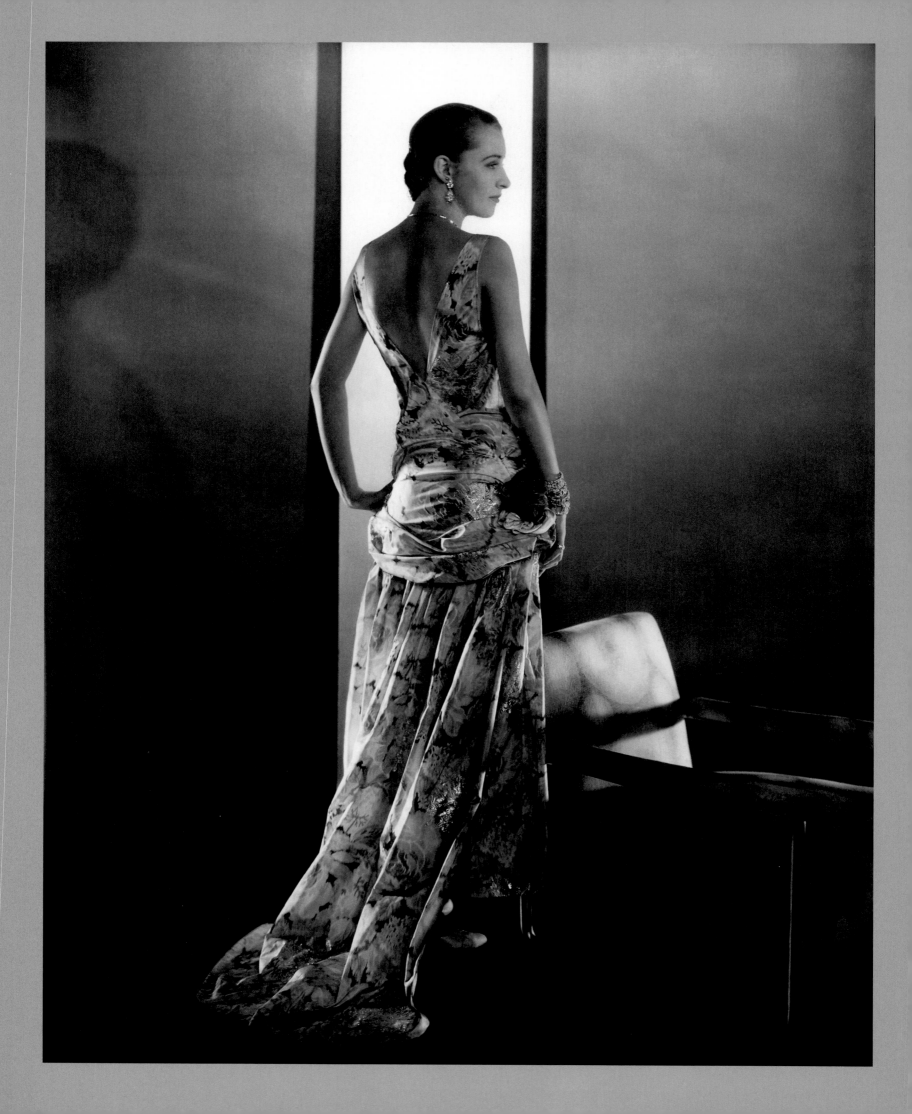

PLATES II *Light is a charlatan*

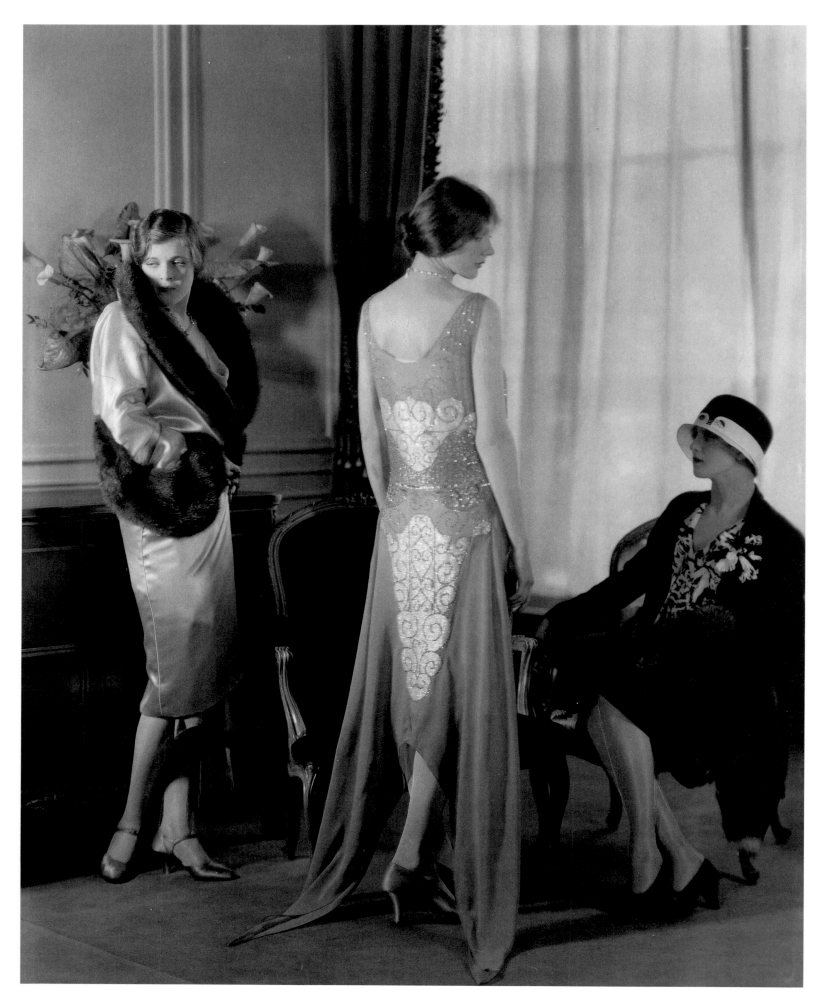

94. TIPPIN PERO, GERTRUDE CLARKE, AND MADAME LASSEN WEARING DRESSES WITH THE "FEELING OF PARIS COUTURE," AT BERGDORF GOODMAN, 1928

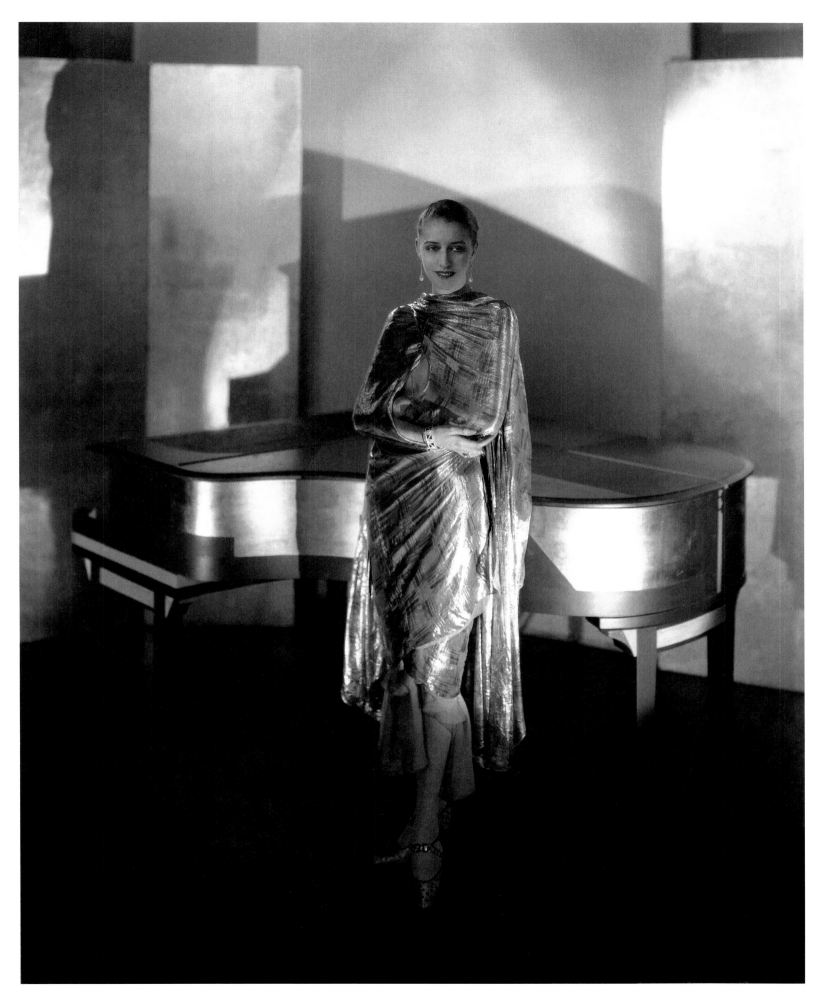

95. MODEL MARION MOREHOUSE WEARING A DRESS BY CHÉRUIT AND JEWELRY BY BLACK,
STARR AND FROST, NEXT TO A PIANO DESIGNED BY STEICHEN, 1928

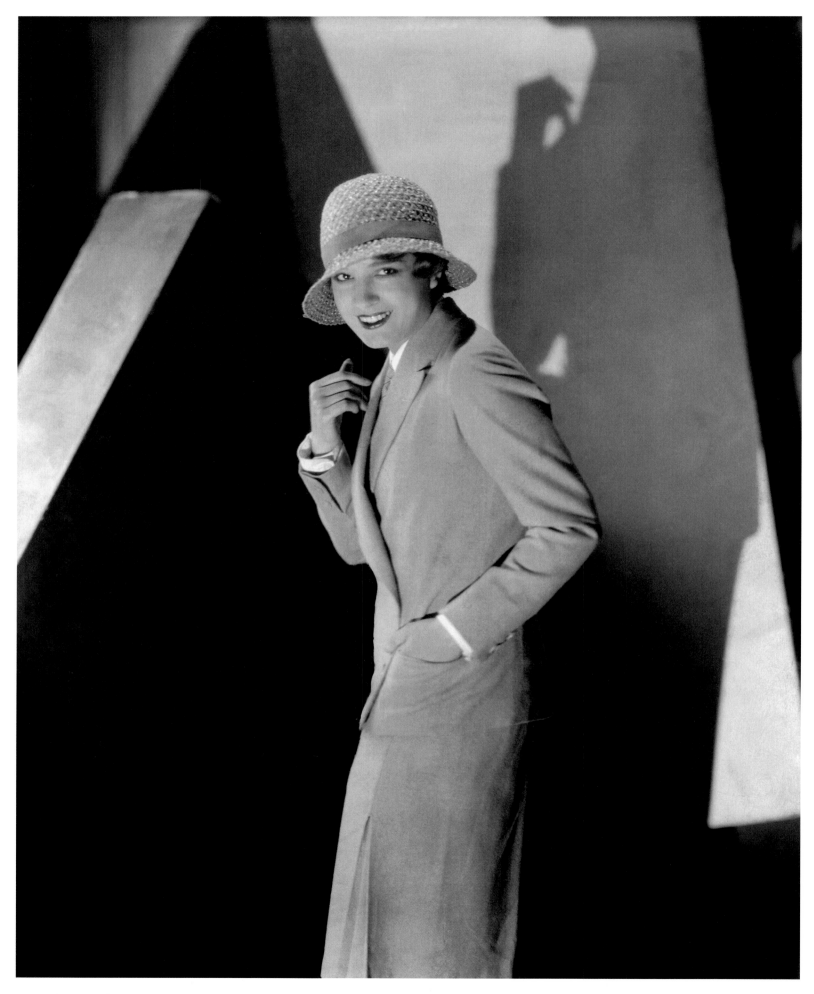

96. ACTRESS LILI DAMITA, 1928

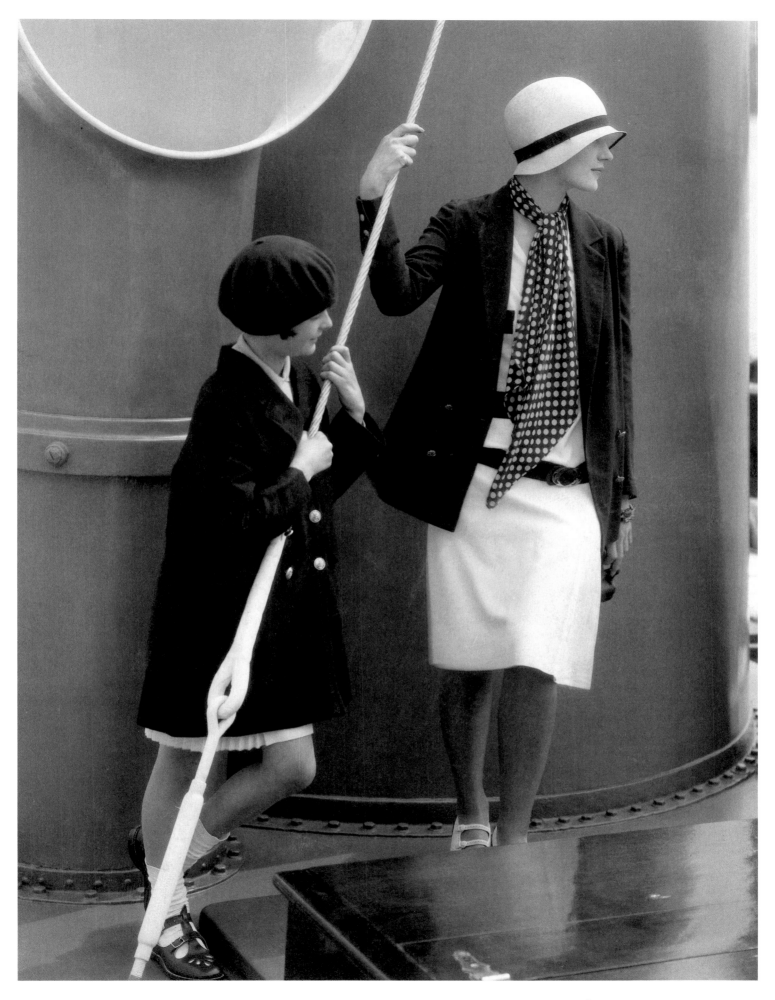

97. MODELS JUNE COX AND LEE MILLER ON GEORGE BAHER'S YACHT, WEARING NAVY
BLAZERS AND WHITE FLANNEL SKIRTS, 1928

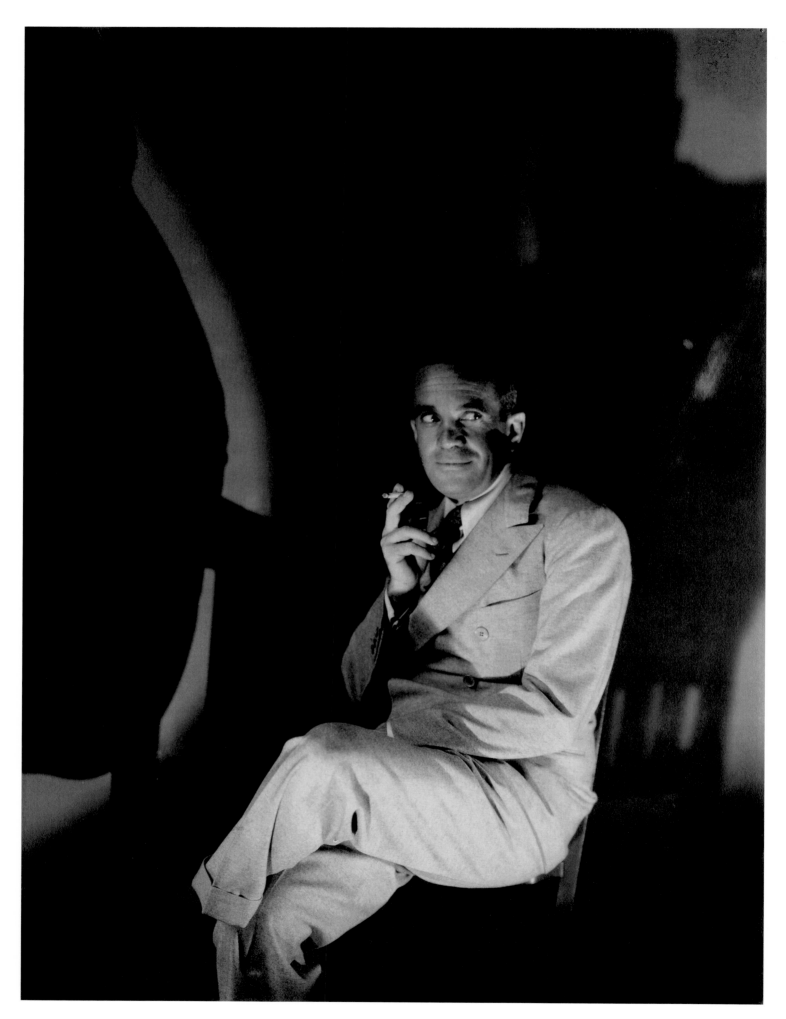

98. SINGER AL JOLSON, 1928

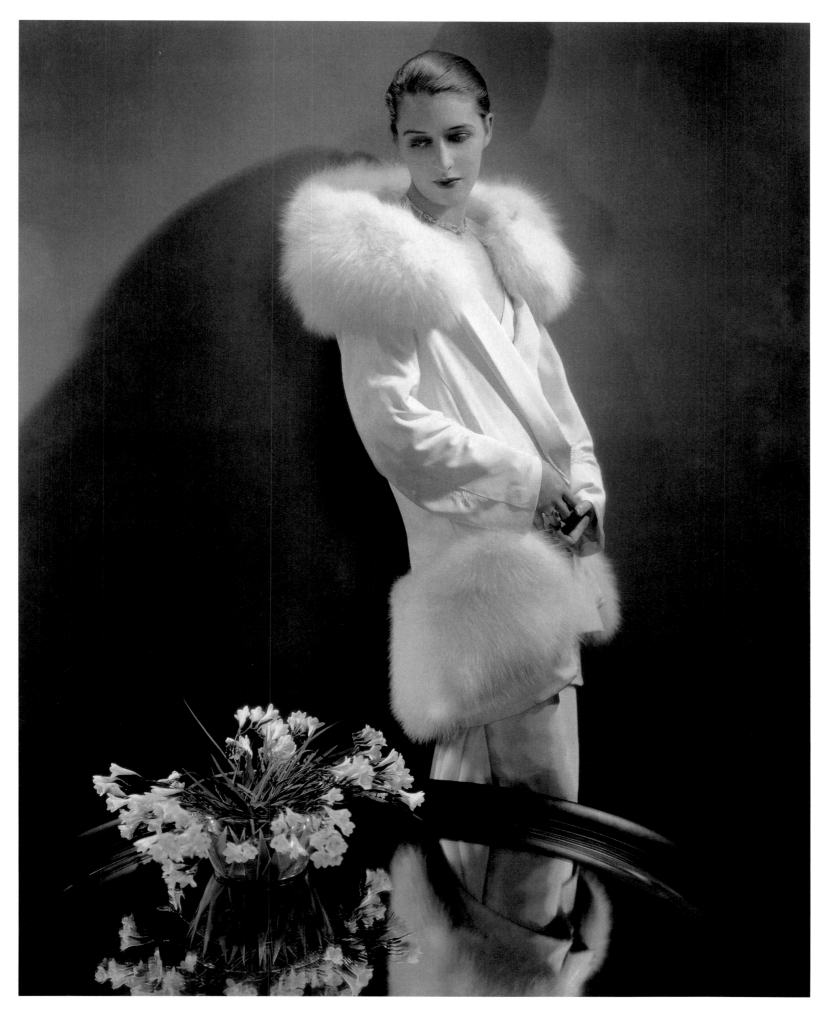

99. MODEL MARION MOREHOUSE IN A CRÊPE WRAP WITH WHITE FOX COLLAR BY AUGUSTABERNARD, 1929

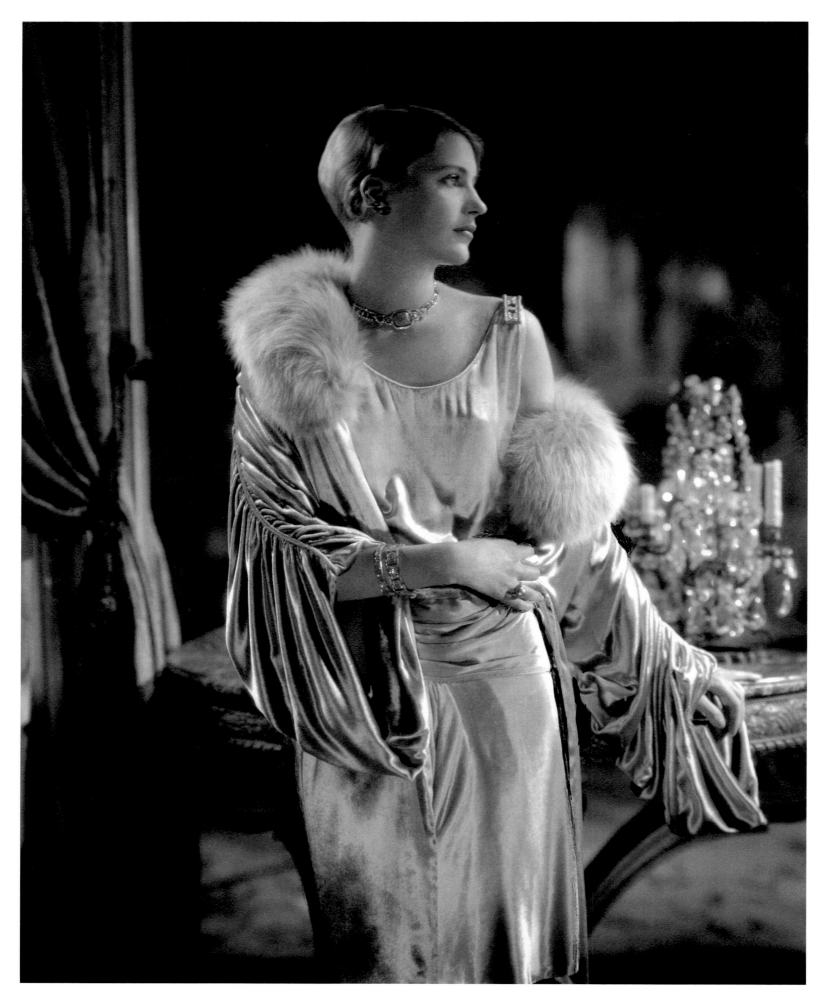

100. MODEL LEE MILLER WEARING A DRESS BY JAY-THORPE AND A NECKLACE BY MARCUS, IN CONDÉ NAST'S APARTMENT, 1928

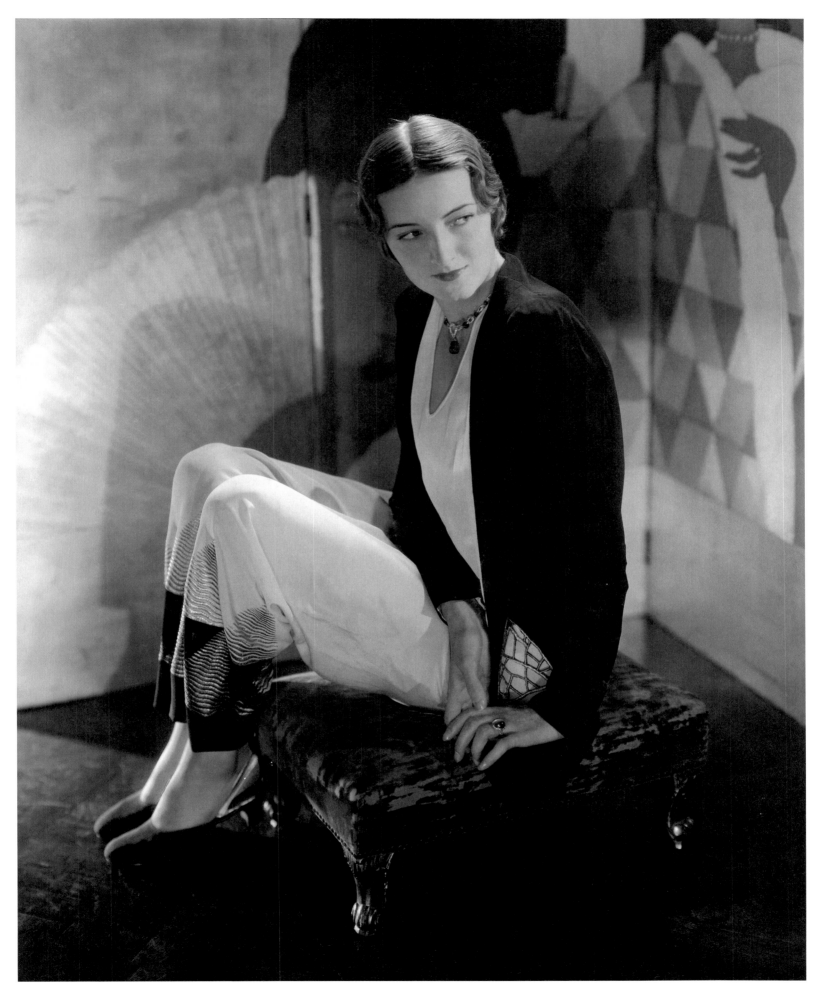

101. MODEL JULE ANDRÉ WEARING FASHION BY DAISY GARSON, 1928

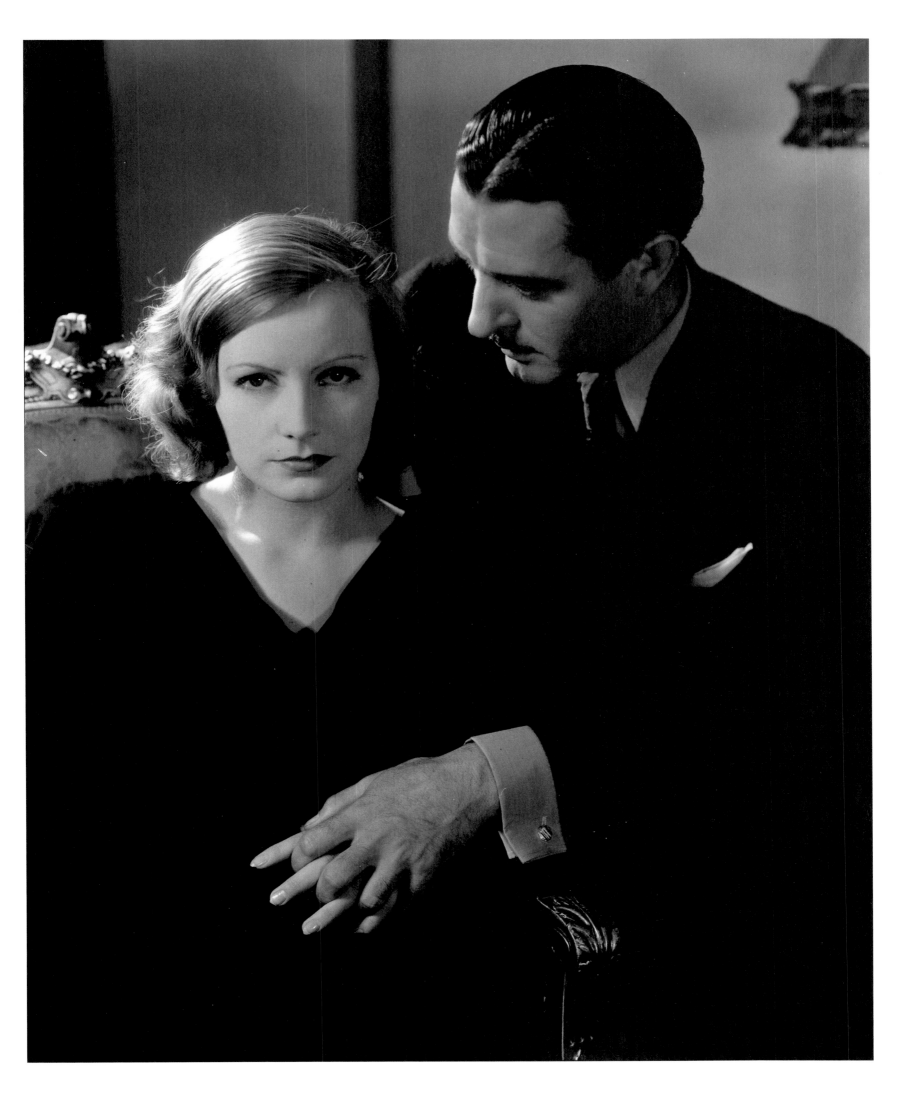

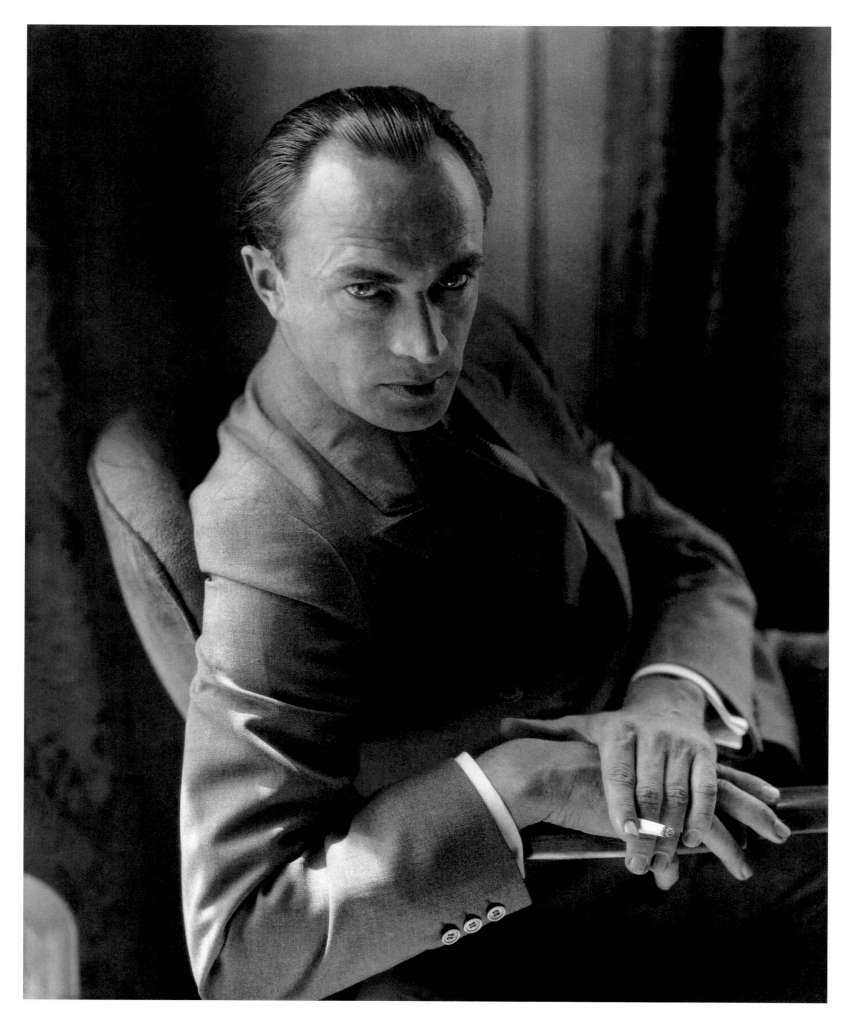

103. ACTOR CONRAD VEIDT, 1929

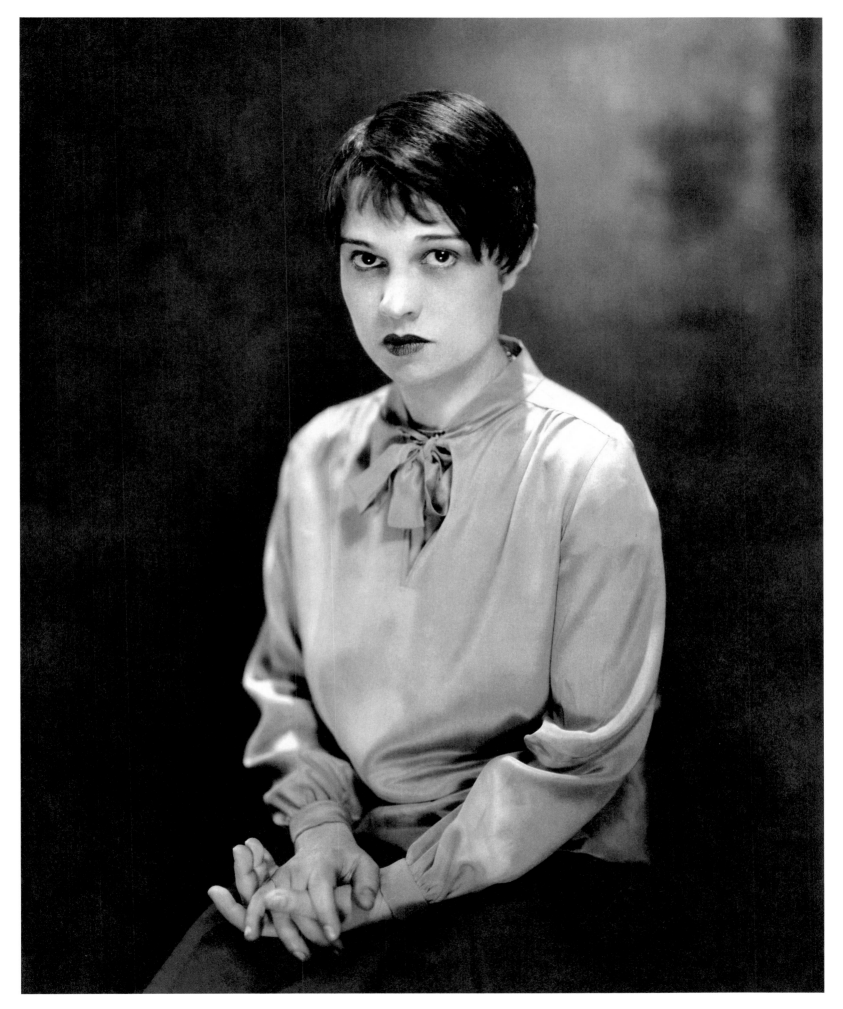

104. SCREENWRITER ANITA LOOS, C. 1928

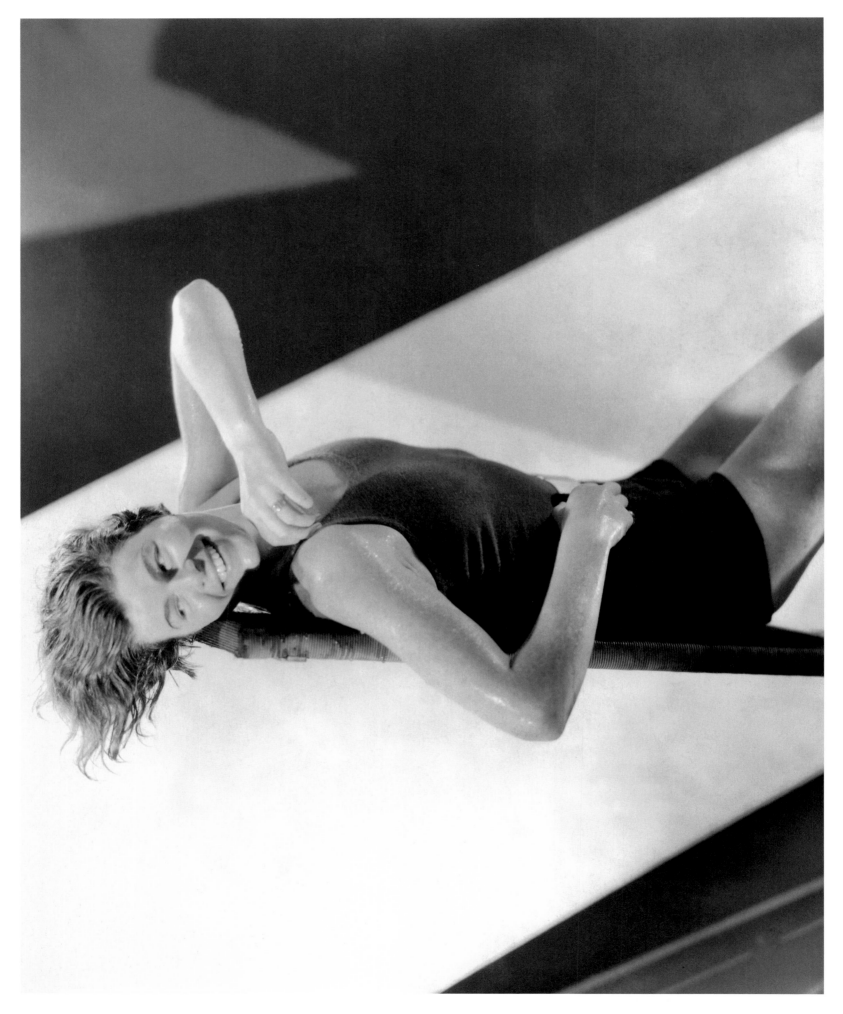

105. OLYMPIC SWIMMING CHAMPION AGNES GERAGHTY, 1929

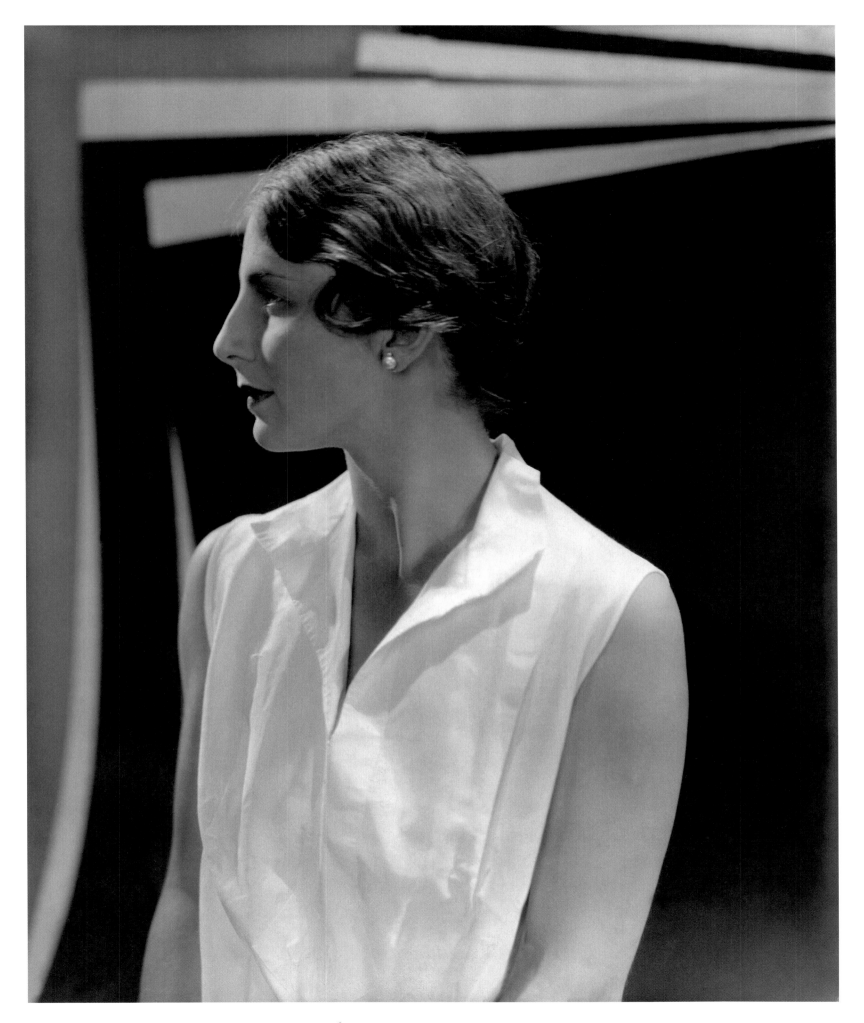

106. TENNIS PLAYER HELEN WILLS, 1929

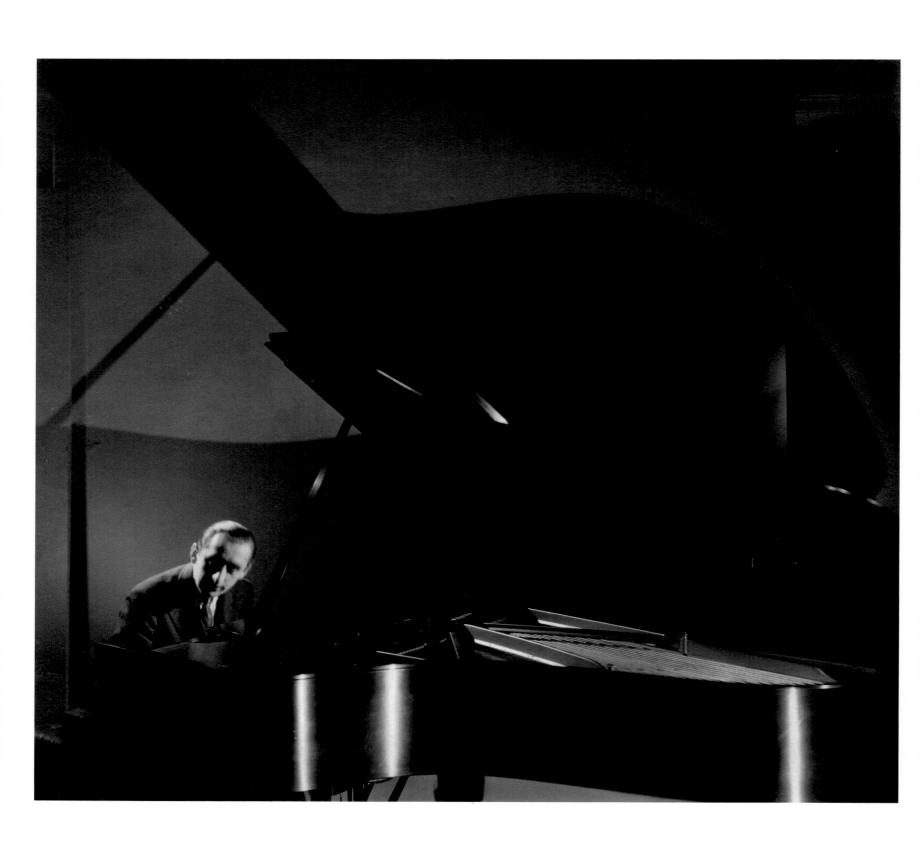

107. PIANIST VLADIMIR HOROWITZ, 1929

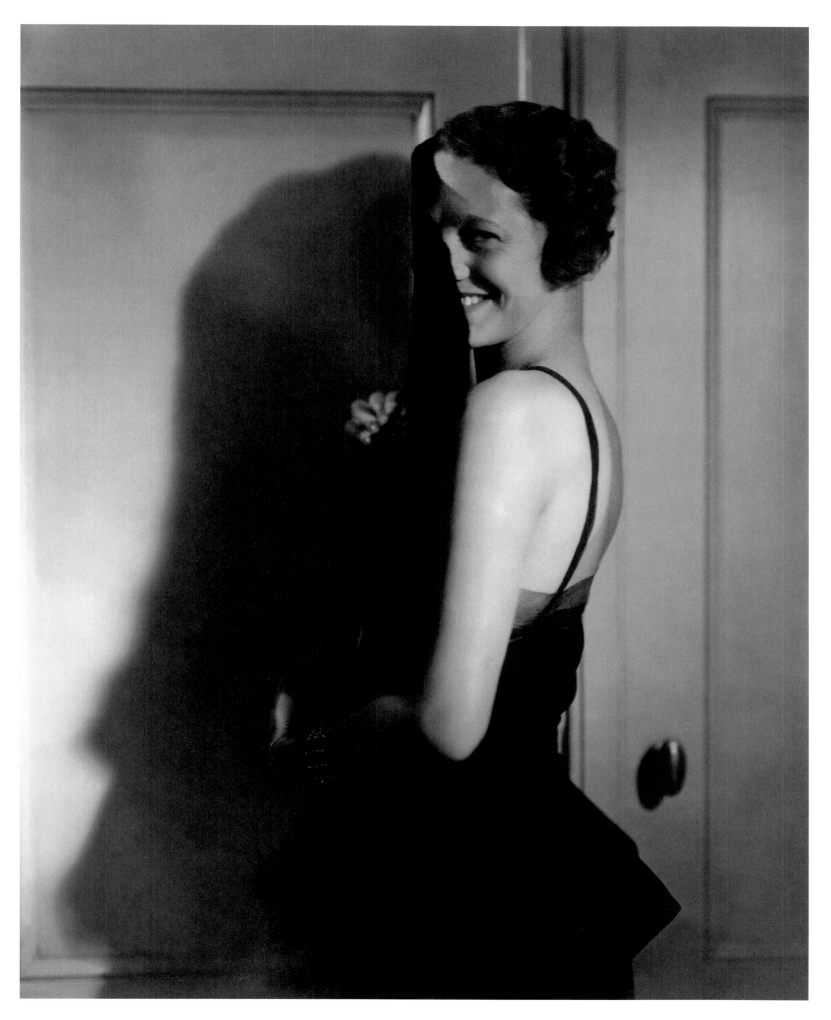

108. ACTRESS GERTRUDE LAWRENCE, 1929

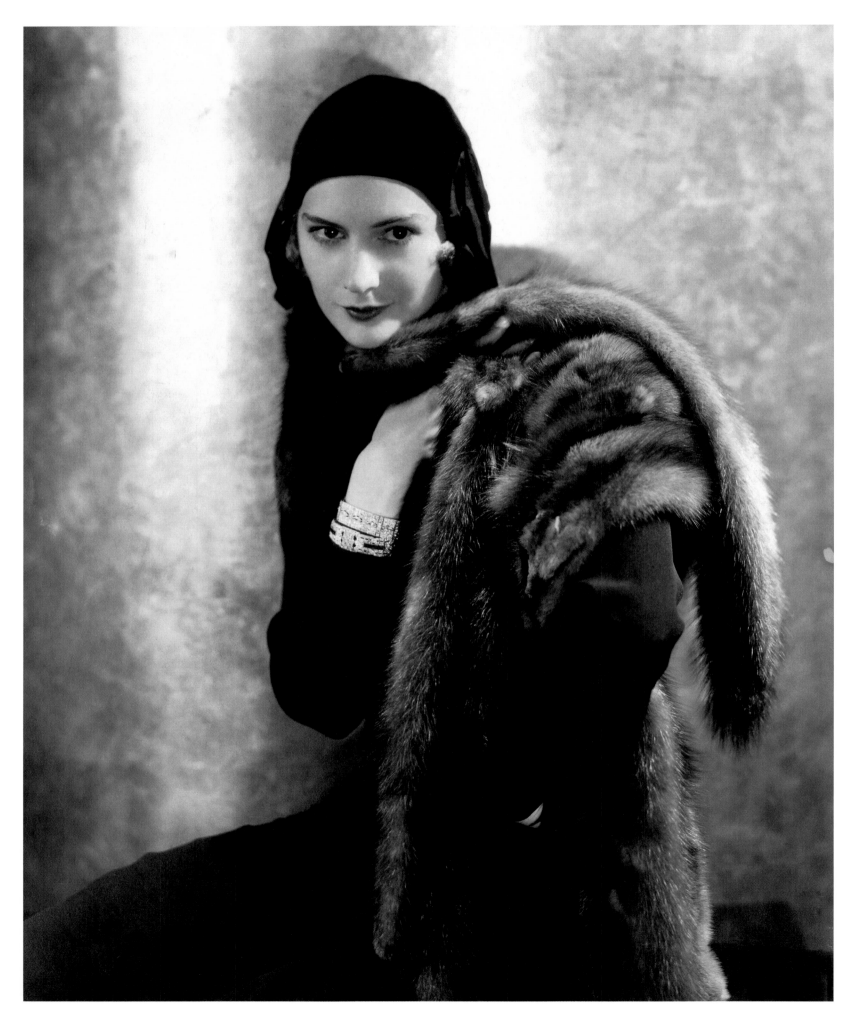

109. ACTRESS HELEN LYONS WEARING FASHION BY MADO AND JEWELRY BY MARCUS, 1929

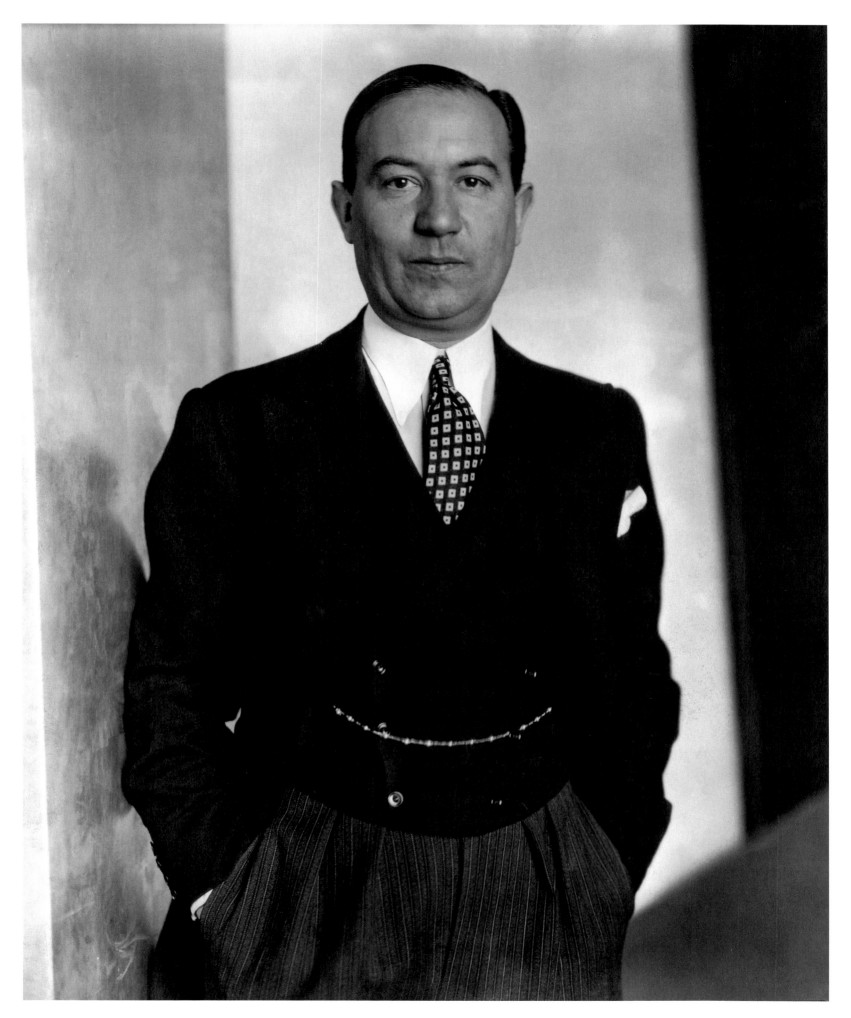

110. WRITER PAUL MORAND, 1929

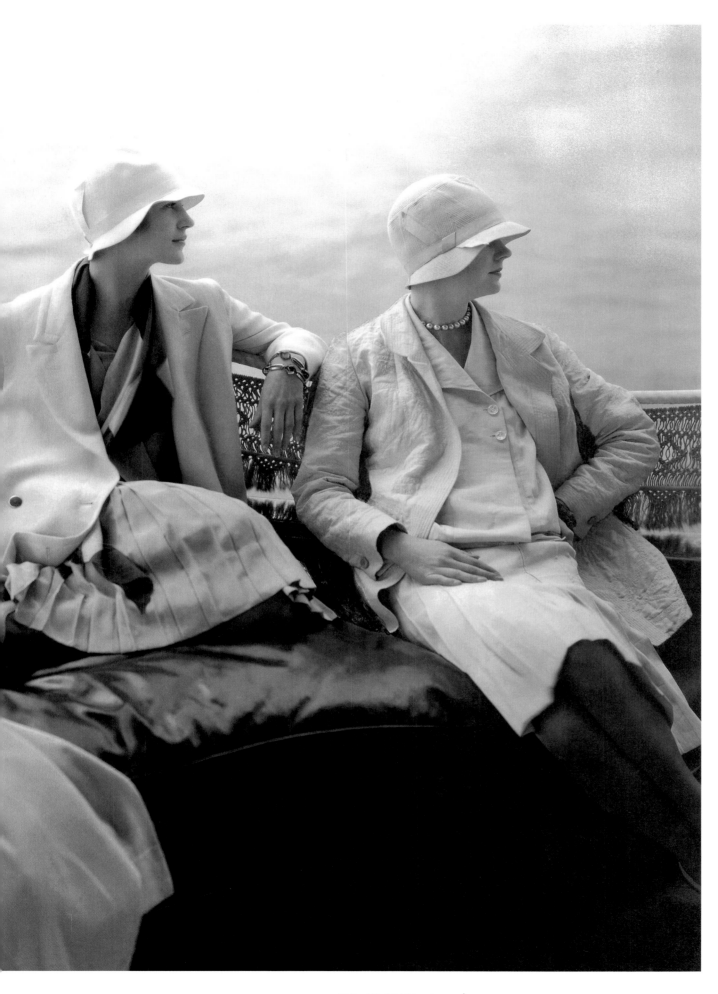

111. ON GEORGE BAHER'S YACHT: JUNE COX WEARING UNIDENTIFIED FASHION; E. VOGT WEARING FASHION BY CHANEL AND A HAT BY REBOUX; LEE MILLER WEARING A DRESS BY MAE AND HATTIE GREEN AND A SCARF BY CHANEL; HANNA-LEE SHERMAN WEARING UNIDENTIFIED FASHION, 1928

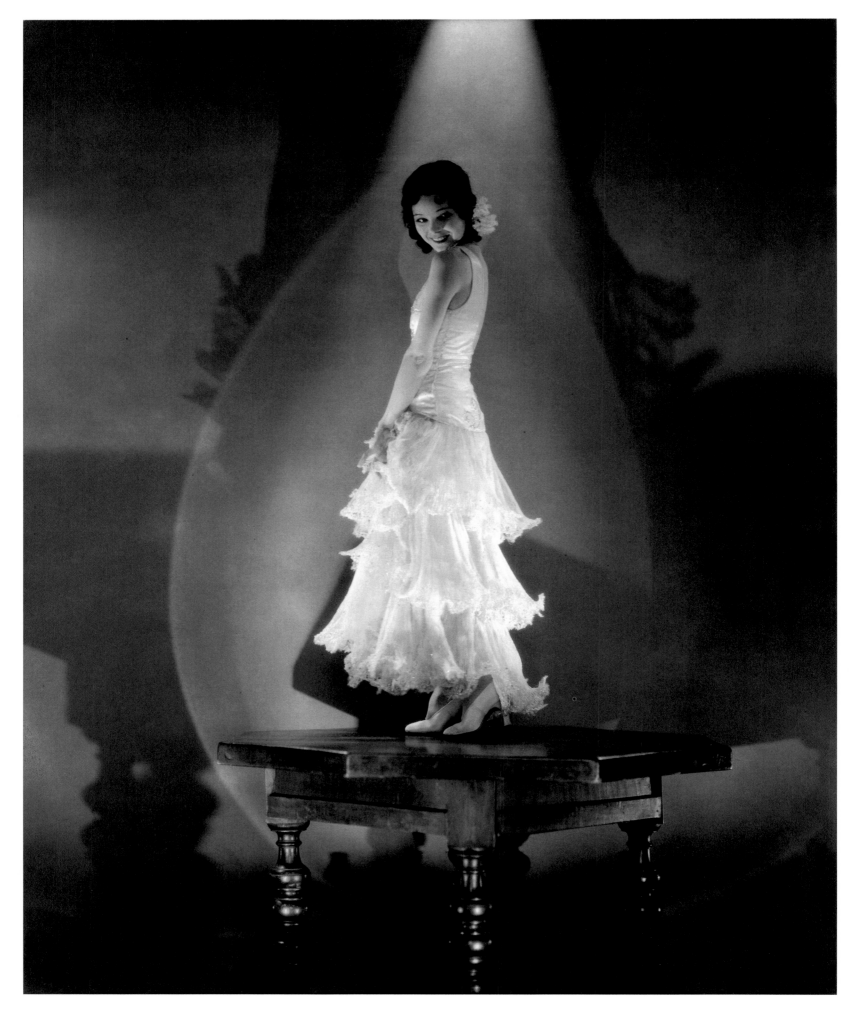

112. ACTRESS ARMIDA, 1930

113. SELF-PORTRAIT WITH PHOTOGRAPHIC PARAPHERNALIA, NEW YORK, 1929

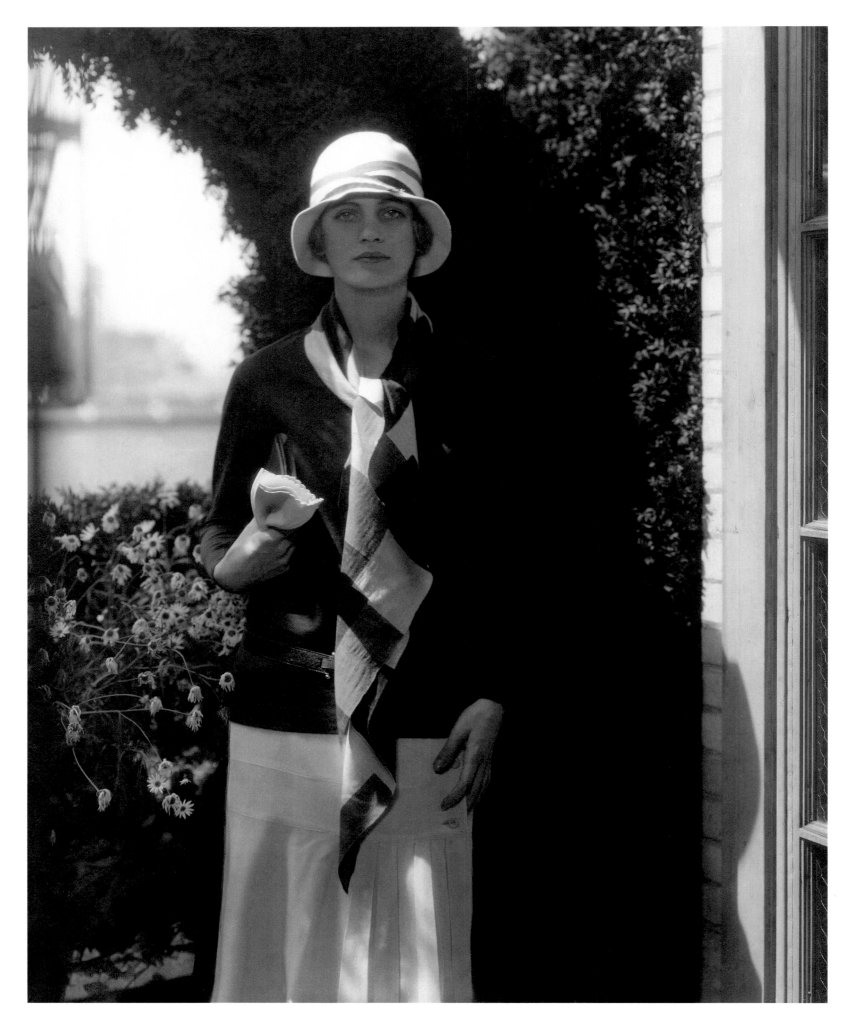

114. MODEL LEE MILLER WEARING FASHION BY CHANEL AND A HAT BY REBOUX, 1928

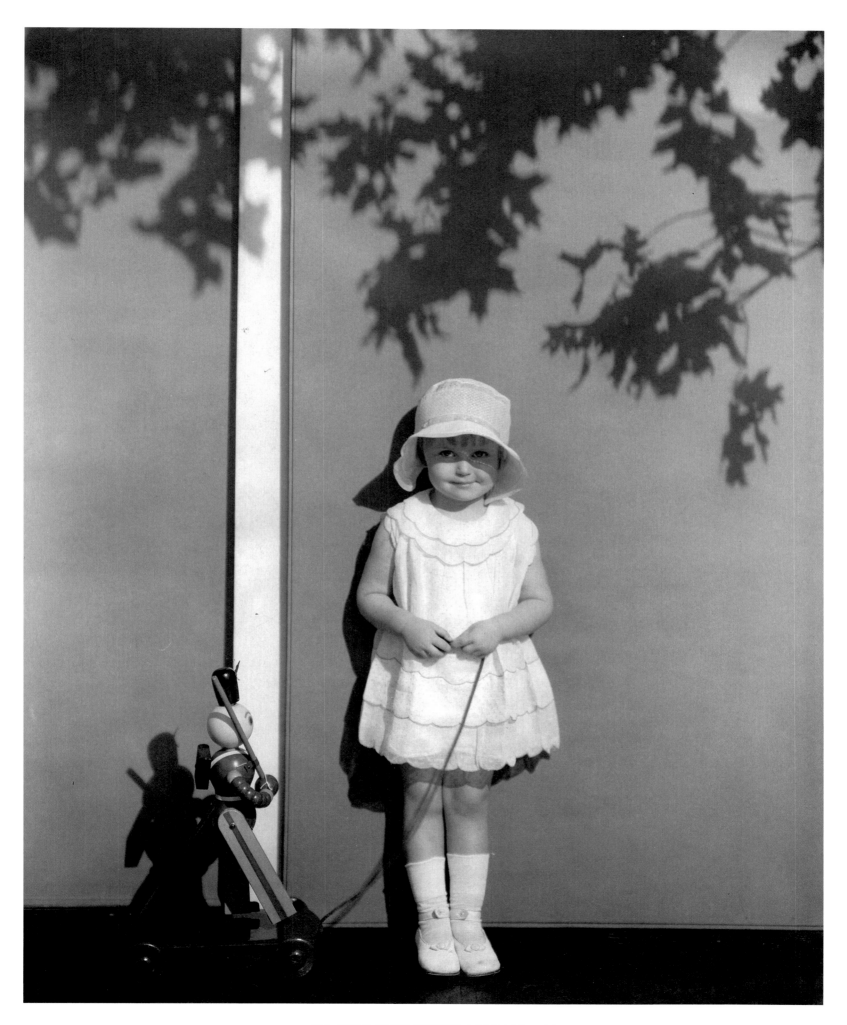

115. CHILD MODEL WEARING A DRESS WITH SCALLOPS, 1929

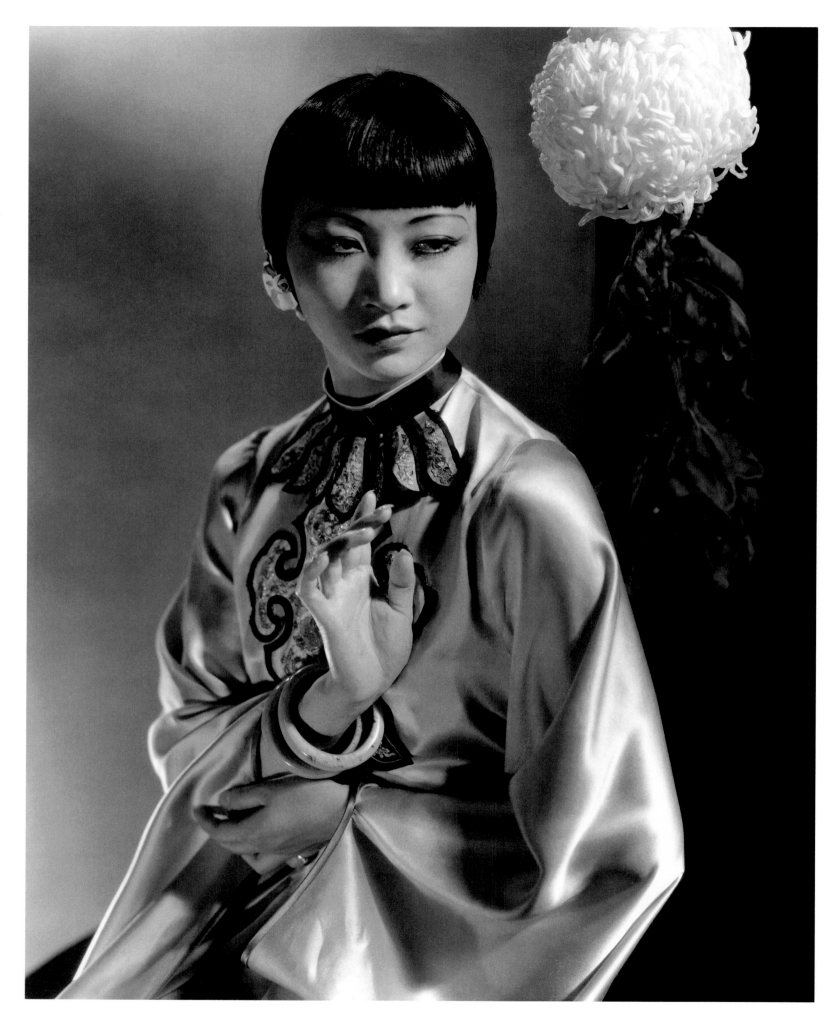

116. ACTRESS ANNA MAY WONG, 1930

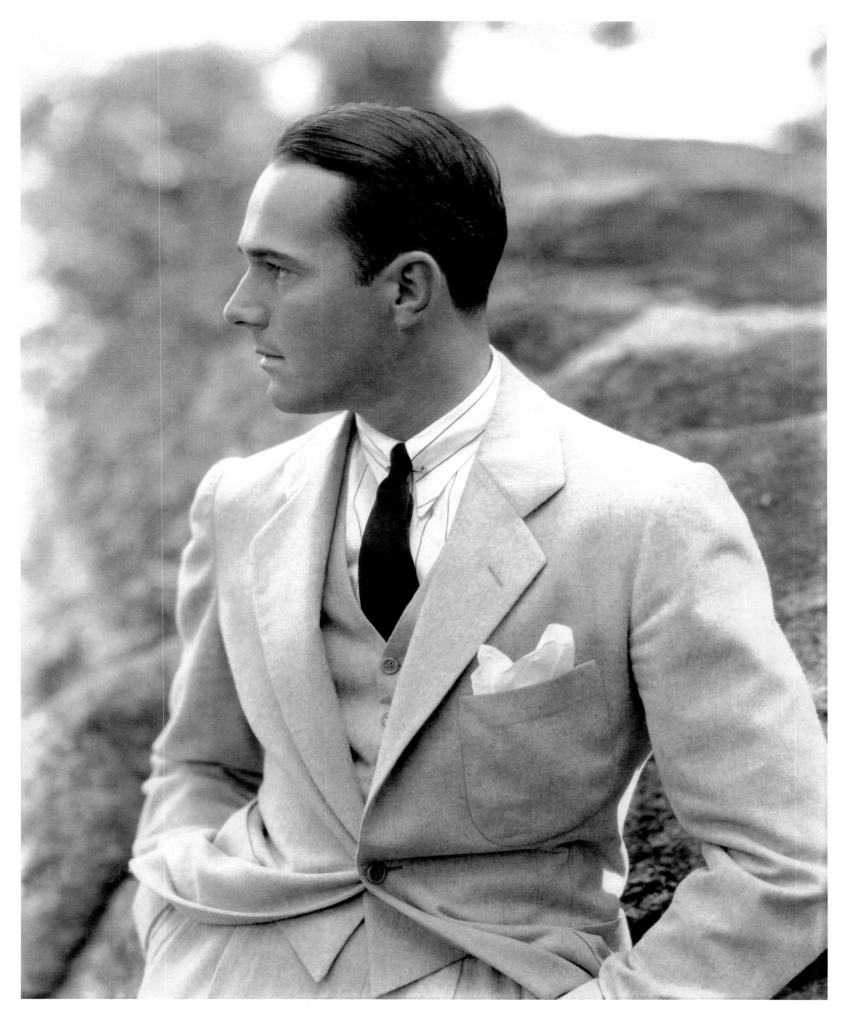

117. ACTOR WILLIAM HAINES, C. 1930

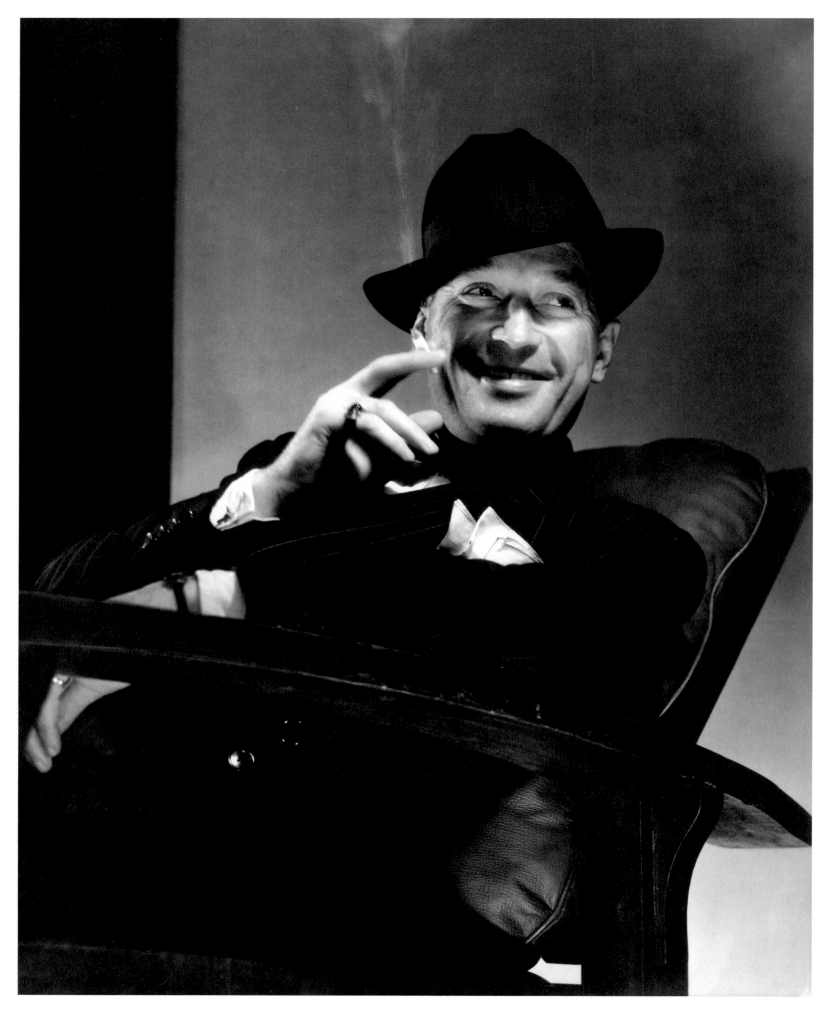

118. ACTOR AND SINGER MAURICE CHEVALIER, 1929

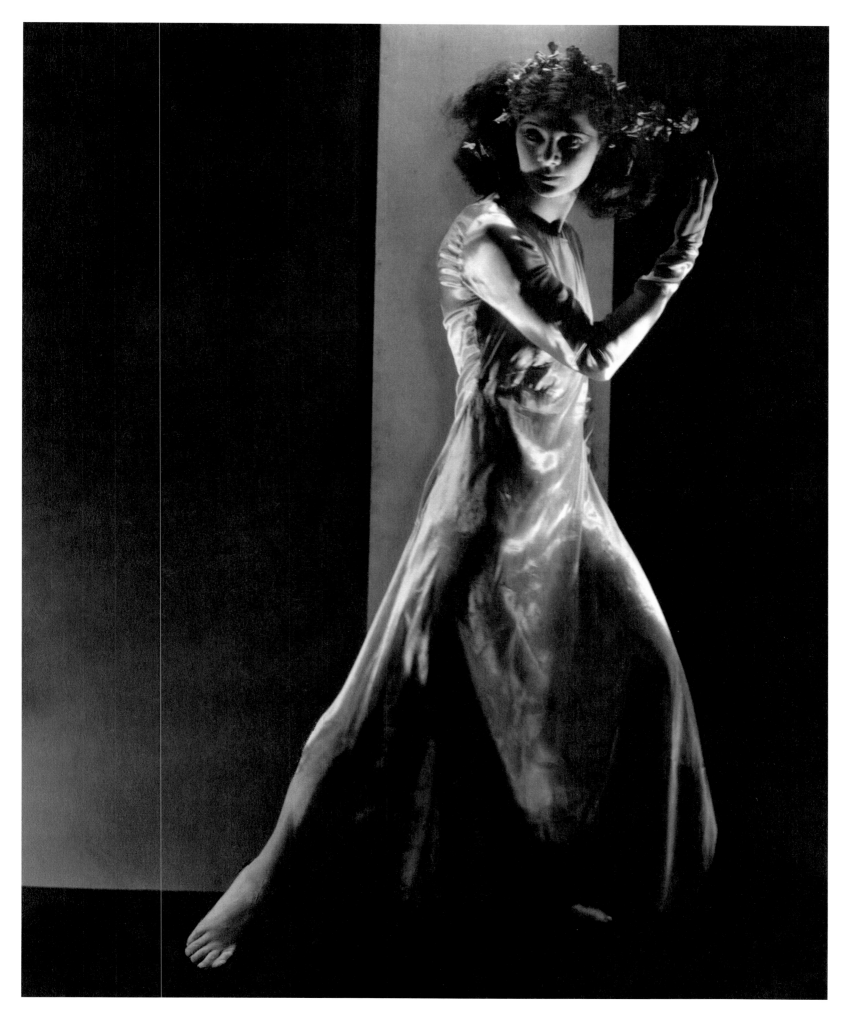

119. DANCER HELEN TAMIRIS, 1930

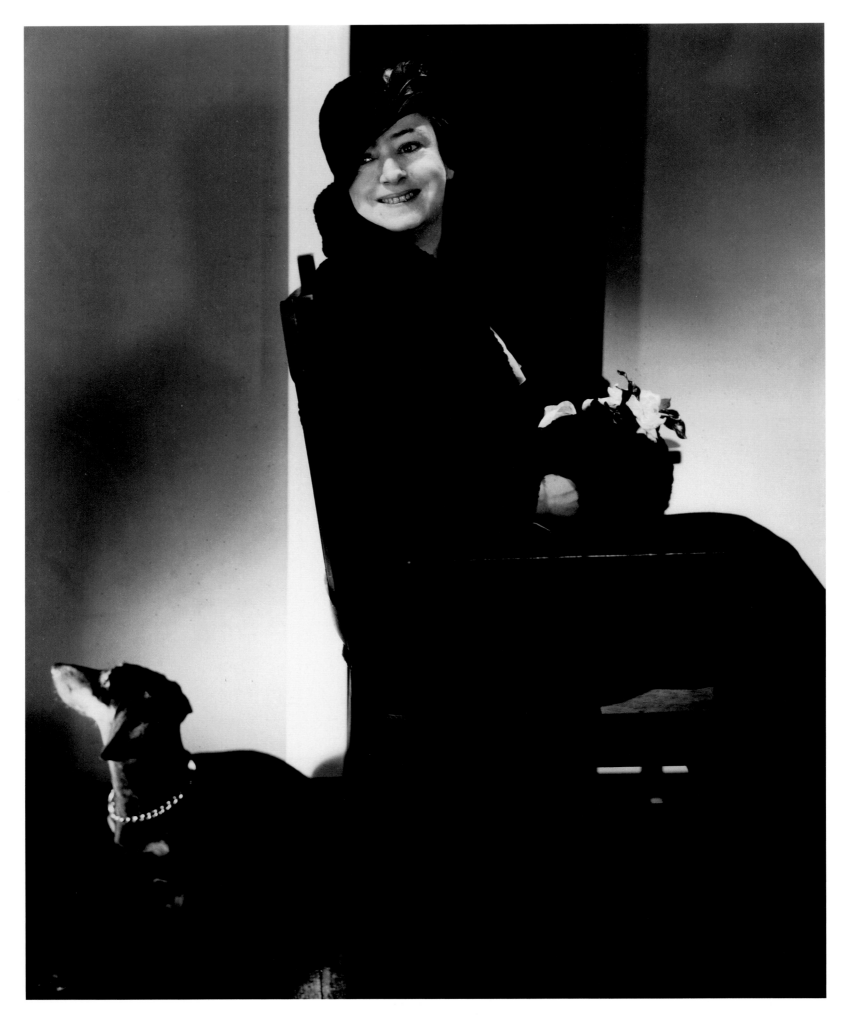

120. WRITER AND POET DOROTHY PARKER, 1931

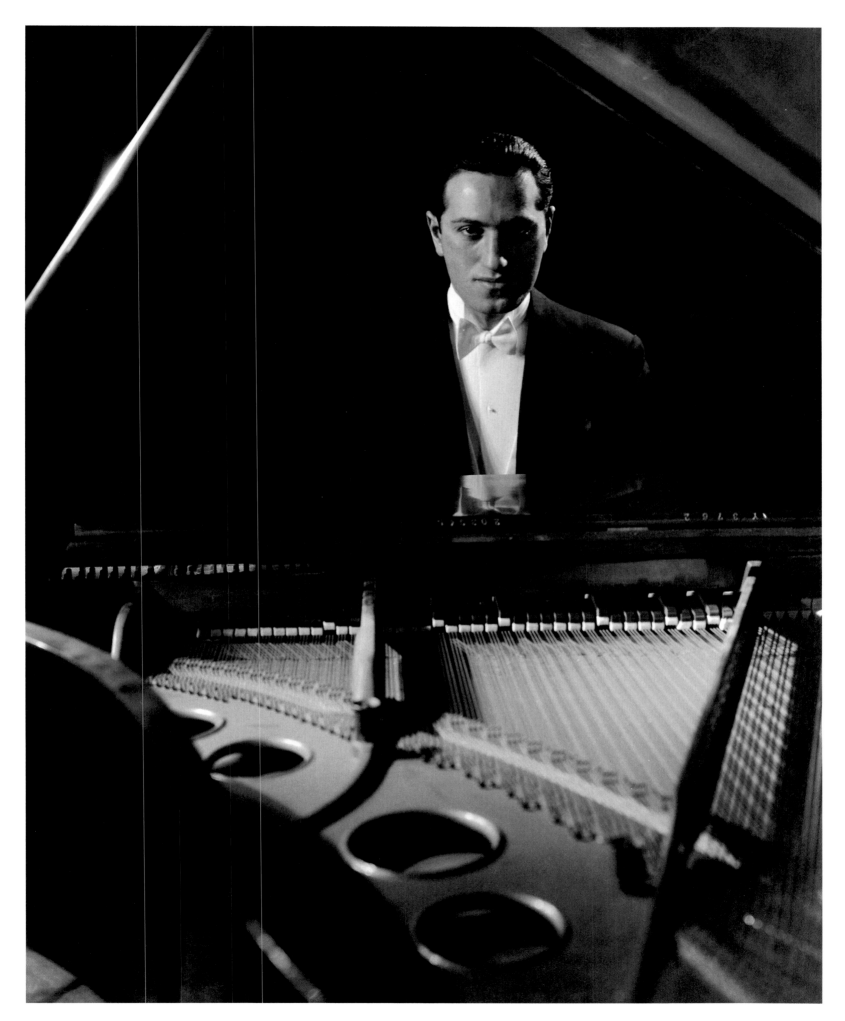

121. COMPOSER GEORGE GERSHWIN, 1931

122. ACTOR GARY COOPER, 1930

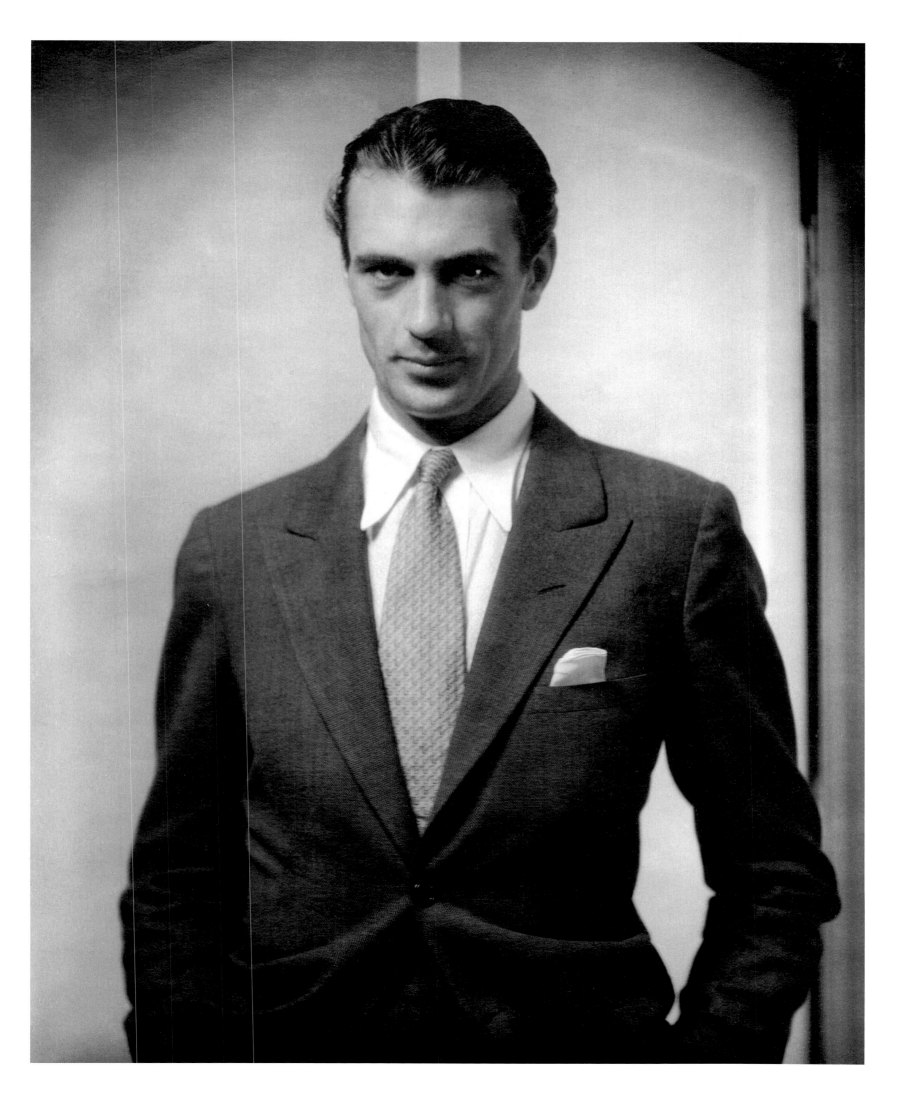

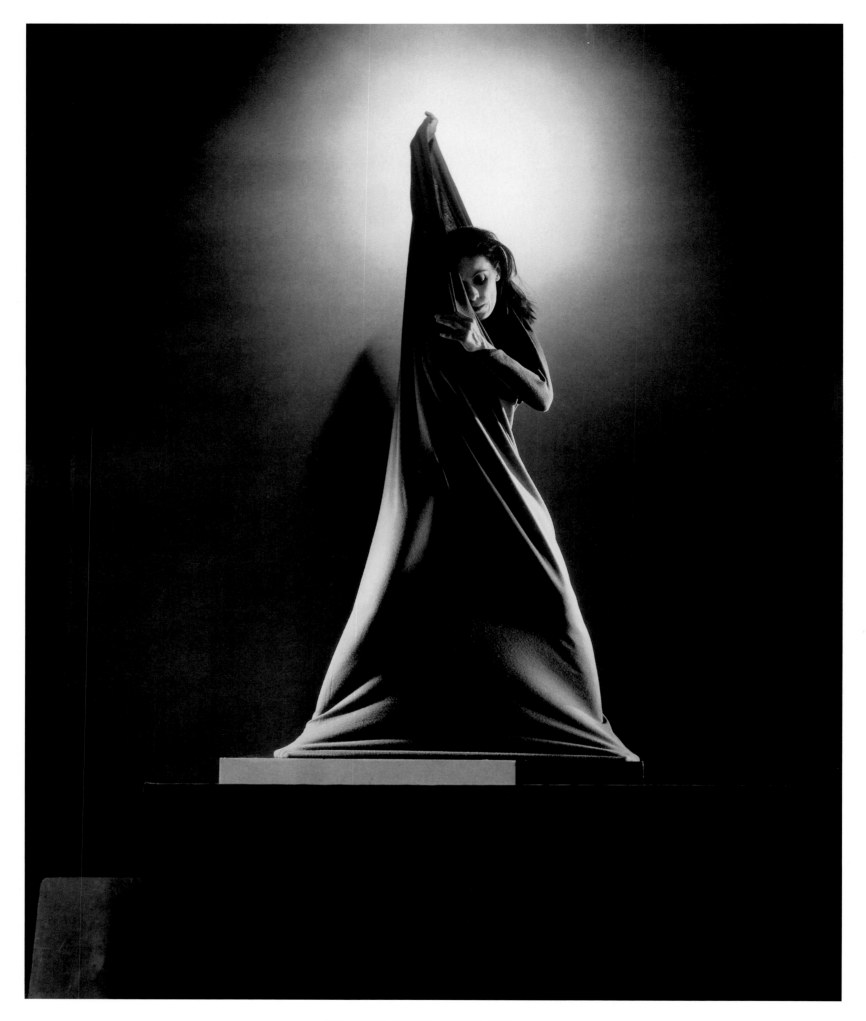

123. DANCER MARTHA GRAHAM, 1931

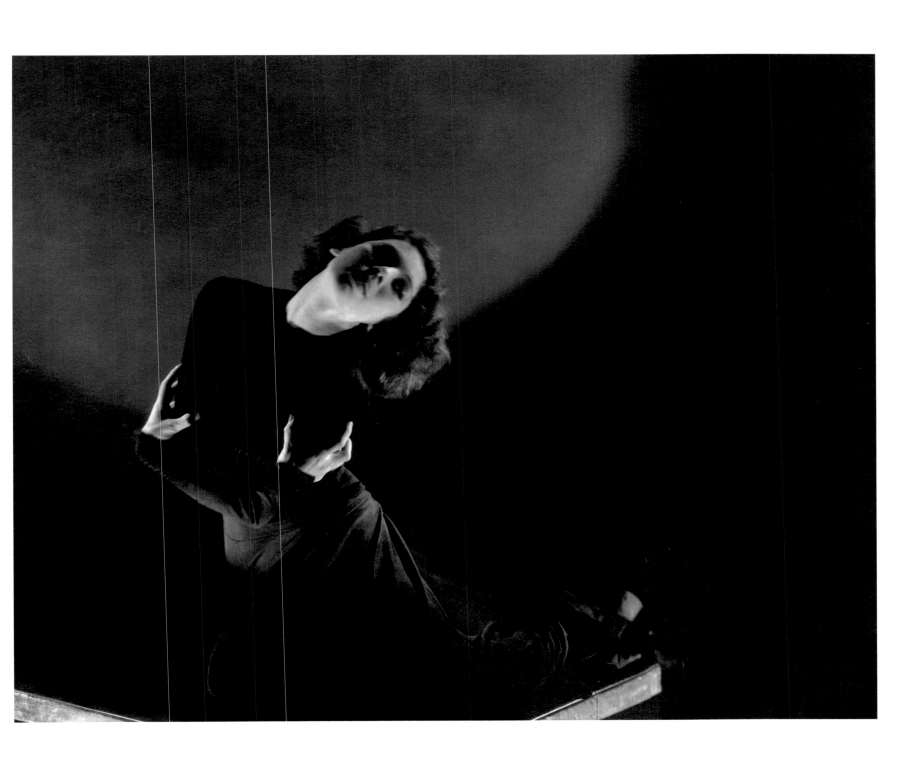

124. DANCER TILLY LOSCH, 1930

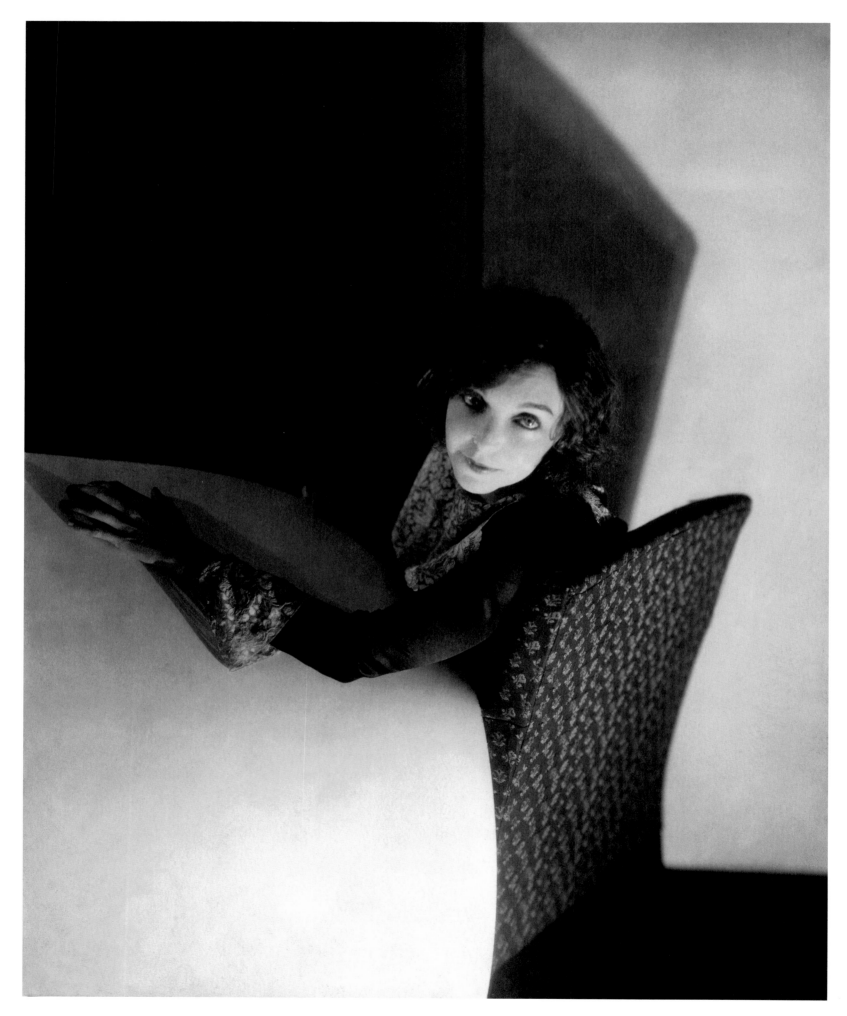

125. ACTRESS ZASU PITTS, 1930

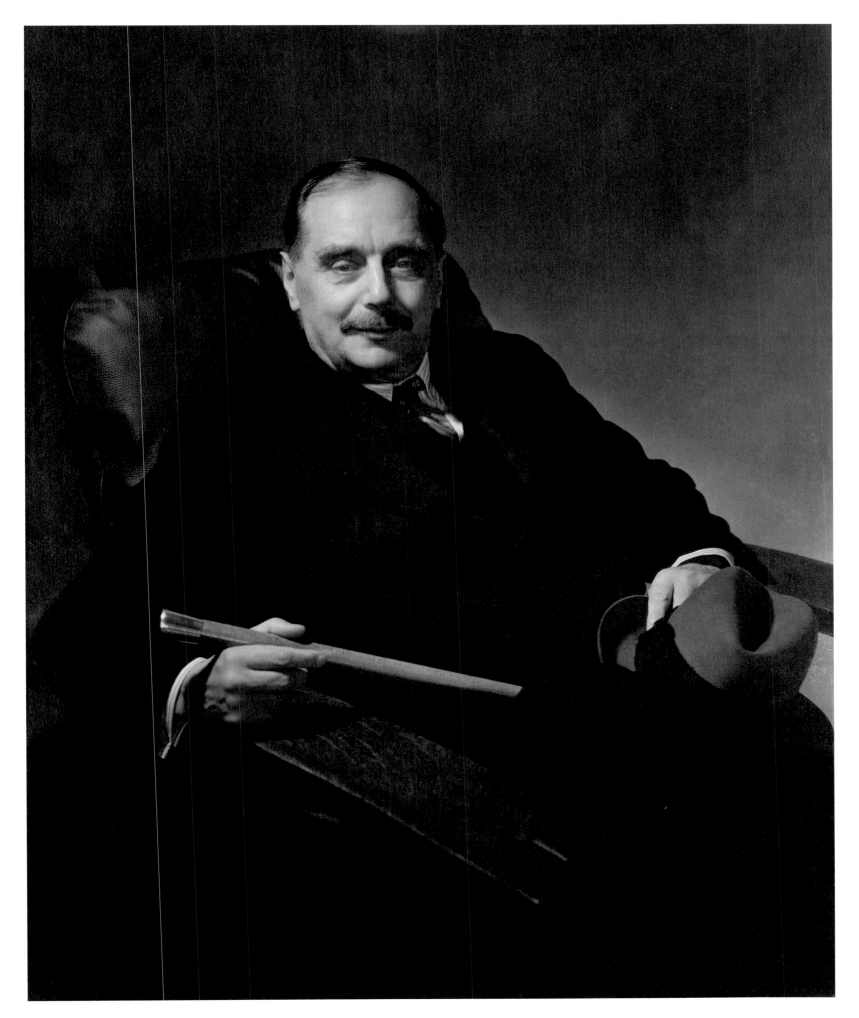

126. WRITER H. G. WELLS, 1931

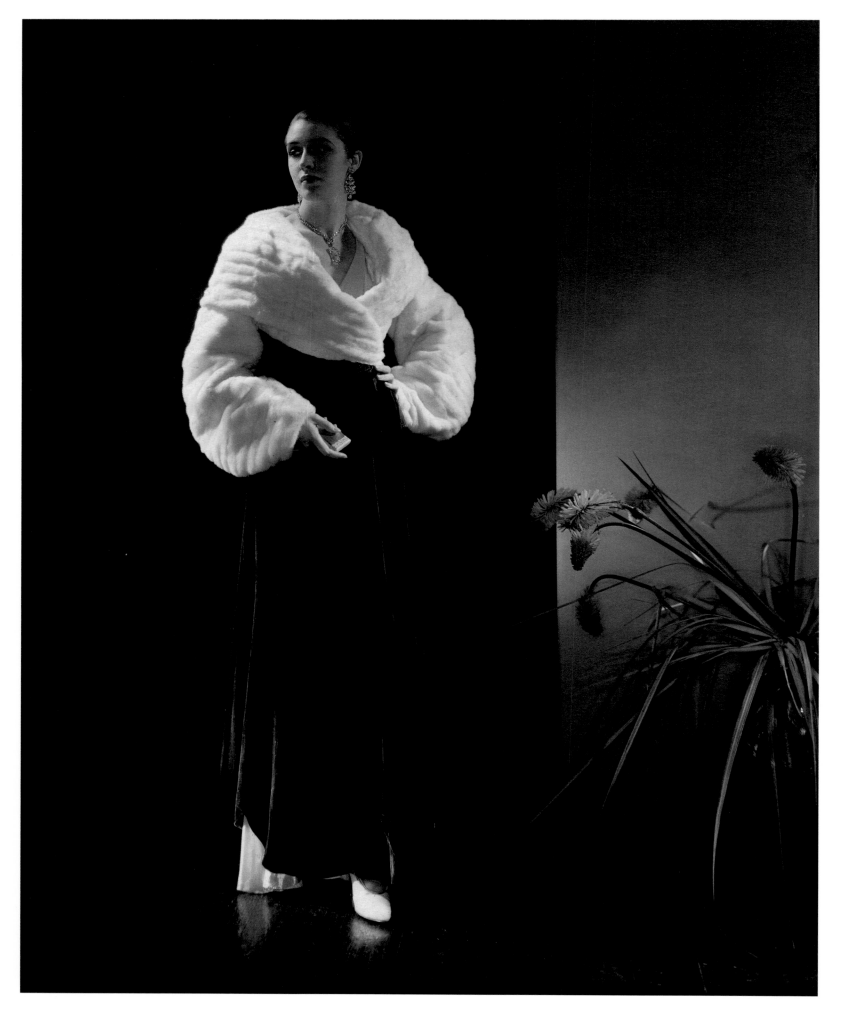

127. MODEL MARION MOREHOUSE IN A DRESS BY VIONNET, 1930

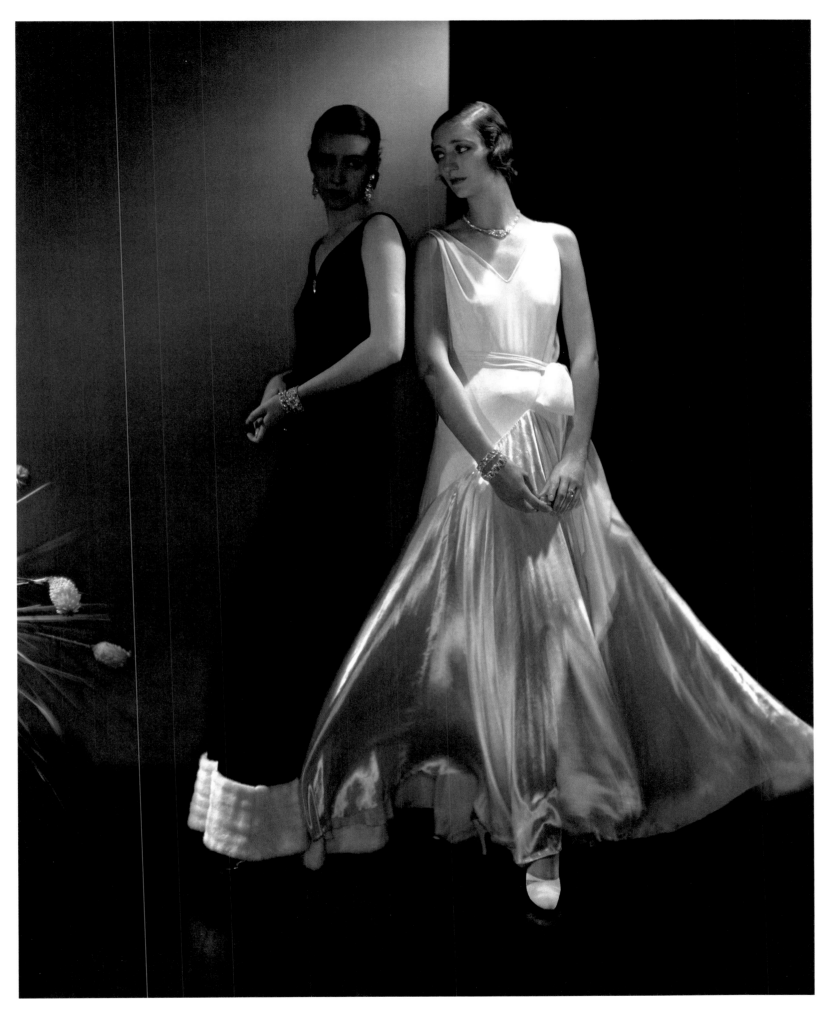

128. MODEL MARION MOREHOUSE AND UNIDENTIFIED MODEL WEARING DRESSES BY VIONNET, 1930

129. THE MARCHIONESS OF MILFORD HAVEN, 1931

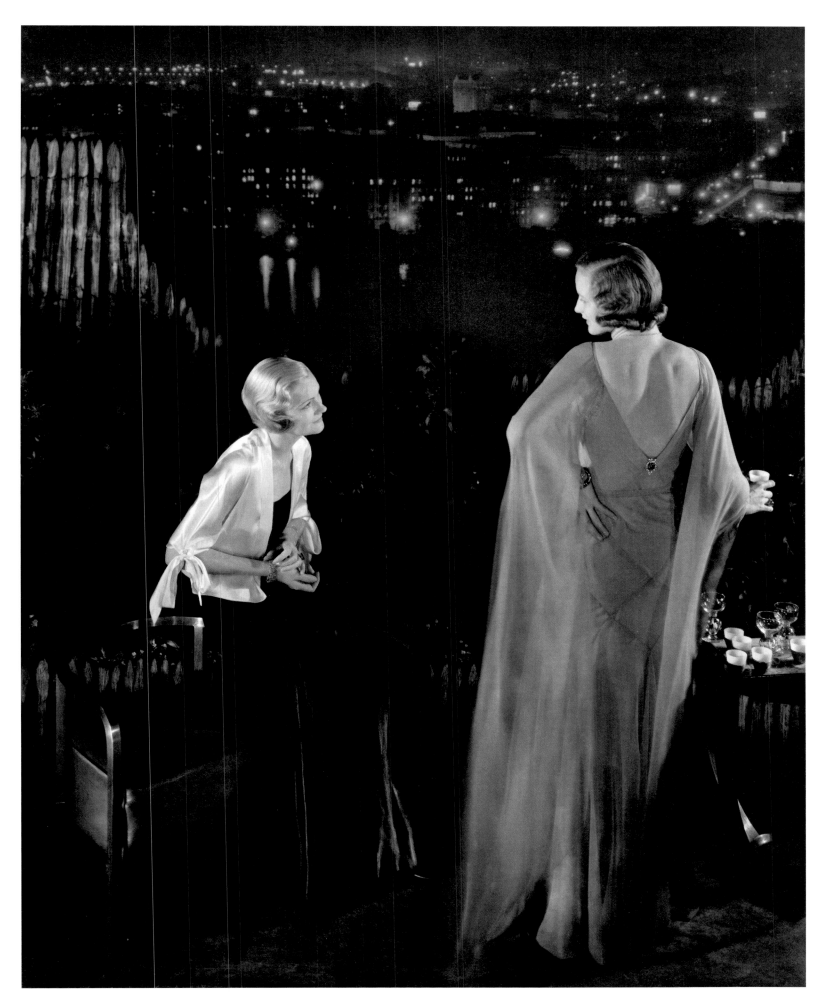

130. MODELS CLAIRE COULTER AND AVIS NEWCOMB WEARING DRESSES BY LANVIN AND CHANEL, AT 1200 FIFTH AVENUE, 1931

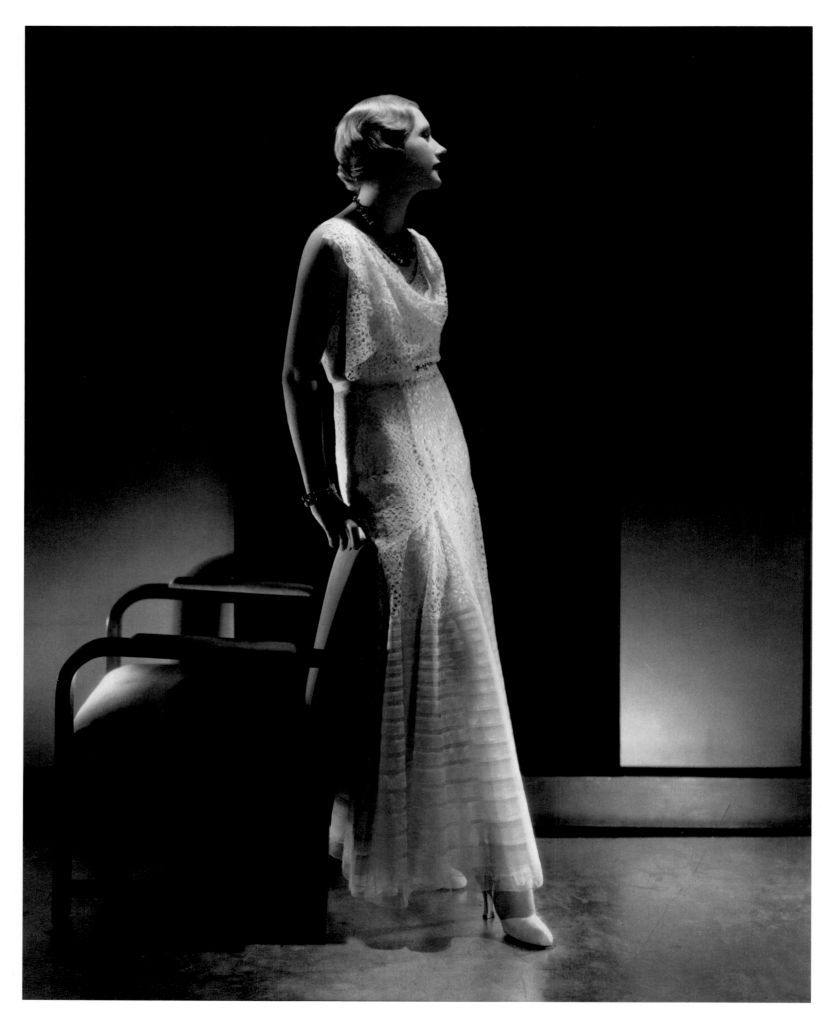

131. MODEL PEGGY BOUGHTON WEARING A GOWN BY LELONG AND A NECKLACE FROM CARTIER, 1930

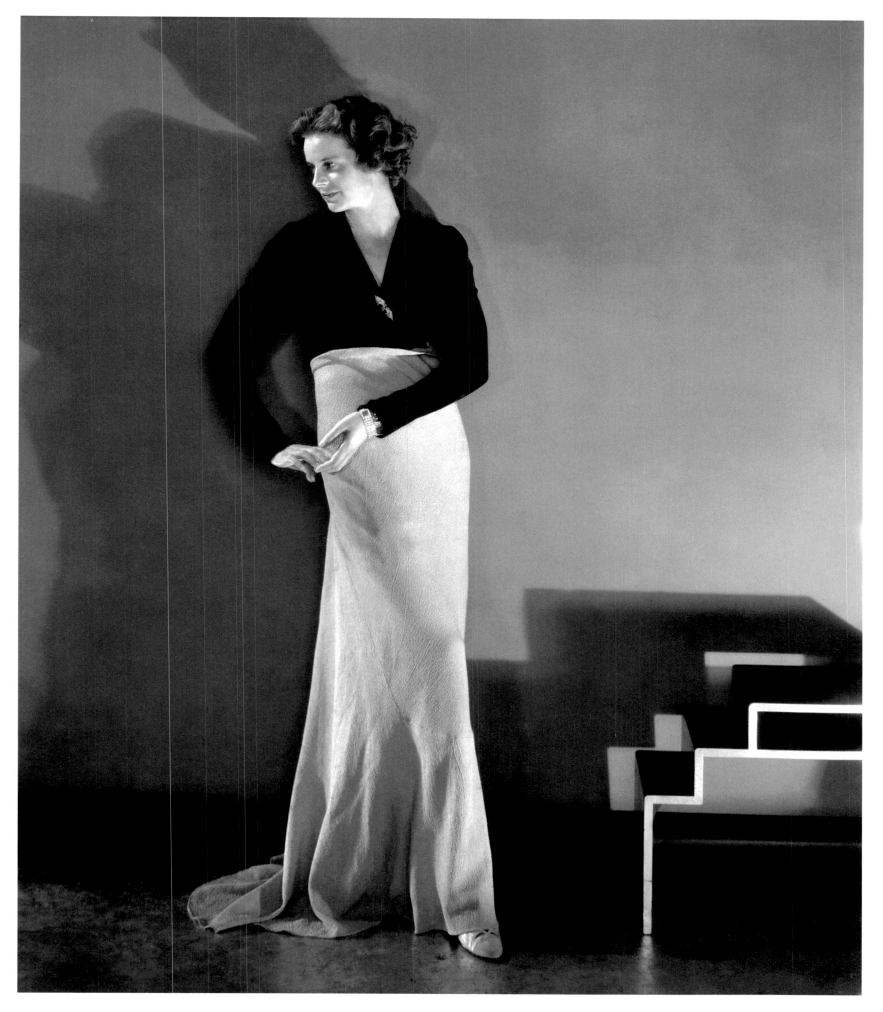

132. MODEL WEARING FASHION BY SCHIAPARELLI, 1931

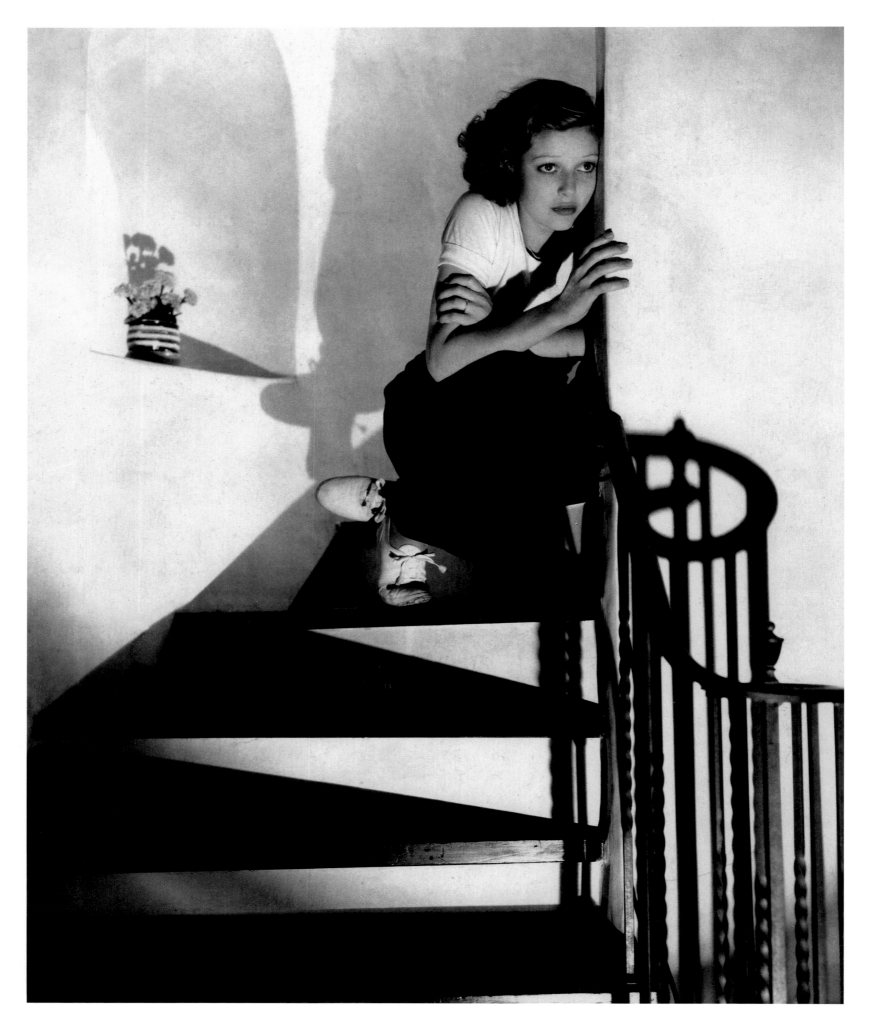

133. ACTRESS LORETTA YOUNG, 1930

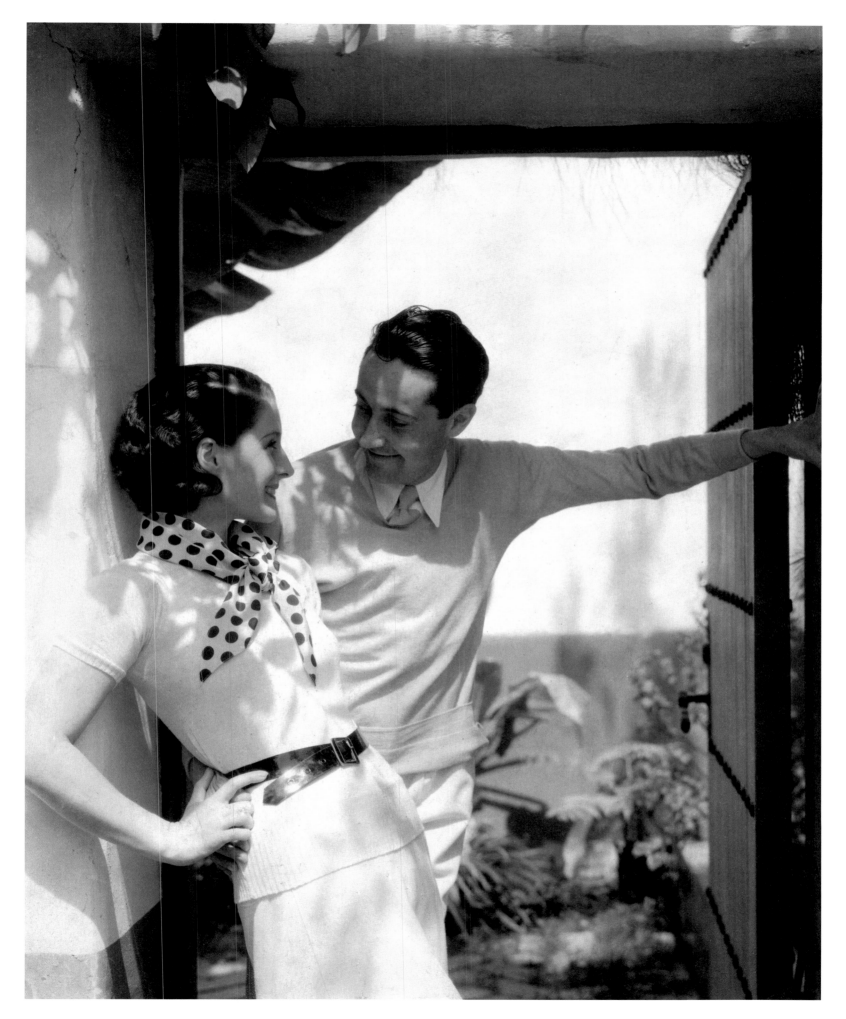

134. ACTRESS NORMA SHEARER WITH THE PRODUCER IRVING THALBERG, 1931

135. ACTOR DOUGLAS FAIRBANKS JR. AND HIS WIFE, THE ACTRESS JOAN CRAWFORD, 1931

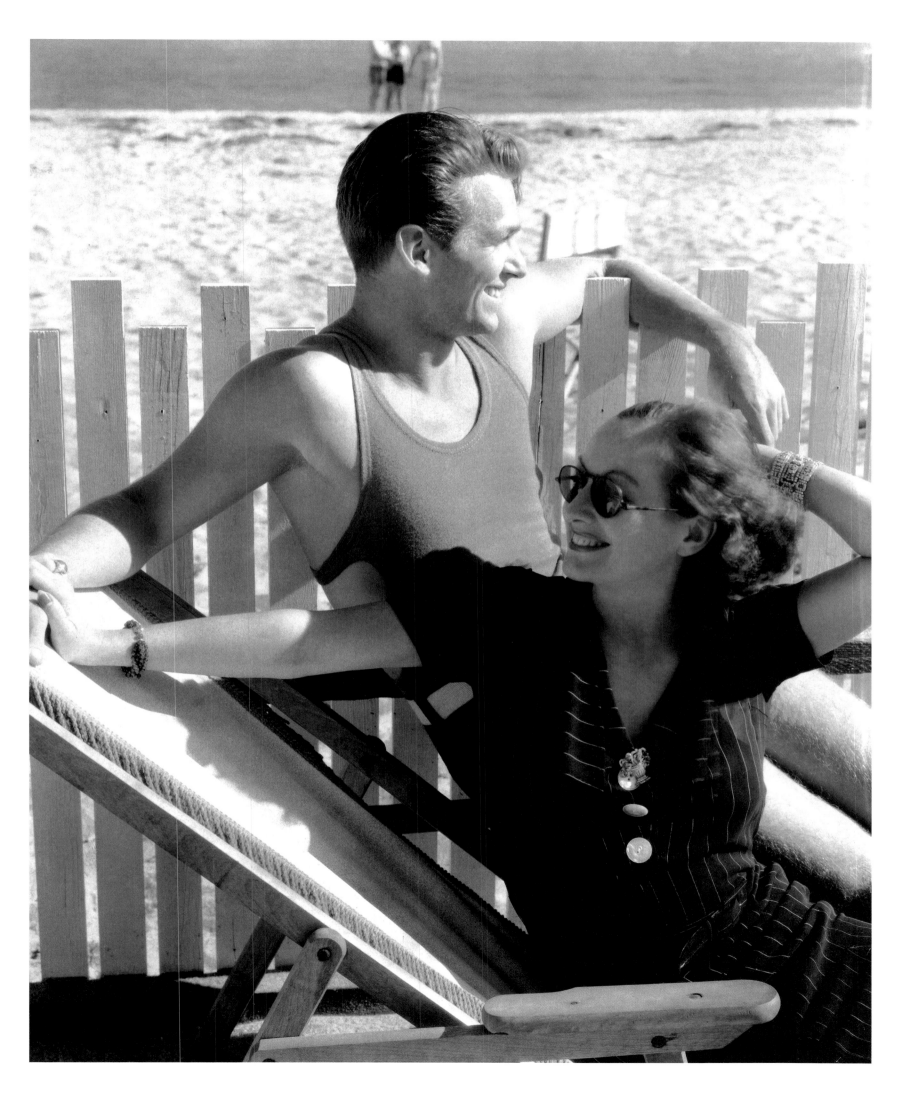

136. FILMMAKER CECIL B. DEMILLE, C. 1930

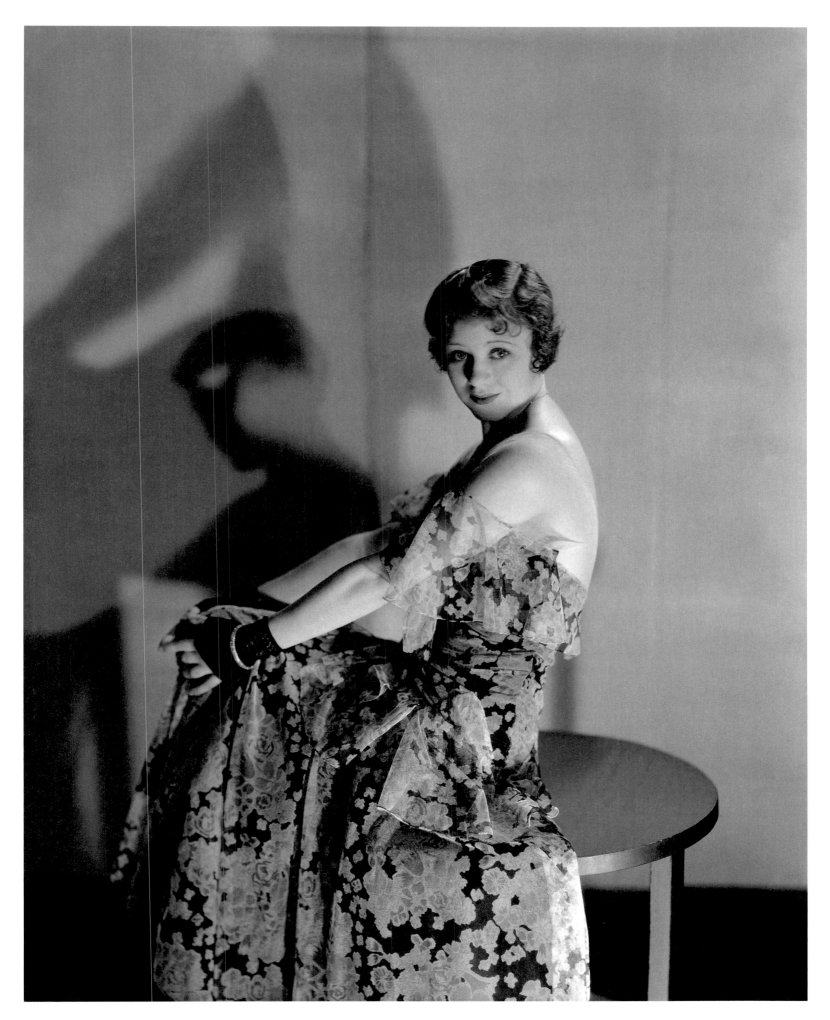

137. DANCER GINGER ROGERS, 1930

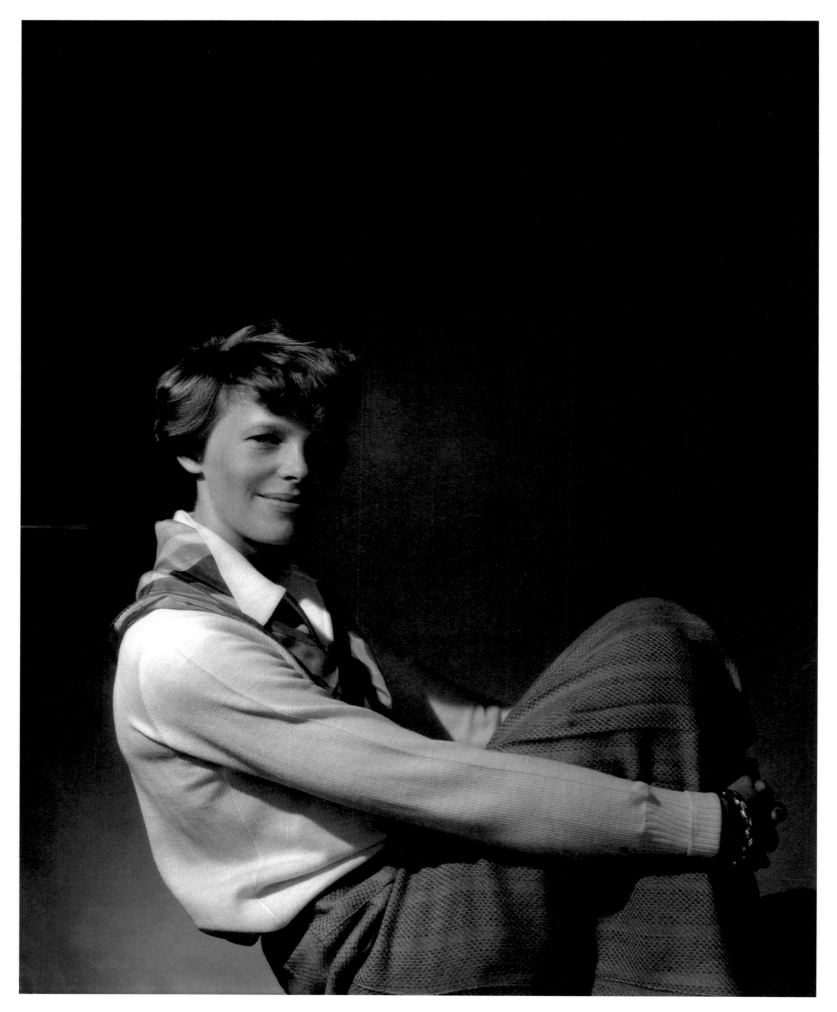

138. AVIATOR AMELIA EARHART, 1931

139. ARCHITECT FRANK LLOYD WRIGHT, C. 1932

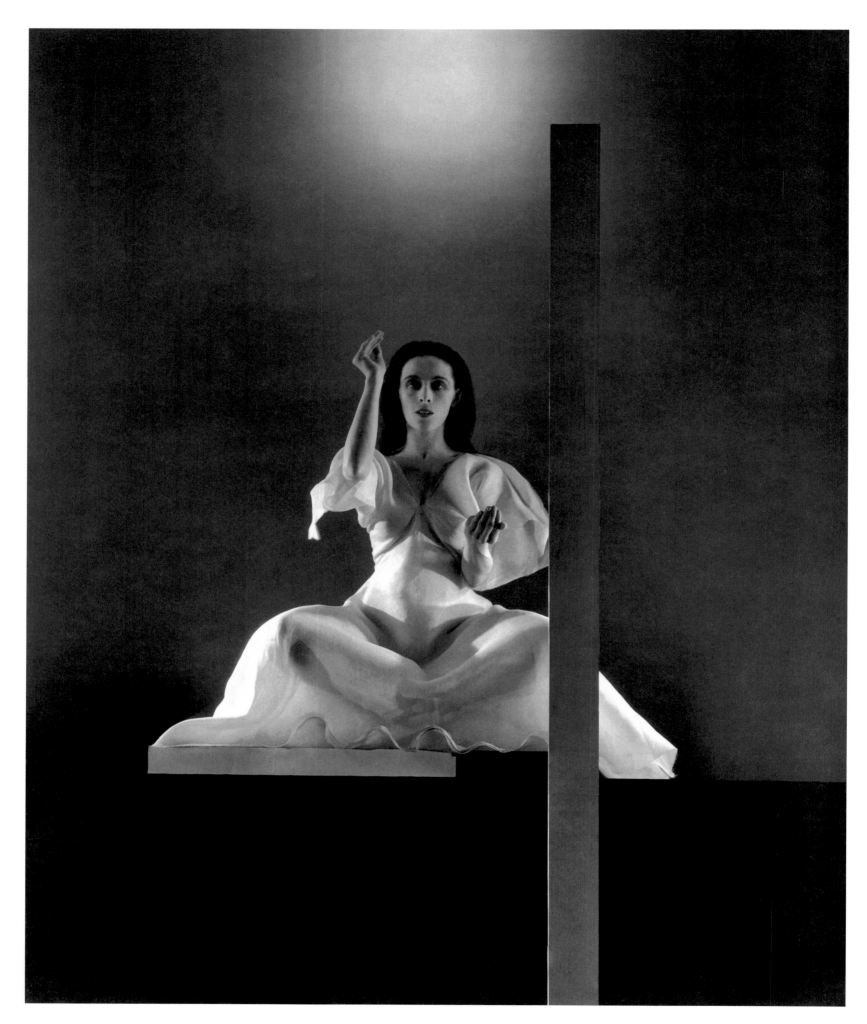

140. DANCER MARTHA GRAHAM IN *PRIMITIVE MYSTERIES*, 1931

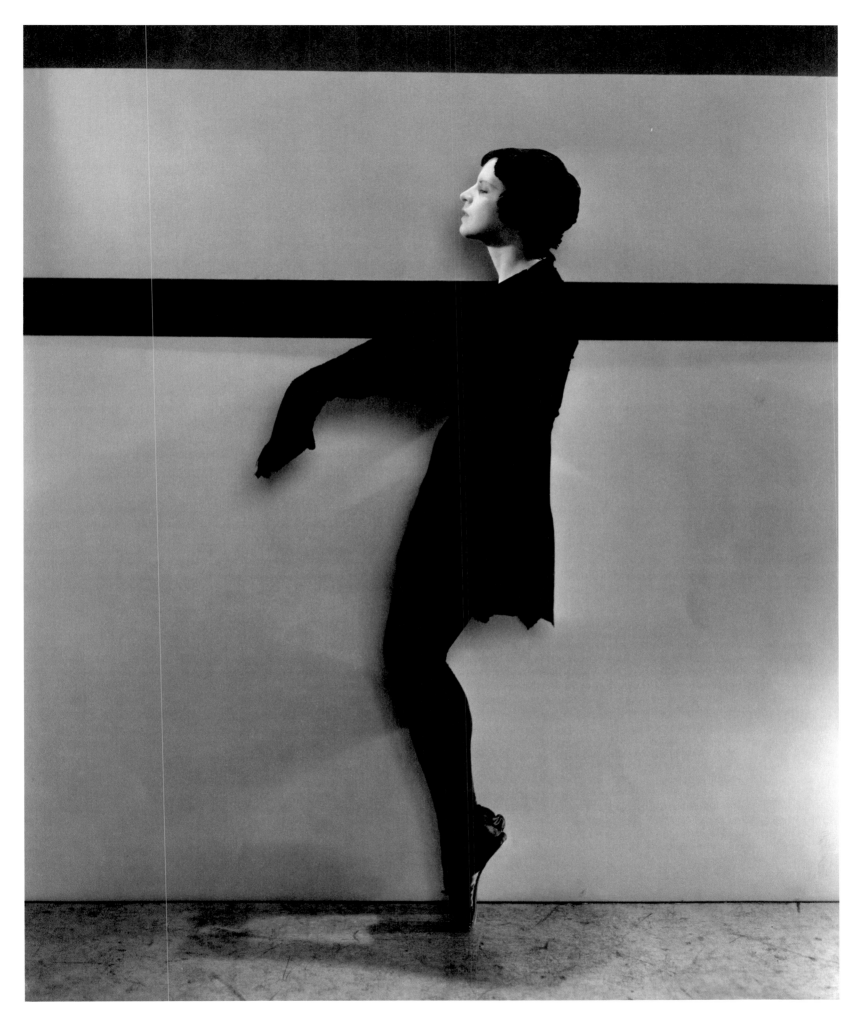

141. DANCER HARRIET HOCTOR, 1932

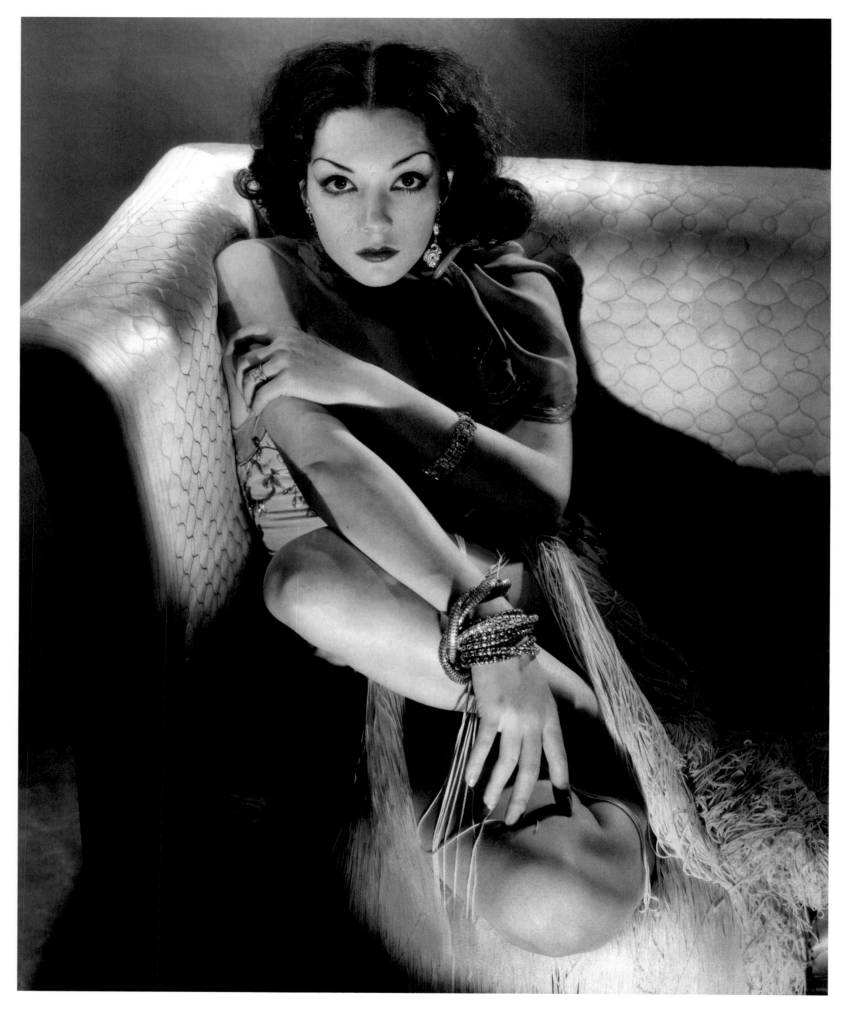

142. ACTRESS LUPE VÉLEZ, 1932

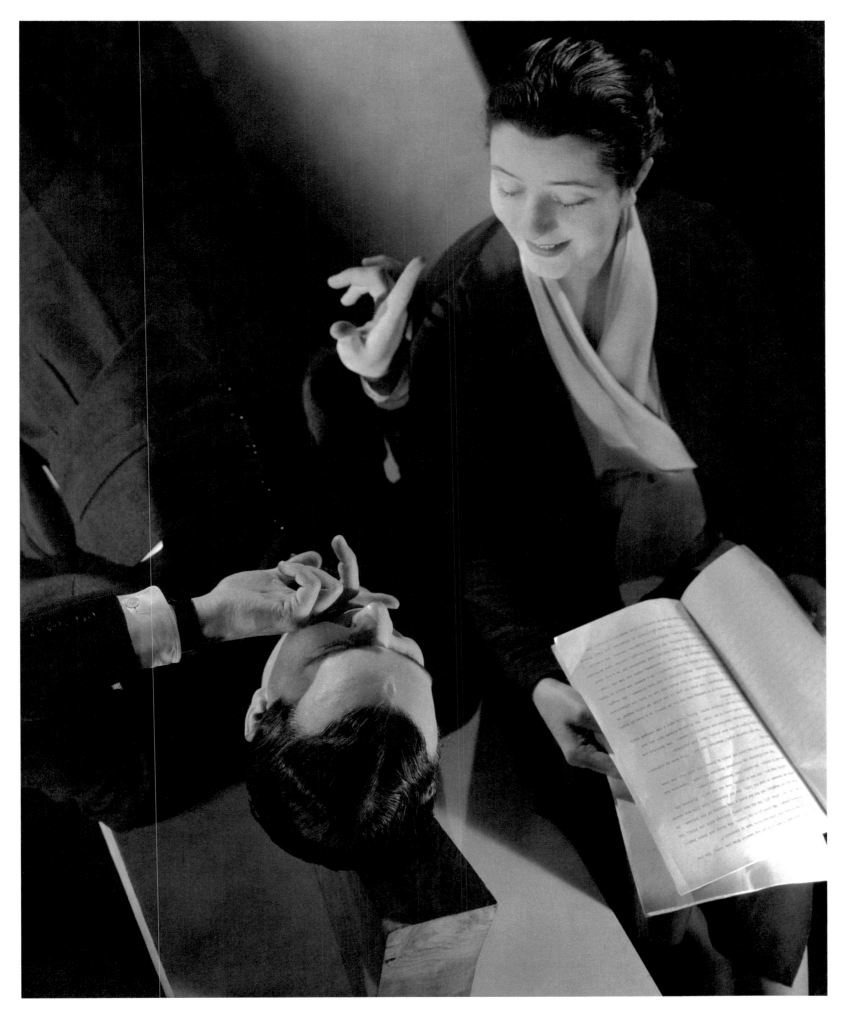

143. ACTORS LYNN FONTANNE AND ALFRED LUNT, 1931

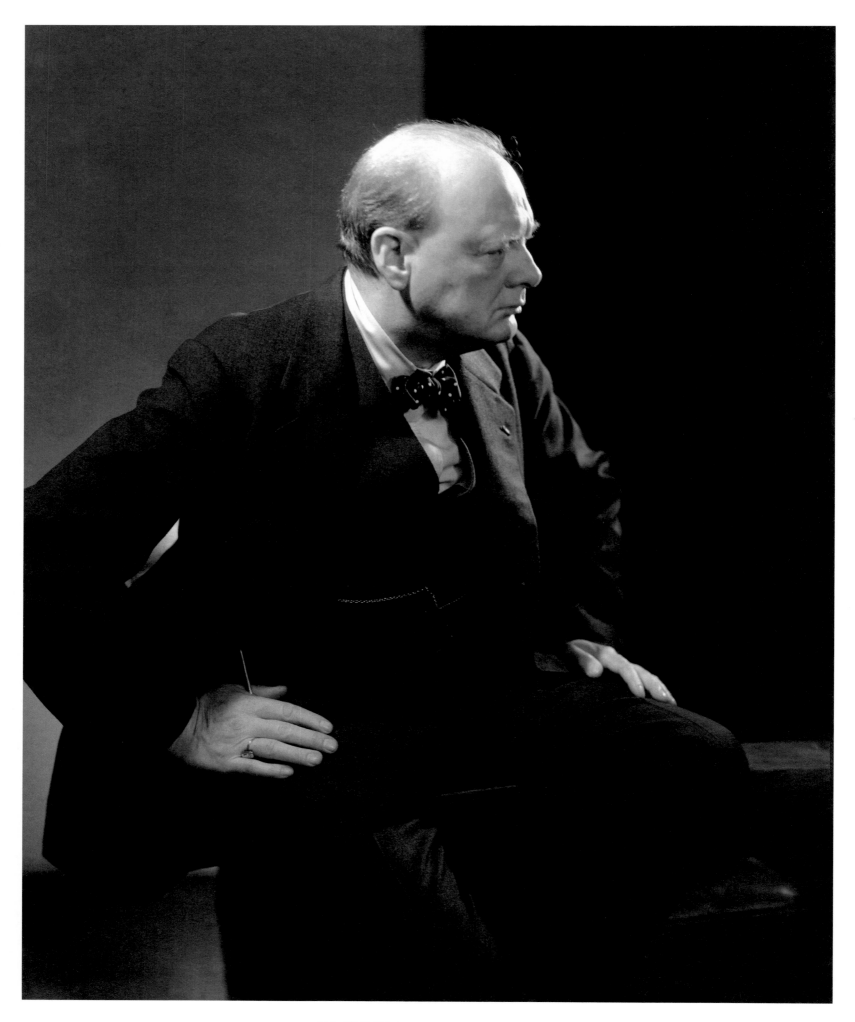

144. WINSTON CHURCHILL, 1932

145. POET WILLIAM BUTLER YEATS, 1932

146. ACTRESS MARLENE DIETRICH, 1932

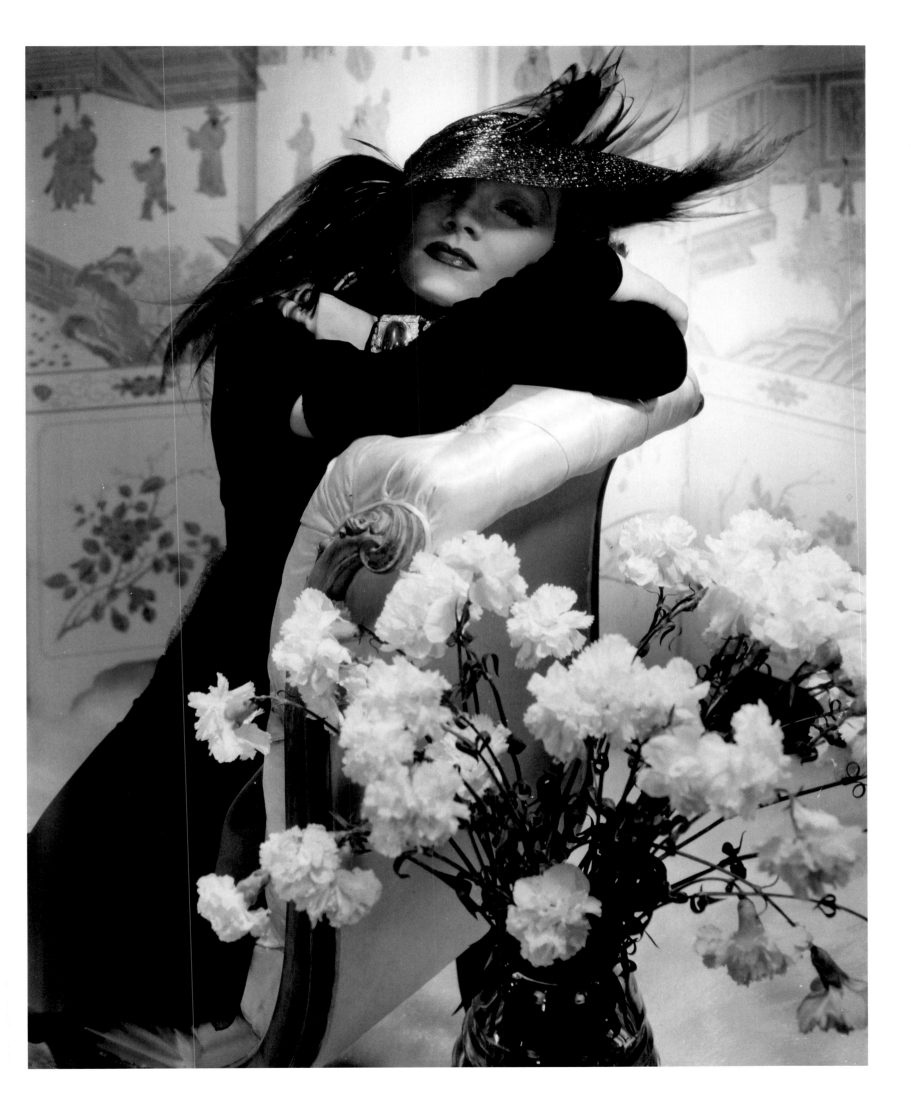

147. WRITER SINCLAIR LEWIS, 1932

148. BRONX ZOO CURATOR RAYMOND DITMARS, 1932

149. ACTORS LYNN FONTANNE AND ALFRED LUNT IN THE PLAY *ELIZABETH, THE QUEEN*, 1931

182

150. FILMMAKER JOSEF VON STERNBERG, 1931

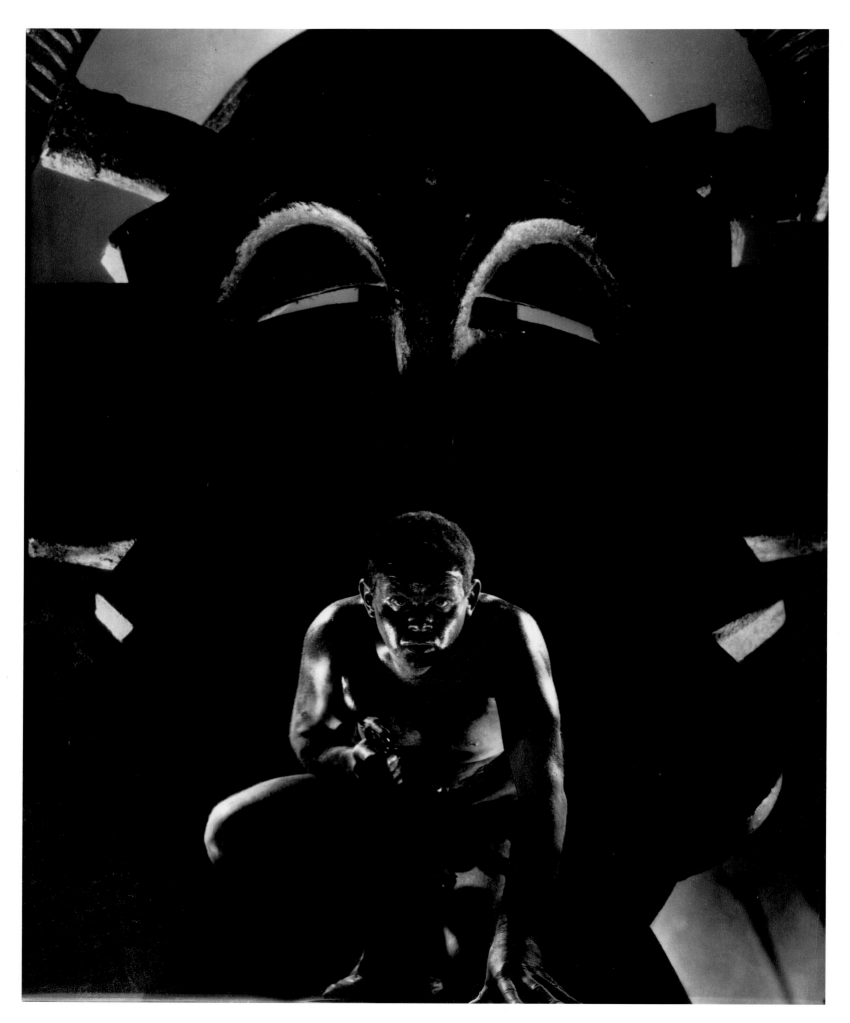

151. OPERA PERFORMER LAWRENCE TIBBETT, 1932

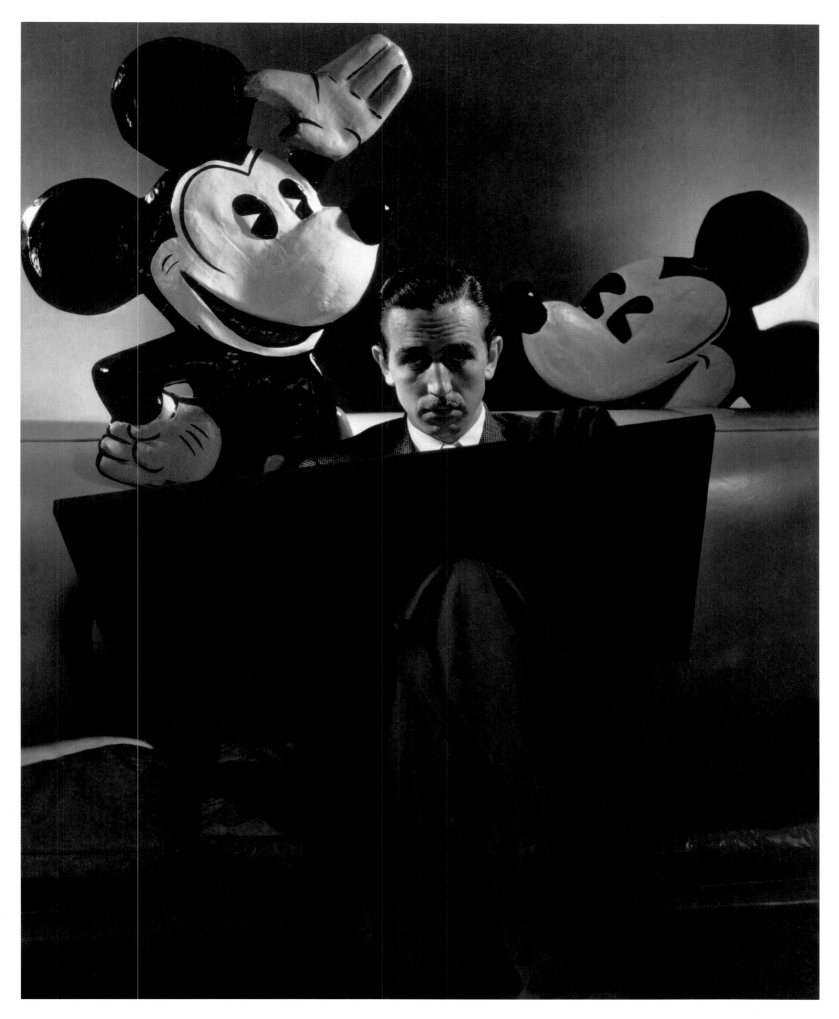

152. WALT DISNEY, 1933

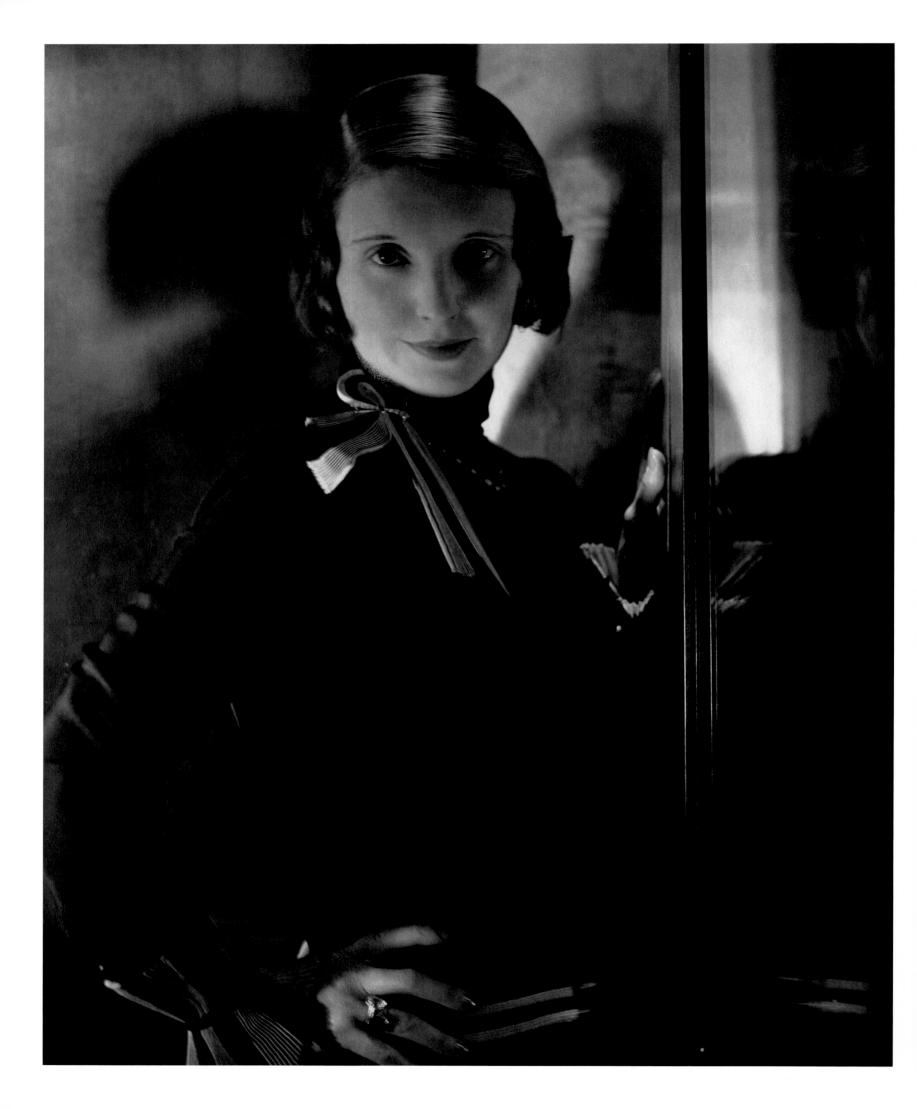

Mrs. Chase:

In connection with our idea about dignified and distinguished presentation of the "beauty" pictures—if they can be done in duotone they will be greatly enhanced. There are some works of art in the Louvre that if presented in a peep show would be condemned as pornographic. In the Louvre they are art—make Vogue *a Louvre.* Steichen[1]

Lights Going All Over the Place

TOBIA BEZZOLA

154. Christian Schad, *Lotte; die Berlinerin,* 1927–28

No other painter of the period could balance so exquisitely the decorative style of Art Deco with its more decadent tendencies.

opposite:
153. Musical comedy actress June Walker, 1928

Forty years after the death of Edward Steichen—a thoroughly researched and widely published classic photographer, already well represented in numerous museums—a substantial body of his work is to go on display for the first time. The reason for this is not simply that the works were archived in Times Square, in the care of a media empire rather than in the collection of the photographer. (It is worth noting here that they were conserved and inventoried in a manner that would do credit to the proudest museum.) The fact is that for many years Steichen's work for *Vogue* and *Vanity Fair* was regarded as a faux pas, a faintly embarrassing aberration on the part of the artist, brought on solely by the vicissitudes of life, that is, his straitened finances. It was considered a skilled contribution to the field of commercial photography but not in itself of any artistic interest.[2]

This view has changed. Now, in the early twenty-first century, thanks to his work for Condé Nast Publications and for the advertising agency J. Walter Thompson, Steichen is seen in a rather different, positive light: as a pioneer in advertising photography[3] and fashion photography and as the de facto inventor of glamour, an aesthetic category that has very much come to the fore in art and photography in the last fifteen years, in the critical responses reflecting this development, and, not least, in the marketplace.[4] In the late twentieth century and still today, many players in the art world have sought to tap into the celebrity culture of our own time. Glossy magazines report on exhibition openings and art fair parties where supermodels, star designers, and art stars lionize one another. The fashion business is ennobled by its association with the art world, and the art world cultivates the latter's flair for spectacle, its glamour, and its star system. More dazzlingly visible than in the past, the art world gains prestige and becomes more marketable. And the backdrops to this higher level of expectation are no longer insider events attended by a few specialists and enthusiasts, but the same magazine pages and parties where for decades the worlds of fashion and film have paraded their wares and propagated their appeal.[5] But unlike the media-led star cult of the modernist past (Dalí, Picasso), in the 1990s the artists in question made their name with a form of artistic production that has itself appropriated a glamorous, spectacular mode of expression—be it ingratiating or ironic, critical or even hoping to go one better.[6] Thus a deliberately frivolous

form of postmodern art finds itself dancing on the same stage or sharing the same *papier glacé* in fashion and lifestyle magazines as the fashion world, which always did have a hankering to dignify its own status.

Steichen's importance in this context—perhaps surprising to some—has its roots in his commissioned work for the advertising industry and for *Vogue* and *Vanity Fair*. For while the process of the glamorization of art was in part set in motion by the acceptance of the fashion photographer as auteur—as an artist— by photohistorians and the art market, it also relied on the discovery of fashion as a legitimate, attractive, productive area of work by the most talented photographers of the day. Both of these factors can be traced back to Steichen's own pioneering work. Following Nancy Hall-Duncan's groundbreaking work in her book *The History of Fashion Photography*, the next author to identify Steichen as the real inventor of glamour photography was Joel Smith, who has suggested that already in the period between 1906 and 1915, Steichen intuitively recognized the rise of the media-made film star as the new idol for the masses.[7] Furthermore, with his keen early interest in making portrait photographs of the rich, the famous, and the powerful, he also laid the ground for what was later to become known as celebrity photography. Accordingly, when Steichen signed a contract with Condé Nast in 1923, this was not an aimless move by a hapless artist but the logical culmination of a photographic strategy that he had been pursuing since the early years of the twentieth century.

However, Steichen's entry into the business of fashion and society photographer has to be seen as a dual operation: it was to have both social and aesthetic implications. As we know, Steichen's artist-photographer colleagues, "the art for art's sake boys in the trade,"[8] volubly reproached this exceptional talent for "selling out" and poured scorn upon him as a corrupted artist who was peddling his wares to the enemy, that is to say, commerce. Steichen's response to these accusations was aggressive, to say the least, and delivered in a tone that in certain respects anticipated Andy Warhol's own belief that real art only justified its existence through commercial success. According to Steichen, "[T]here has never been a period when the best thing we had was not commercial art . . . the artist was what we might call a glorified press agent" and "Commercial pressure is an amazing productive force. Artists, with rare exceptions, are poor producers."[9]

In his comments, Steichen does not balk at explicitly deriding self-consciously artistic photography. He disparages the trend in Europe, following the demise of Pictorialism, to hail the experiments of Dada, Futurism, and Surrealism, the montages and collages of the Constructivists, and the output of the Bauhaus artists as the only valid uses of the techniques of photography.[10] For all their brilliance, in Steichen's view, these were no more than evidence of a form of photography that

155. *L'Oiseau dans l'espace*, by Constantin Brancusi and a piano designed by Edward Steichen, 1928

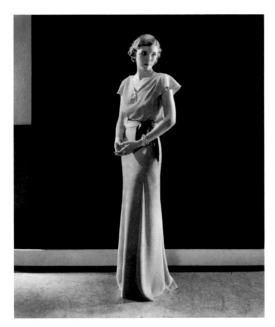

156. Model in a crêpe dinner gown, 1932

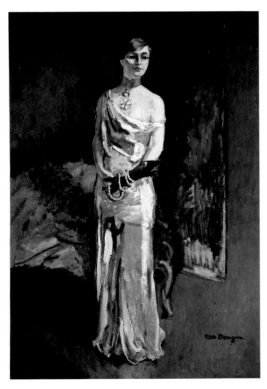

157. Kees van Dongen, *Anna de Noailles*, 1931

This once avant-garde member of the Fauves would in the 1920s become one of Paris's most sought-after society-portrait painters, a radical career shift that Steichen, too, would undertake.

was still slavishly imitating painting and other art forms. As far as he was concerned, his own commercial work had already overtaken the most advanced European concept of modern photography, as championed at the Bauhaus with its notion of purely functional workshop-photography—albeit constantly sabotaged by Bauhaus artists themselves in the cause of avant-garde experimentation. Steichen regarded his work as truly "applied" art photography. (In this view, he failed to take account of the very real excursions into functional and advertising photography by László Moholy-Nagy, Herbert Bayer, and other Bauhaus photographers, although they were not to leave a lasting impression on the commercial photography of the Weimar period.)

ART DECO PHOTOGRAPHY

In his innovative concept of the photographer, which put the latter on a par with the architect and the designer, Steichen logically did not pursue his artistic ambitions (both daring and nonchalant) through a contrived will to art in the modern European sense. For the art in Steichen's commercial photography does not reside where one might initially look for it, namely, in the sporadic flashes of appropriation of the works and styles of contemporary art.[11] Cubo-Futurist fabric patterns, African masks, Expressionist decors, and avant-garde sculptures are never more than props. Even Constantin Brancusi's *L'Oiseau dans l'espace* is simply a chic extra (Fig. 155). And the sculpture responds to the photographer's mise-en-scène like any graceful model might do. This marks the difference between Steichen and Man Ray and (somewhat later) Erwin Blumenfeld, the other two "art-photographers" who devoted their talents to fashion and glamour. For *Vogue* and *Vanity Fair*, Steichen developed a pragmatically professional visual language that tries neither to be "arty" nor to impress with its avant-garde style.

Steichen was equally cool, sparing, and detached in his use of the most prevalent templates of the glamorizing photography of the time: the Hollywood glamour shot and the film stills of the 1920s and 1930s as practiced by James Abbe, Ruth Harriet Louise, and Eugene Robert Ritchie and the eroticized portraits of Broadway stars as cultivated and perfected by Alfred Cheney Johnston (working alongside Steichen in New York).[12] Steichen learned from Hollywood, but circumvented its melodramatic pathos and countered the dubious, provocative veneer of glamour images with a worldly, elegantly muted eroticism that never needed to be "risqué," as people used to say. On the contrary, his work for Condé Nast reflects his striving for a modern, *urphotographic* ideal of beauty. Compared to his predecessors, Steichen makes a stylistic leap that is equal to the transition from silent movies to talking pictures. His art comes into its own through its formulation of modern beauty; his perspective recalls that of the

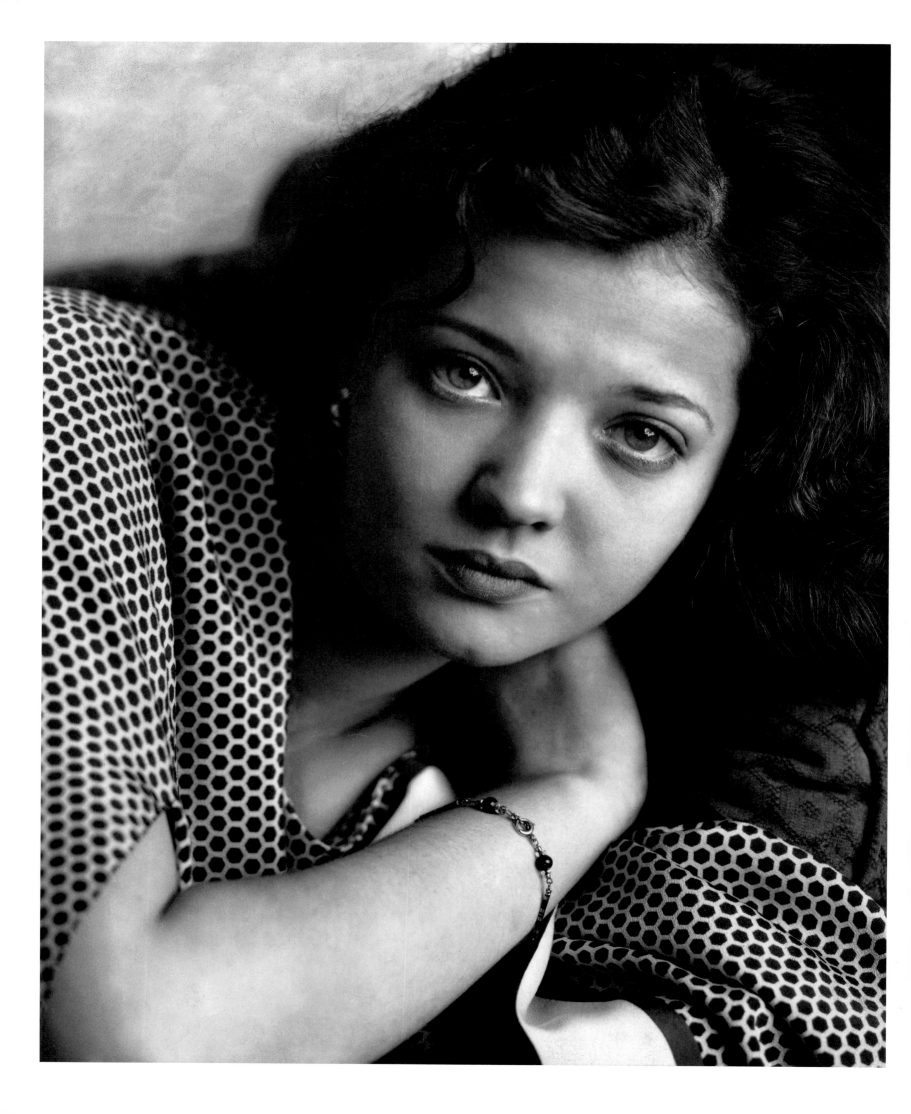

Goncourt brothers, who in their writings looked back on the art and society of eighteenth-century France. Like the Goncourts, Steichen sought the truth of his own time in the realms of fashion, by taking its formal caprices seriously. He thus transformed and restyled aging silent movie vamps and young flappers as the icons of Art Deco. For—in for a penny, you might say—having abandoned Pictorialism and its dependency on Art Nouveau and Symbolism, he spent the next decade and a half as by far the finest Art Deco photographer.

And his forceful, experimental genius—never harking back to past photographic styles—was also reflected in his insistence that all his work for Condé Nast, not only the portraits but also the fashion photography, should be published under his name, and *only* under his name, as authored photography. It is no secret that the publishers had expected that Steichen would want to have his "lowlier" commissioned work published anonymously or under a pseudonym, and they would have had no objection to doing this. Nothing could have been further from Steichen's mind: "I also said if I made a photograph I would stand by it with my name; otherwise I wouldn't make it."[13] This brave, emphatic declaration of allegiance to fashion photography as authored photography carved out a route that generations of photographers would later choose. Steichen did not hesitate to define the fashion photographer as an artist who was best able to realize his talents in commercial photography; as such he was the "father" of a whole swath of photographers, from George Hoyningen-Huene, Cecil Beaton, and Horst P. Horst to Richard Avedon, Helmut Newton, and Guy Bourdin.

"TAKE GOOD PHOTOGRAPHS AND THE ART WILL TAKE CARE OF ITSELF"

In terms of technique, commercial photography was a new departure for Steichen. After many years of experimenting with post-Pictorialist, objectively cool modes of representation, he was now in a position to apply them. At the core of the new method was the fact that a photograph that will be reproduced as a halftone in a magazine requires a very different lighting setup than one destined to be exhibited as a framed original print on a wall. Now, for the first time, the use of artificial light became central to Steichen's work: "For one whole year, I used daylight plus one light. Then, gradually, I added lights, one at a time, until, in the later years of my work for *Vogue* and *Vanity Fair*, there were lights going all over the place."[14] Another crucial factor was the photographer's capacity for teamwork. Slow, lonely experimentation in the darkroom was now replaced by a working process that, like film production, involves a large group of people, seeing to everything from set design and lighting, makeup and styling to copying prints, lithography, retouching, and the integration of the pictures into the layout of the magazine.

159. Christian Schad, *Mafalda*, 1927

The new style of European portraiture was much influenced by the "American style"—youthful, natural, and sporty—as promoted by such magazines as *Vanity Fair*.

opposite:
158. Actress Sylvia Sidney, 1929

160. Jean-Auguste-Dominique Ingres, *Portrait de Louis-François Bertin*, 1832

Ingres developed a style of portraiture that ennobled the bourgeoisie in a manner hitherto associated with the elite. His influence can be felt in portrait painting and photography to this day, and it clearly had an effect on Steichen.

161. Winston Churchill, 1932

opposite:
162. Mrs. Le Roy King in costume as the Spanish *infanta* for the New York Junior League Feria benefit at the Hotel Astor, 1925

As early as 1914, Steichen had already exhibited photographs by his immediate predecessor at Condé Nast, Baron Adolphe de Meyer, at Alfred Stieglitz's gallery 291. De Meyer was the first artistically ambitious fashion photographer in New York. He was appointed by Condé Nast as chief photographer at *Vogue* in 1914, and his style was influenced mainly by Pictorialism. Atmospheric lighting created the mood, if necessary at the expense of precise detail. De Meyer tended toward dramatic lighting, extravagant props, and poses that were almost mannered in their effect. But—of crucial importance to Steichen—de Meyer also has to be credited with being the first to have developed a form of fashion photography that itself engaged in the art of seduction rather than merely serving to document the art of the couturier. The objective qualities of the clothing were of scant interest to him. De Meyer discovered how much more important the emotional charge of the image is when it comes to arousing the viewer's desire to identify with the models and to buy the clothes they are wearing.

Steichen immediately replaced his predecessor's theatrical settings with a more open, clearer concept. Because stars such as Greta Garbo, Gloria Swanson, and Marlene Dietrich were already the focus of general media interest and by definition embodied concepts of beauty, the high life, and luxury, Steichen was able to make the best possible use of his experience as a portrait photographer. He simply sidestepped the underlying conceptual difference between a portrait and a fashion photograph. He turned fashion photography into portrait photography. He presented "portraits" of anonymous models, and his mannequins—even if they were not stars of stage and screen—became recognizable personalities. In his collaboration with Marion Morehouse, he in effect laid the ground for the idea of an identifiable supermodel.

During its infancy in Paris, fashion photography had turned the spotlight on the clothes, and the women wearing them were used as little more than animated shopwindow dummies. Steichen photographed models in specially created settings, as though the intention were to present a portrait of a woman's character, personality, and social status, and as though the gowns were purely incidental. His fashion photographs can look like snapshots, or they can be styled as conversation pieces; Steichen also liked to integrate his models into decorative, curvilinear compositions in which the lines and silhouettes of the furniture and interiors frame and put the focus on the figure. Whether his images are carefully composed, decoratively alienating, spontaneous as a snapshot, or dispassionately realistic, the genius of Steichen's work derives not from his formulation and application of a single stylistic idiom but from his transformation of fashion photography, in its various guises, into portraiture.

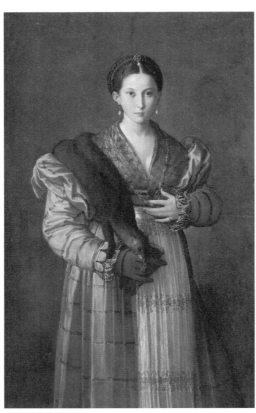

163. Parmigianino, *Antea*, c. 1535–38

In the sixteenth century, courtesans and mistresses were added to the ranks of those deemed worthy of having their portrait painted, a privilege hitherto restricted to royalty and the nobility. In the pages of *Vanity Fair*, portraits of Hollywood stars gradually encroached on the terrain previously reserved for dignified society matrons and debutantes.

opposite:
164. Model Marion Morehouse wearing fashion by Paquin and a necklace by Black, Starr and Frost, in Condé Nast's apartment, 1927.

"MAKE *VOGUE* A LOUVRE"

For all his protestations to the contrary and his resolve that photography should become autonomous and no longer seek to emulate painting, Steichen was, in the methods of his commercial photography (if not in its style), always a Pictorialist, even if a rather eclectic one. In other words, his ambition to turn a fashion photograph into a portrait and to turn portraits into pictures, into tableaux, can still be traced back to the masterpieces hanging in picture galleries. The very concept of "glamour" is older than the word itself, the etymology of which has its roots in *grammar*.[15] From its origins, the glamorous has always been linked with the "noble"—the nexus of such descriptions as "splendid," "shining," and "famous"—which is already present in the Greek adjective *aglaon*, and soon enough these visual attributes of certain human beings came to be regarded as the attributes of certain pictures. Since the Renaissance, at the latest, artists have produced a steady stream not only of paintings that seek to capture the splendor of a person's fame but also of paintings that seek to lend the sitter splendor and an aura that they may well not have had in reality. For Steichen, painting—from the Renaissance and Baroque eras through the portrait-euphoria of the Second Empire and right up until the salon painting of Art Deco—provided him with an effective means to fetishize his subjects and put at his disposal an endless repertoire of ways to glamorize individuals.

For when Steichen refers in the memo cited above (sent to Mrs. Edna Chase, editor in chief at *Vogue*) to the "dignified and distinguished presentation" of "beauty pictures," in terms of the elevation of what are in reality pornographic motifs in certain paintings in the Louvre, he was simply suggesting that the vulgar or banal genre of fashion photography and "glamour shots" should be presented in a manner that raises them to the level of art. And it is hardly surprising that he looks to the traditions of painting in this context. For Steichen's photographs for Condé Nast, however wide the variety of styles and methods, all reflect his determination to use the formal potential of great painting to breathe new life into the "lesser" genres of photographic portraiture and fashion photography—by means of a greater dynamic intensity, a more reflective mode of composition, and a use of light that is designed to be more than merely descriptive. By consciously or unconsciously drawing on a vast repertoire of tried and tested portrait types—in his own inner Louvre, you might say—the trained painter Steichen removed the existing constraints on the genre of "beauty pictures." This led him to bold *mise en page*—the multiply interlocking interplay of viewpoints and angles, a daring wealth of compositional structures, a huge fund of poses, gestures, and sets, all in conjunction with the very deliberate exploitation of the functions of light. The use of artificial lighting freed Steichen from any obligation

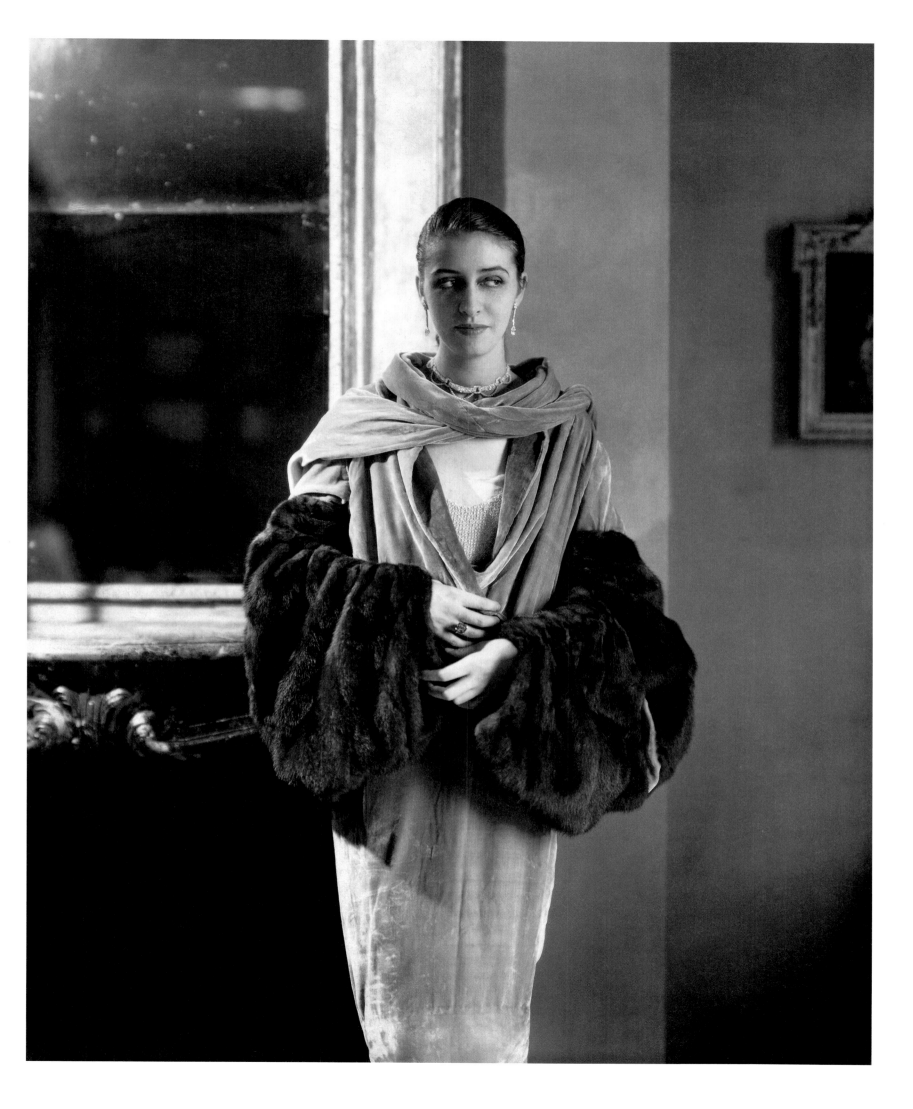

to descriptive precision; the autonomous pictorial value of a shot was no longer dominated by the meticulous portrayal of a gown or of a person, and even the vainglory of famous models had to bow to the laws of the photographic tableau. In the process, Steichen explored more or less all the variants of traditional portraiture: heads and busts, sitters facing forward or in three-quarter profile, half figures, figures extending to the hips or the knees, full-length standing figures (the *portrait en pied officiel*), and a whole range of seated figures. As a rule, commissions were for portraits of individuals, but there were occasional double portraits. For the fashion industry he made portraits of whole groups that often seem to recall genre painting; by the same token, he also took up forms developed by nineteenth-century French masters such as Edgar Degas and Édouard Manet in their syntheses of portrait and still life or portrait and interior.

The presentation of fashion in art museums, implied by Steichen in his "Louvre memo," seems perfectly natural nowadays. In recent decades, world-class art museums in Paris, London, and New York have welcomed the work of fashion designers into their exhibition rooms. However, the ensuing tension—the conflict between the museum's expectations of permanence and uniqueness on the one hand and the transience and whimsy of fashion on the other—generally seems to benefit the art institution rather than the exhibitions. For fashion, as such, lives only in the past, in that moment when it was in vogue. This basic volatility of fashionable forms explains the mildly contrived, labored air of efforts to stabilize their existence in a museum context, which often serves only to highlight their banality and, in retrospect, the slightly ridiculous nature of any passing fashion rather than its enduring significance.

However, looking back at the twentieth century, it turns out that the marriage of the fashionable physiognomy of the moment and the photographic "staging" of the same has had the opposite effect on photography. As it became fashionable in Steichen's hands, as it apparently succumbed to fashion, photography in fact overcame the limitations of its own fashionability. Following Steichen's photographic imaging of the day-to-day production of the couturiers' studios, every fashionable trend and epoch in the twentieth century came to depend on being suitably photographed so that it could be accessed through the mass media. Furthermore, as a form of higher-level documentation, at its best fashion photography managed also to achieve what no creation by any couturier could ever do, for gowns in display cases can never be more than sad, shabby memorabilia. Even the noblest and most pompous museum cannot rid them of the odor of the flea market, the melancholy of things past their prime.

Pictures are what thrive in museums, offering retrospective insight and breathing new life into the past. And the pictures by the best fashion photogra-

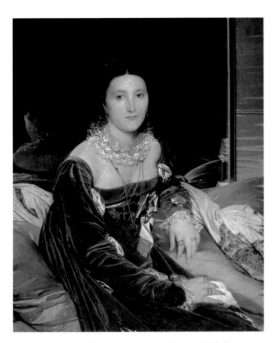

165. Jean-Auguste-Dominique Ingres, *Portrait de Madame Senonnes*, 1814

One of the most successful and famous society portrait painters in nineteenth-century Europe, Ingres had a particular flair for the sumptuous depiction of fabric, a gift Steichen would share.

phers of the twentieth century, including those working for *Vogue*, would indeed not be out of place in the Louvre. An old piece of fabric can never fully capture the spirit of the day when it was made into a garment. Contrary to the words of Charles Frederick Worth, the founder of haute couture, *une toilette* ne *vaut* pas *un tableau* (an outfit does *not* have the same value as a painting). It was only when Steichen and the leading fashion photographers of the twentieth century who followed in his footsteps took the ephemeral creations of their own time seriously and captured their spirit in photographic tableaux that the now immortalized creations of the day could give us a much deeper insight into the longings, needs, hopes, and fears of a bygone age.

Translated from the German by Fiona Elliott

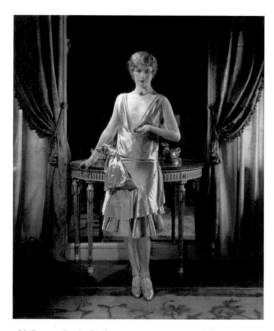

166. Dancer Portia Grafton wearing a two-tiered flounce-skirted satin gown by Patou, 1927

1. Letter from Edward Steichen to Edna Chase, c. 1926, Condé Nast Archive, Condé Nast Publications, Inc., New York.

2. Penelope Niven's 750-page biography includes a detailed account of the circumstances surrounding Steichen's engagement by Condé Nast but devotes only a few short paragraphs to the work he produced for them over a period of fifteen years. Penelope Niven, *Steichen: A Biography* (New York: Clarkson Potter Publishers, 1997), 498 ff.

3. See Patricia Johnston, *Real Fantasies: Edward Steichen's Advertising Photography* (Berkeley and Los Angeles: University of California Press, 1997).

4. For more on the theme of "glamour," see, for instance, *Glamour: Fashion, Industrial Design, Architecture* (exhibition catalogue) (San Francisco: San Francisco Museum of Modern Art; New Haven and London: Yale University Press, 2004); *The Future Has a Silver Lining: Genealogies of Glamour* (exhibition catalogue) (Zürich: Migros Museum für Gegenwartskunst, 2004); and Christoph Doswald, ed., *Double-Face: The Story about Fashion and Art from Mohammed to Warhol* (Zürich: JRP Ringier, 2006).

5. See Isabelle Graw, "Kunst, Markt, Mode. Prinzip Celebrity—Porträt des Künstlers in der visuellen Industrie," *Lettre International*, no. 74 (Fall 2006): 44 ff.

6. For instance, John Armleder, Jeff Koons, Sylvie Fleury, Cindy Sherman, Daniele Buetti, Mariko Mori, Ugo Rondinone, and many more.

7. Nancy Hall-Duncan, *The History of Fashion Photography* (exhibition catalogue, International Museum of Photography at George Eastman House) (New York: Alpine Book Company, 1979); Joel Smith, *Edward Steichen: The Early Years* (exhibition catalogue) (Princeton, NJ: Princeton University Press in association with the Metropolitan Museum of Art, New York, 1999).

8. Niven, *Steichen: A Biography*, 567.

9. Carl Sandburg, *Steichen: The Photographer* (New York: Harcourt, Brace, 1929), 51 ff.

10. Edward Steichen, "Commercial Photography," in Ronald J. Gedrim, ed., *Edward Steichen: Selected Texts and Bibliography* (Oxford: Clio Press, 1996), 81.

11. See, for example, Figs. 42, 43, 79, 150, 151, 198, and 217.

12. On Hollywood photography, see Michael Bhatty, *Geschichte und Vermarktung der Hollywood-Glamour-Photographie* (Frankfurt am Main: Peter Lang, 1997); on Johnston, see Robert Hudovernik, *Jazz Age Beauties: The Lost Collection of Ziegfeld Photographer Alfred Cheney Johnston* (New York: Universe, 2006).

13. Edward Steichen, *A Life in Photography* (Garden City, NY: Doubleday, published in collaboration with the Museum of Modern Art, New York, 1963), unpaginated.

14. Ibid.

15. This genealogy leads us back to a theological-political polemic in sixteenth-century Scotland in which *grammar* was taken to refer to the rules of Catholic scholasticism, which was denounced by Protestant propagandists as black magic and seductive trickery.

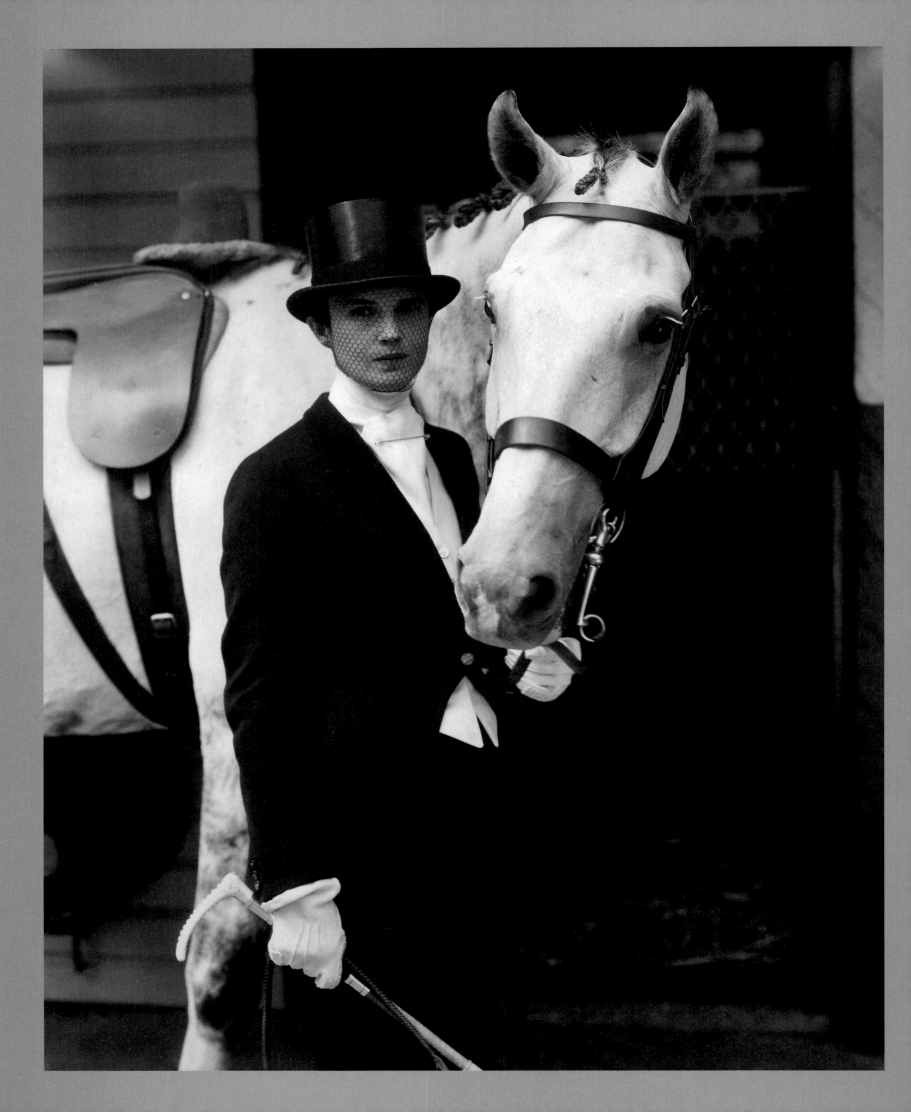

PLATES III *Make* Vogue *a Louvre*

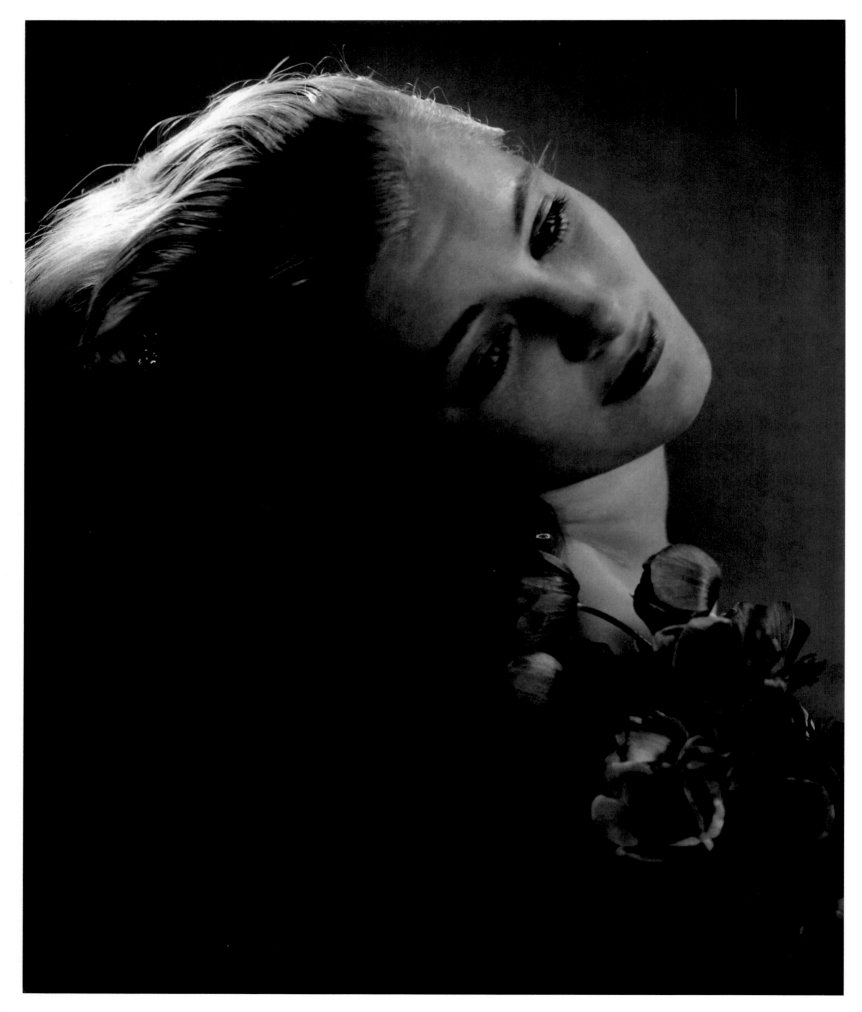

167. ACTRESS LINDA WATKINS, 1931

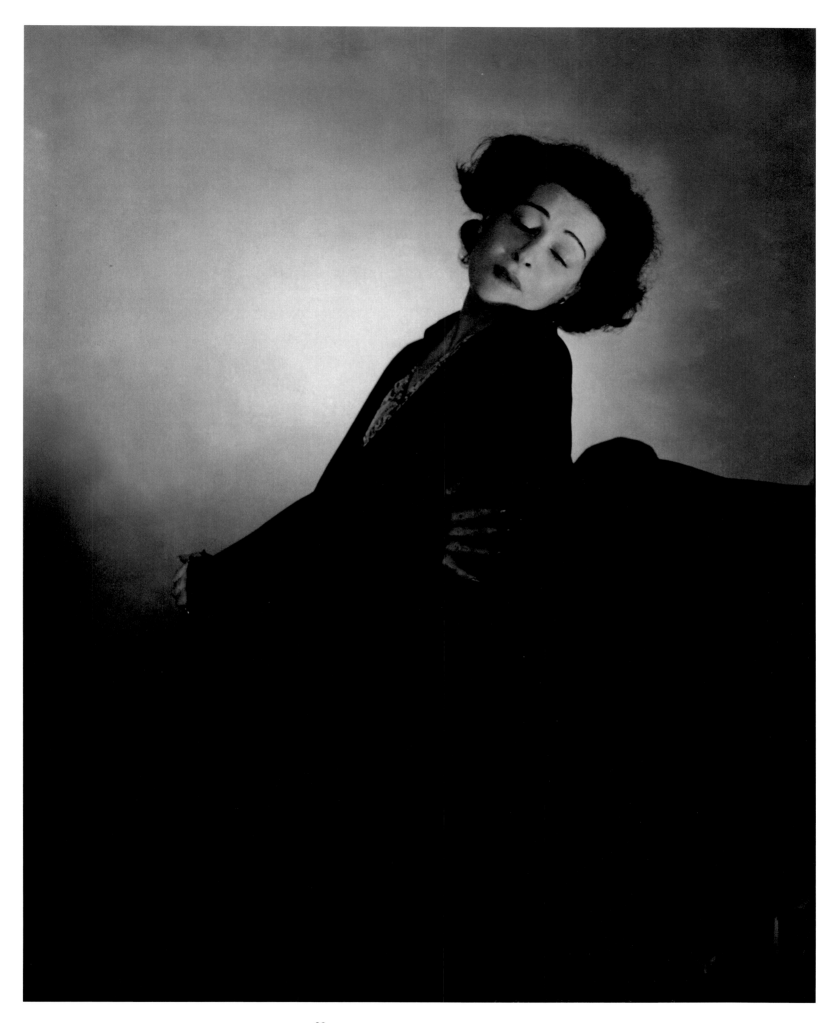

168. ACTRESS ALLA NAZIMOVA, 1931

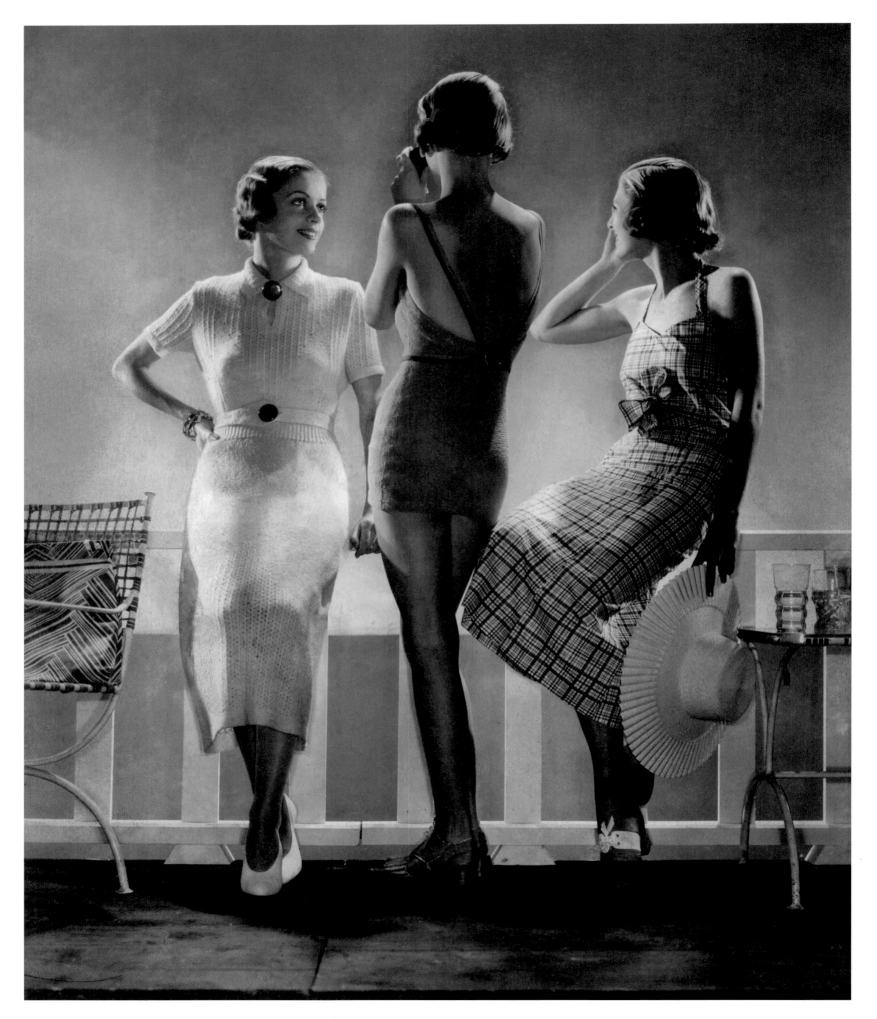

169. MODELS IN BEACHWEAR, 1932

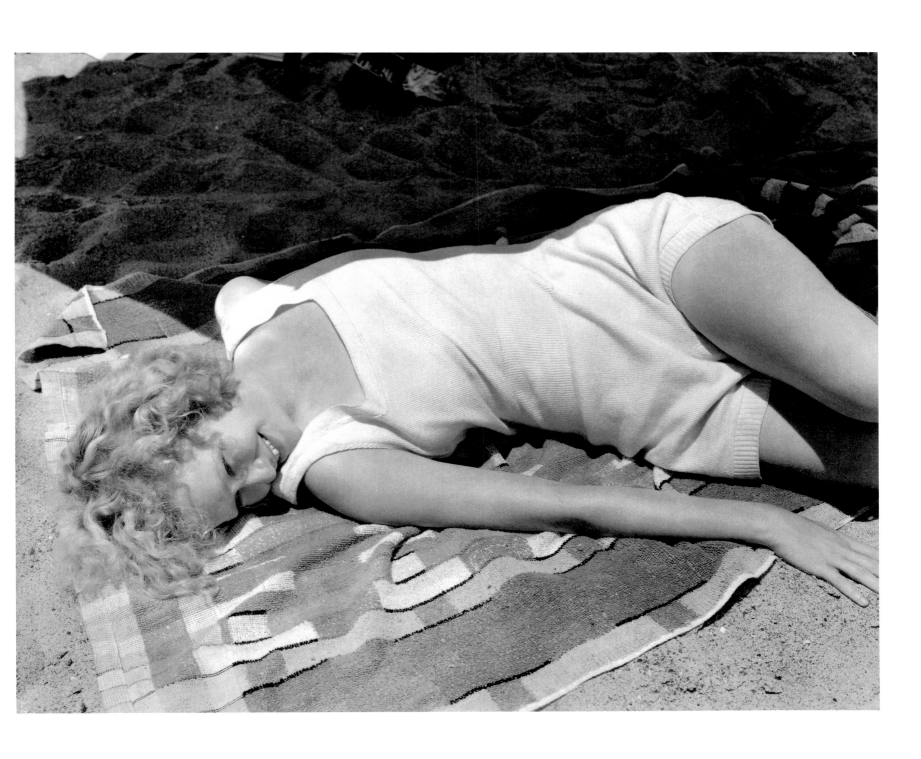

170. ACTRESS MIRIAM HOPKINS, 1933

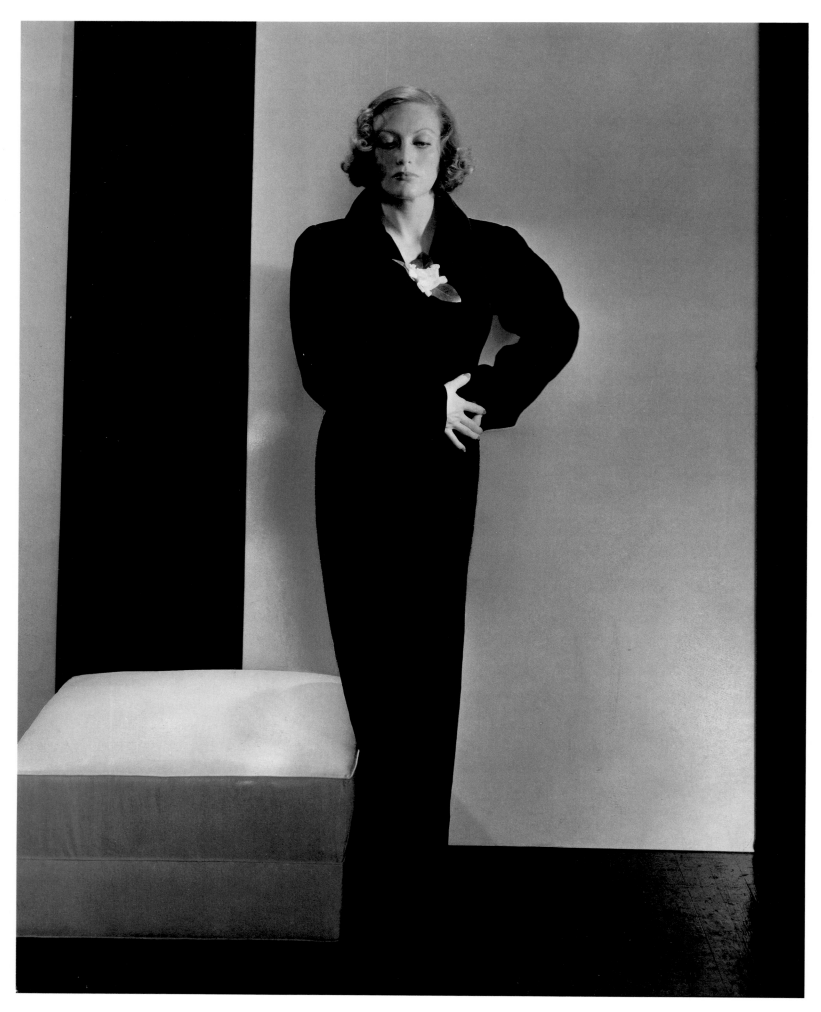

171. ACTRESS JOAN CRAWFORD IN A DRESS BY SCHIAPARELLI, 1932

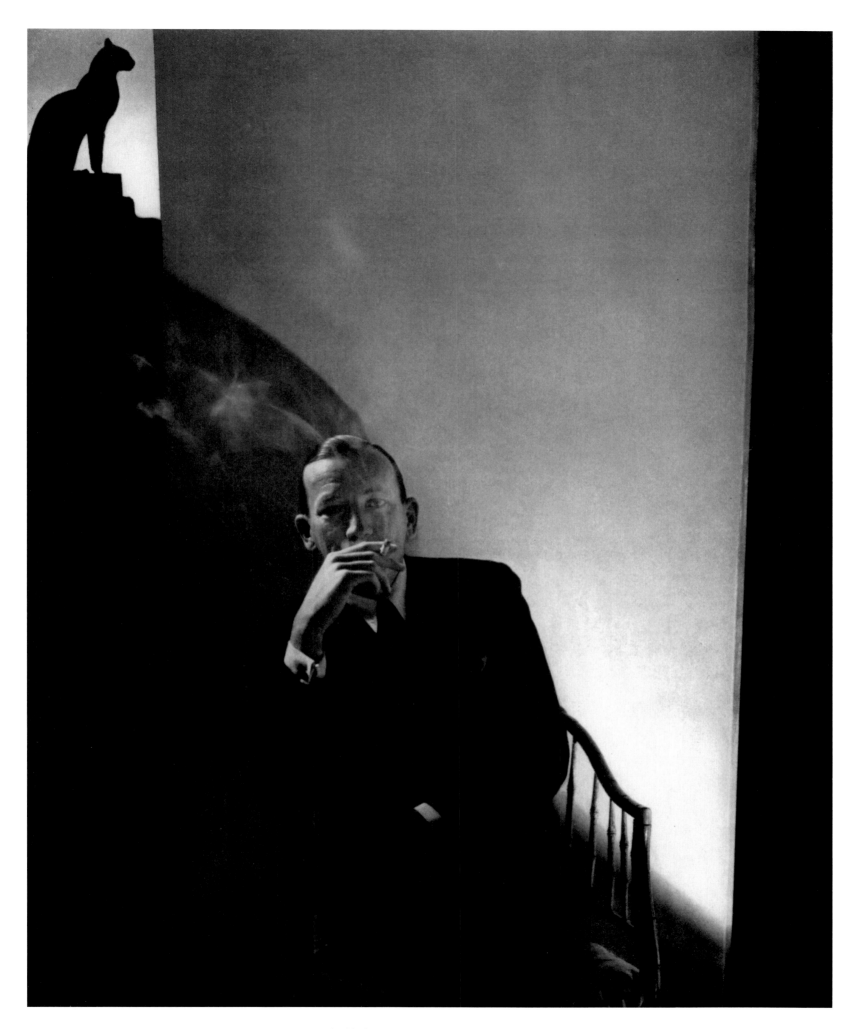

172. ACTOR AND PLAYWRIGHT NOEL COWARD, 1932

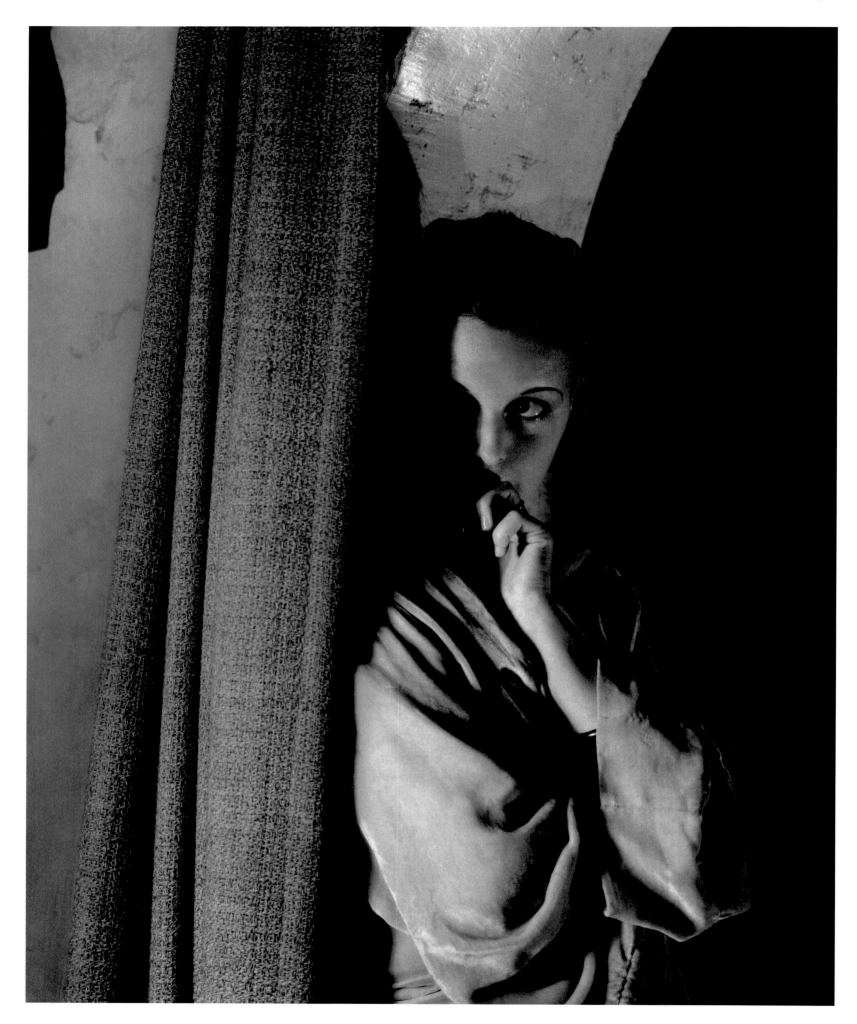

173. ACTRESS MARY ASTOR, 1933

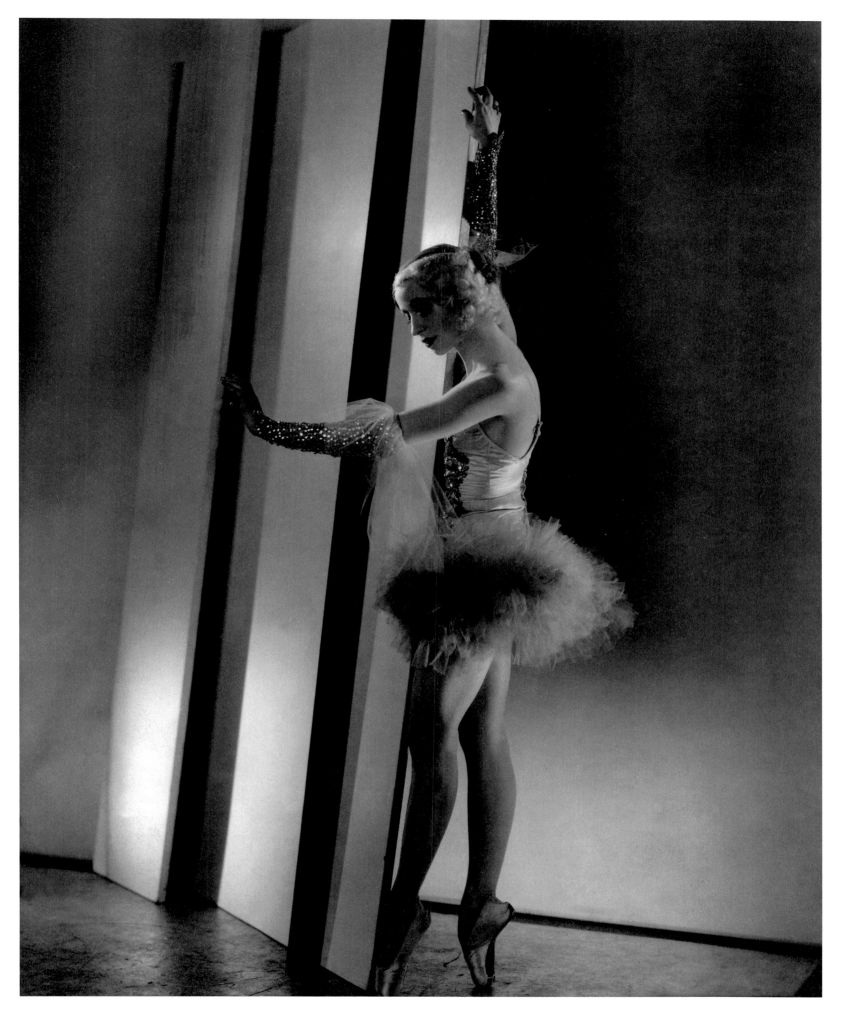

174. DANCER PATRICIA BOWMAN, 1932

175. OLYMPIC DIVER KATHERINE RAWLS, 1931

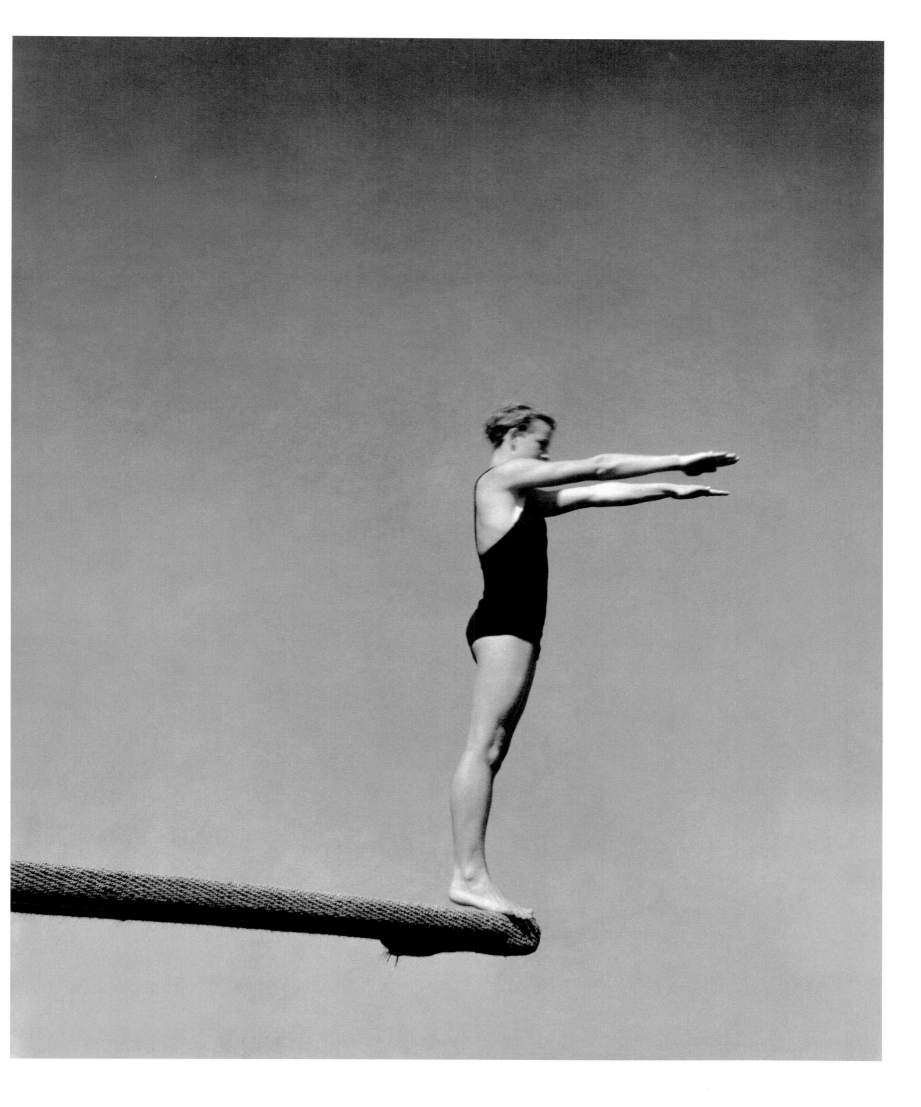

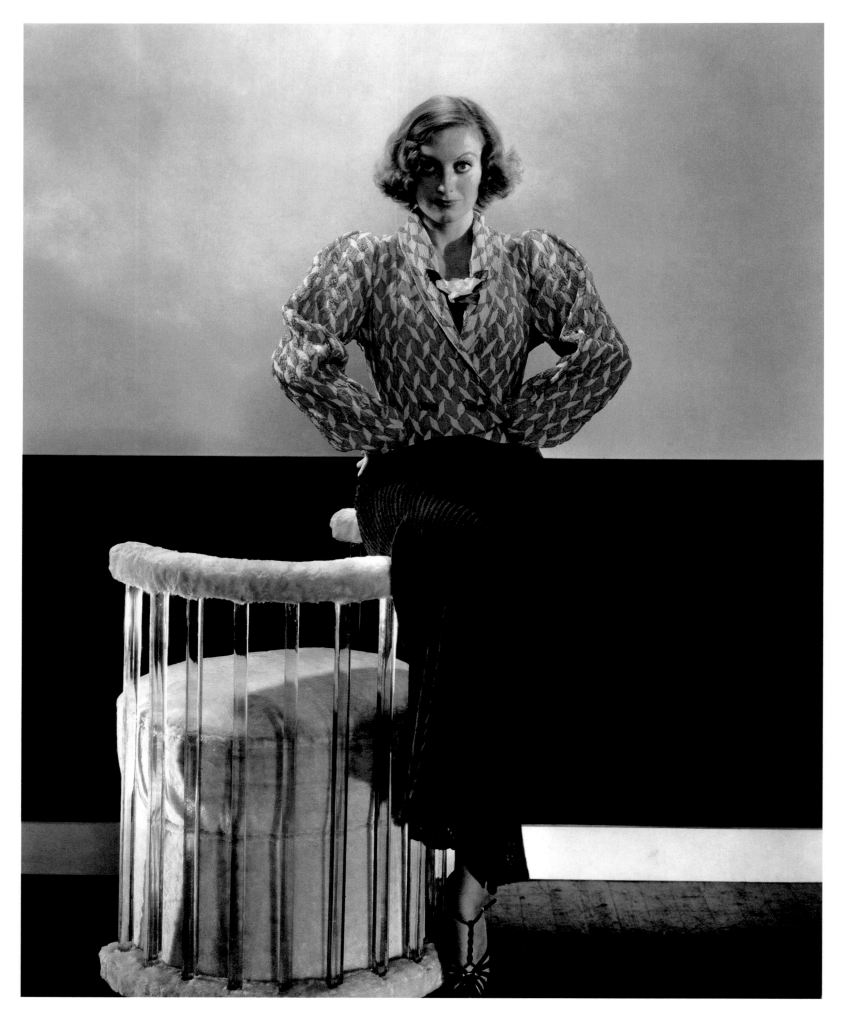

176. ACTRESS JOAN CRAWFORD WEARING A JACKET AND A DRESS BY SCHIAPARELLI, 1932

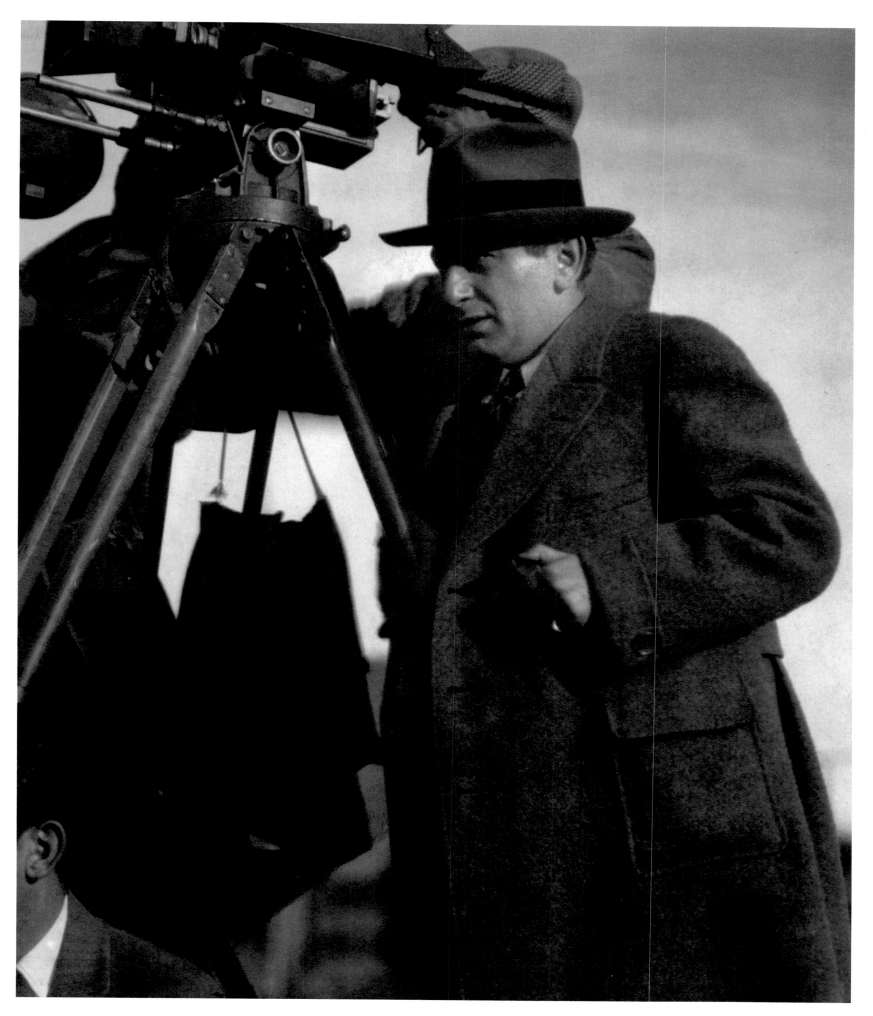

177. FILMMAKER ERNST LUBITSCH, C. 1935

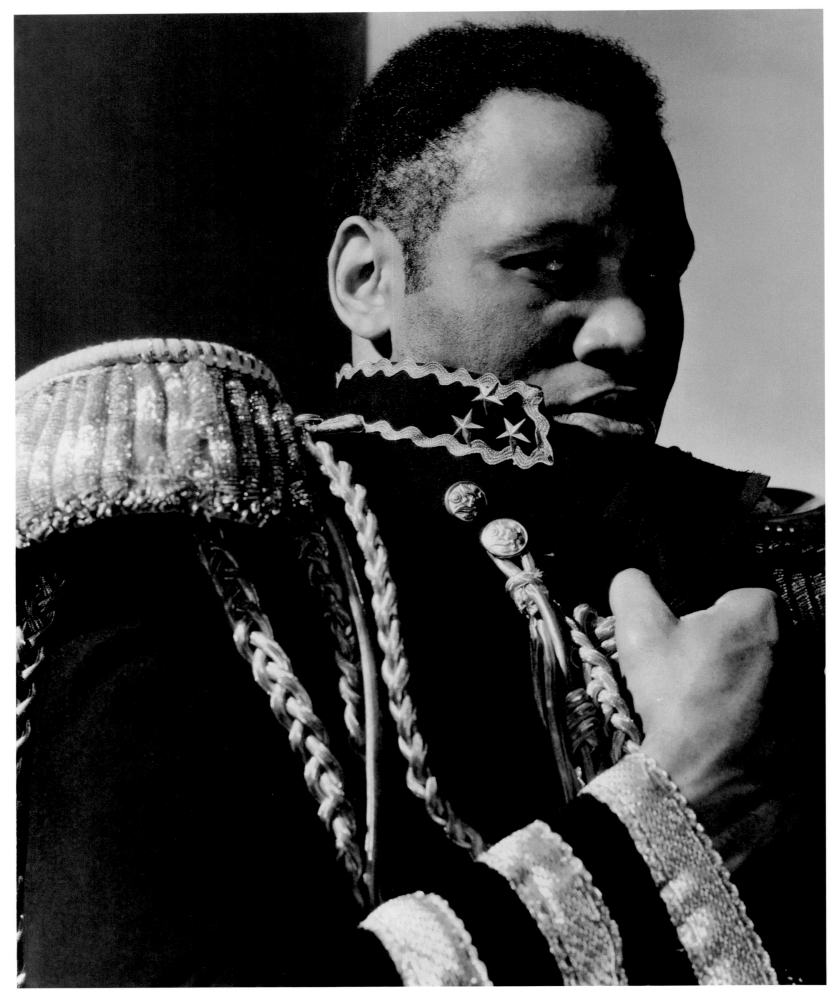

178. ACTOR PAUL ROBESON AS THE EMPEROR JONES, 1933

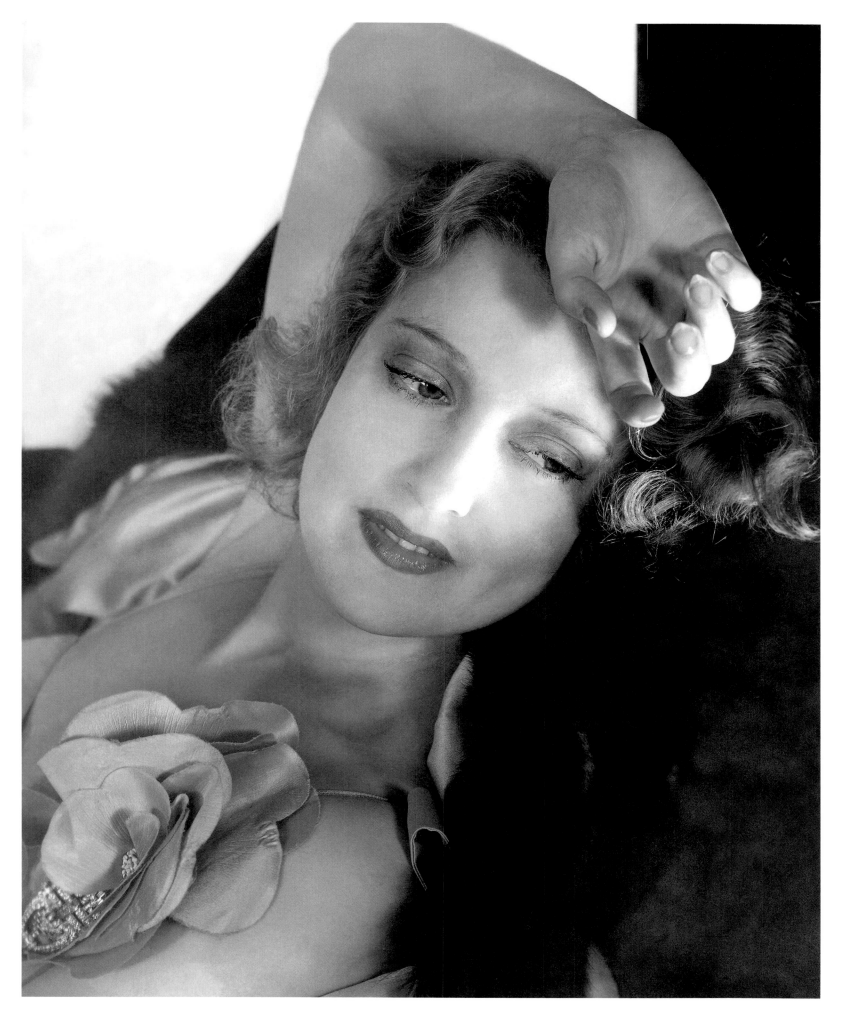

179. ACTRESS JEANETTE MACDONALD, 1933

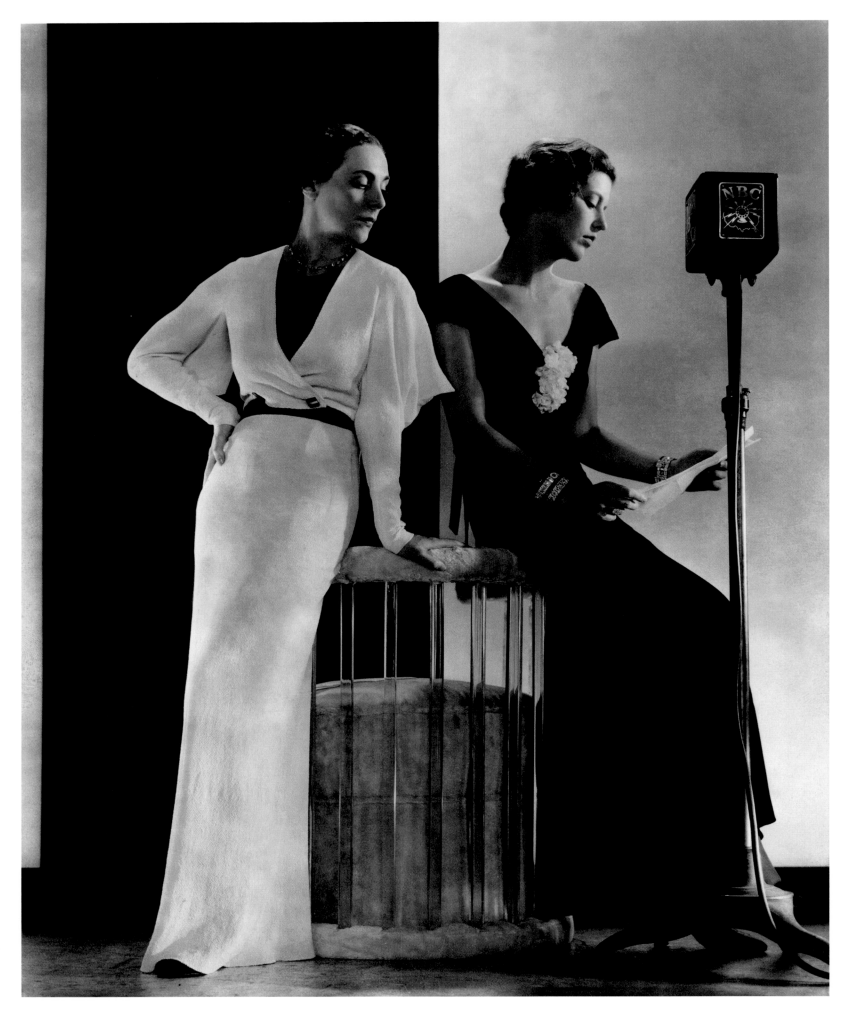

180. MODELS HARRIET HAMIL AND ELEANOR BARRY WEARING DINNER GOWNS, 1932

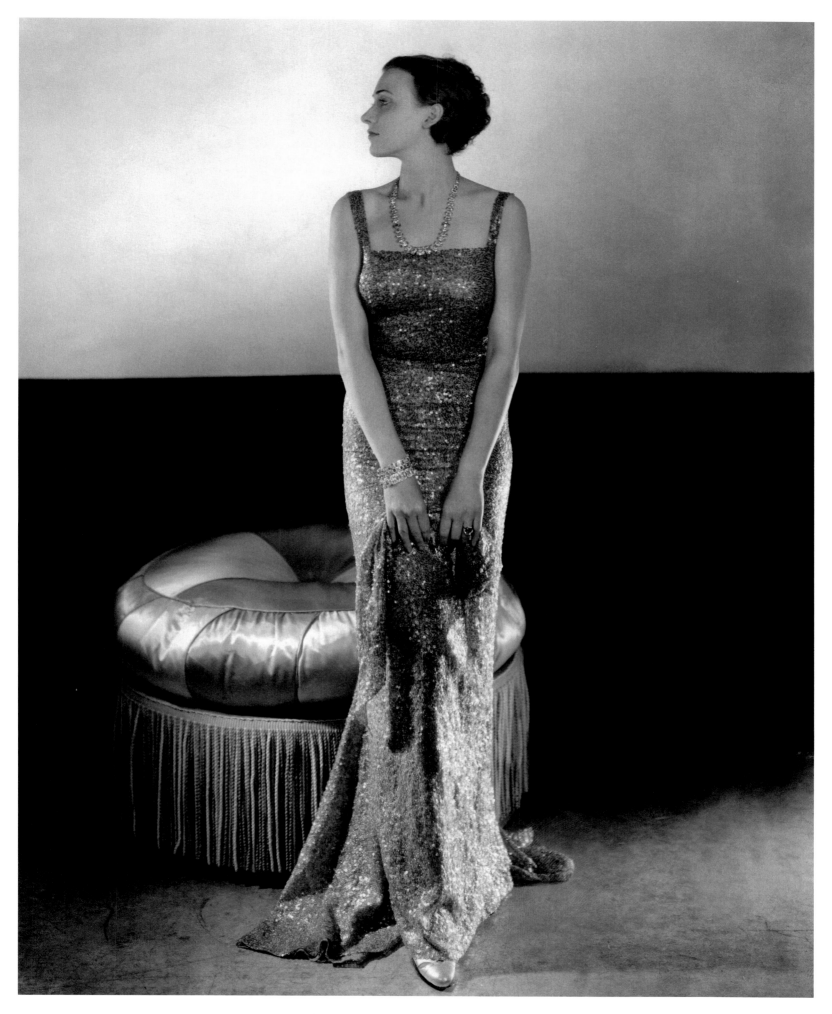

181. MODEL IN A SEQUINED GOWN, 1933

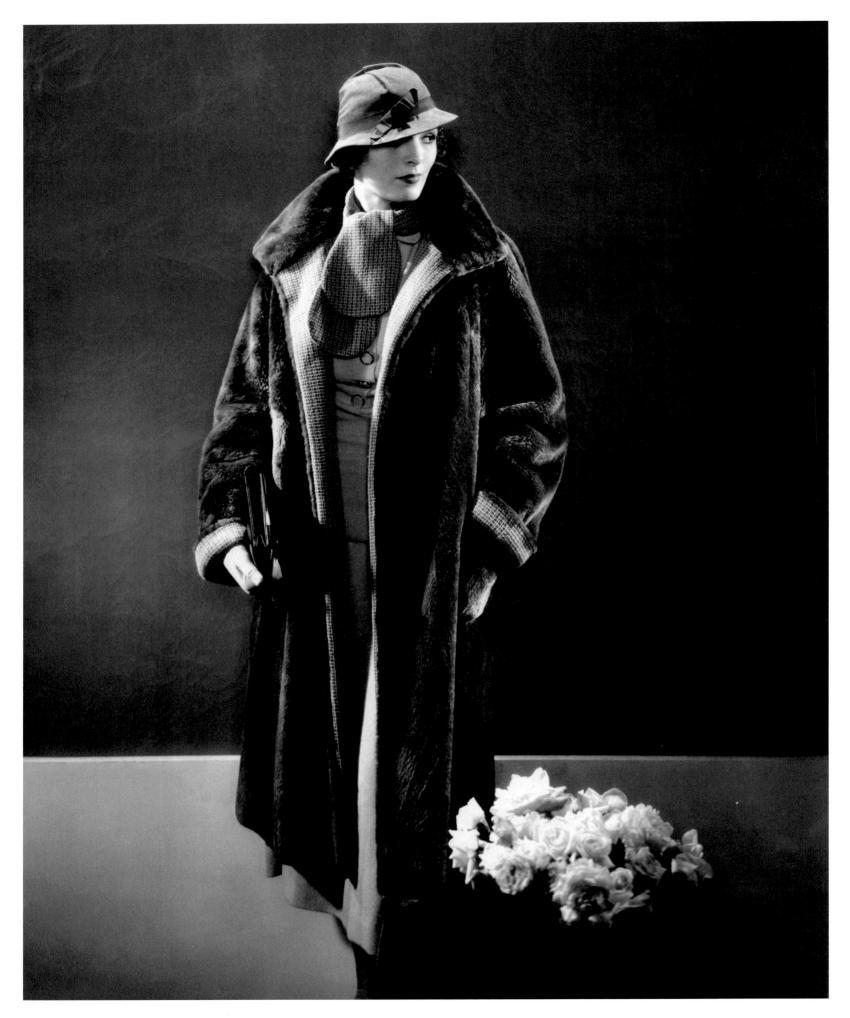

182. MODEL MARY OAKES WEARING A FUR COAT BY PEGGY MORRIS AND A HAT BY ROSE DESCAT, 1933

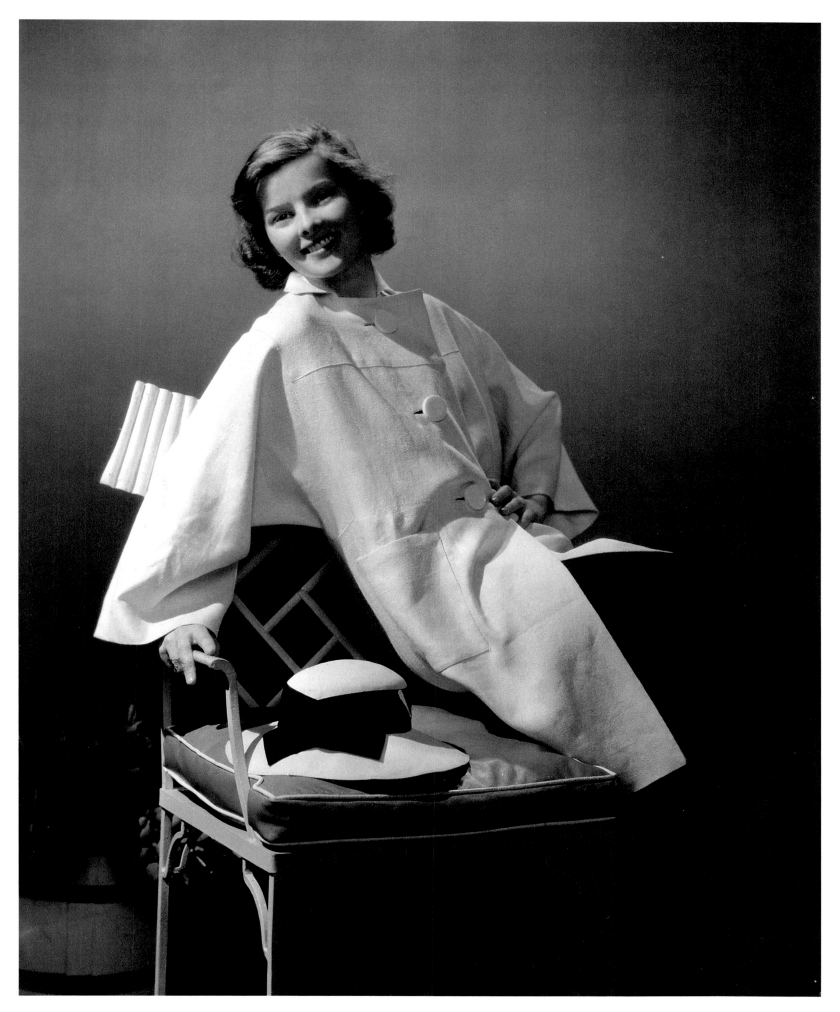

183. ACTRESS KATHARINE HEPBURN WEARING A COAT BY CLAREPOTTER, 1933

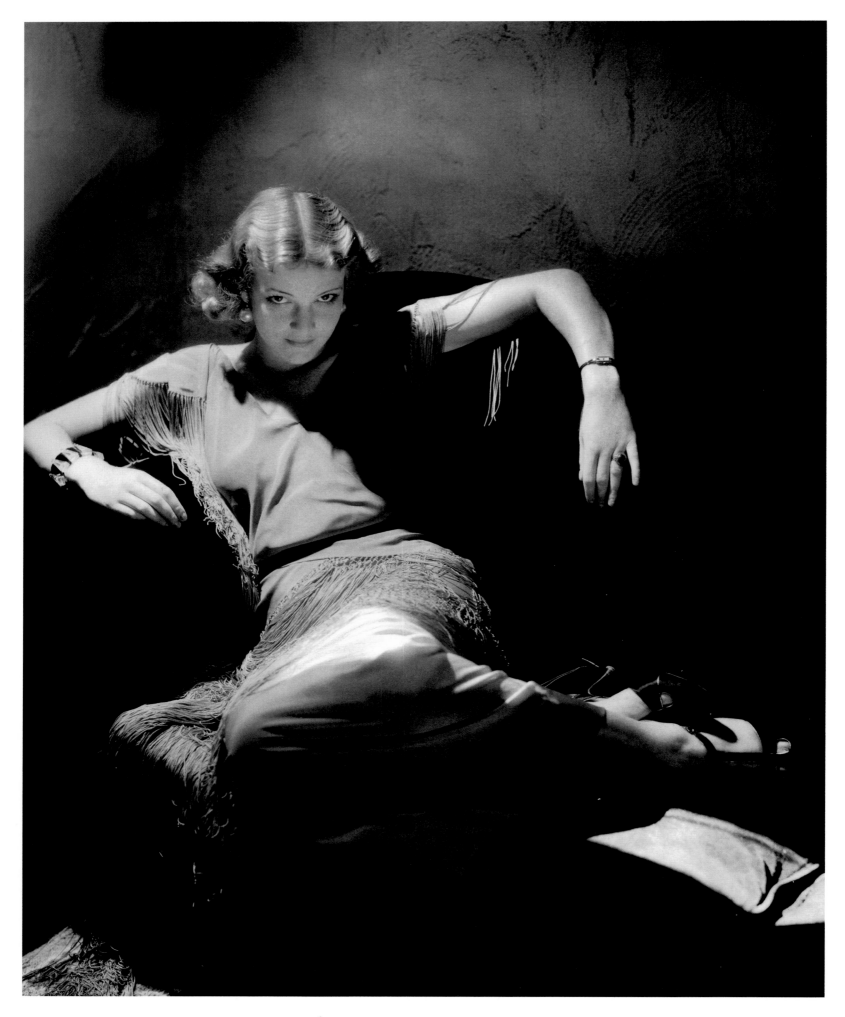

184. ACTRESS ELISSA LANDI, 1933

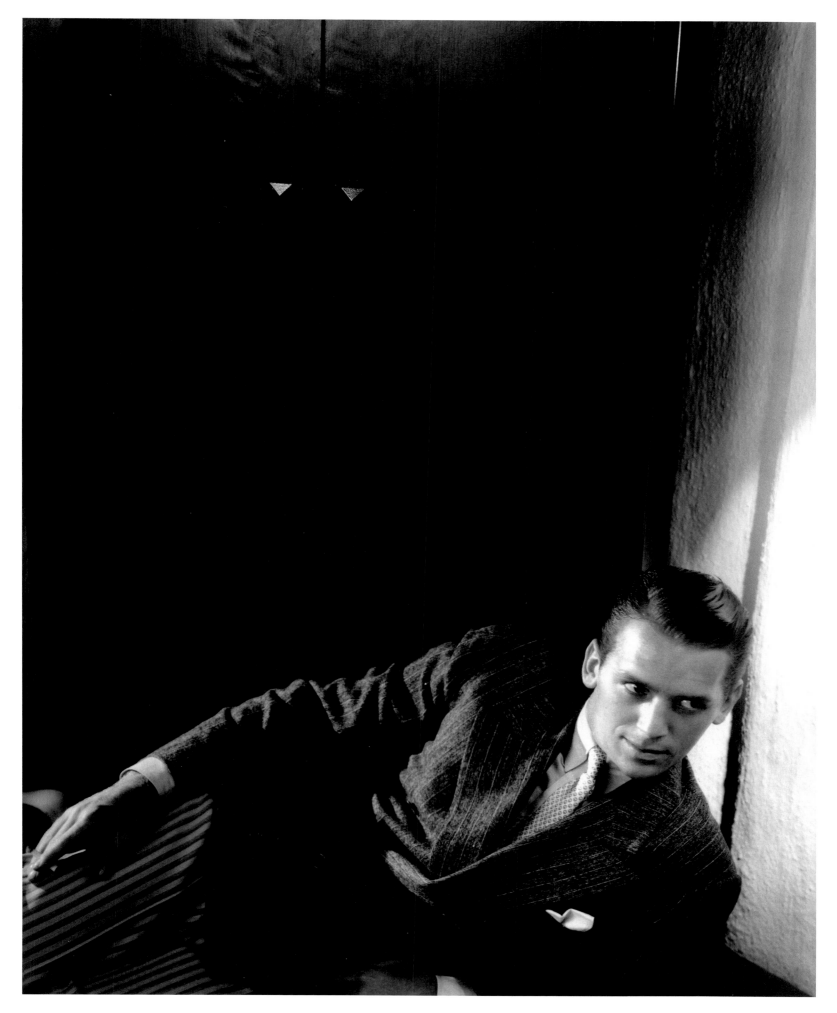

185. ACTOR DOUGLAS FAIRBANKS JR., 1933

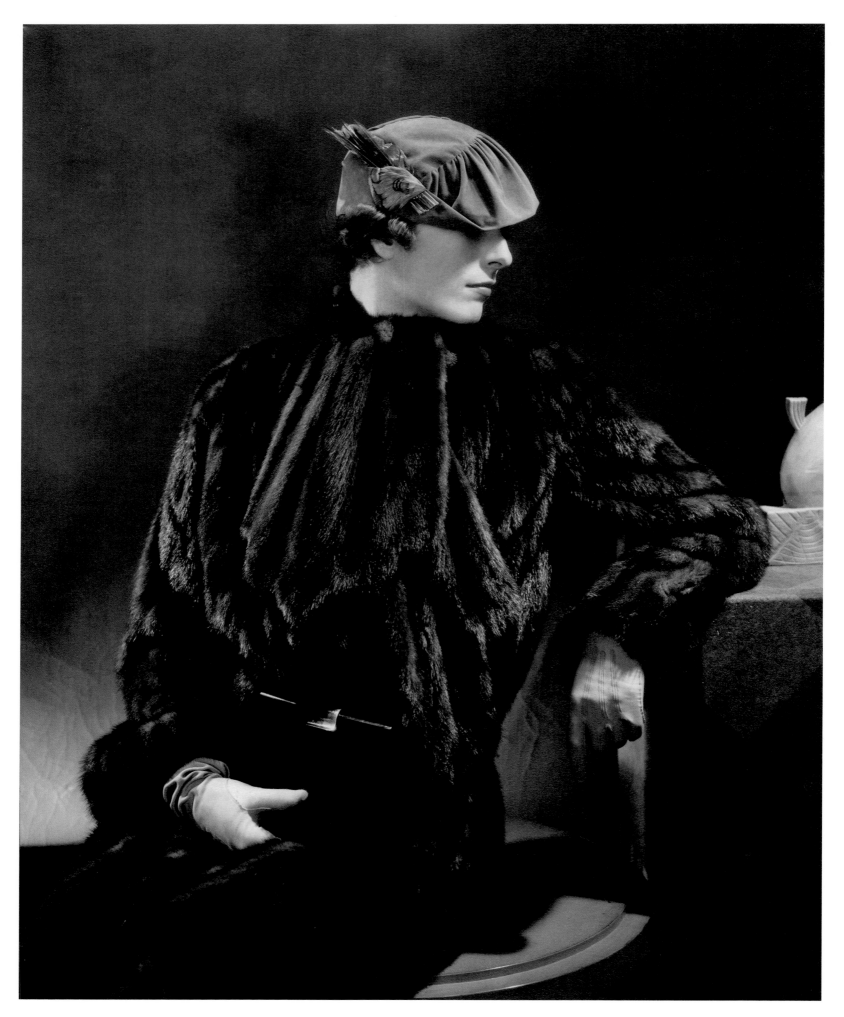

186. MODEL MARY OAKES WEARING FASHION BY JAY-THORPE, 1933

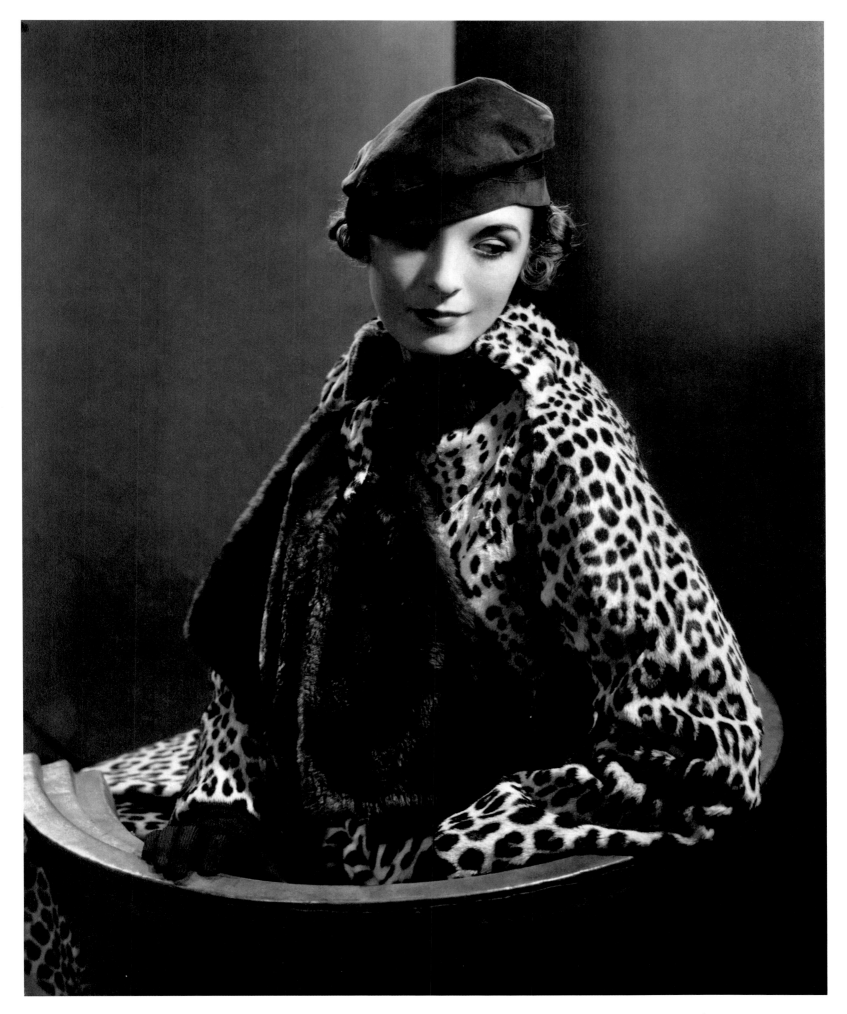

187. MODEL MARY OAKES WEARING A LEOPARD FUR COAT BY REVILLON FRÈRES, 1933

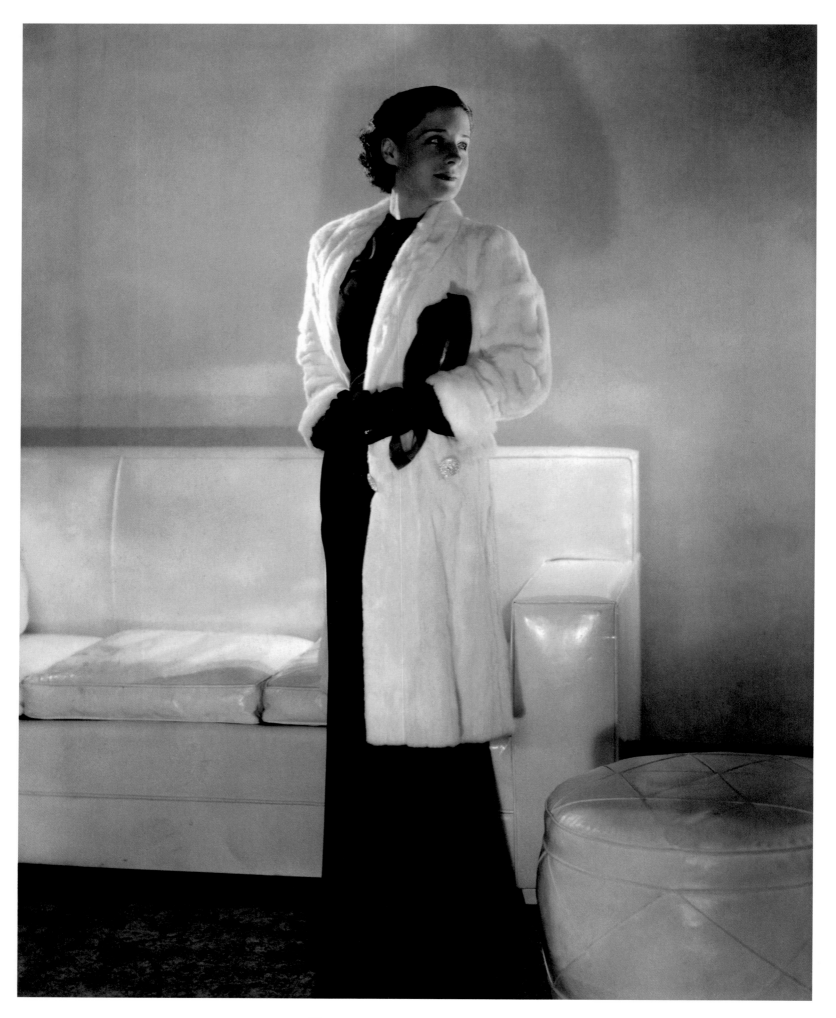

188. ACTRESS NORMA SHEARER WEARING AN ERMINE COAT BY HATTIE CARNEGIE, 1933

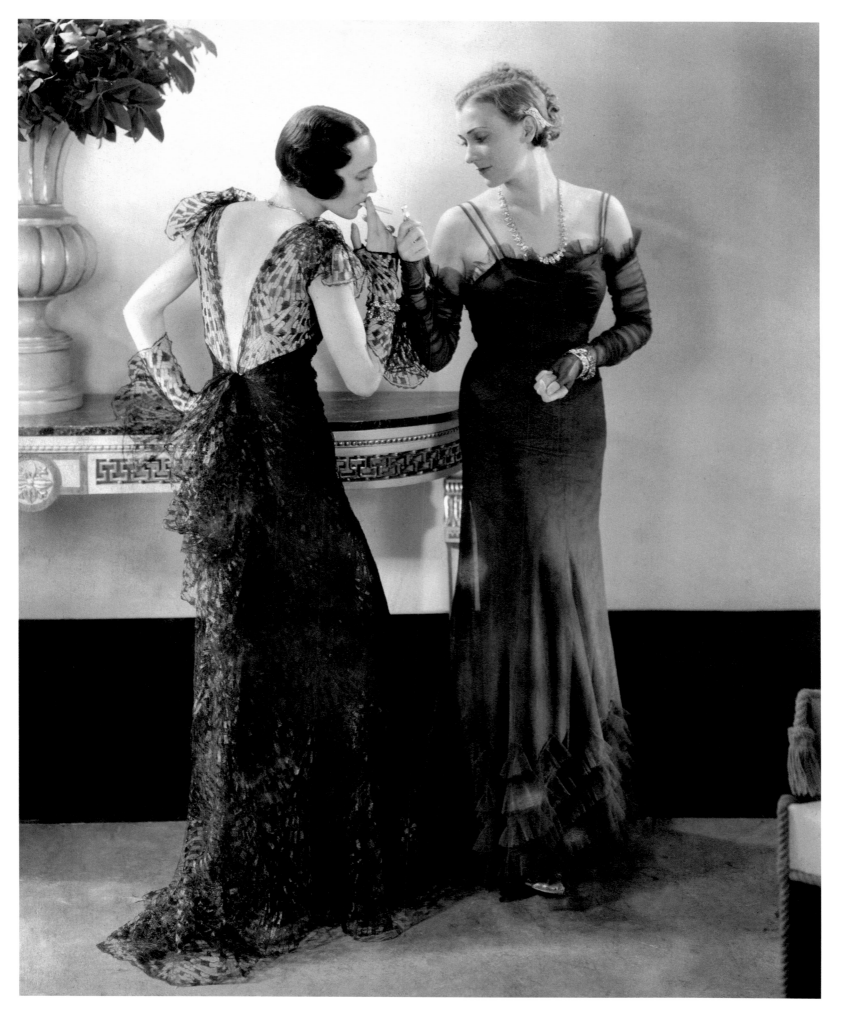

189. MODELS WEARING EVENING GOWNS, 1933

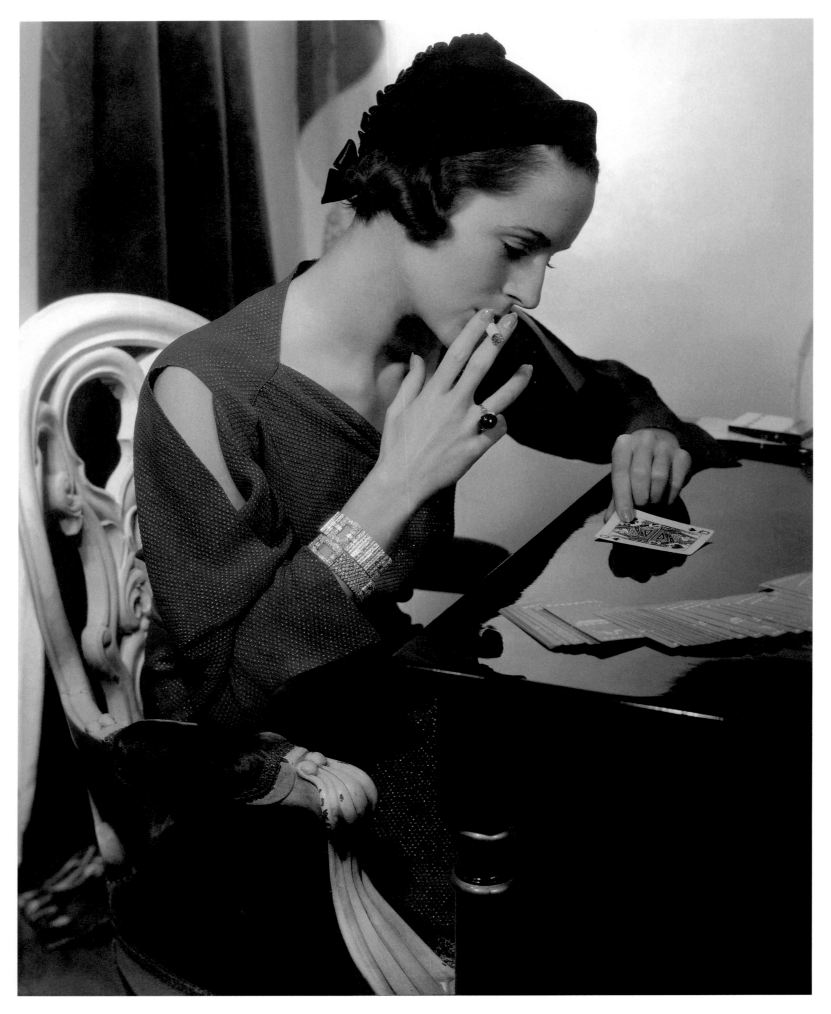

190. MRS. WILLIAM WETMORE IN A DRESS BY ROSE AMADO AND A BONNET BY SALLY VICTOR, 1933

191. CONDUCTOR AND COMPOSER WERNER JANSSEN, 1934

192. MODEL IN A DRESS BY CHANEL, 1932

193. PLAYWRIGHT EUGENE O'NEILL, 1934

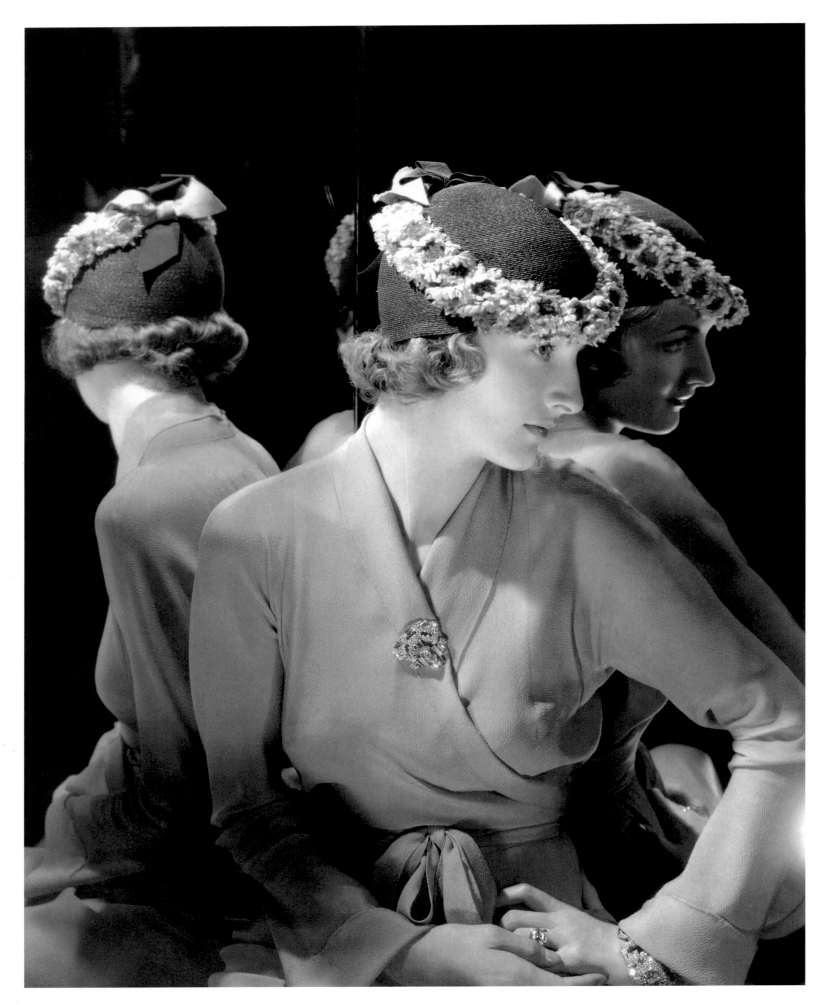

195. MODEL WEARING A STRAW HAT BY REBOUX AND JEWELRY FROM MAUBOUSSIN, 1932

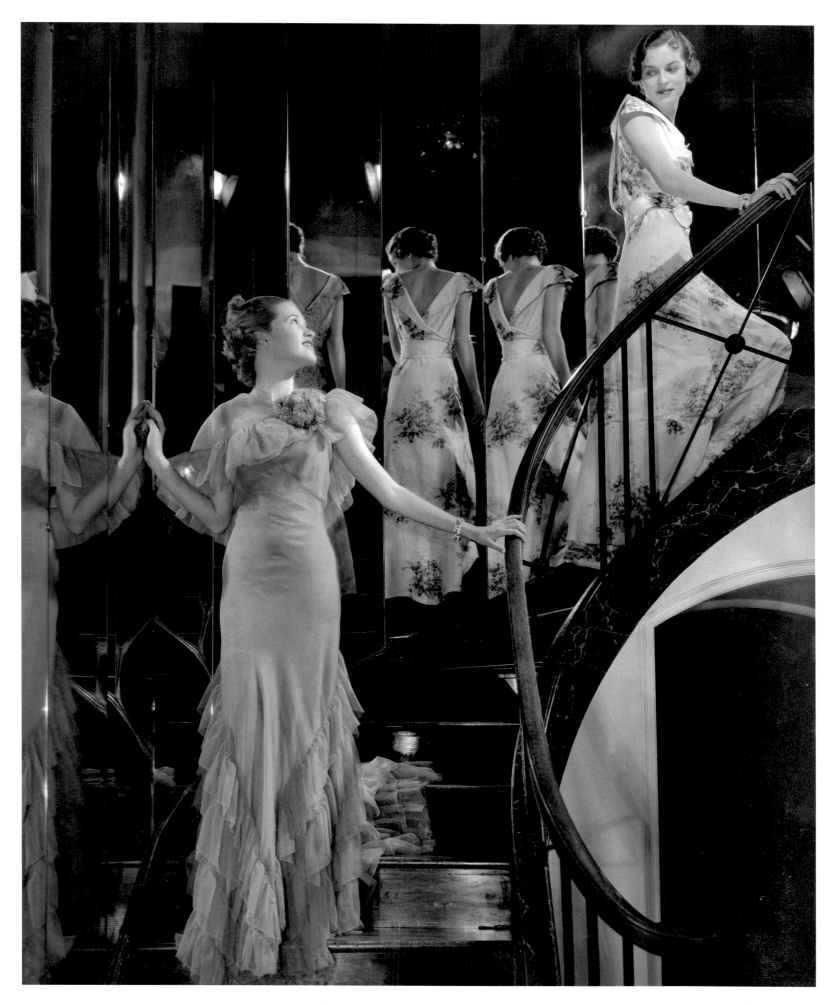

196. MODELS MARY TAYLOR IN A CHIFFON GOWN AND ANNE WHITEHEAD IN A MOIRÉ DRESS;
MIRRORED STAIRWAY DESIGNED BY DIEGO DE SUAREZ, 1934

197. AUTHOR AND DIPLOMAT HAROLD NICOLSON, 1933

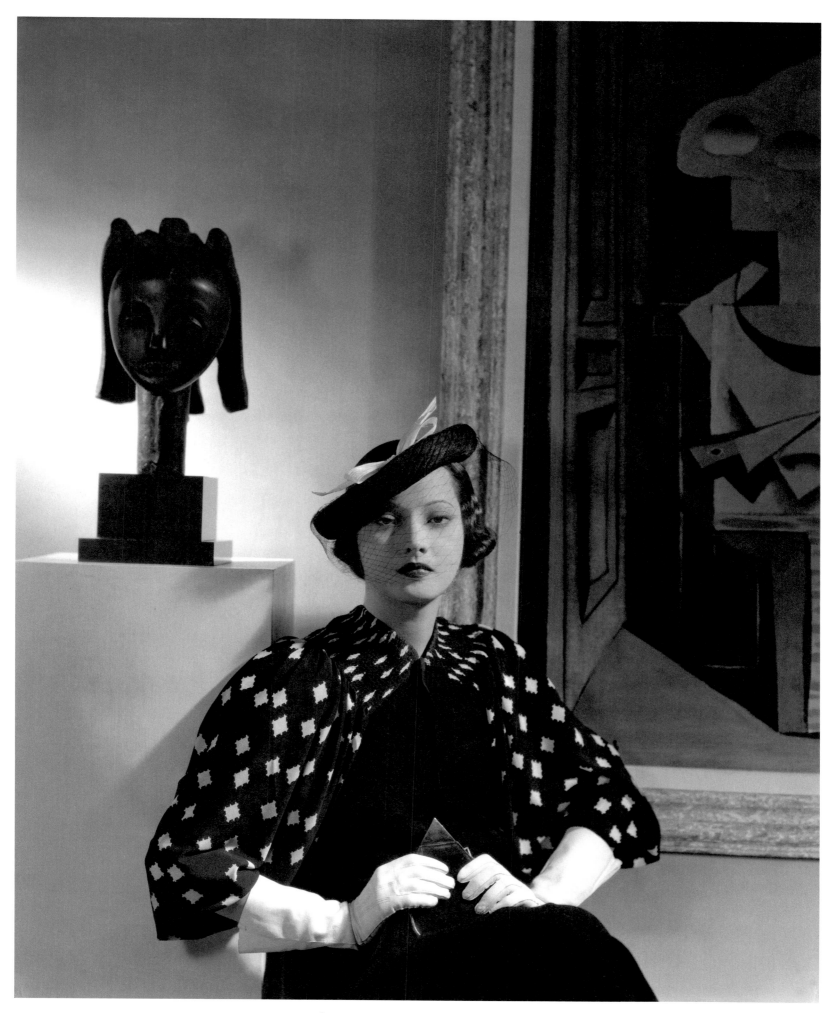

198. ACTRESS MERLE OBERON IN THE APARTMENT OF HELENA RUBINSTEIN, 1935

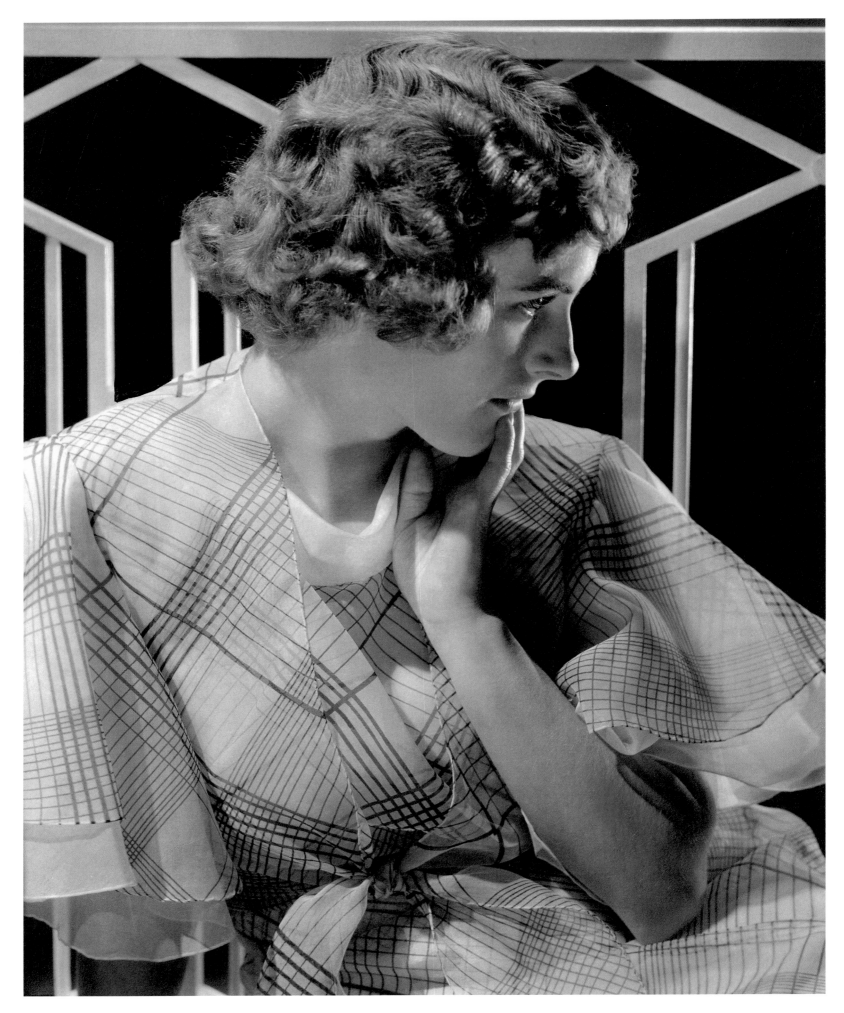

199. ACTRESS LOIS MORAN, 1933

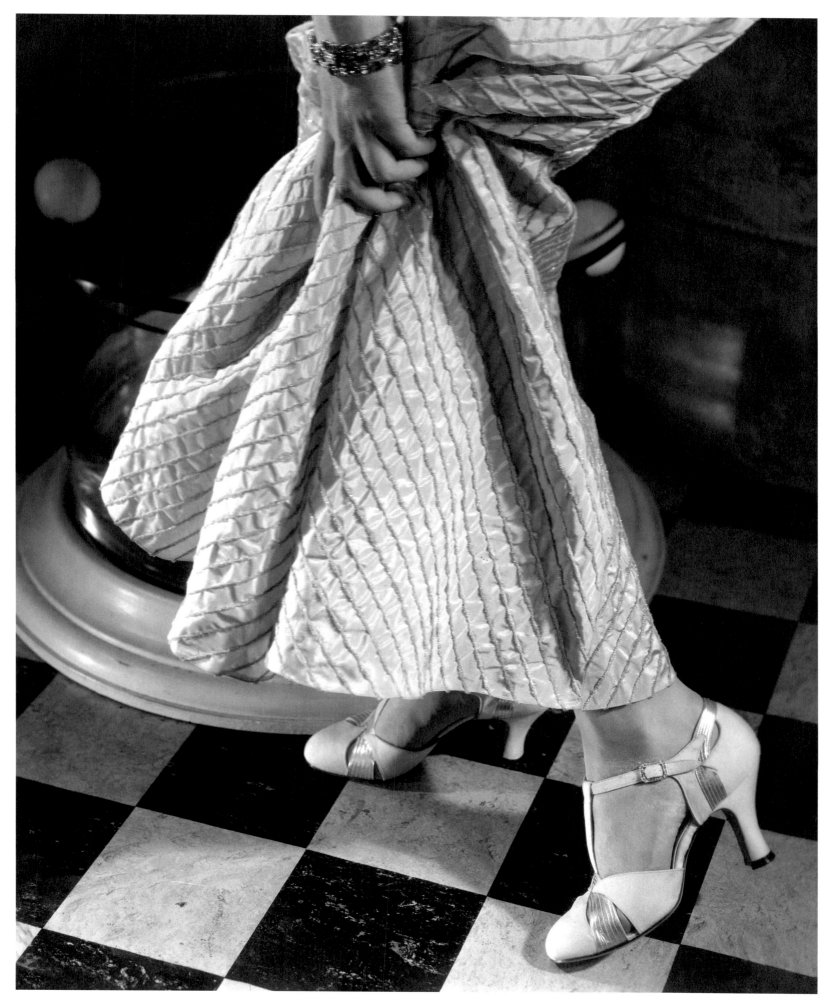

200. MODEL WEARING A DINNER DRESS BY ROSE CLARK AND SANDALS BY PREMIER, 1934

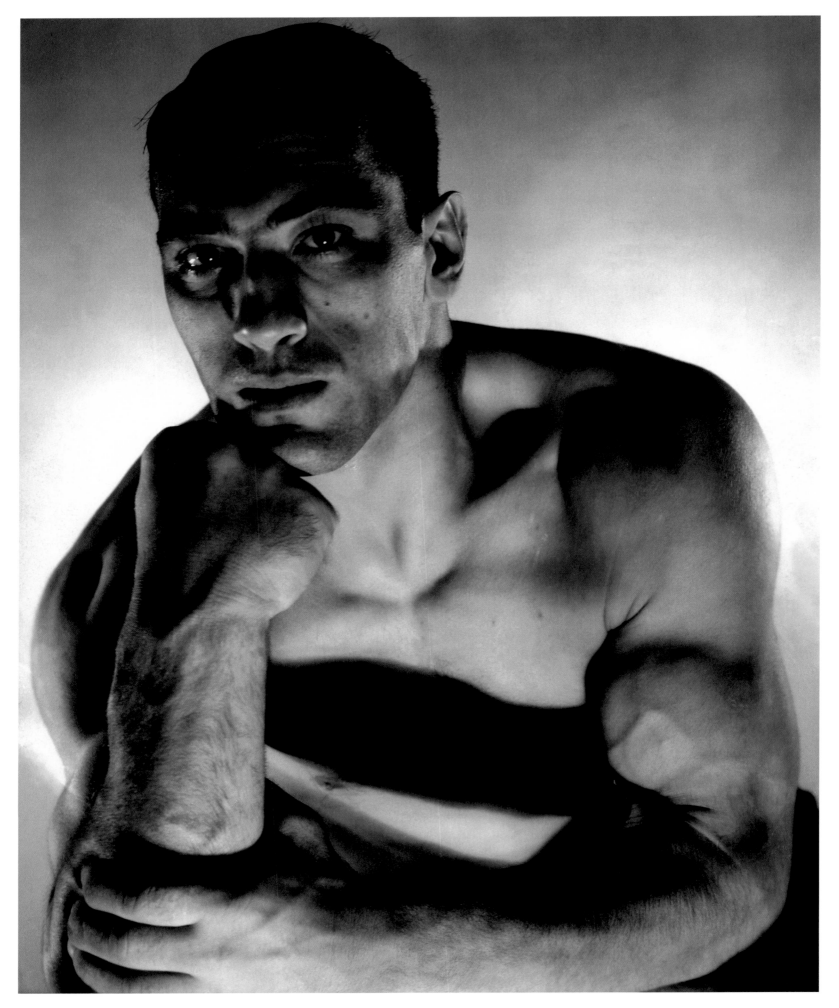

201. HEAVYWEIGHT BOXING CHAMPION PRIMO CARNERA, 1934

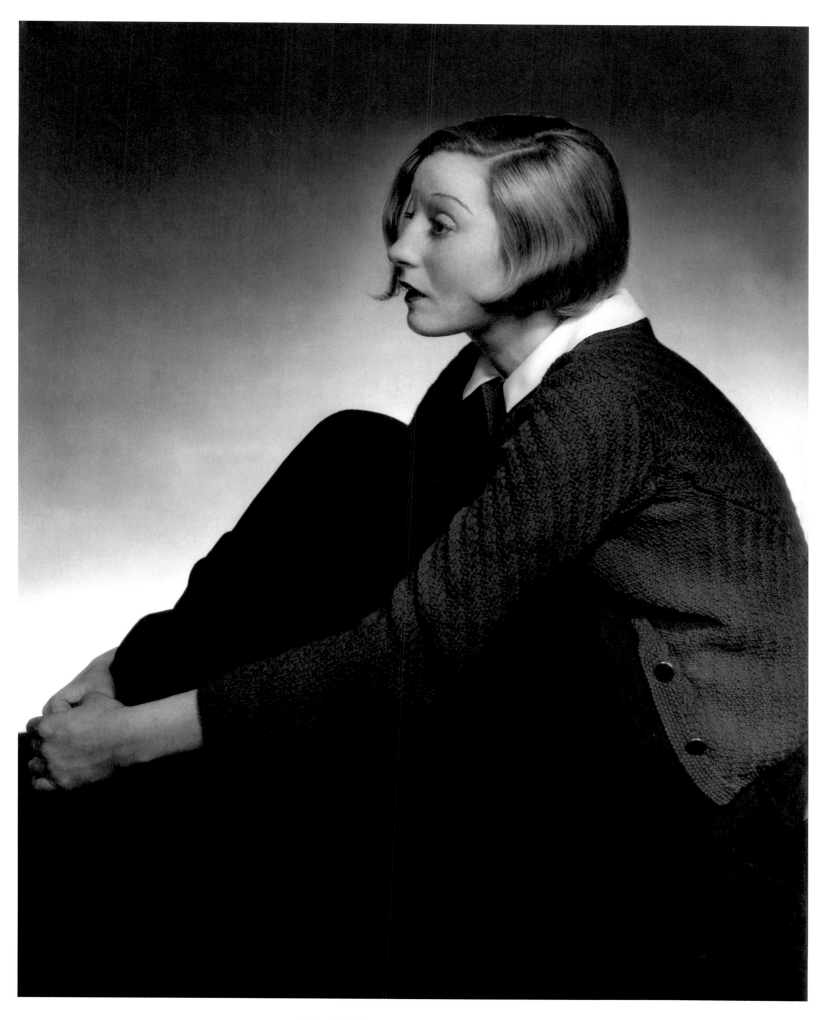

202. ACTRESS ELISABETH BERGNER IN THE PLAY *ESCAPE ME NEVER*, 1935

203. SECRETARY OF STATE CORDELL HULL, 1934

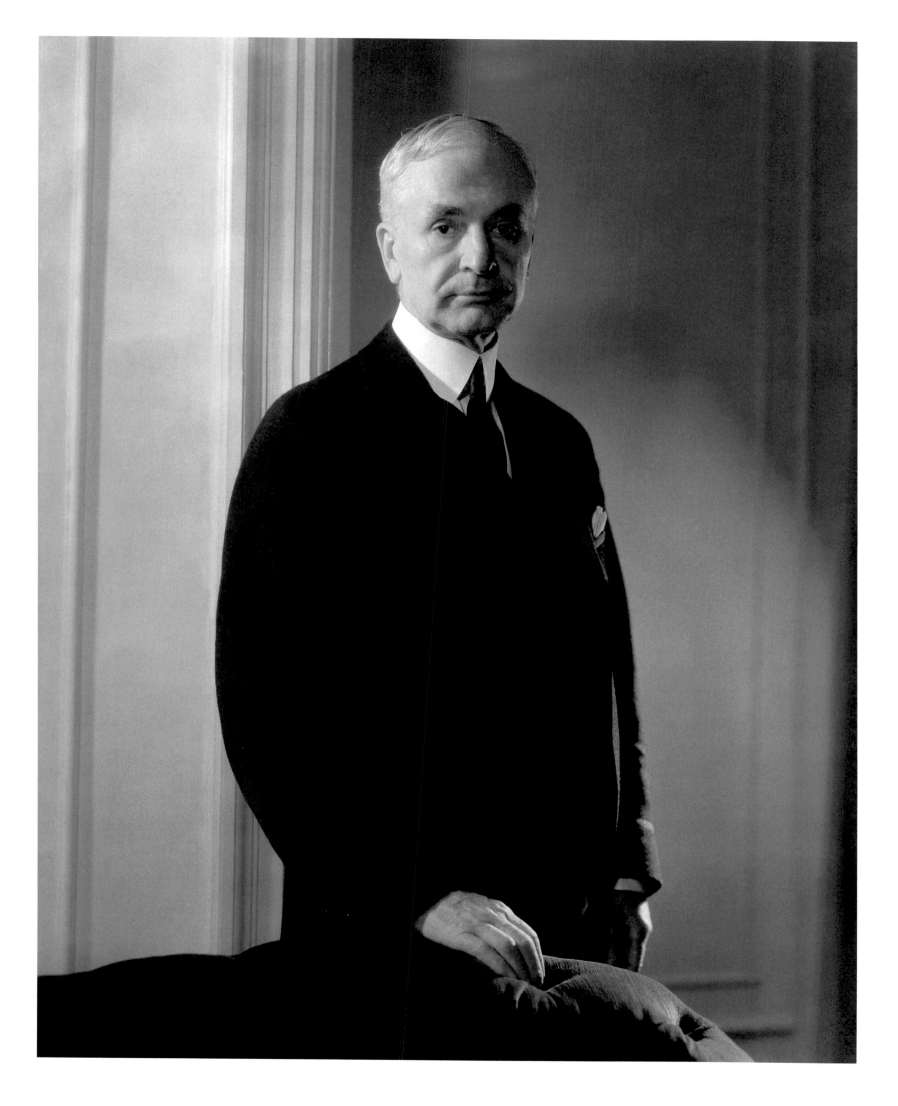

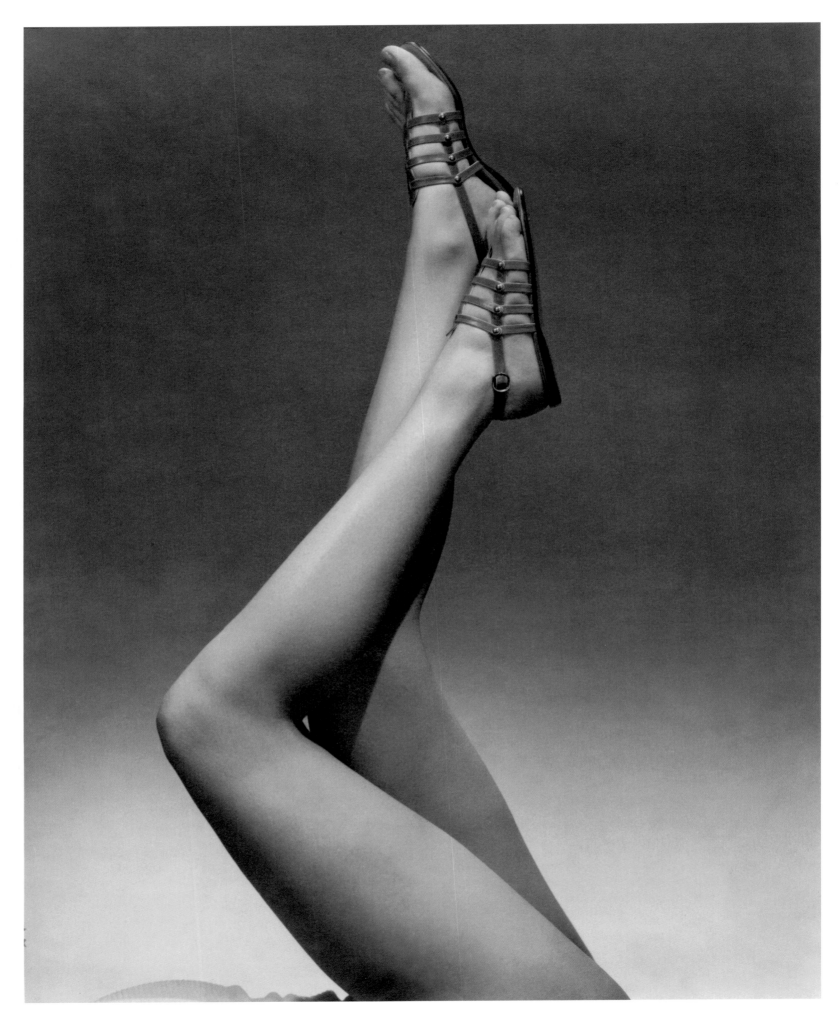

204. MODEL WEARING SANDALS, 1934

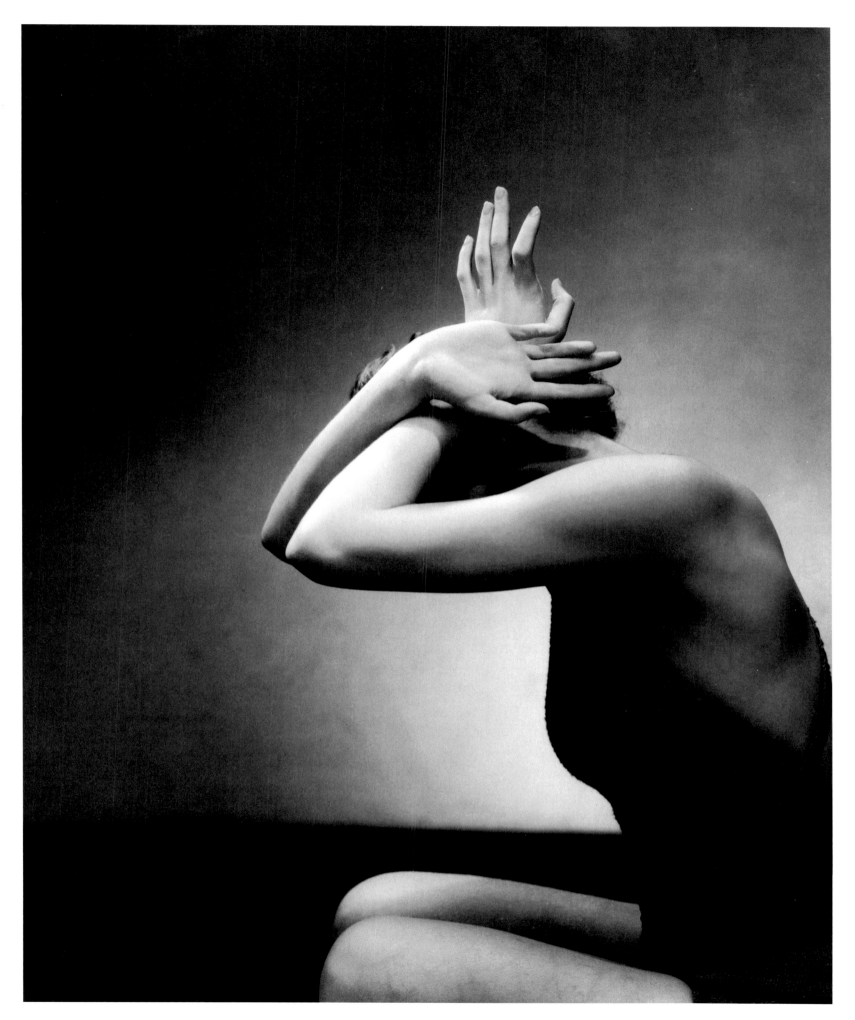

205. MODEL POSING FOR "BEAUTY PRIMER" ON HAND AND NAIL CARE, 1934

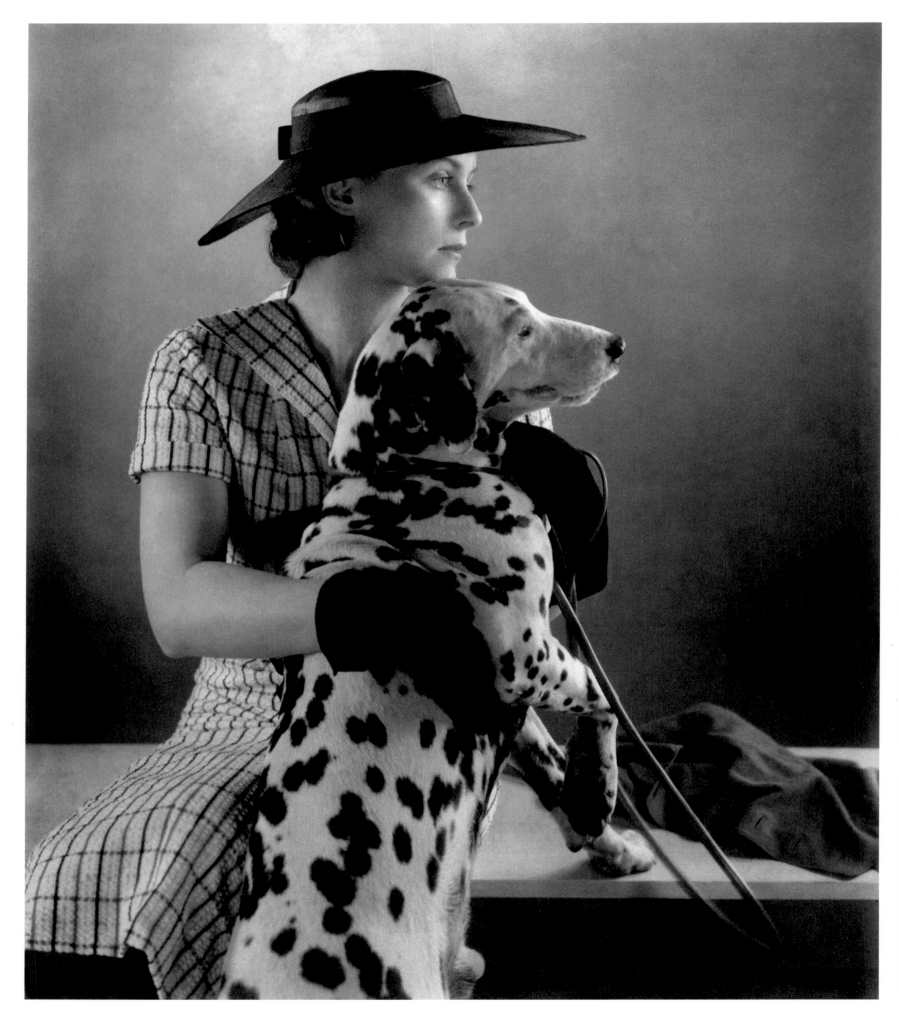

206. MODEL ELIZABETH BLAIR IN A SEERSUCKER DRESS, 1934

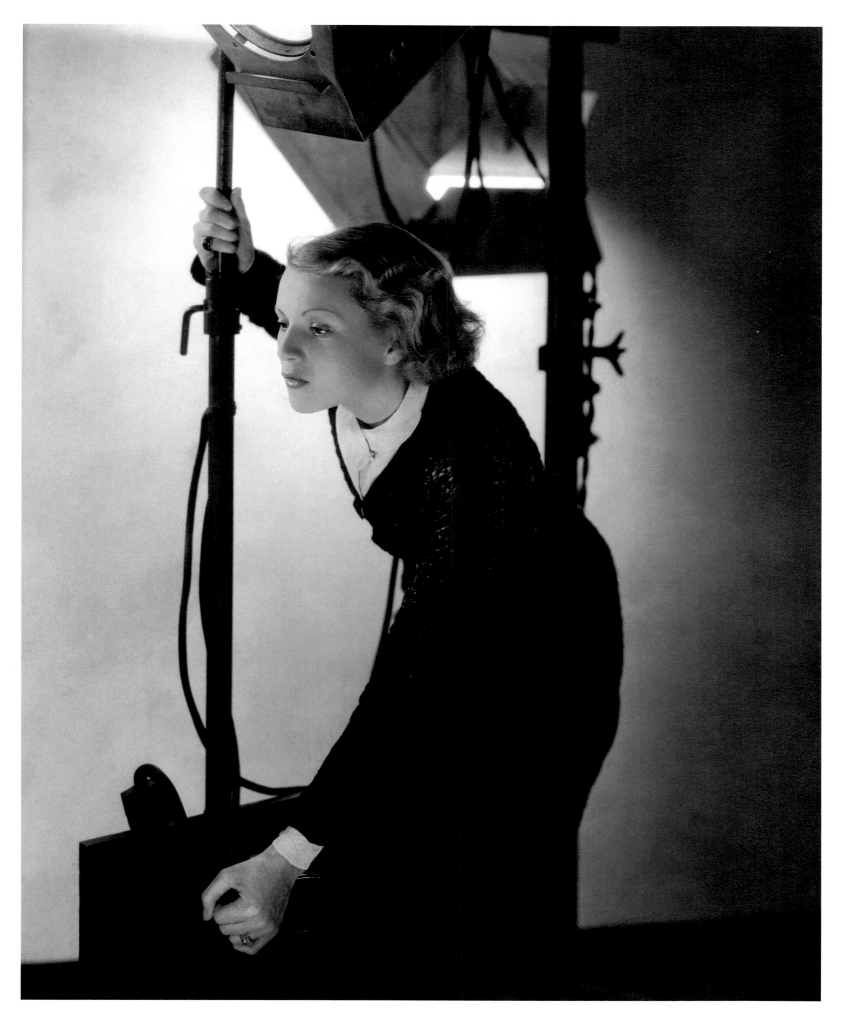

207. ACTRESS ANNABELLA, 1934

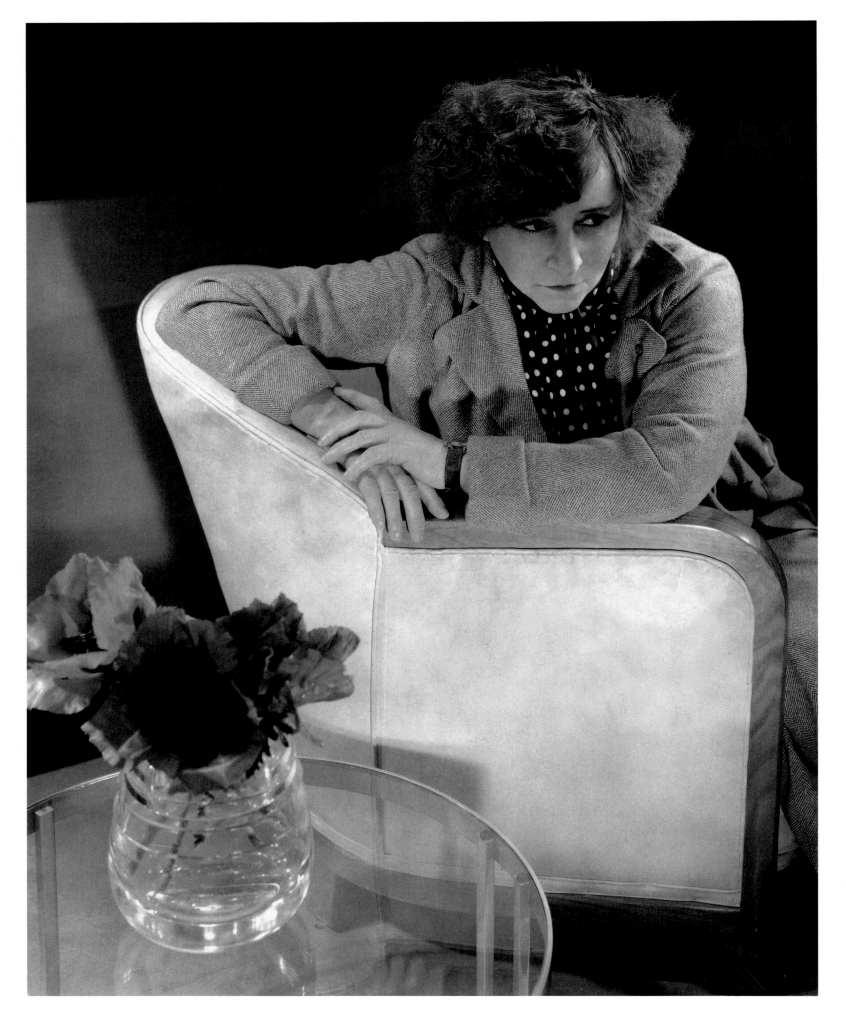

208. WRITER COLETTE, 1935

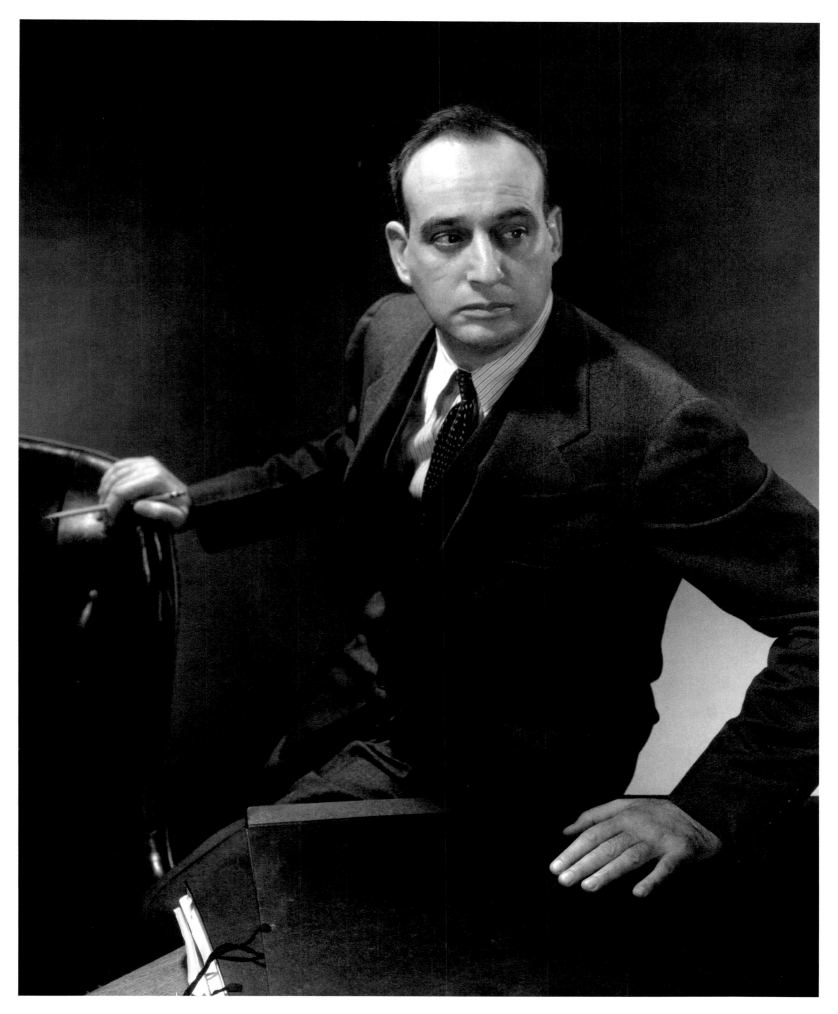

209. NEW YORK CITY PARK COMMISSIONER ROBERT MOSES, 1935

210. MODEL ELIZABETH BLAIR IN THE STEUBEN GLASS SHOP, 1935

211. ACTRESS ROSE HOBART IN A DRESS BY HENRI BENDEL AT THE ST. REGIS HOTEL, 1935

212. MODEL BETTY MCLAUCHLEN IN CARROLL CARSTAIRS GALLERY, 1935

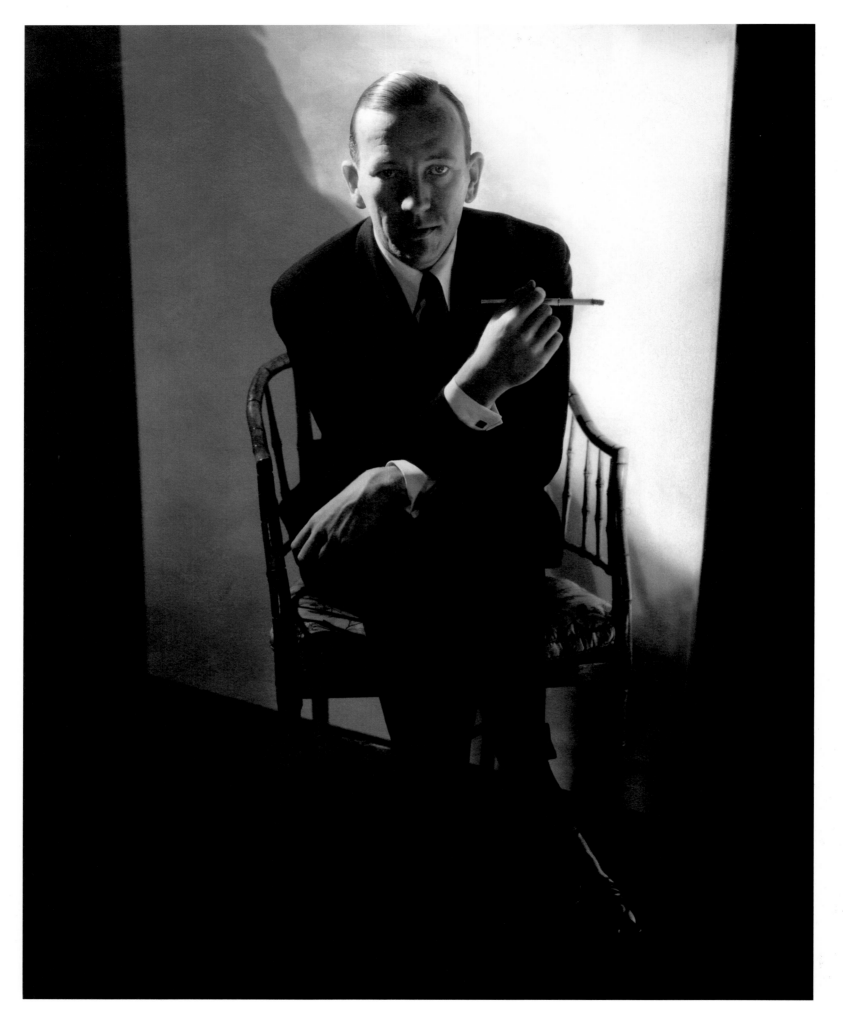

213. ACTOR AND PLAYWRIGHT NOEL COWARD, 1932

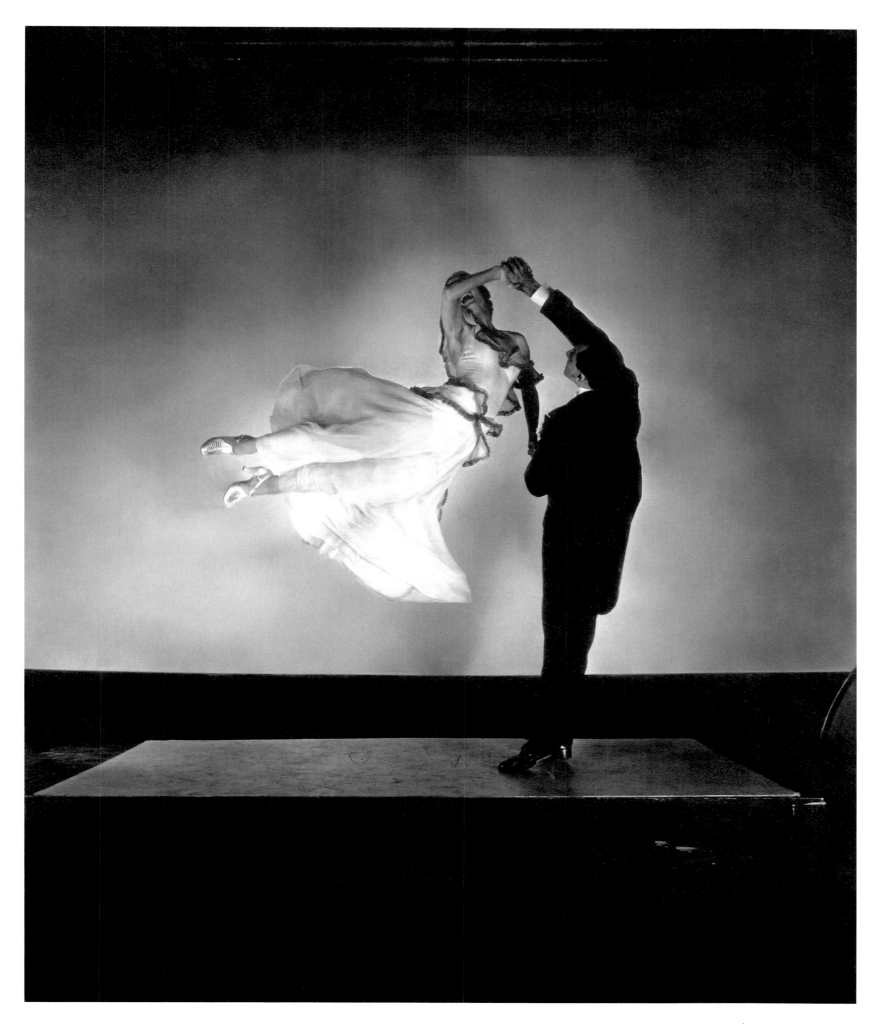

214. THE RENOWNED BALLROOM DANCING TEAM ANTONIO DE MARCO AND RENÉE DE MARCO, 1935

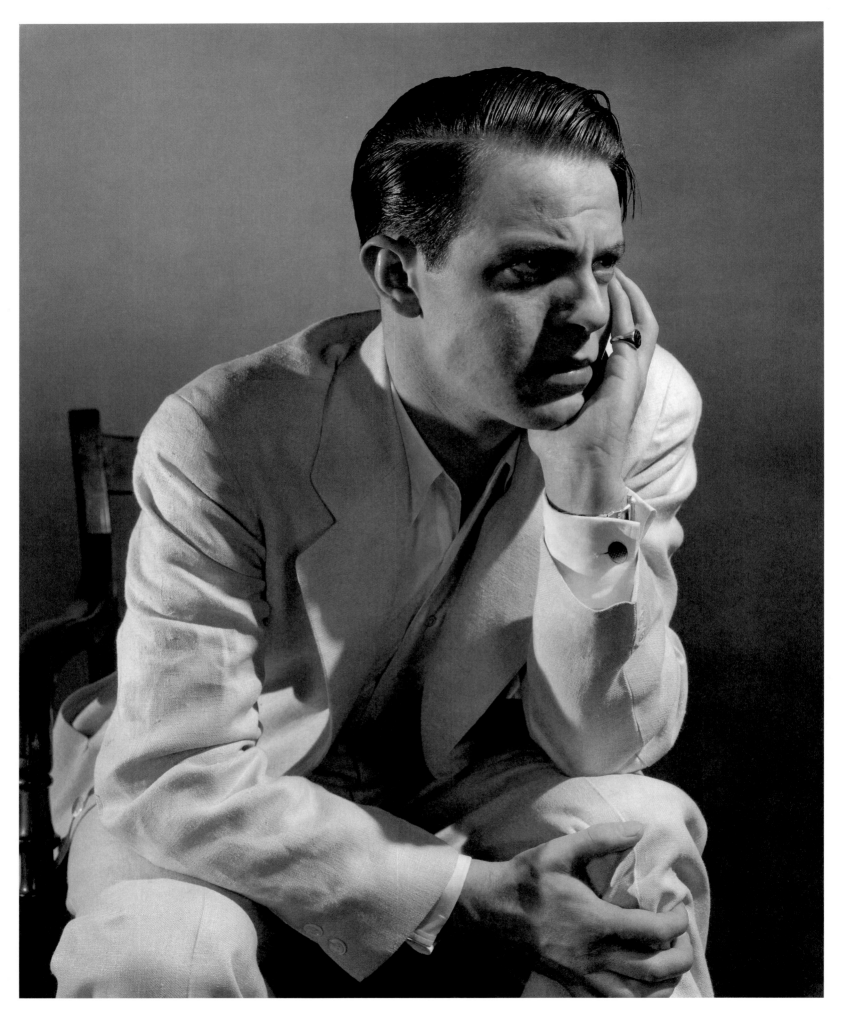

215. ACTOR LOUIS HAYWARD, 1935

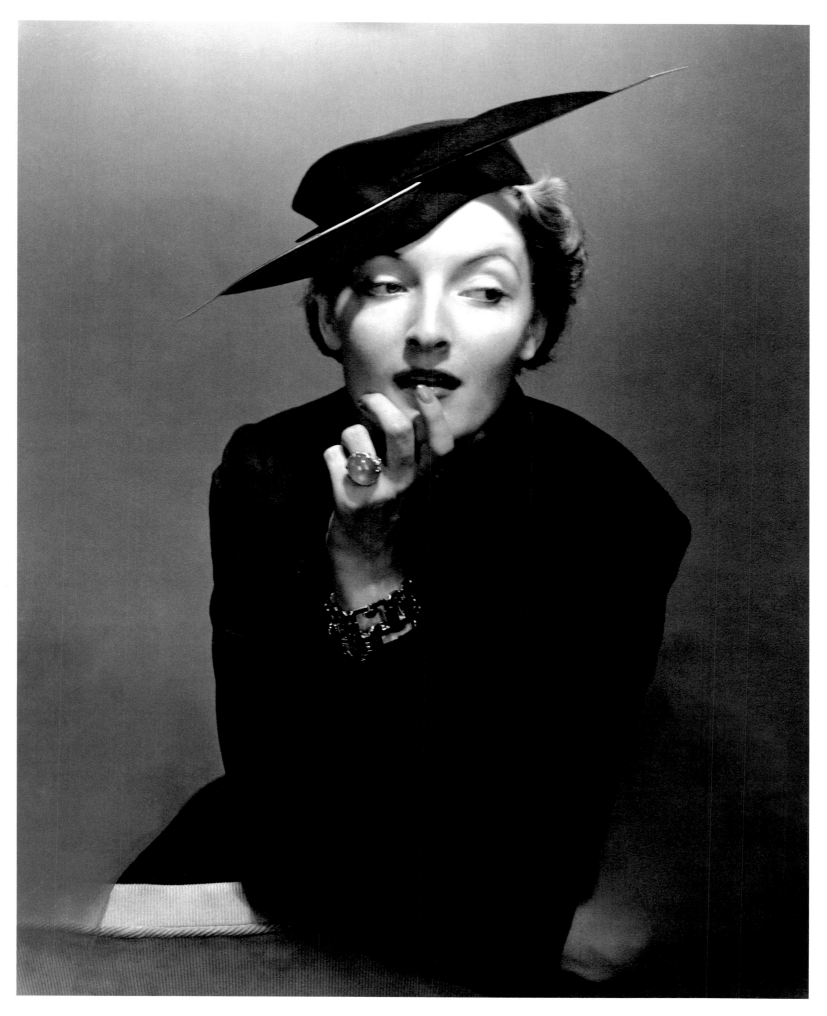

216. ACTRESS GWILI ANDRÉ WEARING A HAT BY ROSE DESCAT AND JEWELRY FROM TIFFANY, 1936

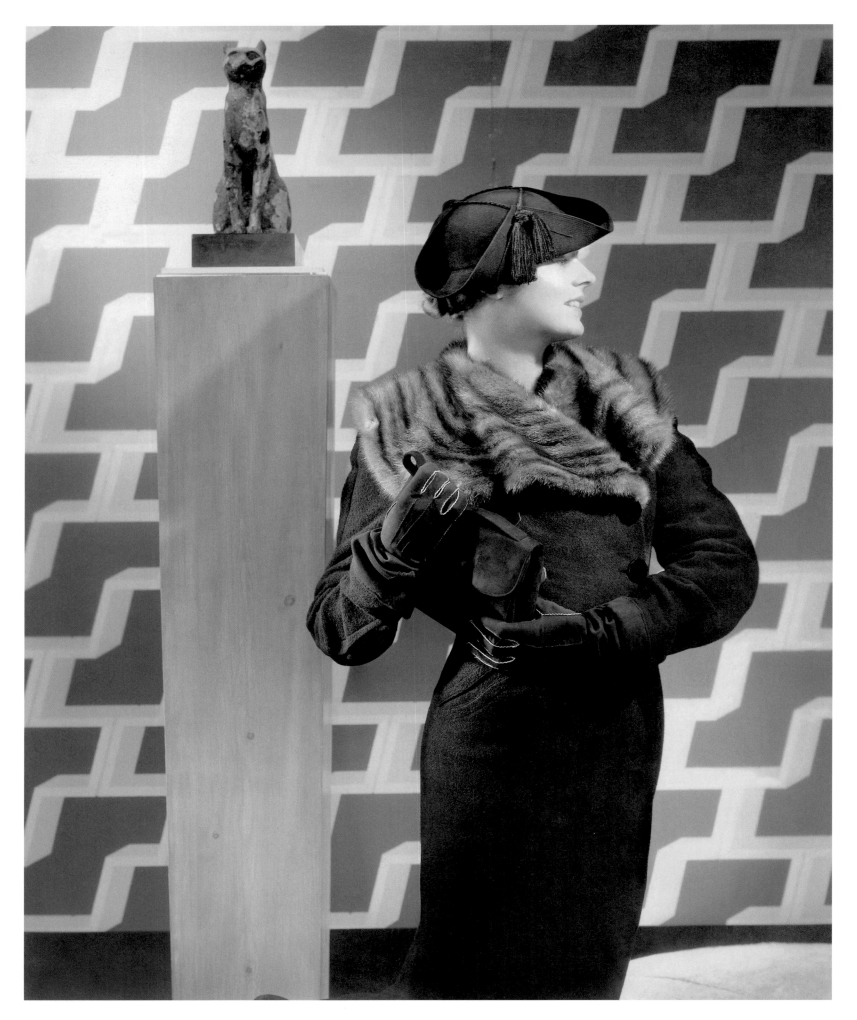

217. MRS. ROBERT JOHNSON IN A COAT WITH MINK COLLAR, 1934

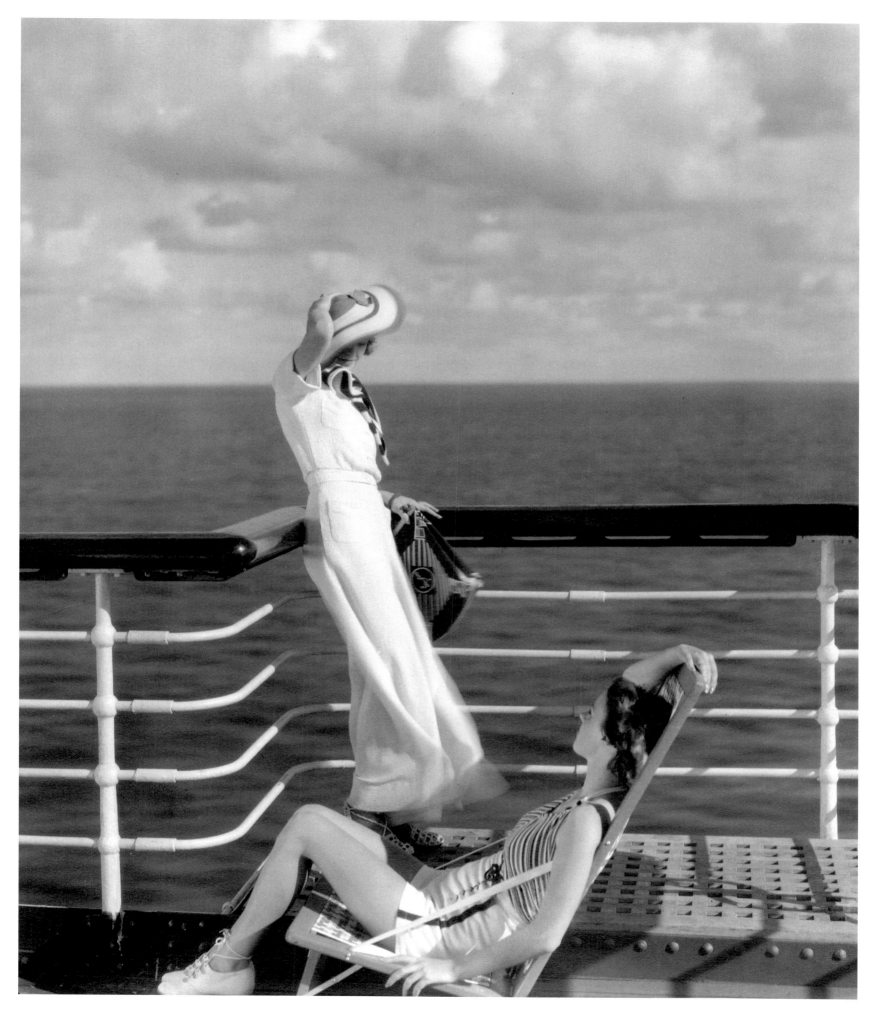

218. ON THE SS *LURLINE*, TO HAWAII, 1934

219. ACTOR CHARLES LAUGHTON, 1935

220. WRITER LUIGI PIRANDELLO, 1935

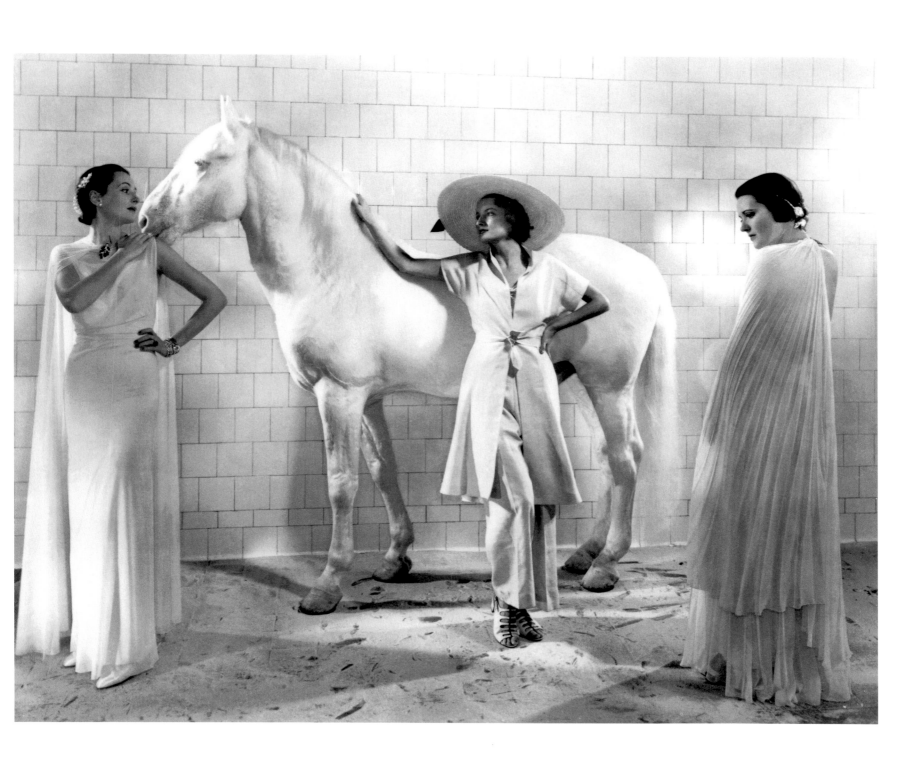

221. "WHITE," 1935

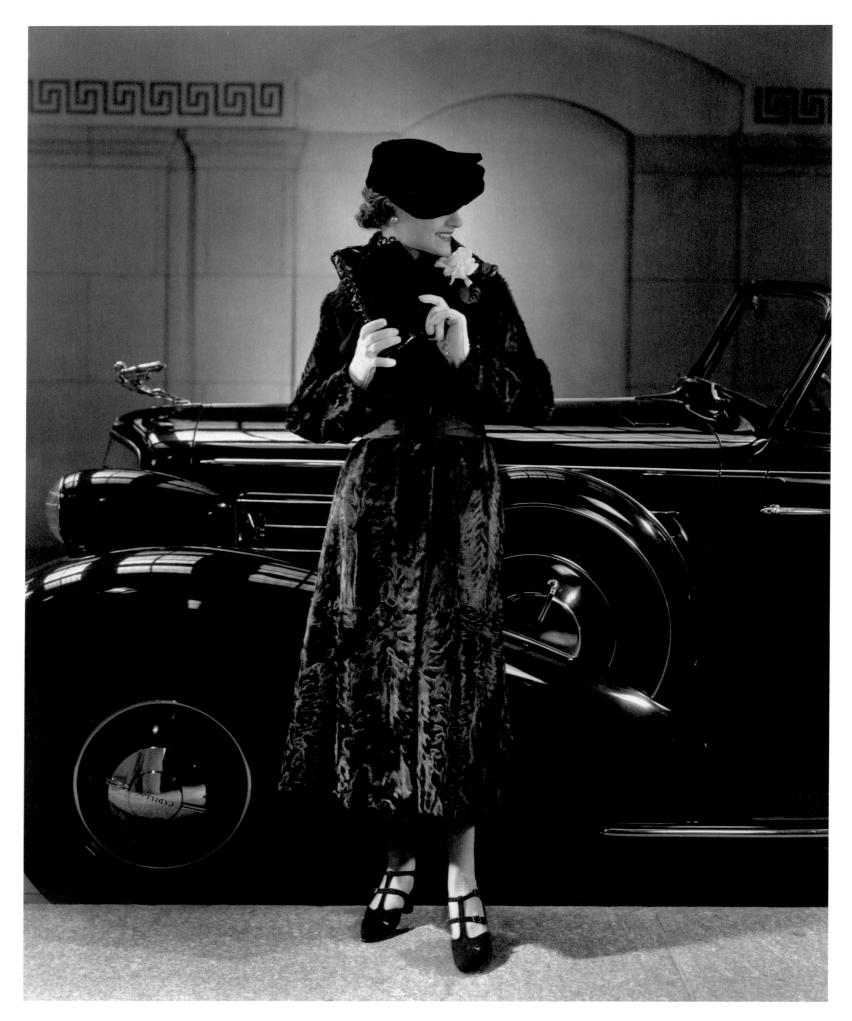

222. MODEL JANE POWELL IN FRONT OF A CADILLAC AT 10 GRACIE SQUARE, 1935

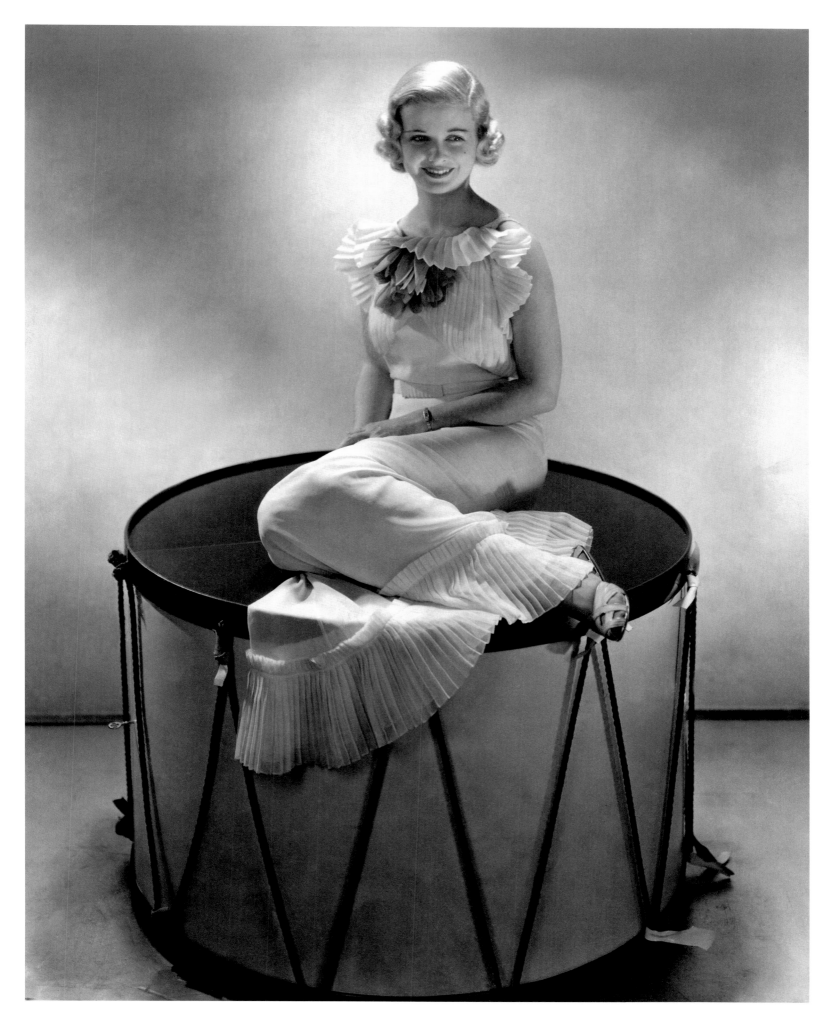

223. ACTRESS JOAN BENNETT, 1935

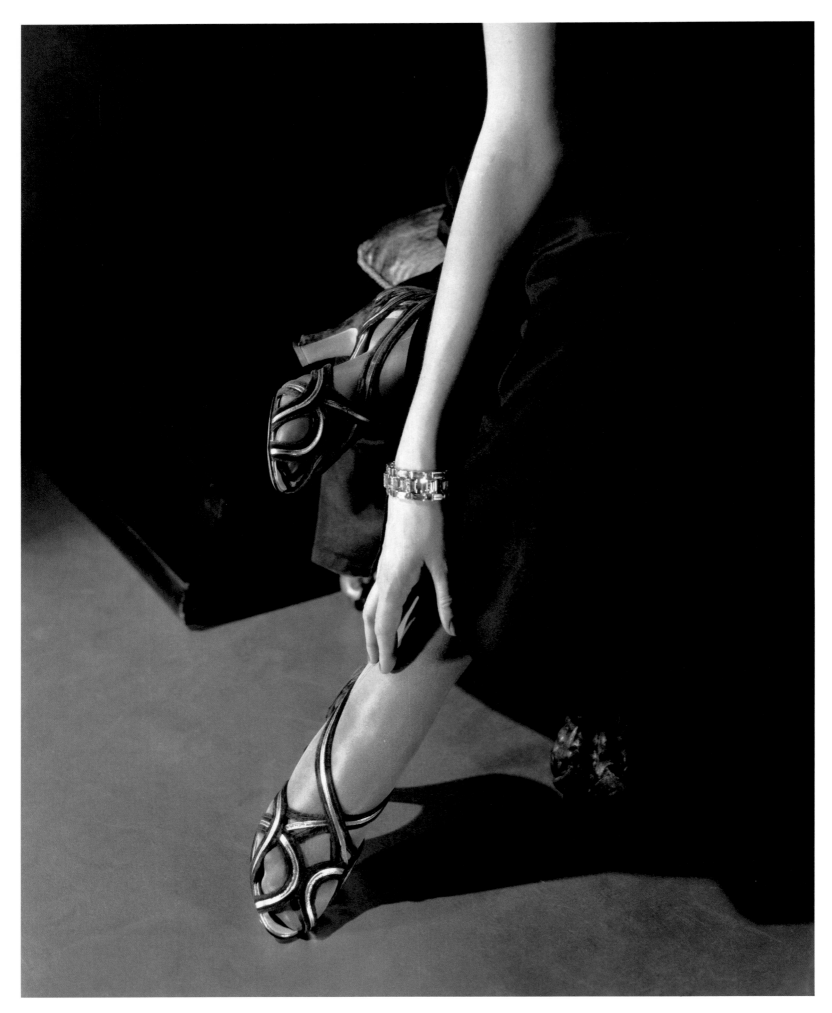

224. PRINCESS NATHALIE PALEY WEARING SANDALS BY SHOECRAFT, 1934

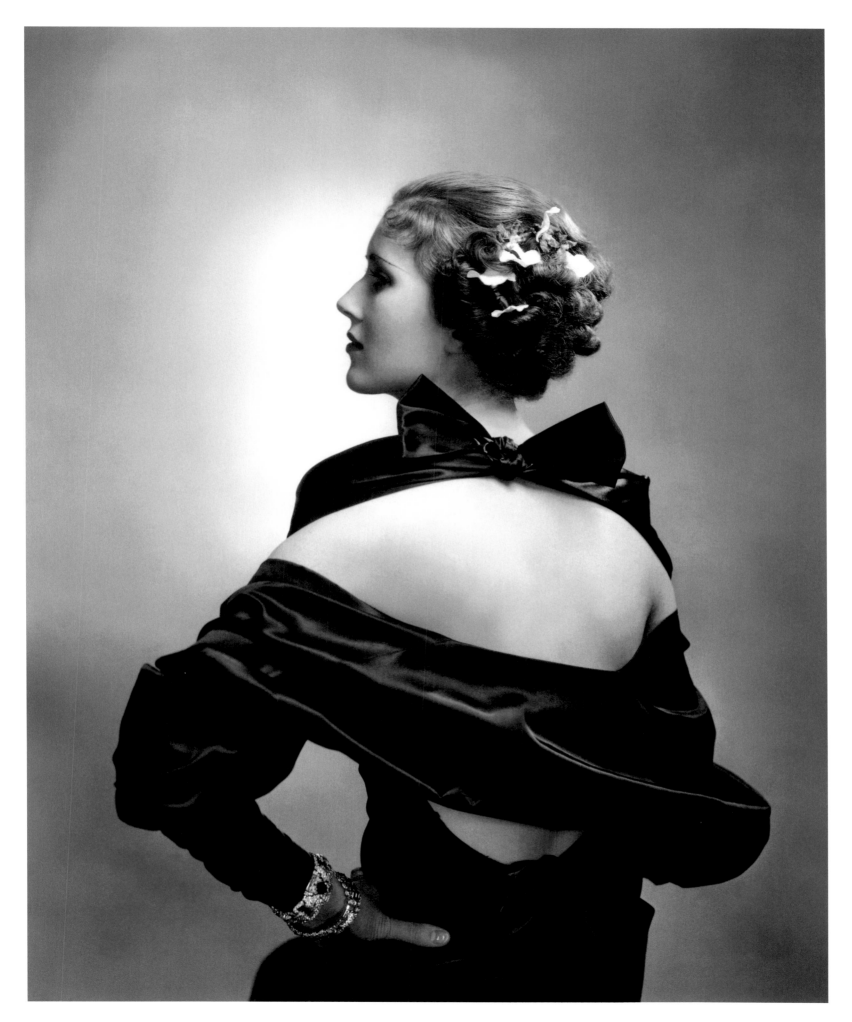

225. ACTRESS MARY HEBERDEN, 1935

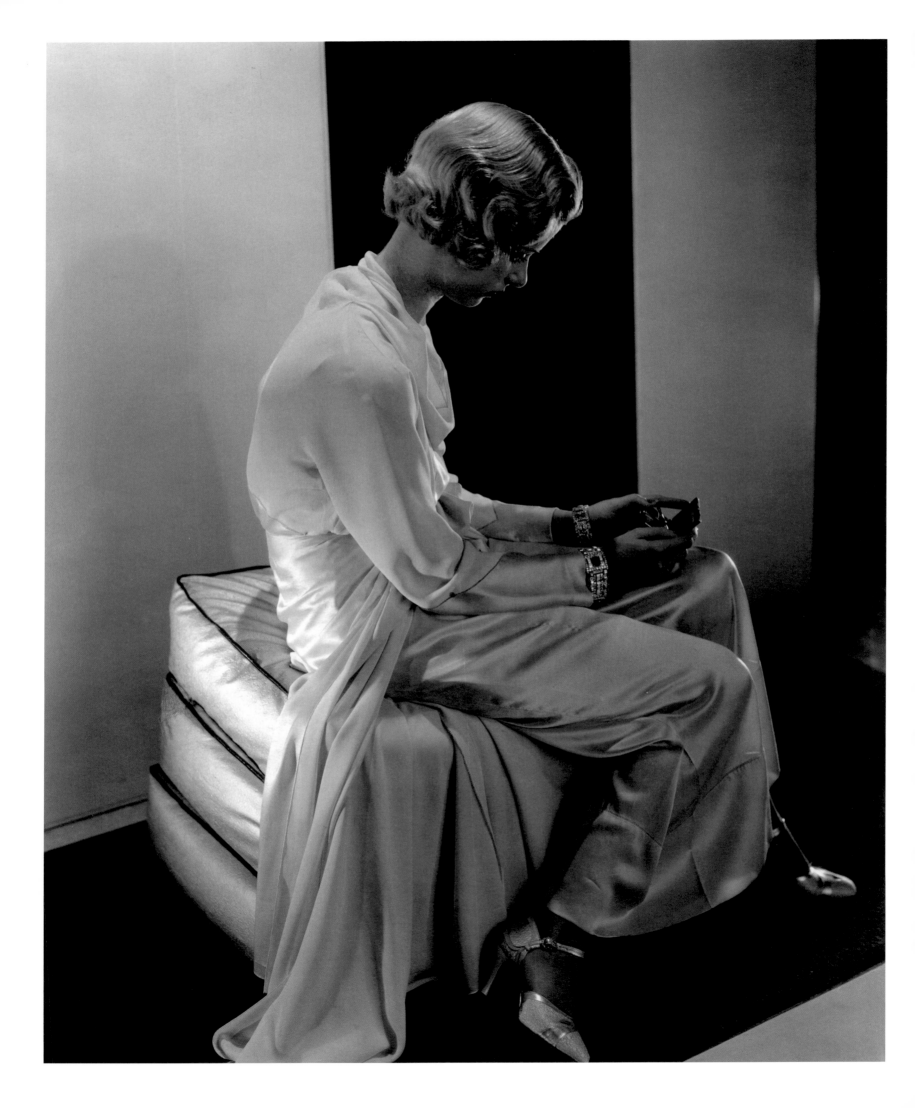

In the Days of Chic

NATHALIE HERSCHDORFER

CHIC [French, probably from German *Schick*, fitness, order, skill...]
(*noun*) 1: artistic cleverness and dexterity especially in painting; 2: easy elegance and sophistication of dress or manner—STYLE, SWANK, CHARM; 3: VOGUE, FASHION, MODISHNESS "the *chic* of the latest hats"
(*adjective*) 1: cleverly stylish, having chic; 2: in vogue, currently fashionable
—*Merriam-Webster's Third New International Unabridged Dictionary*

In 1924, *Vogue* launched a new column, "Guide to Chic," that published the most fashionable addresses in Paris and New York. Even as a new and vibrant consumer culture was emerging in the United States, in tandem with an economic boom in the 1920s, Paris remained the capital of elegance and the benchmark of style. *Vogue* therefore maintained a Paris branch so as to keep a close eye on new trends in French fashion and inform its readers of the latest fabrics, cuts, and finishes.[1]

Elegance and *purity* were the watchwords for *Vogue*, but another term also came to the fore in the 1920s: chic. It evoked good taste, youthfulness, grace, and harmony along with authenticity and simplicity. In this spirit, women on both sides of the Atlantic clamored for Coco Chanel's fashion designs, and bolder women enthusiastically adopted the "garçonne look," inspired by the heroine of Victor Margueritte's 1922 novel *La Garçonne* (translated into English as *The Bachelor Girl* in 1923).

To model the latest designs of the fashion houses, *Vogue* called upon New York's high society, Europe's countesses and duchesses, and the stars of Broadway and silent films. Clara Bow, Lillian Gish, Pola Negri, Mary Pickford, and Gloria Swanson all incarnated chic. In the pages of *Vogue*, fashion photography merged with society photography. Stars of the silver screen slowly replaced the anonymous models of the magazine's early fashion shots. These new ambassadresses of the fashion houses promoted a lifestyle defined by elegance, beauty, and leisure, thus fueling the dreams of countless female readers, from secretaries to high-society ladies.

The emancipation of women during the interwar period could be read in their dress. Changes in fashion conveyed changes in lifestyle that affected all layers of society. Although two styles of dress coexisted after World War I—romantic fashion and flapper fashion—*Vogue* readers tended to identify with modern women whose svelte bodies evoked the image of a woman who was simultaneously feisty and chic. Such a woman was no longer chained to the home, and she adopted behaviors traditionally reserved for men: she could go out on the town, smoke cigarettes, drink alcohol, participate in sports, drive a car (and even fly a plane), travel, vote in elections (from 1920 onward in the United

226. Actress Joan Bennett wearing a satin pajama by Vionnet and slippers by Hattie Carnegie for Bergdorf Goodman, 1930

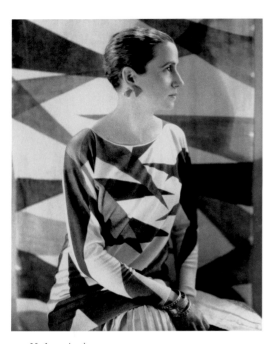

227. Madame Agnès, 1925

States), and hold a job. Marion Morehouse, one of the first professional fashion models and Steichen's muse, represented this new image of women in the pages of *Vogue*—sure of herself, chic, and feminine without being sentimental. By promoting this new ideal of beauty, the magazine backed the emerging trend.

The profile of the modern woman's dress was simple and sober. The straight lines of her garments offered freedom of movement even as they outlined her figure. Beauty was henceforth associated with good health, coinciding with a growing infatuation for sports and an acknowledgment of the beneficial effects of the sun. Clara Bow and Louise Brooks incarnated the new, flapper-style femininity, which was characterized by an androgynous appearance, with chest and hips flattened by the discarding of corsets and multiple layers of cloth. Skirts were shortened, rising from the ankle to the knee in the 1920s, and then dropping again after 1928. Shoe designers devised high heels and began decorating sandals, now that feet could be openly displayed. Age differences narrowed, black could be worn at any time, and hair was cut short.

Nightlife gave birth to fashionable evening clothes. Dresses were slit up the side, made of shiny silks and shimmering satins, and decorated with sequins, beads, or fringes that swayed to the rhythms of jazz music, the Charleston, and the tango. When the line did not follow the body's contours, the emphasis was placed instead on a full, deconstructed silhouette inspired by modern art and embodied by hand-painted silk pajamas and embroidered cashmere shawls. Silk, jersey, and crêpe were soft, comfortable fabrics that suited an active lifestyle. Sportswear—leisure clothing—provided new sources of inspiration for the designers who were creating the modern woman's wardrobe. *Vogue* reflected these changes and provided readers with the addresses of all the chic spots and the most sought-after designers and artists.

In 1925, Paris hosted the Exposition des Arts Décoratifs et Industriels Modernes, which featured the latest trends in interior decoration, furnishings, architecture, and jewelry. The goal of the event was not to spawn a new art, but to display the things that delighted the rich and famous clientele who had become the ambassadors of the Art Deco style. Fashion played a considerable role at this world's fair. In addition to a show of Paul Poiret's designs on three river barges, haute couture was present in a number of pavilions, notably the Pavillon de l'Élégance, which hosted the fashion houses of Lanvin, Jenny, Worth, Callot Soeurs, Madame Paquin, and Madeleine Vionnet. "Modern decorative art finds its application in fashion," stated *Vogue* that year.[2] The magazine's pages henceforth favored the regular, angular, geometric lines of modernism. In addition to Art Deco, inspiration for new fashion came from exotic sources such as Japanese kimonos, Chinese motifs, African art, and Russian furs and embroidery.

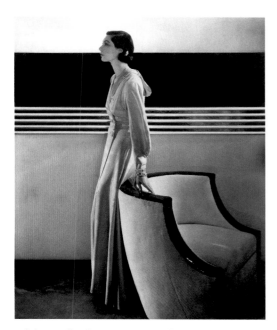

228. Actress Ilka Chase in a long moiré housecoat, jewelry from Black, Starr and Frost-Gorham, 1933

Among the designers hailed by the magazine, Charles Worth is especially noteworthy. Of British origin, Worth set up shop in Paris in 1858 and was the first to establish the connection between dress, style, and celebrity. He was followed by Poiret, whom *Vogue* dubbed the "Prophet of Simplicity" in 1913 and who was represented often in the magazine's pages. Poiret profoundly revamped women's fashion as early as 1903, when he set up his own firm after training under designer Jacques Doucet in the late nineteenth century. Poiret was hailed for favoring form over ornament. His sleek daytime dresses, which raised the waist up to the bustline, provided an ideal canvas for bright, contrasting colors and geometric prints.

Poiret's success waned just as *Vogue* began celebrating Chanel, whose simple designs based on straight lines broke down class barriers and associated elegance with youth. Her garments, adapted to outdoor activities and beach resorts, underscored the movement of the body. She became known for having defined the modern woman's wardrobe in terms of blazers, pleated skirts, soft jackets, berets, and trousers (though *Vogue* would wait until 1939 before picturing ladies in trousers). With Chanel, black became a color that could be worn at any time of day. In 1926, *Vogue* predicted that her soon-to-be-iconic "little black dress" had a future as promising as the Ford Model T automobile.[3]

Other designers were featured in the pages of *Vogue*. Madeleine Vionnet, like Chanel, placed freedom of movement at the heart of her concerns. She had the cloth of her dresses cut on the bias, which helped wed the design to the body and underlined feminine curves. By 1924, she was drawing inspiration from Greek vases and Egyptian frescoes, forging a Neoclassical style that would be reflected in the designs of Lucien Lelong and Augustabernard, triumphing in the 1930s. Jeanne Lanvin, meanwhile, headed the romantic movement and designed dresses in pastel colors trimmed with ribbon, as did Madame Paquin and Callot Soeurs. Lanvin's approach culminated in the *robe de style* with fitted bodice and waist, falling just above the ankle. By 1925, Jean Patou was rebelling against the low-waisted flapper style and took the risk of lengthening skirts, as did Louiseboulanger. Patou's success was confirmed in 1929, when he launched a return to a more feminine silhouette with simplified lines, creating a fashion that would be described as "Parisian." Elsa Schiaparelli, who sought to design clothing for modern women, advocated functional garments that could be variously worn together according to the occasion. Her first evening gown in crêpe de chine would bring her to the attention of the editors at *Vogue* in the 1930s. Her use of padded shoulders in her garments was also popular. Furthermore, Schiaparelli showed creativity by emphasizing ornamentation and designing hats in conjunction with her artist friend Salvador Dalí. Madame Agnès who, like

Schiaparelli, was familiar with modern art, designed hats in collaboration with artists Fernand Léger and Piet Mondrian.

Every type of creation coming from the French fashion designers—from evening gowns to cloaks, from hats to shoes, from accessories to jewelry—was photographed by Steichen with an equal concern for perfection. *Vogue* was the guide to elegance, and its photographs had to incarnate not only the latest trends in women's fashion but also an entire lifestyle. Condé Nast, driven by an aesthetic sensibility, wanted his magazine to educate the tastes of readers on both sides of the Atlantic.

The stock-market crash of 1929 put an end to the euphoria. Massive unemployment followed. French haute couture, dependent on the American market, went through difficult times. Paris still dominated the fashion market but was soon rivaled by London and New York, as a new generation of French-inspired American designers, such as Hattie Carnegie, began designing mass-produced garments to be sold in department stores. Bergdorf Goodman and Saks Fifth Avenue offered their own affordable lines of clothing in addition to designs by Doucet, Jenny, Lanvin, Paquin, Molyneux, and Louiseboulanger.

But in the 1930s, fashion in the United States found another trump card, in Hollywood. The wardrobes of movie stars were cleverly calculated, and Paris fashion houses were highly influential at first. In 1931, Chanel was offered a million dollars to design clothing, for both the screen and everyday life, for the stars at Metro-Goldwyn-Mayer. However, the actresses didn't take to the designs suggested by Chanel, preferring a more glamorous style, so MGM hired young designers to produce the costumes worn in the movies. Glamour took the form of an elegant woman posing sexily in a long, sleek dress of white satin. The influence of Hollywood fashion grew swiftly: the town wear donned by both men and women soon mirrored the image of stars of the silver screen. *Vogue* promoted the trend by having celebrities of the new talking films pose for its photographs. Fred Astaire, Gary Cooper, Marlene Dietrich, Greta Garbo, and Jean Harlow, among others, brought the dream of the chic life to readers from every walk of life. New fashion trends were henceforth born in Hollywood.

The fashion of the 1930s was characterized by a return to well-dressed elegance. Garments became more flowing, while the tailoring accentuated feminine curves. Belts underscored the waistline, skirts flared slightly, and hemlines lengthened. This curvilinear silhouette was accompanied by bare backs and plunging necklines. For daytime, hats were still *de rigueur* and those designed by Caroline Reboux were highly prized. Even if a woman didn't have the means to buy a new dress, she could purchase a fashionable handbag or a pair of gloves to stay on top of the latest trends. Women of the 1930s celebrated

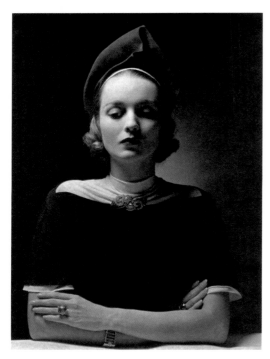

229. Model as Saskia, Rembrandt's wife, wearing a dress and a hat by Bonwit Teller, 1937

a healthy, tanned body; they played outdoor sports and let their hair grow longer. Thanks to new cosmetics, women could imitate the alluring makeup worn by Hollywood stars. The pages of *Vogue* provided models that women could follow, thereby shaping the styles of the day as fashion and celebrity became one and the same.

1. *Vogue* had launched a British edition in 1916 and a French edition in 1920.
2. "L'art décoratif moderne trouve son application dans la mode," *Vogue*, May 1925, quoted in Pierre Cabanne, *Encyclopédie Art Déco* (Paris: Somogy, 1986), 78.
3. "Chanel's Ford Model T," *Vogue*, November 1, 1926.

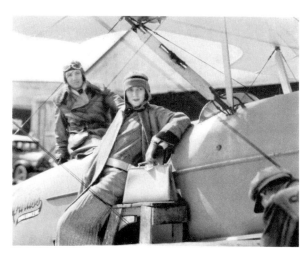

230. Model wearing a costume by J. Suzanne Talbot standing against a Curtiss airplane, 1926

Models and
Sitters:
A Who's Who

NATHALIE HERSCHDORFER

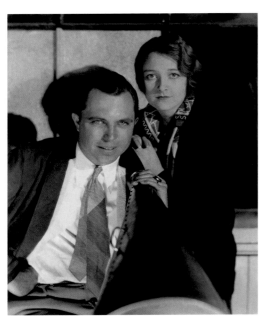

231. Filmmaker King Vidor and his wife, the actress Eleanor Boardman, 1927

Note: Despite efforts to identify all of Steichen's models and sitters, a few gaps remain. A certain number of people slowly vanished from sight–often models from fashionable circles or young women who changed their names upon marriage.

ANDRÉ, GWILI (1908–1959), Danish actress (original name: Gurli Andresen; also known as Jule). André arrived in the United States about 1930 to pursue a career in Hollywood, but met with less success than expected and ceased to appear on-screen after 1942.

ANDRÉ, JULE. See André, Gwili.

ANNABELLA (1910–1996), French actress (original name: Suzanne Georgette Charpentier, known as Annabella, a stage name she chose after reading Edgar Allan Poe's poem "Annabel Lee"). At age fifteen, she was spotted by the French director Abel Gance, who cast her in *Napoléon* (1927). Talkies made Annabella famous throughout Europe, and she was working in Hollywood by 1934.

ARMIDA (1911–1989), Mexican American actress (original name: Armida Vendrell). Under contract to Associated Artists, she became the first Hollywood star of Mexican origin. Armida was a talented dancer, singer, and vaudeville actress. She played opposite John Barrymore in the 1930 film *On the Border*.

ASTAIRE, ADELE (1896–1981), American dancer (original name: Adele Marie Austerlitz). The elder sister of Fred Astaire, she formed a famous music-hall duo with her brother, appearing in the Ziegfeld Follies on Broadway.

ASTAIRE, FRED (1899–1987), American actor, dancer, and choreographer (original name: Frederick Austerlitz). He learned to dance at age seven, performing with his sister Adele. Astaire became famous for his Hollywood tap-dancing sequences from 1933 onward. His style revolutionized musicals, notably in those films in which he starred with Ginger Rogers.

ASTOR, MARY (1906–1987), American actress (original name: Lucille Vasconcellos Langhanke). Astor's career began at age fourteen with a beauty contest, and in 1924 she was cast opposite John Barrymore in the film *Beau Brummel*. After a long period of popularity, her stardom began to fade in the 1940s.

BAINTER, FAY (1891–1968), American actress. Bainter began acting in 1910 and made her Hollywood debut 1934. Her swift success led to an Academy Award for Best Supporting Actress in 1938 for her role in William Wyler's *Jezebel*.

BARRY, ELEANOR, American actress. Barry began her career in 1914 and appeared in many films during the 1920s.

BENNETT, JOAN (1910–1990), American actress, sister of Barbara and Constance Bennett. By age four, she was playing before the footlights, and

in 1929 she launched her screen career. Her sophisticated character was much appreciated in the 1930s and 1940s, notably by George Cukor and Fritz Lang.

BERGNER, ELISABETH (1897–1986), British actress originally from Austria (original name: Elisabeth Ettel). Before the age of twenty, she was performing onstage in Vienna and Zürich as well as posing as a model. She appeared in her first film in 1923, in Germany. She fled Hitler's regime in 1933, first to London and then to the United States during the war. She was nominated for Best Actress in 1935 for *Escape Me Never*.

BOARDMAN, ELEANOR (1898–1991), American actress and model who got her start by posing for Eastman Kodak ads. Spotted by the director King Vidor, Boardman began her acting career in 1923. She then married Vidor and appeared in most of his silent films, slowly fading from the screen starting in the mid-1930s.

BOW, CLARA (1905–1965), American actress nicknamed the "It" girl, after the title of one of her greatest films (1927). Bow was the first actress to became famous for her eroticism. She incarnated a plucky urchin in 1920s movies and was long a leading Hollywood figure despite a pause in her career in the 1930s.

BOWMAN, PATRICIA (1904–1999), American dancer who became famous by performing in musicals. On Broadway she enjoyed a heyday as a ballerina at Radio City Music Hall.

BRADY, ALICE (1892–1939), American actress who broke into the movies as early as 1914. Her father, William A. Brady, was an influential theater producer. Her career took off in the 1930s, and she won an Academy Award for Best Supporting Actress in 1938 for her role in Henry King's *In Old Chicago*.

CARNERA, PRIMO (1906–1967), American prizefighter born in Italy, known for his imposing stature (6 foot 9 inches, 268 pounds). Carnera became the world heavyweight champion in 1933.

CHAPLIN, CHARLIE (1889–1977), British actor, director, musician, screenwriter, and producer (original name: Charles Spencer Chaplin). Chaplin was one of the most creative figures of the silent movies. Within a few years of his successful debut in 1914, he became the highest paid director and the most popular comedian in the world by inventing his own comic persona. Once he began making feature-length films, he retained complete control over the production and distribution of his movies to avoid compromising his artistic freedom.

CHASE, ILKA (1905–1978), American actress and novelist. She was the daughter of Edna Woolman Chase, editor in chief of *Vogue*. Thanks to her mother, Ilka entered New York's fashionable society in 1923 and began her theatrical career on Broadway one year later. She went to

Hollywood in 1926 and from then on alternated between stage and screen appearances. She also wrote several novels.

CHEVALIER, MAURICE (1888–1972), French singer and actor. Chevalier launched his career in Paris, and then in 1929 moved to Hollywood, where he appeared in talking films. He excelled in the music-hall genre. In the late 1930s, he returned to France, where he became typecast as a charming French bachelor wearing a boater hat.

CHURCHILL, WINSTON (1874–1965), British statesman. A conservative member of Parliament who headed several ministries, Churchill served as prime minister from 1940 to 1945 and again from 1951 to 1955. In the 1930s, he devoted much time to lecturing and writing, including the books *My Early Life* (1930), *Thoughts and Adventures* (1932), and *Marlborough: His Life and Times* (1933–38), a biography of his ancestor, John Churchill). Realizing the threat of Nazi Germany as early as 1938, Churchill was the leading figure in Britain's war effort during World War II.

CLAIRE, INA (1883–1985), American actress. Claire was a vaudeville performer in New York prior to World War I and appeared in just a few silent films. She featured in the Ziegfeld Follies in 1915–16 and remained a Broadway favorite in the 1920s.

CLEMENT, JOAN (born 1907), London-born actress and comedian who spent most of her career on Broadway.

COLETTE (1873–1954), French writer (née Sidonie Gabrielle Colette). Colette first earned recognition in the late nineteenth century with her series of "Claudine" novels, published under her husband's pen name, Willy. She then followed a career in vaudeville, between 1906 and 1912, until she became a journalist for *Le Matin*. Literary fame came in the 1920s with novels such as *Chéri*. Colette traveled to the United States in 1935. A recipient of many honors, she was made a grand officer of the Légion d'Honneur and was elected to the Académie Goncourt; furthermore, she is the only Frenchwoman to have been granted a national funeral.

COOPER, GARY (1901–1961), American actor (original name: Frank James Cooper). Cooper began his career in 1925 by playing cowboys, acquiring a reputation for incarnating the Western pioneer. Slowly the range of his parts grew, and he became one of the most respected actors on the American screen. His career spanned forty years and included more than one hundred films made with some of the greatest directors of the classic Hollywood era.

CORNELL, KATHARINE (1893–1974), American actress. Cornell was a great tragic actress who was also highly acclaimed for her character roles on Broadway. Her career began in 1917 and blossomed in the 1920s and 1930s.

COWARD, NOEL (1899–1973), British author, composer, and actor. After his debut on the London stage, he went to New York in 1921. In 1924 he wrote, directed, and performed in *The Vortex*, a play evoking the rampant sex and drug use in high society. Despite the scandal, the play was a success that made Coward famous on both sides of the Atlantic. His subsequent career was notable for the fact that he acted in plays he also wrote and directed.

CRAWFORD, JOAN (1904–1977), American actress (original name: Lucille Fay LeSueur). After a successful debut in 1925, Crawford enjoyed a career in which she chose her roles with care, seeking to transcend her typecast image as a beautiful, sassy young woman. She became an icon of American film and was married to Douglas Fairbanks Jr. from 1929 to 1933. Her influential forty-year career spanned the silent movie era to the 1960s.

DAMITA, LILI (1904–1994), American actress originally from France (original name: Liliane Carré). As a vaudeville star, Damita replaced the famous Mistinguett as the headliner of the revue at the Casino de Paris. Drawn to the movies as early as 1920, she acted in films in Germany and Austria before leaving for Hollywood, where she became a star and married Errol Flynn. She retired from the movies in 1936.

DE MARCO, ANTONIO AND RENÉE, American dancers. The couple enjoyed a heyday in the 1930s.

DEMILLE, CECIL B. (1881–1959), American film producer known for his Hollywood superproductions and historical reconstructions. His movies featured casts of thousands and dealt with subjects of historical, philosophical, and religious interest. He was one of the first producers to attain the status of a star in his own right.

DEMPSEY, JACK (1895–1983), American prizefighter who was heavyweight champion of the world between 1919 and 1926 (original name: William Harrison). His technique made him one of the stars of modern boxing, and a particular weaving move, the "Dempsey roll," was named after him.

DIETRICH, MARLENE (1901–1992), American actress originally from Germany (original name: Maria Magdalena Dietrich). She started acting in movies in 1922, but it was in 1930 that Josef von Sternberg cast her in *The Blue Angel*, Germany's first sound film. Following this major hit, the director took Dietrich to Hollywood. The films that followed forged the Dietrich myth, a combination of elegance, sensuality, and glamour. During World War II, she launched herself on a singing career.

DINARZADE (1896–1987), American fashion model (original name: Lillian Mulligan, becoming, through marriage, Lillian Fischer, then Lillian Farley). She began a career as a model in 1917, when she was hired in New York by the English fashion house Lucile, which is when she adopted the professional name of Dinarzade. She appeared regularly in the pages of *Vogue* and *Harper's Bazaar*. About 1923, she briefly used the stage name Petra Clive. In 1924 the fashion designer Jean Patou hired her to work as model in Paris. In the mid-1930s, she was the Paris editor of *Harper's Bazaar*.

DISNEY, WALT (1901–1966), American screenwriter, director, and producer of Irish descent (original name: Walter Elias Disney). He became a mythical figure as the magnate of an animated-film empire. In 1923 he founded Walt Disney Studios in Hollywood, in 1928 invented the character of Mickey Mouse, and in 1938 made his first animated feature-length movie, *Snow White and the Seven Dwarfs*. This undisputed giant of cartoons won twenty-nine Academy Awards.

DITMARS, RAYMOND LEE (1876–1942), American specialist in herpetology who belonged to the New York Zoological Society. He joined the staff of the Bronx Zoo in 1899, as curator of reptiles, and carried out his research there on reptiles, mammals, and insects. He published some twenty books on reptiles.

EARHART, AMELIA (1897–1937), American aviator. In 1928 she became the first woman to fly across the Atlantic Ocean, repeating the feat—this time solo—in 1932. Among her other records, she was the first woman to make a nonstop flight across the American continent. Earhart was at the height of her fame in the United States when she vanished at sea while attempting to fly around the world from east to west.

EATON, MARY (1901–1948), American actress. She began her career in New York in 1915 and enjoyed a certain success in the Ziegfeld Follies on Broadway in the 1920s. She appeared on-screen with her sisters, Doris and Pearl, and was appreciated for her song-and-dance routines.

EPSTEIN, JACOB (1880–1959), British sculptor, born in New York, who spent much of his career in England. Epstein was a pioneer of modern sculpture and revolutionized ways of looking at the human figure. He executed many sculpted portraits.

FAIRBANKS, DOUGLAS, JR. (1909–2000), American actor. His father had been a leading actor who cofounded Associated Artists with D. W. Griffith and Charlie Chaplin. Douglas Junior began acting in 1923, but his career took off with the arrival of talkies.

FAL DE SAINT PHALLE, MRS. (née Jeanne Jacqueline Harper), wife of French financier André Marie Fal de Saint Phalle, who went bankrupt in the stock-market crash of 1929. She was born into a wealthy American family and divided her time between France and the United States. Among her five children is the renowned artist Niki de Saint Phalle, born in 1930.

FIELDS, W. C. (1880–1946), American actor and writer (original name: William Claude Dukenfield). Considered one of the leading comics of his day, he appeared in the Ziegfeld Follies between 1915 and 1925. At the same time, he acted in short

films. It wasn't until 1925 that he made his feature-film debut, in D. W. Griffith's *Sally of the Sawdust*. He appeared in many films in the 1930s, becoming famous for his cryptic monologues and songs.

FONTANNE, LYNN (1887–1983), British-born actress (original name: Lillie Louise Fontanne) who spent most of her career in the United States. For nearly forty years, she appeared on Broadway, playing opposite her husband, Alfred Lunt, whom she met in 1920. In 1933 Noel Coward wrote a play for the couple, *Design for Living*.

GARBO, GRETA (1905–1990), American actress originally from Sweden (original name: Greta Lovisa Gustafsson). Thanks to her beauty and the legend she wove around herself, Garbo is considered one of the greatest film stars of all time. She began acting in Sweden and Germany, appearing in her first Hollywood movie in 1926. Having successfully made the transition from silent movies to talkies, her career reached a peak in the 1930s. Following the flop of the 1941 George Cukor film *Two-Faced Woman*, she retired from the movies.

GAY, ALDEN (1899–1979), American actress. Gay worked as a fashion model in the 1920s while also performing on the Broadway stage. She then moved to Hollywood where she played an active role in the Screen Actors Guild.

GERAGHTY, AGNES, champion swimmer who won an Olympic medal in 1924 for the 200-meter breaststroke.

GERSHWIN, GEORGE (1898–1937), American composer (original name: Jacob Gershvin). Gershwin composed most of his songs with his brother, Ira, as lyricist. They began collaborating on musical reviews in New York in 1918. Many of their later songs were written for the movies, many of which starred Fred Astaire. Gershwin also composed many classic jazz pieces.

GILBERT, JOHN (1897–1936), American actor (original name: John Cecil Pringle). Gilbert was a silent-movie star who played opposite Mary Pickford and Lillian Gish, though it was his films with Greta Garbo that established his international reputation. Gilbert had a shrill voice, and so talkies put an end to his career.

GISH, LILLIAN (1893–1993), American actress. Gish first went on stage at the age of five, with her sister Dorothy. Spotted by D. W. Griffith in 1912, she acted in a dozen of his films. Her career blossomed in the 1910s, and she remained a star of the silent screen throughout the 1920s. With the arrival of talkies, Gish appeared less frequently on-screen and turned to radio and theater. She made a comeback in the movies in the late 1940s.

GOUDAL, JETTA (1891–1985), French actress of Dutch descent (original name: Julie Henriette Goudeket). After immigrating to the United States about 1915, she made a name for herself on Broadway. Goudal made her screen debut in 1922, became a star in 1925, and was featured in numerous films until 1932.

GRAFTON, PORTIA, American ballerina. She was a member of the Albertina Rasch Dancers, who performed on Broadway in the 1920s. Grafton was the company's prima ballerina.

GRAHAM, MARTHA (1894–1991), American dancer and choreographer. Graham became a professional dancer in 1916 and began teaching dance in 1925, later opening her own school. She founded the Martha Graham Dance Company in 1926. Her technique was based on breathing, contraction, and release. She choreographed 181 ballets in a style that revolutionized twentieth-century dance.

GRAY, GILDA (1901–1959), American actress and dancer, born in Poland (original name: Marianna Winchalaska). In 1919 she launched a dance craze called the "shimmy" by shaking her shoulders and hips while keeping the rest of her body still. The dance became highly popular in film and theater productions of the 1920s.

HAINES, WILLIAM (1900–1973), American actor. He appeared in silent films from 1923 into the 1930s, starring with Mary Pickford and Norma Shearer.

HAMPDEN, WALTER (1879–1955), American actor (original name: Walther Hampden Dougherty). Hampden launched his career in London in 1901. On returning to the United States in 1907, he won recognition as a Shakespearean actor. In 1923 he first played Cyrano de Bergerac, a role he would re-create throughout his career. Hampden was director of the Colonial Theater on Broadway.

HAYWARD, LOUIS (1909–1985), American actor originally from South Africa (original name: Seafield Grant Hayward). He spent his childhood in England, where he met Noel Coward, who gave him his first roles. Hayward then left for the Broadway stage before moving to Hollywood in 1935.

HEBERDEN, MARY, American actress. Heberden had her first New York stage appearance in 1925 and performed regularly on Broadway in the 1930s.

HEPBURN, KATHARINE (1907–2003), American actress and Hollywood icon. After a less than successful stint as a stage actor, Hepburn began her legendary career in the movies in 1932, when she starred with John Barrymore. She then met George Cukor and acted in many of his films. The Hollywood machine of the 1930s turned her into a major star. She won the Academy Award for Best Actress four times.

HOBART, ROSE (1906–2000), American actress. Hobart made her screen debut in 1930, acting in some forty films until the late 1940s, including *Dr. Jekyll and Mr. Hyde* in 1931.

HOCTOR, HARRIET (1905–1977), American dancer known for her performances on Broadway. Hoctor also had a movie career in the 1930s, when she played the role of a dancer in several Hollywood films.

HOOVER, HERBERT (1874–1964), President of the United States, 1929–33. Having served as U.S. Secretary of Commerce, Hoover won the presidential election in November 1928. Not long after his inauguration, he had to face the economic crisis stemming from the stock-market crash of 1929.

HOPKINS, MIRIAM (1902–1972), American actress. Hopkins made her theatrical debut in 1926. Without totally abandoning her stage career, she moved in 1930 to Hollywood, where she acted in films directed by Ernst Lubitsch and Howard Hawks. But having a reputation for being temperamental, she got her best roles from the theater.

HOROWITZ, VLADIMIR (1903–1989), American pianist, born in Russia, of international renown. He studied at the conservatory in Kiev, where he gave his first public recital at the age of seventeen. Starting in 1926 he gave concerts in Europe and, from 1928 onward, in the United States. Based in Paris by 1933, he left France in 1939 to live in New York.

HOWARD, LESLIE (1893–1943), British actor, director, and producer (original name: Leslie Stainer). Howard made his start in the theater but by 1930 found his true calling in the movies. He appeared in many Hollywood films in the 1930s, his most famous part coming in 1939 with *Gone with the Wind*. He returned to Europe during World War II and was killed when his plane was shot down by the Luftwaffe.

HUGHES, LEONORE (b. 1899, d. unknown), American dancer. Hughes and Maurice Mouvet formed a famous dancing couple, performing in cabarets and nightclubs in the United States and Europe. In 1925 Hughes married an Argentinean millionaire, who drowned ten years later.

HULL, CORDELL (1871–1955), American statesman. Hull became U.S. Secretary of State under President Franklin Delano Roosevelt in 1933, remaining in that job for eleven years. In 1945 Hull was awarded the Nobel Peace Prize for his role in founding the United Nations.

HULL, HENRY (1890–1977), American actor famous for the special quality of his voice. He acted in films continuously from 1917 into the 1960s. In 1935 he appeared in the first werewolf movie, *The Werewolf of London*.

JANSSEN, WERNER (1889–1990), American composer and conductor of international renown. After making his start in New York, he traveled widely, notably in Europe, where he conducted many orchestras. In 1934–35, Janssen was conductor of the New York Philharmonic Orchestra.

JENNEY, DANA, American fashion model who posed regularly for *Vogue*.

JOLSON, AL (1886–1950), American singer and actor originally from Lithuania (original name: Asa Yoelson). He immigrated to the United States at an early age and became one of the most

popular vaudeville performers of the late 1920s; he owed much of his fame to radio.

KENYON, DORIS (1897–1979), American actress. Kenyon made her first screen appearance in 1917, and in 1924 acted in one of her most famous movies, *Monsieur Beaucaire*, opposite Rudolph Valentino. She also published a collection of short stories, *Doris Kenyon's Monologues*, in 1929.

LANDI, ELISSA (1904–1948), American actress (original name: Elizabeth Marie Kuehnelt). Landi made her start in London in 1924 and then acted in Hollywood films until 1943. She then returned to the Broadway stage and wrote several novels between 1944 and 1948.

LAUGHTON, CHARLES (1899–1962), American actor and director originally from Britain. With his exceptional acting style, he turned his lack of good looks into an asset. He worked under the greatest directors (DeMille, Preminger, Hitchcock, Wilder, Renoir) while at the same time pursuing a glamorous stage career. He began directing at the age of fifty-six, making *The Night of the Hunter* in 1955.

LAWRENCE, GERTRUDE (1898–1952), British actress and singer (original name: Alexandra Dagmar Lawrence Klasen). A star of the London and Broadway stage, she became Noel Coward's muse. She was famous on both sides of the Atlantic, and her talent was more suited to the theater than to the silver screen.

LE ROY KING, MRS., a New York socialite who was married to a descendent of Peter Stuyvesant, the Dutch governor of New Amsterdam (now New York) in the seventeenth century.

LEWIS, SINCLAIR (1885–1951), American novelist (original name: Harry Sinclair), known for the critical, sarcastic eye he brought to America's capitalist society. Lewis was offered the Pulitzer Prize in 1926 for his caustic novel *Arrowsmith*, but turned it down. In 1930 he was the first American author to win the Nobel Prize for Literature.

LLOYD, HAROLD (1893–1971), American actor and producer. Along with Buster Keaton and Charlie Chaplin, Lloyd was one of the most popular comedians of the silent-film era. By 1917 he was appearing as "the young man with horn-rimmed glasses," a character that made him famous.

LOOS, ANITA (1888–1981), American novelist and screenwriter. From 1912 to 1917, Loos wrote comedies for D. W. Griffith and John Emerson, her husband. She was particularly famous for her 1925 novel *Gentlemen Prefer Blonds*. She worked as a screenwriter on more than sixty films.

LOSCH, TILLY (1903–1975), American dancer originally from Austria. She began training at the Vienna Opera at the age of six and became a professional ballerina at fifteen. Losch appeared in Hollywood films in the 1930s and 1940s, with Fred Astaire as a partner.

LOVE, BESSIE (1898–1986), American actress (original name: Juanita Horton). Spotted by D. W. Griffith, she won her first role in 1915. Her greatest hit was the 1928 musical *Broadway Melody*. Despite that success, she had a hard time making it in talkies.

LUBITSCH, ERNST (1892–1947), American director originally from Germany. After an initial acting career on the stage in Berlin, he began appearing in movies in 1913. The very next year he moved behind the camera, directing actress Pola Negri, among others. In 1922 Lubitsch left for the United States, settling in Hollywood in 1923. He went on to direct countless films.

LUBOVSKA, DÉSIRÉE (1893–1974), American dancer (original name: Winniefred Foote). She adopted her stage name even though she had neither French nor Russian roots. Lubovska was the leading ballerina and artistic director of her own company, the National Ballet Theater.

LUNT, ALFRED (1892–1977), American actor, married to actress Lynn Fontanne. He became a stage star by 1919. Lunt was highly active on Broadway, usually performing opposite his wife, and was also the owner of the Lunt-Fontanne Theater.

LYONS, HELEN, American actress who appeared in several Broadway plays in the 1920s.

MACDONALD, JEANETTE (1903–1965), American actress and singer. She became famous on Broadway for her voice, singing in several musicals until she was noticed by Ernst Lubitsch, who hired her to perform with Maurice Chevalier in his first talkie, *The Love Parade* (1929). In addition to movies, MacDonald performed in operettas after the 1930s.

MANN, THOMAS (1875–1955), German writer. A product of the Munich bourgeoisie, Mann consistently portrayed the decadence of that social class. He published *Death in Venice* in 1912 and *The Magic Mountain* in 1924. In 1929 he was awarded the Nobel Prize for Literature. He moved to Switzerland in 1933 and was stripped of his German nationality three years later. In 1938 he immigrated to the United States.

MCLAUCHLEN, BETTY (died 2002), American fashion model who worked mainly for *Vogue* from the 1930s onward.

MENCKEN, H. L. (1880–1956), American writer, literary critic, and journalist (full name: Henry Louis Mencken). He became famous for his newspaper columns, notably in the *Baltimore Sun*. In 1922 he published the essay "On Being an American," one of the highpoints of his polemical art. Considered a major intellectual figure of the twentieth century, Mencken marked the 1920s with his satirical writings about the United States.

MENJOU, ADOLPHE (1890–1963), American actor born in Paris. By 1912 he was appearing in silent films and on the vaudeville stage. In 1923 he partnered with Pola Negri and convincingly played the role of a man-about-town in Charlie Chaplin's *Woman of Paris*. Menjou was subsequently offered several leading roles in films by Ernst Lubitsch, Josef von Sternberg, and Frank Capra. With the arrival of sound films, he became one of Hollywood's most high-profile actors.

MENKEN, HELEN (1901–1966), American actress of French and German background (original name: Helen Meinken). Menken made her first appearance on the Broadway stage in 1917. She was married to Humphrey Bogart from 1926 to 1928.

MILFORD HAVEN, MARCHIONESS OF (1896–1963) (original name: Countess Nadejda de Torby), daughter of Michael Michaelovich Romanov, grand duke of Russia and cousin of Czar Nicolas II. In London in 1916, she married German-born Prince George of Battenburg [later Mountbatten], second marquess of Milford Haven. She was also a descendent of the Russian poet Aleksandr Pushkin.

MILLER, LEE (1907–1977), American photographer (original name: Elizabeth Miller). She began her professional career by posing as a model for *Vogue* between 1924 and 1929. She then lived in Paris from 1929 to 1932, where she worked with Man Ray and became the Surrealists' muse. Miller also started doing her own portrait and fashion photography, becoming an artist in her own right. In 1944 she worked as a war reporter for the U.S. Army.

MONTEREY, CARLOTTA (1888–1970), American actress (original name: Neilson Taasinge). She began appearing on the Broadway stage in 1915. While performing in the play *The Hairy Ape* in 1921, she met the playwright Eugene O'Neill, whom she married in 1929.

MORAN, LOIS (1909–1990), American actress originally from Ireland. She sang and danced at the Paris Opéra. Moran had her first film hit in 1925 and went on to make many films in which she danced and sang, although her career flagged with the transition to talkies.

MORAND, PAUL (1888–1976), French diplomat and writer. He began a career as a diplomat in 1913, and made his first attempts at literature while working as an attaché in London. In the 1920s and 1930s, he wrote numerous novels, short stories, and travel tales in a strikingly lively style. In 1929 he published *New York*, about life in that city in the 1920s.

MOREHOUSE, MARION (1906–1969), American actress. Morehouse appeared in several Broadway plays in the 1920s, but was above all Steichen's favorite model. She then launched her own career as a photographer. In 1932 she married the poet E. E. Cummings.

MOSES, ROBERT (1888–1981), American urban developer who had a major impact on city planning in New York City between 1930 and 1950. Hired by the city administration, he soon became New York's biggest builder of parks, bridges, and roads.

MOUVET, MAURICE (1888–1927), American dancer originally from Belgium. In 1907 Mouvet first arrived in Paris, where he learned to dance from an Argentinean teacher. He then brought the tango to the United States in 1911. Constantly inventing new steps, he influenced the dance scene of his day by forming famous partnerships, first with Florence Waltron and then with Leonore Hughes.

NAZIMOVA, ALLA (1879–1945), American actress originally from Russia. She immigrated to the United States in 1906 and was appearing on the silver screen by 1916. She acted in numerous films in the 1920s, and then performed mainly on the stage until her return to the movies in the 1940s.

NEGRI, POLA (1894–1987), Polish-born actress (original name: Pola Barbara Apollonia Chalupiec). Negri's screen career began in Poland, but in Germany, Ernst Lubitsch turned her into a star. In 1923 she followed the director to Hollywood and was equally popular there. The transition to talkies nevertheless signaled the end of her career.

NICOLSON, HAROLD GEORGE (1886–1968), British writer, diplomat, and politician. Nicolson married the poet Vita Sackville-West. In the 1920s he published biographies of literary figures such as Paul Verlaine, Charles-Augustin Sainte-Beuve, Alfred Tennyson, and Lord Byron. Prior to 1929, his diplomatic career took him notably to Madrid, Constantinople, and Tehran. From 1931 onward he entered politics and won a seat in Parliament (1935–45).

OAKES, MARY (1909–1997), American actress who began her career as a fashion model for *Vogue*. She began appearing in movies when Samuel Goldwyn, the famous producer, took her to Hollywood in the mid-1930s

OBERON, MERLE (1911–1979), British actress born in India (original name: Estelle Merle O'Brien Thompson). Oberon arrived in London in 1928 and made a reputation for herself by the 1930s, achieving fame when she played opposite Charles Laughton in *The Private Life of Henry VIII*. Hollywood embraced her when she moved there in 1935.

O'NEILL, EUGENE (1888–1953), American playwright. His style, based on the exploration of dark, tormented characters, profoundly influenced American theater. His plays include *The Emperor Jones* (1920), *Desire Under the Elms* (1925), and *Strange Interlude* (1928). He won the Pulitzer Prize in 1920 and the Nobel Prize for Literature in 1936. He was married to actress Carlotta Monterey.

PALEY, PRINCESS NATHALIE (1905–1981), Franco-American actress, born in France of Russian parents (née Natalia Pavlovna Paley). The granddaughter of Czar Alexander II, she lived in Russia until her father and brother were executed by Bolshevik revolutionaries. Having moved to France, in 1927 she married the fashion designer Lucien Lelong. She wore her husband's designs, posed for *Vogue*, socialized with major figures of the day, and had an affair with Jean Cocteau. In 1933 she began her acting career in France, which she then pursued in Hollywood. In 1937 she moved to New York.

PARKER, DOROTHY (1893–1967), American poet and actress (née Dorothy Rothschild). Parker began by writing theater reviews for *Vanity Fair* in 1919, and by 1925 was writing for the *New Yorker*. She enjoyed a very productive writing career, becoming famous for her short stories and poetry. In 1934 she moved to Hollywood and started writing screenplays. She was noted for her caustic humor and her merciless view of the society around her.

PIRANDELLO, LUIGI (1867–1936), Italian author who wrote many short stories and plays. Between 1922 and 1924, he became a major public figure and he ran the Teatro d'Arte di Roma from 1925 onward. He won the Nobel Prize for Literature in 1934.

PITTS, ZASU (1894 or 1898–1963), American actress whose stage name was a contraction of her first two names, Eliza Susan. After getting her start on the stage, Pitts appeared in her first film in 1917. As a star of the silent era, she was cast in her greatest role, in *Greed*, by Erich von Stroheim in 1925.

POLIGNAC, COUNTESS MARIE-BLANCHE DE (1897–1958) (née Marguerite Lanvin), daughter of the fashion designer Jeanne Lanvin. She became Marie-Blanche de Polignac in 1925 on her marriage to Count Jean de Polignac. A talented singer, she nevertheless took over the Lanvin fashion business upon the death of her mother in 1946.

RAWLS, KATHERINE (1918–1982), American champion swimmer of the 1930s. She won more career medals than any other swimmer of her day.

ROBESON, PAUL (1898–1976), American singer and actor (full name: Paul LeRoy Bustill Robeson). Robeson became famous in 1924 for his performance in Eugene O'Neill's *The Emperor Jones*, a role he re-created for the movies in 1933. In the late 1930s he moved to England, where he was better received. His defense of African Americans and his support for the Soviet Union were not always appreciated, and his political convictions alienated him from the film studios.

ROGERS, GINGER (1911–1995), American actress (original name: Virginia Katherine McMath). She made her Broadway debut in 1929, and her appearance in George Gershwin's *Girl Crazy* turned her into a star at the age of nineteen. She went to Hollywood in 1931 and began to shine as an actress, dancer, and singer. Her career really took off thanks to her musical numbers with Fred Astaire; the pair made ten films together.

RUBENS, ALMA (1897–1931), American actress. Rubens became a star at the age of nineteen performing in silent movies. She appeared frequently until 1924 and her career came to an end with talkies.

SEVERN, MARGARET (born 1900), American actress. Severn studied dance first in Denver and then in London, where she lived with her family prior to World War I. On returning to New York in 1915, she began to dance on the Broadway stage. Within a matter of years, she became a well-known performing artist, often wearing highly expressive painted masks. In the 1930s Severn pursued a ballet career in Paris.

SHEARER, NORMA (1902–1983), American actress born in Canada (original name: Edith Norma Shearer). She arrived in New York after World War I, working as an advertising model and an extra in the movies by 1920. Noticed by Irving Thalberg, whom she married several years later, she began acting for the recently founded MGM studios in 1924. Success came quickly, and she made one film after another, garnering an Academy Award in 1930.

SHERMAN, HANNA-LEE (1905–2001), American fashion model who was the great-niece of William Tecumseh Sherman, a Northern general during the Civil War. She not only posed for *Vogue* but also became famous for appearing in several ad campaigns, notably for Chesterfield cigarettes. In 1934 she married Walter W. Stokes, a state senator in New York.

SIDNEY, SYLVIA (1910–1999), American actress born of a Russian father (original name: Sophia Kosow). After studying acting at the Theater Guild School, Sidney made her screen debut in 1927. She was hired by Paramount in 1931, where she made a series of film in the 1930s, notably directed by Fritz Lang and Alfred Hitchcock. She was often cast as a penniless young lady in distress.

STERNBERG, JOSEF VON (1894–1969), American filmmaker originally from Austria (original name: Jonas Sternberg). Sternberg's film career began in New York in 1912, when he cleaned and repaired reels of film. He then worked as an editor, screenwriter, and photographer before becoming an assistant director, a job that took him to Europe. He also did some acting. He directed his first film, *The Salvation Hunters*, in 1925. The following year Charlie Chaplin recommended him for *A Woman by the Sea*, and he was offered an eight-film contract by MGM. In 1930 he directed *The Blue Angel* in Berlin, starring Marlene Dietrich. It was the first in a series of films he would make with Dietrich.

STROHEIM, ERICH VON (1885–1957), American actor and filmmaker originally from Austria (original name: Erich Oswald Stroheim). He immigrated to the United States around 1909 and moved to Hollywood in 1914. First a stunt man, then a film extra, he became an assistant director as well as an actor. He directed his first film in 1919 after having watched D. W. Griffith at work. As an actor, he often played the role of a detestable German officer. From 1928 onward, having been excluded by the film studios, which found him too demanding as a director, he concentrated on his acting career.

SWANSON, GLORIA (1899–1983), American actress (original name: Gloria May Josephine Svensson). Swanson was one of the greatest and most glamorous stars of the silent era. In 1915 she had a small role in a Charlie Chaplin short, *His New Job*. She moved to Hollywood, where she was hired by the Keystone Company. Cecil B. DeMille made her famous in 1919, and her elegance and sensuality marked the films of the 1920s. The transition to talkies prompted her to abandon movies for the theater and radio, but she nevertheless returned to make a few films in the 1950s, notably *Sunset Boulevard* (1950). Her last screen appearance was in 1974, in *Airport 1975*.

TALBOTT, MRS. HAROLD E. (1898–1960) (née Margaret Thayer), wife of Harold Elstner Talbott, a key Chrysler shareholder. His wealth allowed him to finance three presidential campaigns (1940, 1948, 1952), and in 1953 he was appointed Secretary of the Air Force by President Dwight D. Eisenhower.

TALMADGE, NORMA (1893–1957) and CONSTANCE (1897–1973), American actresses. The two sisters were stars of the silent screen, making many films in the 1920s. Another sister, Natalie, was also an actress and married Buster Keaton. The arrival of talkies ended their careers.

TAMARIS. See Tamiris, Helen.

TAMIRIS, HELEN (1903–1966), American dancer and choreographer born into a Russian family (original name: Helen Becker, also known as Helen Tamaris). She studied dance at the Metropolitan Opera and chose the stage name Tamiris for its exotic sound. From 1927 to 1944, she was a solo performer and one of the first choreographers to use jazz and spiritual music. She is recognized as an innovator of modern dance in the United States.

TAYLOR, MARY, American fashion model who posed regularly for *Vogue*.

THALBERG, IRVING (1899–1936), American producer. The son of German immigrants, he became a Hollywood powerhouse. He got his start in 1918 with a job at Universal Studios, and then went on to work with several production firms, including MGM. Thalberg was the first Hollywood producer to stress artistic quality, and he launched the careers of Greta Garbo and Norma Shearer (who became his wife in 1927).

TIBBETT, LAWRENCE (1896–1960), American baritone. After a start as an actor, Tibbett launched a career as a vocalist with the Metropolitan Opera in 1923. Within two years he was a leading baritone and continued to perform for twenty-seven seasons. He became a national legend, appearing all across the country and in Europe as well as in films.

VEIDT, CONRAD (1893–1943), British actor originally from Germany. Veidt began his movie career in Germany in 1917. A key figure of German Expressionist cinema, he was often cast as a madman or murder (notably the sleepwalking murderer in *The Cabinet of Dr. Caligari*, 1919). Between 1926 and 1929, he worked in the United States, but the arrival of talkies took him back to Germany. The rise of Nazism forced him to flee to England, where he pursued his acting career.

VÉLEZ, LUPE (1908–1944), Mexican actress (original name: Maria Guadalupe Velez de Villalobos). After studying dance in 1924, she made her debut at the Teatro Principal in Mexico City. She went to Hollywood in 1927, acting alongside Douglas Fairbanks Jr. She then appeared in numerous films, often playing the part of an exuberant Mexican woman.

VIDOR, KING (1894–1982), American film director. After taking an interest in the movies as an amateur, in 1916 Vidor married an actress and followed her to Hollywood. There he worked as an extra, assistant, accountant, technician, and screenwriter. In 1920 he founded his own studio, Vidor Village, which folded three years later. He then directed sweeping cinematic epics such as *The Big Parade* (1925) and *The Crowd* (1928). He went to Paris with his second wife, Eleanor Boardman. Upon returning to Hollywood in 1929, he directed *Hallelujah!* the first film with an all-black cast. In the early 1950s, for lack of film work, he turned to writing and painting.

WALKER, JUNE (1900–1966), American actress. She became famous in 1926 for her role in the Broadway production of *Gentlemen Prefer Blondes*, which ran for 190 performances. Walker went to Hollywood in the 1930s.

WATKINS, LINDA (1908–1976), American actress. She made her Broadway debut at the age of sixteen. Although popular on the stage, she failed to find the same success in the movies in the 1930s and subsequently returned to the theater.

WATSON, LUCILE (1879–1962), Canadian actress. Her success on Broadway took her to Hollywood, where she appeared in many films in the 1930s and 1940s.

WELLS, H. G. (1866–1946), British writer and historian. He wrote some of the first science-fiction novels, including *The Time Machine* (1895), *The Island of Dr. Moreau* (1896), *The Invisible Man* (1897), and *The War of the Worlds* (1898). In 1922 he wrote a history of the world that enjoyed great popularity. As a socialist intellectual, his influence spread to political circles and he sought to convince people of the need to found a world state.

WILLS, HELEN (1905–1998), American tennis player (full name: Helen Newington Wills). Between 1923 and 1938, Wells won many medals and was considered one of the greatest sportswomen of her day.

WOLHEIM, LOUIS (1880–1931), American actor known for his characteristic broken nose. He got his start in 1917, but only became well known in 1927 after having appeared in many silent films. He was often cast as a gangster.

WONG, ANNA MAY (1905–1961), Chinese American actress (original name: Lu Tsong Wong). Wong was the first actress with Asian features to become a star, and Americans often thought she was a foreigner. She made her screen debut in 1919, achieving recognition in 1924. Wong acted in Europe as well as Hollywood, but her career went into a decline in the 1950s.

WRIGHT, FRANK LLOYD (1867–1959), American architect. Wright got his start in Chicago, working with Louis Sullivan. In 1889 he built a house at Oak Park, the first in his series of Prairie Houses, notable for their horizontal lines that merged with the surrounding landscape. A trip to Japan in 1917 had a major influence on his work, which in turn made a lasting impact on modern architecture. Wright's accomplishments include Fallingwater House (1936) and the Guggenheim Museum in New York (1956–59).

YEATS, WILLIAM BUTLER (1865–1939), Irish poet. Yeats was one of the most important figures in twentieth-century literature. He began writing poetry in the 1880s. Early in the twentieth century, he participated in the Irish literary revival and helped to found the Abbey Theatre (1904). Yeats won the Nobel Prize for Literature in 1923.

YOUNG, LORETTA (1913–2000), American actress (original name: Gretchen Michaela Young). Having moved to Hollywood with her family, she made her screen debut in 1927 at the age of fourteen. Comfortable with both comedy and tragedy, she appeared in numerous films up to the 1950s.

YOUSSOUPOFF, PRINCESS (1895–1970) (née Irina Alexandrovna), grand duchess of Russia, niece of Czar Nicolas II. At age nineteen she married Prince Felix Youssoupoff, who plotted the assassination of Rasputin in 1916. Forced to flee Russia in 1919, the couple went first to London, then to Paris (1920), where they founded the Irfé fashion house. The princess was the firm's main muse and model.

Works in the Exhibition*

(as of October 2007)
*A list of illustrated works not in the exhibition immediately follows.

All works are by Edward Steichen and courtesy the Condé Nast Archive, Condé Nast Publications, Inc., New York, except as noted.

Unless otherwise indicated, all works are gelatin silver prints. The name of the publication in which the image appeared is given, along with the publication date and the page number, when available. Works are listed by the year in which they were taken, not by publication date.

Actor Henry Hull in the play *The Youngest*, 1923
Vogue, March 1, 1925, p. 66
(Fig. 31)

Actor Walter Hampden as Cyrano, 1923
Vanity Fair, January 1, 1924, p. 36
(Fig. 19)

Actors Helen Menken and Will Rogers from the feature film *A Page of Actorplasms*, 1923
Vanity Fair, July 1, 1923, p. 50

Actress Doris Kenyon wearing fashion by Callot, 1923
Vogue, November 15, 1923, p. 46
(Fig. 81)

Actress Mary Eaton from the Follies, 1923
Vanity Fair, September 1, 1923, p. 63
(Fig. 20)

Dancer Gilda Gray as a Javanese dancer, 1923
Vanity Fair, August 1, 1923, p. 43
(Fig. 22)

Dancer Margaret Severn, 1923
Unpublished (for *Vanity Fair*)
(Fig. 21)

Model Jetta Goudal wearing a satin gown by Lanvin, 1923
Vogue, November 1, 1923, p. 59
(Fig. 24)

Actress Alden Gay wearing an evening dress by Chanel, 1924
Vogue, October 15, 1924, p. 62
(Fig. 32)

Actress Betty Blythe wearing a crêpe dress by Lenief and a straw picture hat by Maria Guy, 1924
Vogue, May 1, 1924, p. 63

Actress Carlotta Monterey wearing a diamond head bandeau by Cartier and a white ermine wrap with a white fox collar, 1924
Vogue, January 1, 1925, p. 52
(Fig. 30)

Actress Florence O'Denishawn in a taffeta gown by Gilbert Clarke, 1924
Vogue, June 1, 1924, p. 55

Actress Gertrude Lawrence as Pierrot in André Charlot's play *Mignonette and Maiden-Glow*, 1924
Vanity Fair, April 1, 1924, p. 48
(Fig. 26)

Actress Gloria Swanson, 1924
Vanity Fair, February 1, 1924, p. 49
The Sylvio Perlstein Collection
(Fig. 36)

Actress Gloria Swanson, 1924
Vanity Fair, February 1, 1925, p. 53
(Fig. 34)

Actress Helen Lyons wearing a gown embroidered with crystal beads and an ostrich feather scarf, 1924
Vogue, July 15, 1924, p. 53

Actress Joan Clement, 1924
Vogue, March 1, 1924, p. 44
(page 36)

Actress Lucile Watson in the play *The Far Cry*, 1924
Vogue, December 15, 1924, p. 52
(Fig. 23)

Dancer Désirée Lubovska wearing a brocade evening gown and a tulle scarf by Callot, 1924
Vogue, November 1, 1924, p. 60
(Fig. 29)

Dancers Leonore Hughes and Maurice Mouvet, 1924
Vanity Fair, March 1, 1924, p. 49
(Fig. 41)

Madame Nadine Varda wearing a crêpe evening gown by Chanel, 1924
Vogue, October 1, 1924, p. 59
(Fig. 25)

Model Dinarzade in a dress by Poiret, 1924
Vogue, November 1, 1924, p. 56
(page 12)

Model Dinarzade wearing a crêpe de chine dress by Lanvin, 1924
Vogue, November 1, 1924, p. 61
(Fig. 37)

Model Marion Morehouse wearing an evening gown by Chanel, 1924
Vogue, February 15, 1925, p. 51
(Fig. 33)

Model wearing a pair of Perugia "slippers," 1924
Vogue, December 15, 1924, p. 56

Model wearing a shawl of crêpe de chine hand-painted by Russian artists, 1924
Vogue, December 15, 1924, p. 74
(Fig. 28)

Mrs. Fal de Saint Phalle in a costume by William Weaver for the Persian Fête at the Plaza Hotel, 1924
Vogue, February 15, 1925, p. 64
(Fig. 53)

Princess Youssoupoff, 1924
Vanity Fair, April 15, 1924, p. 38
(Fig. 27)

Model Marion Morehouse in a dress by Chéruit, in Condé Nast's apartment, 1927
Vogue, May 1, 1927, p. 59
(Fig. 90)

Model Marion Morehouse wearing a riding habit, 1927
Vogue, May 1, 1927, p. 116
(Fig. 75)

Model Marion Morehouse wearing fashion by Paquin and a necklace by Black, Starr and Frost, in Condé Nast's apartment, 1927
Vogue, November 1, 1927, p. 70
(Fig. 164)

Producer Irving Thalberg, 1927
Vanity Fair, April 1, 1927, p. 85
(Fig. 68)

Sculptor Jacob Epstein, 1927
Vanity Fair, January 1, 1928, p. 42
Howard Greenberg Gallery, New York
(Fig. 76)

Summer shoes and hat by Henning, 1927
Vogue, June 15, 1927, p. 61
(Fig. 54)

Young girl standing by a garden statue, 1927
Vogue, August 15, 1927, p. 58

Actress Elsie Janis, 1928
Vanity Fair, November 1, 1928, p. 85

Actress Fay Bainter in the Louis Verneuil's play *Jealousy*, 1928
Vanity Fair, January 1, 1929, p. 49
(Fig. 79)

Actress Greta Garbo, 1928
Vanity Fair, August 1, 1932, p. 17
Howard Greenberg Gallery, New York
(Fig. 78)

Actress Joan Bennett, 1928
Vanity Fair, December 1, 1928, p. 76
(Fig. 77)

Actress Lili Damita, 1928
Vanity Fair, August 1, 1928, p. 55
(Fig. 96)

Dancer Irene Castle, 1928
Vanity Fair, February 1, 1929, p. 69

Future President of the United States Herbert Hoover, 1928
Vanity Fair, publication date unknown
Howard Greenberg Gallery, New York
(Fig. 4)

L'Oiseau dans l'espace by Constantin Brancusi and a piano designed by Edward Steichen, 1928
Vogue, May 1, 1928, p. 86
(Fig. 155)

Model Jule André wearing fashion by Daisy Garson, 1928
Vogue, November 15, 1928, p. 66
(Fig. 101)

Model Lee Miller wearing a dress by Jay-Thorpe and a necklace by Marcus, in Condé Nast's apartment, 1928
Vogue, September 1, 1928, p. 62
(Fig. 100)

Model Lee Miller wearing fashion by Chanel and a hat by Reboux, 1928
Vogue, July 15, 1928, p. 57
(Fig. 114)

Model Marion Morehouse wearing a dress by Chéruit and jewelry by Black, Starr and Frost, next to a piano designed by Steichen, 1928
Vogue, May 1, 1928, p. 64
(Fig. 95)

Models June Cox and Lee Miller on George Baher's yacht, wearing navy blazers and white flannel skirts, 1928
Vogue, July 15, 1928, p. 58
(Fig. 97)

Musical comedy actress June Walker, 1928
Vanity Fair, December 1, 1928, p. 62
(Fig. 153)

On George Baher's yacht: June Cox wearing unidentified fashion; E. Vogt wearing fashion by Chanel and a hat by Reboux; Lee Miller wearing a dress by Mae and Hattie Green and a scarf by Chanel; Hanna-Lee Sherman wearing unidentified fashion, 1928
Vogue, July 15, 1928, p. 59
(Fig. 111)

Silhouette of actress Lynn Fontanne for Eugene O'Neill's play *Strange Interlude*, 1928
Vanity Fair, April 1, 1928, p. 53
George Eastman House, International Museum of Photography and Film, Rochester, New York; Bequest of Edward Steichen by Direction of Joanna T. Steichen

Singer Al Jolson, 1928
Vanity Fair, December 1, 1928, p. 69
(Fig. 98)

Screenwriter Anita Loos, c. 1928
Unpublished (for *Vanity Fair*)
(Fig. 104)

Tippin Pero, Gertrude Clarke, and Madame Lassen wearing dresses with the "feeling of Paris couture," at Bergdorf Goodman, 1928
Vogue, May 1, 1928, p. 58
(Fig. 94)

Actor and singer Maurice Chevalier, 1929
Vanity Fair, July 1, 1930, p. 28
(Fig. 118)

Actor Conrad Veidt, 1929
Vanity Fair, October 1, 1929, p. 82
(Fig. 103)

Actress Clara Bow, 1929
Unpublished (for *Vanity Fair*)
(page 8)

Actress Gertrude Lawrence, 1929
Vanity Fair, September 1, 1929, p. 71
(Fig. 108)

Actress Helen Lyons wearing fashion by Mado and jewelry by Marcus, 1929
Vogue, September 15, 1929, p. 84
(Fig. 109)

Actress Sylvia Sidney, 1929
Vanity Fair, August 1, 1929, p. 41
(Fig. 158)

Child model wearing a dress with scallops, 1929
Vogue, August 17, 1929, p. 61
(Fig. 115)

Model Marion Morehouse in a crêpe wrap with white fox collar by Augustabernard, 1929
Vogue, April 27, 1929, p. 65
(Fig. 99)

Model Marion Morehouse in a dress by Louiseboulanger with jewelry by Mauboussin, 1929
Vogue, November 9, 1929, p. 108
(page 120)

Olympic swimming champion Agnes Geraghty, 1929
Vanity Fair, December 1, 1929, p. 92
(Fig. 105)

Pianist Vladimir Horowitz, 1929
Vanity Fair, February 1, 1930, pp. 34–35
(Fig. 107)

Self-Portrait with Photographic Paraphernalia, New York, 1929
Vanity Fair, October 1, 1929, p. 67
(Fig. 113)

Tennis player Helen Wills, 1929
Vogue, October 12, 1929, p. 104
(Fig. 106)

Three children and their nanny, 1929
Vogue, August 17, 1929, p. 60

Writer Paul Morand, 1929
Vanity Fair, April 1, 1929, p. 58
(Fig. 110)

Actor and singer Maurice Chevalier, 1930
Unpublished (for *Vanity Fair*)

Actor Gary Cooper, 1930
Vanity Fair, February 1, 1930, p. 53
Matthieu Humery Collection, Paris
(Fig. 122)

Actor and playwright George S. Kaufman, 1930
Vogue, October 27, 1930, p. 61

Actress Anna May Wong, 1930
Vanity Fair, September 1, 1931, p. 43
(Fig. 116)

Actress Armida, 1930
Vanity Fair, July 1, 1930, p. 45
(Fig. 112)

Actress Loretta Young, 1930
Vanity Fair, August 1, 1930, p. 30
(Fig. 133)

Actress ZaSu Pitts, 1930
Vanity Fair, May 1, 1930, p. 63
(Fig. 125)

Conductor Leopold Stokowski, 1930
Vanity Fair, April 1, 1930, p. 54

Dancer Ginger Rogers, 1930
Vanity Fair, September 1, 1930, p. 47
(Fig. 137)

Dancer Helen Tamiris, 1930
Vanity Fair, December 1, 1930, p. 77
(Fig. 119)

Dancer Tilly Losch, 1930
Vanity Fair, January 4, 1930, p. 52
(Fig. 124)

Model Peggy Boughton wearing a gown by
Lelong and a necklace from Cartier, 1930
Vogue, February 1, 1931, p. 31
(Fig. 131)

Model Marion Morehouse and unidentified model
wearing dresses by Vionnet, 1930
Vogue, October 27, 1930, p. 43
(Fig. 128)

Model Marion Morehouse in a dress by Vionnet,
1930
Vogue, October 27, 1930, p. 42
(Fig. 127)

Actor William Haines, c. 1930
Unpublished (for *Vanity Fair*)
(Fig. 117)

Filmmaker Cecil B. DeMille, c. 1930
Unpublished (for *Vanity Fair*)
(Fig. 136)

Actor Douglas Fairbanks Jr. and his wife, the
actress Joan Crawford, 1931
Vanity Fair, February 1, 1932, p. 50
(Fig. 135)

Actors Lynn Fontanne and Alfred Lunt, 1931
Vanity Fair, June 1, 1931, p. 45
(Fig. 143)

Actors Lynn Fontanne and Alfred Lunt in the play
Elizabeth, The Queen, 1931
Vogue, March 15, 1931, p. 86
(Fig. 149)

Actress Alla Nazimova, 1931
Vanity Fair, November 1, 1931, p. 37
(Fig. 168)

Actress Fay Wray and her husband, the writer
John Monk Saunders, 1931
Vanity Fair, November 1, 1931, p. 40

Actress Joan Bennett, 1931
Unpublished (for *Vanity Fair*)

Actress Linda Watkins, 1931
Vanity Fair, July 1, 1931, p. 26
(Fig. 167)

Actress Loretta Young, 1931
Vanity Fair, October 1, 1932, p. 51

Aviator Amelia Earhart, 1931
Unpublished (for *Vanity Fair*)
(Fig. 138)

Charlie Chaplin, 1931
Vanity Fair, May 1, 1931, pp. 46–47
Howard Greenberg Gallery, New York
(Fig. 17)

Charlie Chaplin, 1931
Vanity Fair, May 1, 1931, pp. 46–47
Howard Greenberg Gallery, New York
(Fig. 18)

Charlie Chaplin, 1931
Vanity Fair, May 1, 1931, pp. 46–47
Howard Greenberg Gallery, New York

Charlie Chaplin, 1931
Vanity Fair, May 1, 1931, pp. 46–47
Howard Greenberg Gallery, New York

Composer George Gershwin, 1931
Vanity Fair, February 1, 1932, p. 31
(Fig. 121)

Dancer Martha Graham in *Primitive Mysteries*, 1931
Vogue, February 15, 1933, p. 55
(Fig. 140)

Filmmaker Josef von Sternberg, 1931
Vanity Fair, March 1, 1932, p. 53
(Fig. 150)

The Marchioness of Milford Haven, 1931
Vogue, April 1, 1931, p. 42
(Fig. 129)

Model wearing fashion by Schiaparelli, 1931
Vogue, November 1, 1931, p. 40
(Fig. 132)

Models Claire Coulter and Avis Newcomb wearing
dresses by Lanvin and Chanel, at 1200 Fifth
Avenue, 1931
Vogue, July 15, 1931, p. 28
(Fig. 130)

Olympic diver Katherine Rawls, 1931
Vanity Fair, September 1, 1932, p. 31
(Fig. 175)

Writer and poet Dorothy Parker, 1931
Vanity Fair, May 1, 1932, p. 35
Howard Greenberg Gallery, New York
(Fig. 120)

Writer H. G. Wells, 1931
Vanity Fair, January 1, 1932, p. 28
(Fig. 126)

Actor and playwright Noel Coward, 1932
[copy print]
Vanity Fair, November 1, 1932, p. 34
(Fig. 172)

Actor and playwright Noel Coward, 1932
Vogue, January 15, 1933, p. 38
(Fig. 213)

Actor Hugh O'Connell in the musical comedy
Face the Music, 1932
Vanity Fair, May 1, 1932, p. 28

Actress Joan Crawford in a dress by Schiaparelli,
1932
Vogue, October 15, 1932, p. 64
(Fig. 171)

Actress Joan Crawford wearing a jacket and a
dress by Schiaparelli, 1932
Vogue, October 15, 1932, p. 65
(Fig. 176)

Actress Lupe Vélez, 1932
Vanity Fair, June 1, 1932, p. 22
(Fig. 142)

Actress Marlene Dietrich, 1932 (printed 1960s)
Originally published in *Vanity Fair*, 1932, and
again in *Vogue*, May 1, 1973, p. 191
Howard Greenberg Gallery, New York
(Fig. 146)

Bronx Zoo curator Raymond Ditmars, 1932
Vanity Fair, August 1, 1932, p. 13
(Fig. 148)

Dancer Harriet Hoctor, 1932
Unpublished (for *Vanity Fair*)
(Fig. 141)

Dancer Patricia Bowman, 1932
Vanity Fair, February 1, 1933, p. 49
(Fig. 174)

Dr. Jekyl and Mr. Hyde, 1932
Vanity Fair, publication date unknown
George Eastman House, International Museum of
Photography and Film, Rochester, New York;
Bequest of Edward Steichen by Direction of
Joanna T. Steichen

First cover of *Vogue* in color, July 1, 1932
(page 14)

Model in a crêpe dinner gown, 1932
Vogue, January 1, 1933, p. 57
(Fig. 156)

Model in a dress by Chanel, 1932
Vogue, May 15, 1932, p. 57
(Fig. 192)

Model wearing a straw hat by Reboux and
jewelry from Mauboussin, 1932
Vogue, March 15, 1932, p. 76
(Fig. 195)

Models Harriet Hamil and Eleanor Barry wearing
dinner gowns, 1932
Vogue, October 15, 1932, p. 31
(Fig. 180)

Models in beachwear, 1932
Vogue, January 1, 1933, p. 60
(Fig. 169)

Models Marion Morehouse and Ruth Covell wear-
ing a cape by Worth and a dress by Vionnet, 1932
Vogue, October 15, 1932, p. 34

Models Marion Morehouse and Ruth Covell wear-
ing a cape by Worth and a dress by Vionnet, 1932
Vogue, October 15, 1932, p. 34

Opera performer Lawrence Tibbett, 1932
Vanity Fair, February 1, 1933, p. 21
(Fig. 151)

Playwright Eugene O'Neill, 1932
Unpublished (for *Vanity Fair*)

Poet William Butler Yeats, 1932
Vanity Fair, January 1, 1933, p. 17
(Fig. 145)

Winston Churchill, 1932
Unpublished (for *Vanity Fair*)
(Fig. 144)

Winston Churchill, 1932
Unpublished (for *Vanity Fair*)
(Fig. 161)

Writer Sinclair Lewis, 1932
Vanity Fair, December 1, 1932, p. 21
(Fig. 147)

Actor Douglas Fairbanks Jr., 1933
Unpublished (for *Vanity Fair*)
(Fig. 185)

Actor Paul Robeson as the Emperor Jones, 1933
Vanity Fair, August 1, 1933, p. 16
Howard Greenberg Gallery, New York
(Fig. 178)

Actress Elissa Landi, 1933
Unpublished (for *Vanity Fair*)
(Fig. 184)

Actress Ilka Chase in a long moiré housecoat, jew-
elry from Black, Starr and Frost-Gorham, 1933
Vogue, November 15, 1933, p. 59
(Fig. 228)

Actress Jeanette MacDonald, 1933
Vanity Fair, December 1, 1933, p. 48
(Fig. 179)

Actress Katharine Hepburn wearing a coat by
Clarepotter, 1933
Vogue, May 15, 1933, p. 60
(Fig. 183)

Actress Katharine Hepburn wearing a summer
dress, 1933
Vogue, June 1, 1933, p. 34

Actress Lois Moran, 1933
Vanity Fair, August 1, 1933, p. 36
(Fig. 199)

Actress Miriam Hopkins, 1933
Vanity Fair, June 1, 1933, p. 39
(Fig. 170)

Actress Norma Shearer wearing an ermine coat by
Hattie Carnegie, 1933
Vogue, October 15, 1933, p. 72
(Fig. 188)

Author and diplomat Harold Nicolson, 1933
Vanity Fair, April 1, 1933, p. 28
(Fig. 197)

Model in a sequined gown, 1933
Vogue, January 1, 1934, p. 56
(Fig. 181)

Model Mary Oakes wearing a fur coat by Peggy
Morris and a hat by Rose Descat, 1933
Vogue, August 1, 1933, p. 52
(Fig. 182)

Model Mary Oakes wearing a leopard fur coat by
Revillon Frères, 1933
Vogue, August 15, 1933, p. 43
(Fig. 187)

Model Mary Oakes wearing fashion by Jay-
Thorpe, 1933
Vogue, July 15, 1933, p. 16
(Fig. 186)

Model wearing a coat by Cheney and gloves by
J. Suzanne Talbot, 1933
Vogue, April 15, 1933, p. 64
(Fig. 11)

Model wearing a hat with black ostrich feathers
and an ostrich feather boa, 1933
Vogue, November 1, 1933, p. 47
(page 16)

Models next to a giant birdcage by Mr. Frankel,
1933
Vogue, February 15, 1933, p. 30

Models wearing evening gowns, 1933
Vogue, January 1, 1934, p. 27
(Fig. 189)

Models with giant birdcage by Mr. Frankel
(model in the center wearing a dress by Lanvin),
1933
Vogue, February 15, 1933, p. 30

Mrs. Walter Maynard wearing a blouse by Kargère
and a hat by John-Frederics, 1933
Vogue, April 15, 1933, p. 47

Mrs. William Wetmore in a dress by Rose Amado
and a bonnet by Sally Victor, 1933
Vogue, October 15, 1933, p. 48
(Fig. 190)

Mrs. William Wetmore wearing a dinner dress by
Augustabernard and a hat by Madame Pauline,
1933
Vogue, October 10, 1933, p. 49

Actor Leslie Howard, 1934
Vanity Fair, November 1, 1934, p. 64

Actress Annabella, 1934
Vanity Fair, July 1, 1934, p. 21
(Fig. 207)

Actress Lillian Gish in the play *Within the Gates*,
1934
Unpublished (for *Vanity Fair*)
(Fig. 194)

Actress Mary Pickford, 1934
Vanity Fair, March 1, 1934, p. 25

Conductor and composer Werner Janssen, 1934
Vanity Fair, December 1, 1934, p. 25
(Fig. 191)

Heavyweight boxing champion Primo Carnera, 1934
Vanity Fair, June 1, 1934, p. 43
(Fig. 201)

Model Elizabeth Blair in a seersucker dress, 1934
Vogue, April 15, 1934, p. 68
(Fig. 206)

Model Mary Taylor walking in a mirrored stairway
designed by Diego de Suarez, 1934
Vogue, January 15, 1935, p. 32

Model posing for "Beauty Primer" on hand and
nail care, 1934
Vogue, June 1, 1934, p. 44
(Fig. 205)

Model wearing a dinner dress by Rose Clark and
sandals by Premier, 1934
Vogue, November 1, 1934, p. 73
(Fig. 200)

Model wearing sandals, 1934
Vogue, June 1, 1934, p. 46
(Fig. 204)

Models Mary Taylor and Mrs. Robert H. McAdoo
wearing the same dress by Vionnet, one in black
taffeta, one in white taffeta, 1934
Vogue, February 1, 1935, p. 54
(Fig. 14)

Models Mary Taylor in a chiffon gown and Anne
Whitehead in a moiré dress; mirrored stairway
designed by Diego de Suarez, 1934
Vogue, January 15, 1935, p. 30
(Fig. 196)

Mrs. Robert Johnson in a coat with mink collar, 1934
Vogue, September 1, 1934, p. 68
(Fig. 217)

On the SS *Lurline*, to Hawaii, 1934
Vogue, July 15, 1934, p. 35
(Fig. 218)

Playwright Eugene O'Neill, 1934
Vanity Fair, April 1, 1934, p. 39
(Fig. 193)

Princess Nathalie Paley wearing a suit by Lelong and a hat by Reboux, 1934
Vogue, January 15, 1935, p. 36

Princess Nathalie Paley wearing sandals by Shoecraft, 1934
Vogue, March 1, 1935, p. 73
(Fig. 224)

Secretary of State Cordell Hull, 1934
Vanity Fair, June 1, 1934, p. 24
(Fig. 203)

Writer Thomas Mann, 1934
Unpublished (for *Vanity Fair*)
(Fig. 92)

Actor Louis Hayward, 1935
Vanity Fair, April 1, 1935, p. 23
(Fig. 215)

Actors Ruth Gordon, Raymond Massey, and Pauline Lord in Edith Wharton's play *Ethan Frome*, 1935
Vanity Fair, February 1, 1936, p. 43

Actress Elisabeth Bergner in the play *Escape Me Never*, 1935
Vanity Fair, April 1, 1935, p. 22
(Fig. 202)

Actress Joan Bennett, 1935
Vogue, July 1, 1935, p. 44
(Fig. 223)

Actress Mary Heberden, 1935
Vogue, March 15, 1935, p. 82
(Fig. 225)

Actress Merle Oberon in the apartment of Helena Rubinstein, 1935
Vogue, April 1, 1935, p. 69
(Fig. 198)

Actress Rose Hobart in a dress by Henri Bendel at the St. Regis Hotel, 1935
Vogue, October 1, 1935, p. 94
(Fig. 211)

"Black": Model Margaret Horan in a black dress by Jay-Thorpe (left) and model Frances Douelon in a black jersey dress (right), 1935
Vogue, November 1, 1935, pp. 68–69
(pages 2–3)

Model Betty McLauchlen in Carroll Carstairs Gallery, 1935
Vogue, October 1, 1935, p. 92
(Fig. 212)

Model Elizabeth Blair in the Steuben Glass Shop, 1935
Vogue, October 1, 1935, p. 93
(Fig. 210)

Model Jane Powell in front of a Cadillac at 10 Gracie Square, 1935
Vogue, August 1, 1935, p. 38
(Fig. 222)

Model wearing a tucked black silk taffeta dress and an Agnès off-the-face taffeta hat, 1935
Vogue, March 15, 1935, p. 80

Models Guy Hayden and Dana Jenney wearing jewelry from Paul Flato, in the St. Regis Hotel, 1935
Vogue, October 1, 1935, p. 95

Models wearing a gown trimmed with tiny pearl buttons (left) and a piqué dress (right), 1935
Vogue, May 15, 1935, p. 71
(Fig. 88)

New York City Park Commissioner Robert Moses, 1935
Vanity Fair, July 1, 1935, p. 19
(Fig. 209)

The renowned ballroom dancing team Antonio de Marco and Renée de Marco, 1935
Vanity Fair, August 1, 1935, p. 43
(Fig. 214)

"White," 1935 [copy print]
Vogue, January 1, 1936, pp. 36–37
(Fig. 221)

Writer Colette, 1935 (printed 1960s)
Originally published in *Vanity Fair*, August 1, 1935, p. 12
Howard Greenberg Gallery, New York
(Fig. 208)

Writer Luigi Pirandello, 1935
Vanity Fair, October 1, 1935, p. 17
(Fig. 220)

Filmmaker Ernst Lubitsch, c. 1935
Unpublished (for *Vanity Fair*)
(Fig. 177)

Actress Gwili André wearing a hat by Rose Descat and jewelry from Tiffany, 1936
Vogue, August 1, 1936, p. 33
(Fig. 216)

Actress Merle Oberon as Messalina in Josef von Sternberg's film *I, Claudius*, in a decor by Bebe Berard, 1937
Vogue, March 1, 1937
George Eastman House, International Museum of Photography and Film, Rochester, New York; Bequest of Edward Steichen by Direction of Joanna T. Steichen
(Fig. 93)

ILLUSTRATED WORKS NOT IN THE EXHIBITION

Unless otherwise noted, works are by Edward Steichen and courtesy the Condé Nast Archive, Condé Nast Publications, Inc., New York.

Dimensions, when provided, are given in inches followed by centimeters; height precedes width.

Parmigianino, *Antea*, c. 1535–38
Oil on canvas, 53³⁄₁₆ x 33⁷⁄₈ (136 x 86)
Gallerie Nazionali di Capodimonte, Naples
(Fig. 163)

Jean-Auguste-Dominique Ingres, *Portrait de Madame Senonnes*, 1814
Oil on canvas, 41³⁄₄ x 25³⁄₁₆ (106 x 64)
Musée des Beaux-Arts, Nantes
(Fig. 165)

Jean-Auguste-Dominique Ingres, *Portrait de Louis-François Bertin*, 1832
Oil on canvas, 45⁵⁄₈ x 37³⁄₈ (116 x 95)
Musée du Louvre, Paris
(Fig. 160)

Women at the piano, 1859 (illustrator unknown)
La Mode Illustrée, January 1859
(Fig. 13)

Charles-Alexandre Giron, *Femme aux gants dite la Parisienne*, 1883
Oil on canvas, 78³⁄₄ x 35¹³⁄₁₆ (200 x 91)
Musée des Beaux-Arts de la Ville de Paris, Petit Palais, Paris
(Fig. 10)

John White Alexander, *Isabella and the Pot of Basil*, 1897
Oil on canvas, 75⁵⁄₈ x 36¹⁄₈ (192.1 x 91.8)
Museum of Fine Arts, Boston, Gift of Ernest Wadsworth Longfellow
(Fig. 7)

The Frost Covered Pool, 1899
Newspaper clipping with the title *Snowbound*, about the Chicago Photographic Salon
The Museum of Modern Art, New York, 1900
(Fig. 2)

La Rose, c. 1901
Gum platinum print, 5¹³⁄₁₆ x 5³⁄₁₆ (14.8 x 13.2)
The Royal Photographic Society Collection at the National Media Museum, Bradford
(Fig. 8)

In Memoriam, 1904
Gum bichromate print, 18³⁄₈ x 14³⁄₁₆ (46.6 x 36)
Musée d'Orsay, Paris
(Fig. 9)

Richard Strauss, 1904
Direct carbon print, 18³⁄₈ x 12⁷⁄₈ (46.7 x 32.7)
The Metropolitan Museum of Art, New York; Alfred Stieglitz Collection, 1949 (49.55.168)
(Fig. 3)

Bakou et Pâtre (gowns by Poiret), 1911
Art et Décoration, April 1911, p. 106
Musée de l'Elysée, Lausanne
(Fig. 16)

Pompon (gowns by Poiret), 1911
Art et Décoration, April 1911, p. 105
Musée de l'Elysée, Lausanne
(Fig. 15)

Lotus, 1915
Platinum print, 9⁹⁄₁₆ x 7⁹⁄₁₆ (24.3 x 19.2)
The Museum of Modern Art, New York, Frances
Keech Bequest
(Fig. 83)

Baron Adolphe de Meyer, Actress Elsie Ferguson
wearing a dress by Callot, 1920
Vogue, February 1, 1920, p. 40
(Fig. 82)

"Terpsichore of Two Continents": Leonore
Hughes, 1923
Vanity Fair, May 1, 1923, p. 38
(Fig. 85)

"The Uptilting Poke Shape Intrigues Reboux":
Leonore Hughes, 1923
Vogue, April 15, 1923, p. 67
(Fig. 84)

Actor Louis Wolheim, 1924
Vanity Fair, December 1, 1924, p. 38
George Eastman House, International Museum of
Photography and Film, Rochester, New York;
Bequest of Edward Steichen by Direction of
Joanna T. Steichen
(Fig. 35)

Dancer Désirée Lubovska, 1924
Vogue, March 1, 1924, p. 55
(Fig. 1)

Actors Lynn Fontanne and Alfred Lunt, 1925
Vanity Fair, August 1, 1925, p. 35
(Fig. 46)

Charlie Chaplin, 1925
Vanity Fair, publication date unknown
Howard Greenberg Gallery, New York
(Fig. 57)

Model in a gown by Vionnet, 1925
Vogue, June 1, 1925, p. 75
George Eastman House, International Museum of
Photography and Film, Rochester, New York;
Bequest of Edward Steichen by Direction of
Joanna T. Steichen
(Fig. 43)

Model wearing a costume by J. Suzanne Talbot
standing against a Curtiss airplane, 1926
Vogue, June 15, 1926, p. 64
(Fig. 230)

Christian Schad, *Mafalda*, 1927
Oil on canvas, 15⅜ x 12⁹⁄₁₆ (39 x 32)
Private collection
(Fig. 159)

Dancer Portia Grafton wearing a beach coat and
shorts by Patou with a top by Kurzman, 1927
Vogue, July 15, 1927, p. 61
(Fig. 74)

Dancer Portia Grafton wearing a two-tiered
flounce-skirted satin gown by Patou, 1927
Vogue, November 1, 1927, p. 65
(Fig. 166)

"Paris Still Wears Red," 1927
Vogue, January 15, 1927, pp. 86–87
(page 13, left)

Christian Schad, *Lotte; die Berlinerin*, 1927–28
Oil on wooden board, 26⁹⁄₁₆ x 21⁷⁄₁₆ (66.2 x 54.5)
Sprengel Museum, Hannover
(Fig. 154)

Actors Greta Garbo and John Gilbert, 1928
Vanity Fair, December 1, 1928, p. 89
George Eastman House, International Museum of
Photography and Film, Rochester, New York;
Bequest of Edward Steichen by Direction of
Joanna T. Steichen
(Fig. 102)

Condé Nast's apartment, 1928 (unidentified
photographer)
Vogue, August 1, 1928, p. 44
(Fig. 87)

Actress Joan Bennett wearing a satin pajama by
Vionnet and slippers by Hattie Carnegie for
Bergdorf Goodman, 1930
Vogue, November 24, 1930, p. 56
(Fig. 226)

Kees van Dongen, *Anna de Noailles*, 1931
Oil on canvas, 77³⁄₁₆ x 51⁹⁄₁₆ (196 x 131)
Stedelijk Museum, Amsterdam
(Fig. 157)

Actress Norma Shearer with the producer Irving
Thalberg, 1931
Vanity Fair, March 1, 1932, p. 48
(Fig. 134)

Dancer Martha Graham, 1931
Vanity Fair, December 1931, p. 50
The Richard and Jackie Hollander Collection,
Los Angeles
(Fig. 123)

Actor and playwright Noel Coward, 1932
(printed 1961)
Gelatin silver print, 16⁹⁄₁₆ x 13⁵⁄₁₆ (42.1 x 33.8)
The Museum of Modern Art, New York; Gift of
the photographer, 1961
(page 4)

Architect Frank Lloyd Wright, c. 1932
Vanity Fair, publication date unknown
Howard Greenberg Gallery, New York
(Fig. 139)

Actress Mary Astor, 1933
Vanity Fair, November 1, 1933, p. 47
(Fig. 173)

Walt Disney, 1933
Vanity Fair, October 1, 1933, p. 26
Gary Davis Collection, United States
(Fig. 152)

Model wearing a hat by Molyneux and a dress by
Bergdorf Goodman; other hats by Sally Victor and
Madame Agnès, 1934
Vogue, January 1, 1935, p. 51
(Fig. 89)

Mrs. Harold E. Talbott, Westbury, Long Island,
1934
Vogue, October 1, 1934, p. 46
The Richard and Jackie Hollander Collection,
Los Angeles
(page 198)

Actor Charles Laughton, 1935
Vanity Fair, August 1, 1935, p. 17
Howard Greenberg Gallery, New York
(Fig. 219)

Black top on crêpe sheath by Jay-Thorpe and
black taffeta dress by Saks Fifth Avenue, 1935
Vogue, September 1, 1937, p. 119
The Richard and Jackie Hollander Collection,
Los Angeles
(page 10)

"Have You Heard," 1935
Vogue, July 1, 1935, p. 58
(Fig. 91)

"Viva Velvet," 1936
Vogue, September 1, 1936, pp. 108–9
(page 13, right)

Model as Saskia, Rembrandt's wife, wearing a
dress and a hat by Bonwit Teller, 1937
Vogue, February 15, 1937, p. 52
(Fig. 229)

Notes on the Contributors

TOBIA BEZZOLA is a curator at the Kunsthaus Zürich. His numerous exhibitions and catalogues include *Max Beckmann and Paris*, *Alberto Giacometti 1901–2001*, *Sade/Surreal*, *Wallflowers: Large-Format Photography*, *La décision de l'oeil: Henri Cartier-Bresson and Alberto Giacometti*, *The Art of the Archive: Photographs from the Archive of the Los Angeles Police Department*, *Miroslav Tichý*, *André Breton—Dossier Dada*, *In the Alps*, and *Erwin Wurm: Hamlet*.

TODD BRANDOW is the founder and director of the Foundation for the Exhibition of Photography and a curator. His recent curatorial projects include *Sacred Legacy: Edward S. Curtis and the North American Indian*, *Saga: Arno Rafael Minkkinen, Thirty-five Years of Photographs*, and *Edward Steichen: Lives in Photography*.

WILLIAM A. EWING is an internationally known author and curator who has worked with many museums over the years. He is currently director of the Musée de l'Elysée in Lausanne. He has written many books on diverse aspects of photography, including *Edward Steichen: Lives in Photography*, *Flora Photographica*, *The Body*, and *Love and Desire*. He has also specialized in the field of fashion photography, producing major retrospectives of the works of George Hoyningen-Huene, Horst P. Horst, and Erwin Blumenfeld. He teaches at the University of Geneva.

NATHALIE HERSCHDORFER is an associate curator at the Musée de l'Elysée in Lausanne, responsible for the organization of major international traveling exhibitions, including *Edward Steichen: Lives in Photography*, *About Face: The Death of the Photographic Portrait*, *ReGeneration: 50 Photographers of Tomorrow*, *Leonard Freed: Worldview*, and *Ray K. Metzker: Light Lines*.

CAROL SQUIERS is a writer, editor, and curator at the International Center of Photography, New York. Her essays have appeared in *Artforum*, the *New York Times*, *Vogue*, *Vanity Fair*, *Parkett*, *Art in America*, and *Aperture*, and she has contributed to a number of publications, including *Strangers: The First ICP Triennial of Photography and Video* and *Barbara Kruger: A Retrospective*. She is the author of *The Body at Risk: Photography of Disorder, Illness, and Healing* and the editor of *Overexposed: Essays on Contemporary Photography*.

Index

Edward Steichen: In High Fashion, The Condé Nast Years, 1923–1937 was curated by William A. Ewing, Todd Brandow, Carol Squiers, and Nathalie Herschdorfer.

The accompanying publication was organized by Todd Brandow with the assistance of Nathalie Herschdorfer, Pauline Martin, and John Roth. Images were sequenced by William A. Ewing.

Project director: Mary DelMonico

Designer: Katy Homans

Editor: Michelle Piranio

Proofreader: Richard G. Gallin

Indexer: Nancy Wolff

Separations: Martin Senn

Printing and binding: Conti Tipocolor, Italy

The book is typeset in Bodoni Old Face and Didot and printed on GardaPat 13 Kiara.

REPRODUCTION AND PHOTOGRAPH CREDITS

Except as noted below, all images are courtesy of Condé Nast Archive, Condé Nast Publications, Inc., New York/Paul Hawryluk, Dawn Lucas, and Rachael Smalley.

© 2007 ADAGP, Paris: 187, 189 (bottom), 191
Courtesy of Tobia Bezzola: 194, 196
Collection of Gary S. Davis, United States/Billy Jim: 185
George Eastman House/Barbara Puorro Galasso: 55, 65, 118, 131, 179
The Richard and Jackie Hollander Collection, Los Angeles/John S. Sullivan: 10, 154, 198
Howard Greenberg Gallery, New York/Martin Senn: 21 (bottom), 32 (top and bottom), 81, 102, 105, 150, 171, 212, 256
Matthieu Humery Collection/Philippe Machecourt: 153
© 1998 The Metropolitan Museum of Art: 21 (top)
Courtesy Musée de l'Elysée, Lausanne: 29 (top), 30, 31
© Musée du Petit Palais/Roger-Viollet: 26
Photograph © 2007 Museum of Fine Arts, Boston: 24
© The Museum of Modern Art/Licensed by SCALA/Art Resource, New York: 4, 20, 57, 110
National Media Museum/Science & Society Picture Library/Paul Thompson: 25 (top)
Réunion des Musées Nationaux/Art Resource, New York/Christian Jean: 192 (top)
Réunion des Musées Nationaux/Art Resource, New York/Patrice Schmidt: 25 (bottom)
Sprengel Museum Hannover/Michael Herling/Aline Gwose: 187
Stedelijk Museum, Amsterdam: 189 (bottom)
Courtesy of Joanna T. Steichen: 20, 55, 65, 110, 118, 131, 179